THE BiG BOOK OF LAYOUTS

THE BiG BOOK OF LAYOUTS

Editor David E. Carter

COLLINS | DESIGN

An Imprint of HarperCollins*Publishers*

HarperCollins books may be purchased for educational, business, or sales promotional use.
For information, please write: Special Markets Department, HarperCollins*Publishers*,
10 East 53rd Street, New York, NY 10022.

First Paperback Edition

First published in 2006 by:
Collins Design
An Imprint of HarperCollins*Publishers*
10 East 53rd Street
New York, NY 10022
Tel: (212) 207-7000
Fax: (212) 207-7654
collinsdesign@harpercollins.com
www.harpercollins.com

Distributed throughout the world by:
HarperCollins*Publishers*
10 East 53rd Street
New York, NY 10022
Fax: (212) 207-7654

Book Design by Designs on You!
Suzanna and Anthony Stephens

Library of Congress Control Number: 2006930941

ISBN: 978-0-06-162675-3

Produced by Crescent Hill Books, Louisville, KY.
www.crescenthillbooks.com

Printed in China

First Paperback Printing, 2009

TABLE OF
CONTENTS

First, you gotta get their
ATTENTION!

So, when a [pick one:]

☐ ART DIRECTOR

☐ VISUAL ARTIST

☐ GRAPHIC DESIGNER

starts a project, the beginning step is the layout.

To put it simply, a good layout attracts attention, then leads the viewer's eyes through the piece the way a conductor leads an orchestra.

Good layouts are the beginning of all effective visual communications, and bad layouts… well, bad layouts quickly kill the potential effectiveness of a piece faster than you can say "Ben Day."

This book has a single purpose: *to help designers create inspired layouts*. Within these covers, you will find more than 750 effective layouts. Each was selected for its ability to help you in the process of what I call "solitary brainstorming."

D. Carter himself

WHAT MAK ES

DESIGN

UNIQUE

AND

IMELESS T

?

DESIGN FIRM
A3 Design
Charlotte, (NC) USA
PROJECT
Unique and Timeless Design
DESIGNERS
Alan Altman,
Amanda Altman

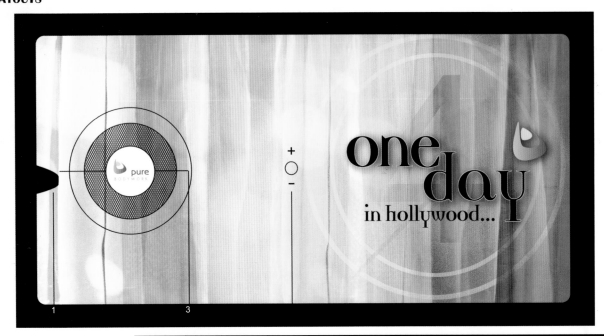

one
day
in hollywood...

1

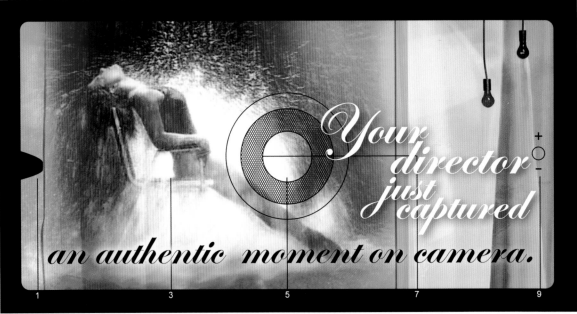

Your director just captured

an authentic moment on camera.

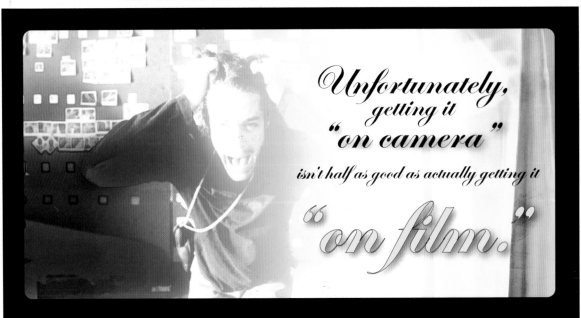

Unfortunately,
getting it
" on camera "
isn't half as good as actually getting it
" on film. "

1 _____

DESIGN FIRM
 JUNGLE 8/creative
 Los Angeles, (CA) USA
CLIENT
 Pure Body Works
CREATIVE DIRECTOR
 Lainie Siegel
DESIGNERS
 Lainie Siegel,
 Justin Cram,
 Gracie Cota
COPYWRITER
 Scott Silverman

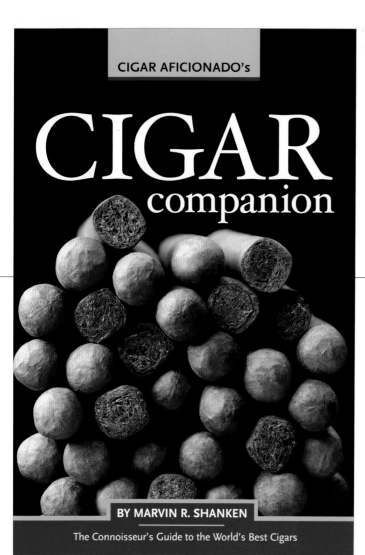

2_____

2_____
DESIGN FIRM
M. Shanken
Communications, Inc.
New York, (NY) USA
PROJECT
Cigar Aficionado's
Cigar Companion
ART DIRECTOR, DESIGNER
Chandra Hira
PHOTOGRAPHER
Bill Milne

3_____
DESIGN FIRM
Octavo Designs
Frederick, (MD) USA
CLIENT
National Association of
School Psychologists
ART DIRECTOR, DESIGNER
Sue Hough

3_____

DESIGN FIRM
Velocity Design Works
Winnipeg, (Manitoba) Canada
PROJECT
Child Find
CREATIVE DIRECTOR, ART DIRECTOR,
DESIGNER
Lasha Orzechowski
ILLUSTRATORS
Lasha Orzechowski, Eric Peters

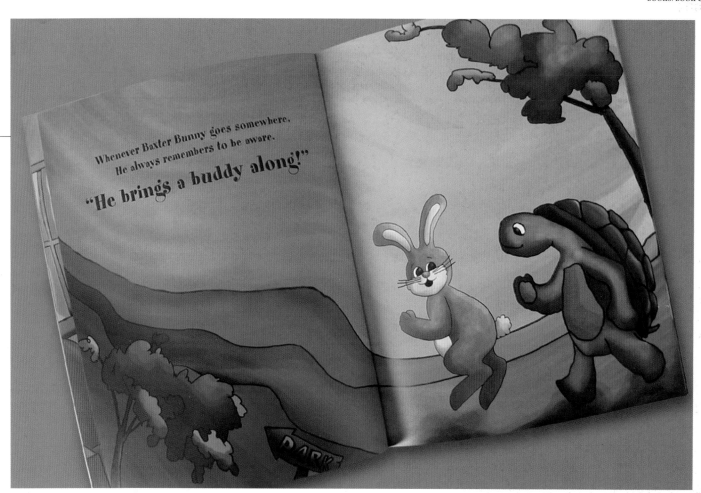

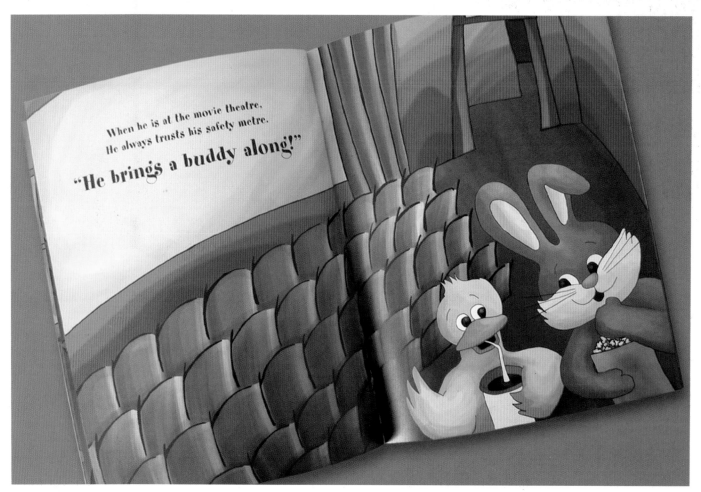

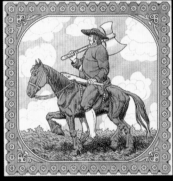

Napisal
FRAN LEVSTIK

Podobe naslikal
Hinko Smrekar

PREŠERNOVA DRUŽBA

DESIGN FIRM
KROG, Ljubljana
Ljubljana, Slovenia
CLIENT
Presernova druzba, Ljubljana
ART DIRECTOR, DESIGNER
Edi Berk
COPYWRITER
Fran Levstik
ILLUSTRATOR
Hinko Smrekar

BRDAVS! BRDAVS!

Ko prideta na DUNAJ, je bilo vse mesto

ČRNO PREGRNJENO;

ljudje so pa klavrno lazili, kakor mravlje,

kadar se jim zapali mravljišče.

Krpan vpraša: »Kaj pa vam je, da vse žaluje?«
»O, Brdavs! Brdavs!« vpije malo in veliko, možje in žene.
»Ravno danes je umoril cesarjevega sina, ki ga je globoko v srce pekla
sramota, da bi ne imela krona junaka pod sabo, kateri bi se ne bal velikana.
Šel se je ž njim skusiti; ali kaj pomaga? Kakor drugim, tako njemu. Do zdaj
se še nihče ni vrnil iz boja.«

KRPAN

veli urno pognati in tako prideta na cesarski dvor, ki pravijo, da je neki silo
velik in jako lep. Tam stoji straža vedno pri vratih noč in dan, v letu in zimi,
naj bo še tako mraz; in brž je zavpila o Krpanovem prihodu, kakor imajo
navado, kadar se pripelja kdo cesarske rodovine. Bilo je namreč naročeno
že štirinajst dni dan za dnevom, da naj se nikomur in nikoli ne oglasi, samo
tačas, kadar se bo pripeljal tak in tak človek.

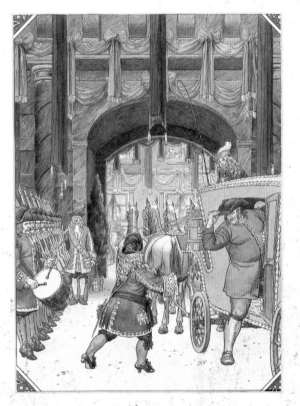

Krpan veli urno pognati in tako prideta na cesarski dvor.

V Notranjskem

stoji vas, Vrh po imenu.
V tej vasici je živel v starih časih
KRPAN,

močan in silen človek. Bil je neki tolik, da ga ni kmalu takega. Dela mu ni bilo mar; ampak nosil je od morja na svoji kobilici angleško sol, kar je bilo pa že tistikrat ostro prepovedano. Pazili so ga mejači, da bi ga kje skrivaj zalezli; poštenega boja ž njim so se bali ravno tako, kakor pozneje Štempiharja. Krpan se je pa vedno umikal in gledal, da mu niso mogli do živega.

Bilo je pozimi, in sneg je ležal krog in krog. Držala je samo ozka gaz, ljudem dovoljna, od vasi do vasi, ker takrat še ni bilo tako cest kakor dandanes. V naših časih je to vse drugače, se ve da; saj imamo, hvalo Bogu, cesto do vsakega zelnika. Nesel je Krpan po ozki gazi na svoji kobilici nekoliko stotov soli; kar mu naproti priženketa lep voz; na vozu je pa sedel cesar Janez, ki se je ravno peljal v Trst. Krpan je bil kmetiški človek, zato ga tudi ni poznal; pa saj ni bilo časa dolgo ozirati se; še odkriti se ni utegnil, temveč prime brž kobilico in tovor ž njo, pa jo prenese v stran, da bi je voz ne podrl. Menite, da je Krpana to kaj mudilo kali? Bilo mu je, kakor komu drugemu stol prestaviti.

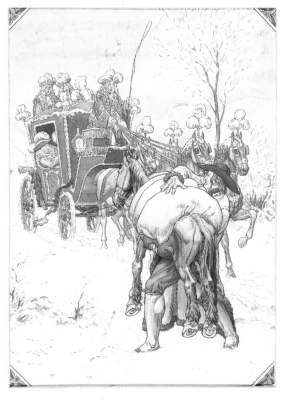

Prime brž kobilico in tovor ž njo, pa jo prenese v stran, da bi je voz ne podrl.

TO IZREČE ...

URNO

zasukneta vsaki svojega konja in
zdirjata si od daleč zopet nasproti.
BRDAVS

visoko vzdigne meč, da bi že v prvem odsekal sovražniku glavo; ali ta mu urno podstavi svoj kij, da se meč globoko zadere v mehko lipovino; in preden ga velikan more izdreti, odjaha

KRPAN

z male kobilice, potegne Brdavsa na tla, pa ga položi, kakor bi otroka v zibel deval, ter mu stopi za vrat in reče:

»No, zdaj pa le hitro izmoli en očenaš ali dva, in pa svojih grehov se malo pokesaj; izpovedal se ne boš več, nimam časa dolgo odlašati, mudi se mi domu za peč; znaj, da komaj čakam, da bi zopet slišal zvon, ki poje na Vrhu pri sveti Trojici.«

To izreče, pa vzame počasi
mesarico ter mu odseka glavo,
in se vrne proti mestu.

To izreče, pa vzame počasi mesarico ter mu odseka glavo.

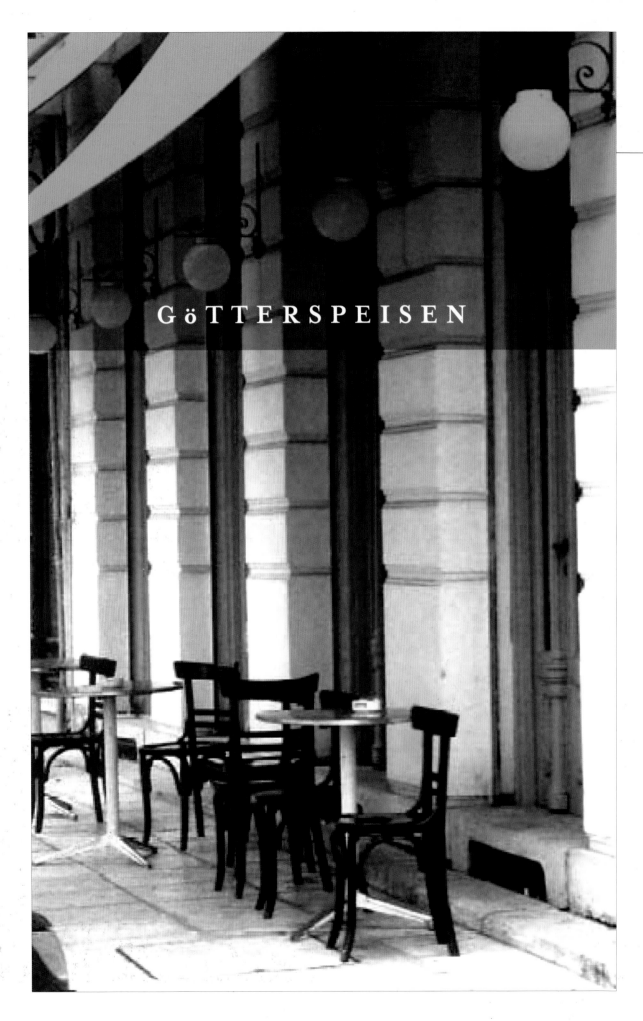

GöTTERSPEISEN

DESIGN FIRM
Barbara Spoettel
New York, (NY) USA
CLIENT
Barbara Spoettel
ART DIRECTOR, PHOTOGRAPHER
Barbara Spoettel

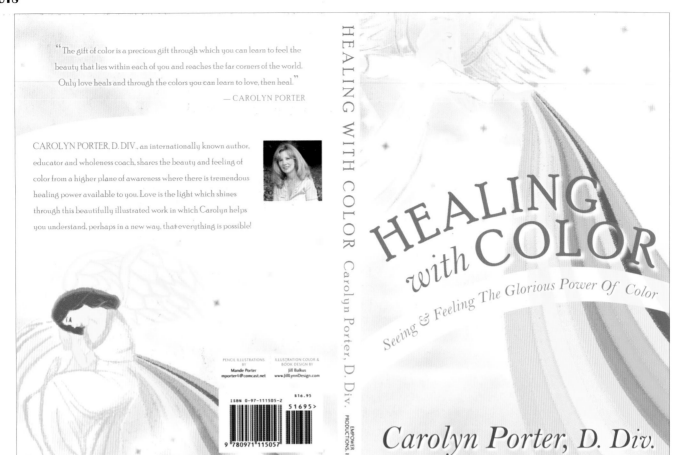

"The gift of color is a precious gift through which you can learn to feel the beauty that lies within each of you and reaches the far corners of the world. Only love heals and through the colors you can learn to love, then heal."
— CAROLYN PORTER

CAROLYN PORTER, D. DIV., an internationally known author, educator and wholeness coach, shares the beauty and feeling of color from a higher plane of awareness where there is tremendous healing power available to you. Love is the light which shines through this beautifully illustrated work in which Carolyn helps you understand, perhaps in a new way, that everything is possible!

PENCIL ILLUSTRATIONS BY
Mande Porter
mporter4@comcast.net

ILLUSTRATION COLOR & BOOK DESIGN BY
Jill Balkus
www.JillLynnDesign.com

ISBN 0-97-111505-2 $16.95
51695>
9 780971 115057

HEALING WITH COLOR Carolyn Porter, D. Div. EMPOWER PRODUCTIONS, INC.

HEALING with COLOR
Seeing & Feeling The Glorious Power Of Color

Carolyn Porter, D. Div.

1_____

2_____

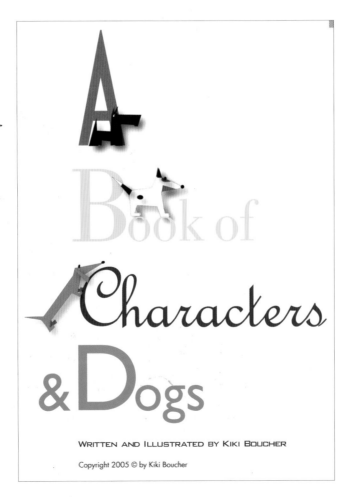

A
Book of
Characters
&Dogs

WRITTEN AND ILLUSTRATED BY KIKI BOUCHER

Copyright 2005 © by Kiki Boucher

1_____
DESIGN FIRM
Jill Lynn Design
Jersey City, (NJ) USA
CLIENT
Empower Productions, Inc.
ART DIRECTOR, DESIGNER
Jill Balkus

2_____
DESIGN FIRM
Acme Communications, Inc.
New York, (NY) USA
PROJECT
A Book of Characters & Dogs
DESIGNER
Kiki Boucher

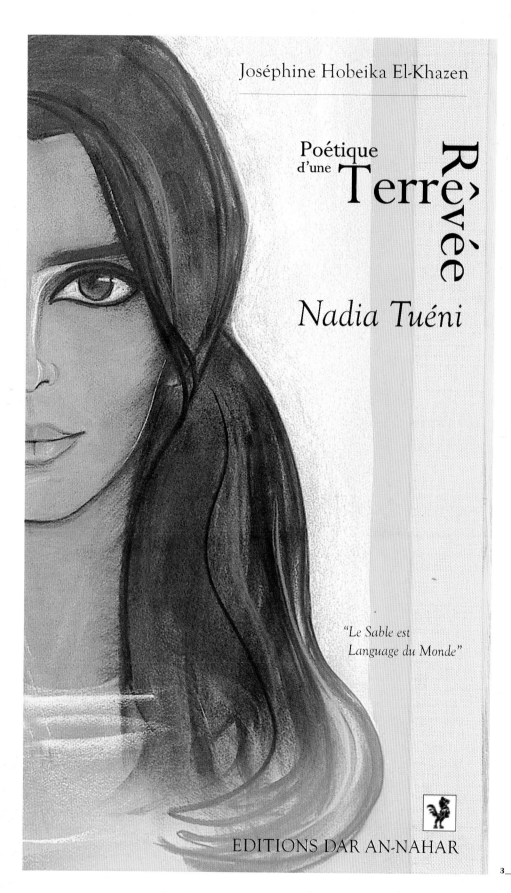

Joséphine Hobeika El-Khazen

Poétique
d'une Terre Rêvée

Nadia Tuéni

*"Le Sable est
Language du Monde"*

EDITIONS DAR AN-NAHAR

3_____
DESIGN FIRM
Raidy Printing Press
Beirut, Lebanon
CLIENT
Dar An-Nahar
DESIGNER
Marie-Joe Raidy
PAINTER
Cici Sursock
PRINTER
Raidy Printing Press

3_____

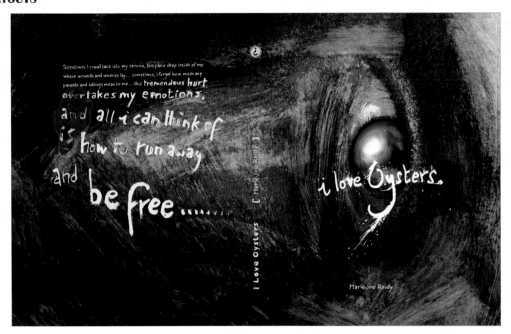

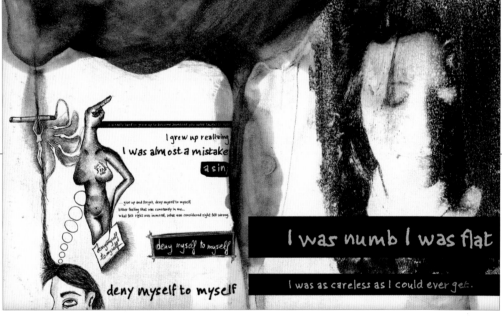

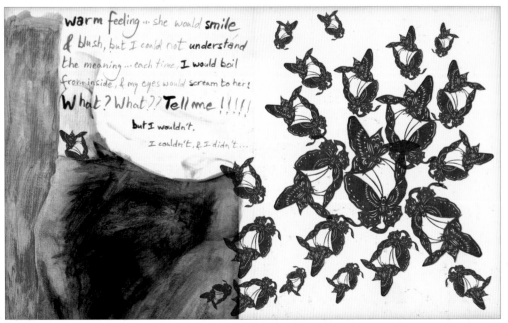

DESIGN FIRM
Raidy Printing Press
Beirut, Lebanon
DESIGNER, ILLUSTRATOR, EDITOR
Marie-Joe Raidy
PRINTER
Raidy Printing Press

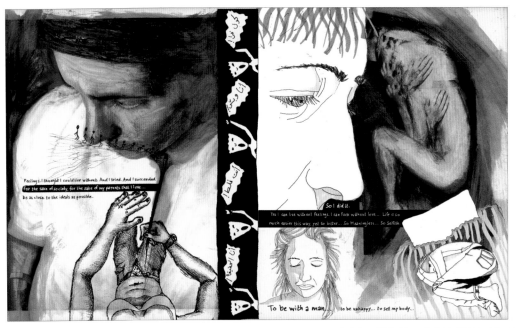

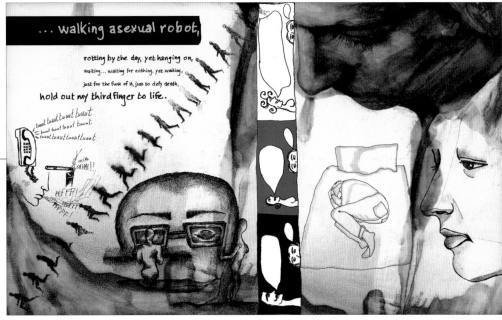

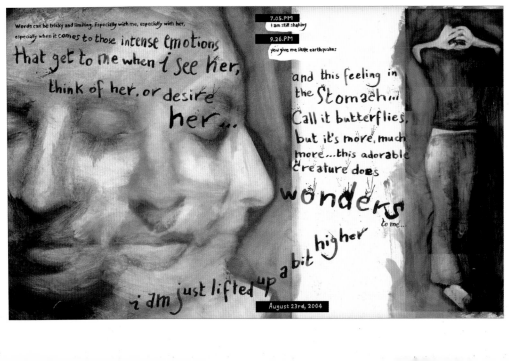

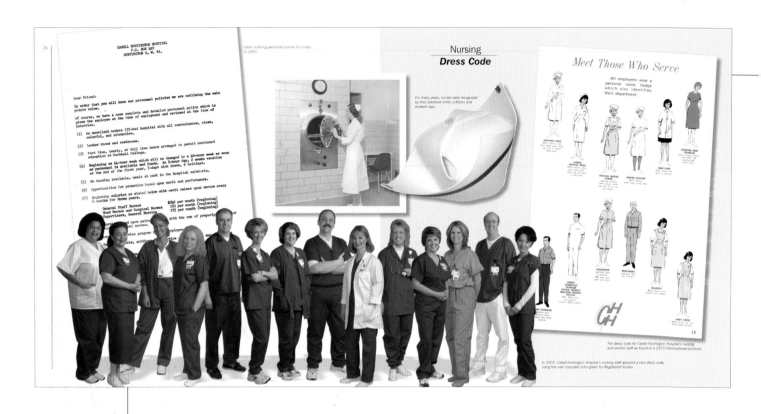

DESIGN FIRM
Designs on You! for
London Books
Ashland, (KY) USA

PROJECT
Fifty Years of Caring

CREATIVE DIRECTOR, EDITOR
Doug Sheils

DESIGNERS
Suzanna Stephens, Anthony Stephens

DESIGN CONSULTANT
Rose Henson

COPYWRITER
James E. Casto

PHOTOGRAPHERS
Rick Lee, David Fattaleh, Rick Haye,
Rose Henson, Kathy Cosco, Doug Sheils,
others

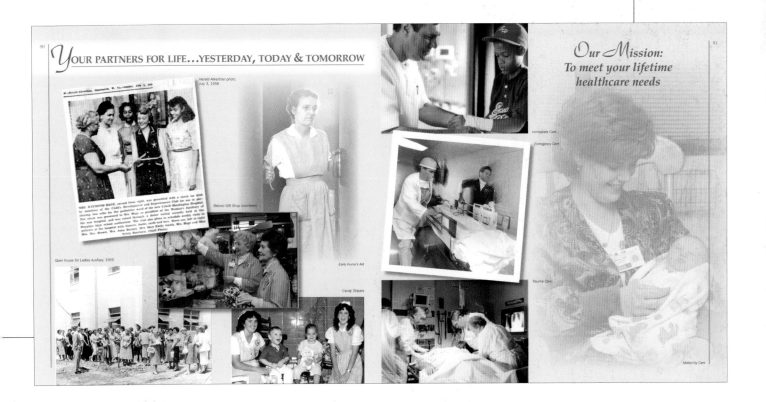

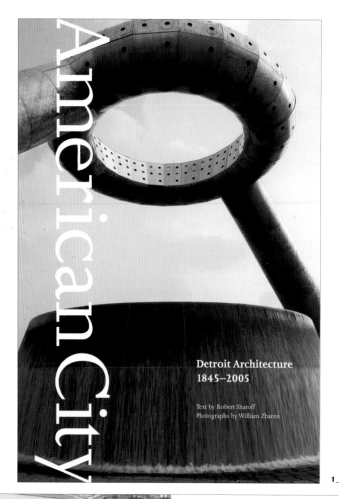

American City

**Detroit Architecture
1845–2005**

Text by Robert Sharoff
Photographs by William Zbaren

1_____

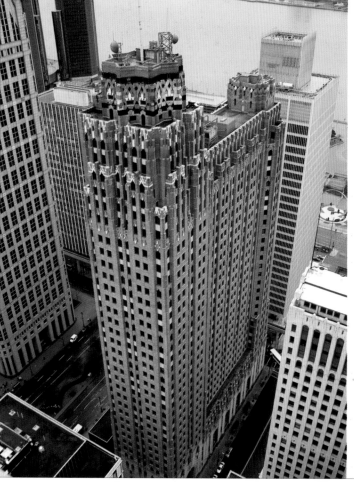

FORT WAYNE

6053 W. Jefferson Avenue
Lieutenant Montgomery C. Meigs
1845–50

In its early years, Detroit had many Federal-style structures, and this is one of the few remaining. Built to counter a British invasion that never materialized, Fort Wayne is both striking and a little beside the point. The imposing star-shaped ramparts — designed along lines laid down in the seventeenth century by French military engineer Sebastien Vauban — were obsolete by the time the fort was built. Still, the barracks building, with five symmetrical Federal-style stone bays, is impressively severe and monumental. Montgomery Meigs went on to have a long, illustrious career as a military officer and an engineer. In addition to serving as quartermaster general of the Union Army during the Civil War, he supervised the construction of the dome of the Capitol Building and chose the site for Arlington National Cemetery.

Self Improvement

$16.95 U.S.

Stacey Mayo has assisted thousands of people in shouting from the rooftops:

"I Can't Believe I Get Paid To Do This!"

Whether you dream of starting a new business, making a career change, taking your current business to new heights or creating financial independence, Master Certified Coach, Stacey Mayo, a.k.a. "The Dream Queen," can help you maximize your success. By applying Stacey's **26 Key Success Principles** you can:

○ Create money in alignment with your passions
○ Laser in on one idea, business or income stream at a time
○ Choose the path of greatest ease
○ Shorten your learning curve
○ Defeat the ambiguity monster
○ Recognize and move beyond self-sabotaging behaviors, and much more…

You will learn proven strategies from remarkable people who have made their dreams come true:

○ the first American woman to successfully climb Mt. Everest
○ a major league pitcher who was the recipient of the MVP award
○ a real estate investor who escaped the rat race and became a multi-millionaire
○ a single mom who became a self-made millionaire
○ an Internet entrepreneur who went bankrupt, then earned his first million
○ a welfare mom who became a Grammy winner and more . . .

"As America's Dream Coach®, I applaud this great book. Stacey has captured the essence of what makes people successful in living out their dreams and shows you how to apply these proven strategies to your own life."
- **Marcia Wieder**, author of *Making Your Dreams Come True*

"One of the smartest paths to 'extreme success' is to learn from people who have achieved it. You get to do just that by listening in on Stacey's private conversations with highly successful people from a variety of fields. Stacey's intuitive ability to ask the right questions is fantastic. Consider yourself lucky to have Stacey as your Dream Coach."
- **Rich Fettke**, author of *Extreme Success*

ISBN 0-9760776-0-4
51695>
9 780976 077602

GOLD LEAF PUBLISHING
www.IGetPaidToDoThis.com

Book Design by Jill Balkus

"I Can't Believe I Get Paid To Do This!" STACEY MAYO

GOLD LEAF

"If you want to get motivated and get in action, read these inspiring stories from people who have overcome obstacles to live out their dreams. Stacey Mayo brings together some truly captivating stories and key success lessons in one jam-packed, page-turning book."
- **Jack Canfield**, *Chicken Soup for the Soul*

" "I Can't Believe I Get **PAID** To Do This!" "

Remarkable People Reveal 26 Proven Strategies for Making Your Dreams a Reality

STACEY MAYO
the DREAM QUEEN

2_____

1_____
DESIGN FIRM
Liska + Associates
Chicago, (IL) USA
PROJECT
American City Book
ART DIRECTOR
Steve Liska
DESIGNER
Vanessa Oltmanns
COPYWRITER
Robert Sharoff
PHOTOGRAPHER
William Zbaren

2_____
DESIGN FIRM
Jill Lynn Design
Jersey City, (NJ) USA
CLIENT
Gold Leaf Publishing
ART DIRECTOR, DESIGNER
Jill Balkus

3_____
DESIGN FIRM
Octavo Designs
Frederick, (MD) USA
CLIENT
National Association of
School Psychologists
ART DIRECTOR, DESIGNER
Sue Hough

Helping Children at Home and School II:

Helping Children at
Home and School II:

Handouts for Families and Educators

Edited by Andrea S. Canter, Leslie Z. Paige, Mark D. Roth, Ivonne Romero, and Servio A. Carroll

3_____

FOOD

Grape Expectations

SHOPPING

OENOPHILES PREMATURELY celebrating last month's Supreme Court ruling on interstate wine shipping might just have to sit back and let the intoxicating notion decant awhile. The ruling merely declared New York law unconstitutional, which makes it Albany's headache. For now, the three-tier system (producer to wholesaler to retailer) is still firmly entrenched—which means wine geeks hoping for instant access to cult Cabs will have to wait. Until the issue wends its way through the courts, and all the compliance and tax issues are resolved, the best we can do is start fantasizing about snagging a coveted spot on a waiting list, or clearing cellar space for those elusive bottlings from tiny producers that, chances are, will remain just as unattainable should direct shipping become a reality. But you never know. If and when that day comes, and a case of Screaming Eagle is only a keyboard click away, we'll toast our good fortune with West Coast wines we've only tasted in our imagination, like the ones we've listed below. And now that New York wines are something to be proud of, we've highlighted a few to keep in mind for shipping the other way—to all those doubting Thomases in reciprocal states who can't tell their Wiemers from their Wölffers.

FROM CALIFORNIA

1

Sean Thackrey Orion
wine-maker.net
The mad genius of Marin County is an iconoclastic, philosophical winemaker, known for unpredictably volatile, unique bottlings.

2

Sine Qua Non
805-649-8901
Manfred and Elaine Krankl's Ventura, California, winery specializes in proprietary Rhone-style blends—here one season, gone the next.

3

Harlan Estate Cabernet Sauvignon
harlanestate.com
Impossible to get and intensely coveted, Harlan's releases personify the California cult Cab.

4

Marcassin Chardonnay
707-258-3608
Helen Turley, Napa's pioneering female winemaker, is renowned for her exquisite—and mostly spoken for—Chards and Pinots.

5

Araujo Estate Sauvignon Blanc
araujoestate.com
Eclipsed by the winery's better-known Cabernet Sauvignon, the white has its own devout fan club.

FROM NEW YORK

1

Bedell Reserve Merlot
bedellcellars.net
A new consultant with Opus One and Mouton-Rothschild on his résumé takes on Long Island's signature varietal.

2

Lenz Gewürztraminer
lenzwine.com
Rose-scented Alsatian-style Gewürz, bursting with litchi and refreshing acidity for under $20 a bottle.

3

Dr. Konstantin Frank Rkatsiteli
drfrankwines.com
This ancient Eastern European grape yields a crisp, off-dry wine that's big in (the republic of) Georgia, and an award winner here.

4

Paumanok Late-Harvest Sauvignon Blanc
paumanok.com
A lip-smacking dessert wine that might be the North Fork's unassuming answer to Sauternes.

5

Hermann J. Wiemer Johannisberg Riesling
wiemer.com
Finger Lakes Rieslings are real attention-getters, ripe and lively and spectacular with food.

JUNE 6, 2005 | NEW YORK 55

1_____

1_____

DESIGN FIRM
New York Magazine
New York, (NY) USA

CLIENT
New York Magazine

DESIGN DIRECTOR
Luke Hayman

ART DIRECTOR
Chris Dixon

PHOTO DIRECTOR
Jody Quon

DESIGNER
Randy Minor

PHOTOGRAPHER
Carina Salvi

2_____

DESIGN FIRM
Peterson Ray & Company
Dallas, (TX) USA

CLIENT
Rough Magazine for
Dallas Society of
Visual Communications

CREATIVE DIRECTOR, DESIGNER
Miler Hung

COPYWRITER
Aaron Barker

3_____

DESIGN FIRM
A3 Design
Charlotte, (NC) USA

CLIENT
Music Maniacs

DESIGNERS
Alan Altman,
Amanda Altman

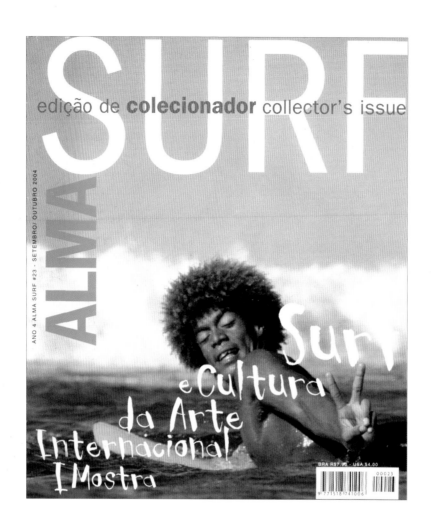

DESIGN FIRM
Mike Salisbury LLC
Venice Beach, (CA) USA
PROJECT
Surf
CREATIVE DIRECTOR
Mike Salisbury
ART DIRECTOR
Gustavo Morais

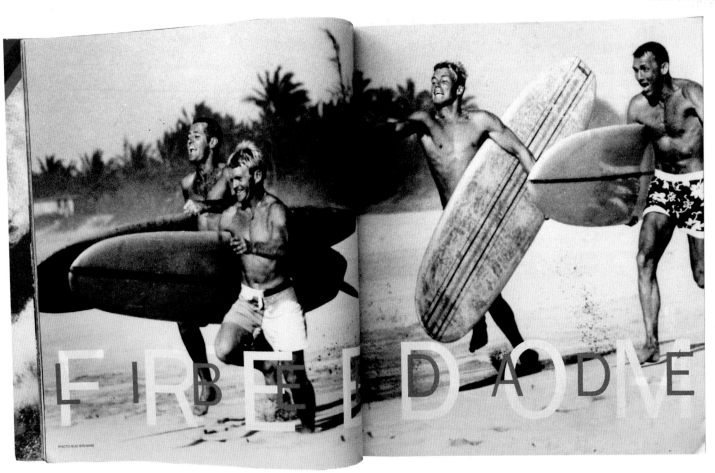

FREEDOM

PHOTO BUD BROWNE

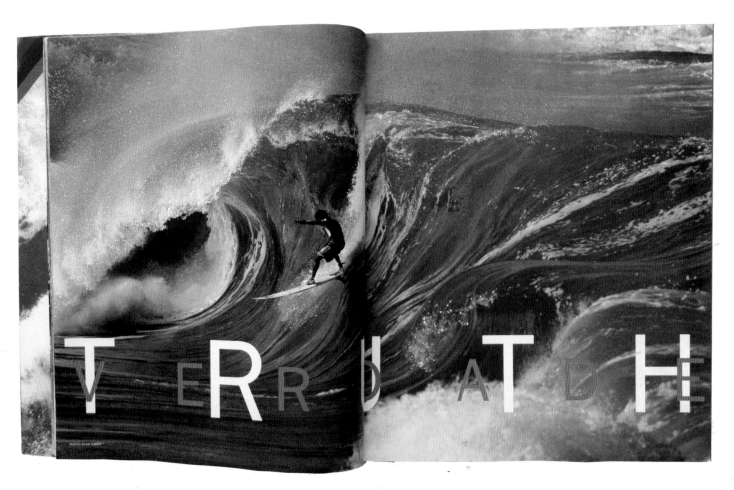

VERR DATH

PHOTO SEAN DAVEY

NORTHERN INDIANA
LAKES
MAGAZINE

PEOPLE + LIFESTYLE + HOME + OUTDOORS

THE OFFICIAL PUBLICATION FOR THE GOOD LIFE IN NORTHERN INDIANA

2006 media kit

LAKES
MAGAZINE

MISSION

Northern Indiana LAKES Magazine, the Official Publication for the Good Life in Northern Indiana, celebrates the people and places past and present ... of the Hoosier Lakes Country.

" *Northern Indiana LAKES Magazine* is devoted solely to the people, homes, lifestyles and outdoor activities of the area we love. Every page is suffused with rich features and photography on travel, history, personalities, food, folklore and fun.

CONTENT

Northern Indiana LAKES Magazine is our area's premier lifestyle publication. *Northern Indiana LAKES Magazine* helps our readers experience the very best that Northern Indiana has to offer by showcasing outstanding homes, outdoor adventures on land and water and glorious spectacles of seasonal color. Every other month *Northern Indiana LAKES Magazine* fills its pages with the best in home and interior

design, recreation, music, festivals, businesses, sports, towns, shops, restaurants, people and culture that embody a well-led lake life. Combining award-winning editorial, stunning photography and compelling special features, *Northern Indiana LAKES Magazine* provides a superb review of Northern Indiana's rich history, exposes its extraordinary beau- and celebrates the quality of life that has brought calm and reflection to generations of lake enthusiasts.

Upscale without being uppity, the hallmarks of *Northern Indiana LAKES Magazine* are editorials that will warm your heart, stir a memory or motivate you to action. In the process we make a significant difference in our reader's lives- those that live here, those that wish they did and all those who visit regularly.

READERS

A must read, *Northern Indiana LAKES Magazine* is the premier bi-monthly showcase for our area's retail and service businesses, offering intimate and cost-effective advertising messages to an active, upscale audience.

THE OFFICIAL PUBLICATION FOR THE GOOD LIFE IN NORTHERN INDIANA

editor's letter

WHEN I WAS A CHILD DAD would load
the family into the old Rambler station wagon for Sunday drives to-gether. We would often end up near a quiet, secluded lake where my brother Mike and I would hunt for arrow heads or skip stones across the water. It was as magical a moment as any child could ever hope.

Of course, we were not alone in our reverie. For generations Hoo-siers have been "going to the lake." And somewhere along the way the notion of "going to the lake" became synonymous with "having a good time." Whether large or small, plain or fancy, calm or crowded, "the lake" has always been a sanctuary, a place of relaxation and comfort that is a million mental miles away from the big ... or not so big ... city.

While admittedly upscale, LAKES Country is hardly uppity. "The Lake" is, without question, one of the few places where one can have a well-made martini while wearing flip-flops. Or enjoy a local micro-brew while casting a line.

It is there we gather with those we love; where we steal away to be alone with our thoughts in times of struggle. It is there we rest and restore world-weary souls. It is there we are refreshed and renewed. It is there we reflect and hear the ancient echoes of ancestors. Little wonder, then, that "the lake" ... whichever lake one may choose ... has always been considered a place of majesty, wonder and, yes, magic. Truly, LAKES Country is a wondrous place.

It is the goal of all at *Northern Indiana LAKES Magazine* to create a rare and unbreakable bond between those of you who know what it means to live, work and play in LAKES Country, and those of us who endeavor, however vainly, to adequately reflect it.

In a place that embodies such diversity, with so many communities, lifestyles and attitudes, it would be impossible to represent them all in any one issue. Thankfully, we look forward to ex-ploring each story in more detail in future issues. Along the way we hope to discover new stories, relationships and friends.

My father and his Rambler are both gone now; my memories of LAKES Country, however, are not. I am pleased to note that there are always new roads to see and different vistas to explore. I invite you along for the ride. I'm sure you'll enjoy the trip.

Warmly,

GREG PERIGO
Editor-in-Chief + Publisher

DESIGN FIRM
Studio D
Fort Wayne, (IN) USA
PROJECT
Lakes Magazine
ART DIRECTOR
Holly Decker

Our readers step inside everything from restored cabins and remodeled Victorians to grand lake-front estates and new log homes, and meet the designers, builders, suppliers and crafts people who created them. Northern Indiana LAKES Magazine's affluent readers own homes with average values exceeding $300,000 and enjoy annual household incomes of more than $150,000, resulting in high levels of discretionary spending. In addition, these readers have a passion for causes that are reflected in their generous support of charitable giving.

Northern Indiana LAKES Magazine's readers are at the pinnacle of the Northern Indiana demographic. They are well-educated, affluent and influential and have an active interest in their lake homes, neighborhood associations and communities. Northern Indiana LAKES Magazine's readers are exactly the consumers that will respond to your advertising message.

DEMOGRAPHICS

Northern Indiana LAKES Magazine is a subscriber-based publication. Its readers are:

Affluent: Their annual household incomes exceed $150,000 and they live in Lakes Country homes with average values exceeding $300,000.

Educated: 89% have college + educations.

Female: 60% of Northern Indiana LAKES Magazine readers are female.

Rooted: Readers have spent on average of 15 years in Lakes Country.

Active: Nearly 90% participate in civic activities through volunteerism or philanthropy.

In addition, our readers are the opinion shapers of Lakes Country.

· 77.1% are C-Level Executives.

· 39.7% are self-employed or own their own companies.

· 81.2% serve on at least one company Board of Directors.

· 84.9% serve on at least one Board of Directors of a local institution or organization.

· 50% serve on at least three Boards of Directors of a local institution or organization.

Source: Johnson Smith Group, Erdos & Morgan Survey

LAKES

EACH ISSUE PROVIDES

· **Yada Yada Yada:** Intereresting people worth meeting. Sometimes famous, frequently not ... but always, always interesting.

· **Scrapbook:** Your photos of the Lakes Country social scene.

· **Lake Life:** Our section of news and notes from out and about Lakes Country.

· **Diversions:** Your guide to arts, entertainment, events, music, museums and more.

· **Local Flavor:** From down-home and casual to upscale and elegant, Northern Indiana's most comprehensive guide to restaurants, fine food and fun recipes.

· **Of House + Home:** Our peek inside some of the most interesting homes in Lakes Country.

· **P.S.:** The last word in Lakes Country in words and pictures.

WWW.NILAKES.COM

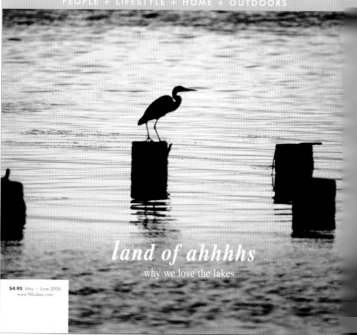

NORTHERN INDIANA
LAKES
MAGAZINE

PEOPLE + LIFESTYLE + HOME + OUTDOORS

land of ahhhhs
why we love the lakes

$4.95 May + June 2006
www.NILakes.com

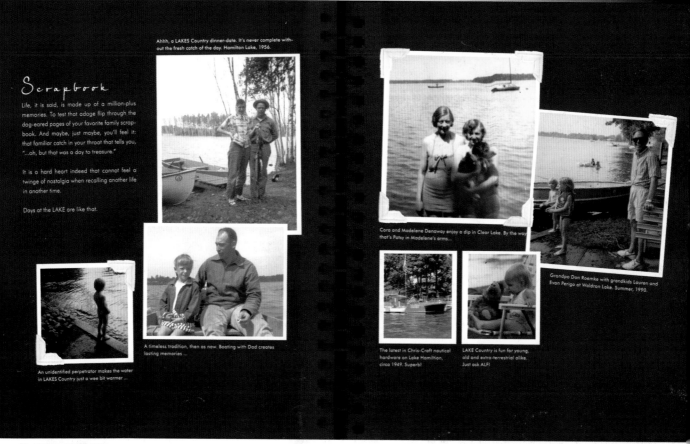

Scrapbook

Life, it is said, is made up of a million-plus memories. To test that adage flip through the dog-eared pages of your favorite family scrapbook. And maybe, just maybe, you'll feel it: that familiar catch in your throat that tells you, "...oh, but that was a day to treasure."

It is a hard heart indeed that cannot feel a twinge of nostalgia when recalling another life in another time.

Days at the LAKE are like that.

Ahhh, a LAKES Country dinner-date. It's never complete without the fresh catch of the day. Hamilton Lake, 1956.

A timeless tradition, then as now. Boating with Dad creates lasting memories ...

An unidentified perpetrator makes the water in LAKES Country just a wee bit warmer ...

Cora and Madelene Denaway enjoy a dip in Clear Lake. By the way, that's Patsy in Madelene's arms...

Grandpa Don Roemke with grandkids Lauren and Evan Perigo at Waldron Lake. Summer, 1990.

The latest in Chris-Craft nautical hardware on Lake Hamilton, circa 1949. Superb!

LAKE Country is fun for young, old and extra-terrestrial alike. Just ask ALF!

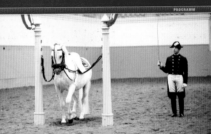

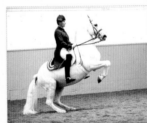

1 _____

DESIGN FIRM
designation Studio für Visuelle Kommunikation
Austria

PROJECT
Spanische Hofreitschule

ART DIRECTOR
Jürgen G. Eixelsberger

aircraft rescue & firefighting

BURN

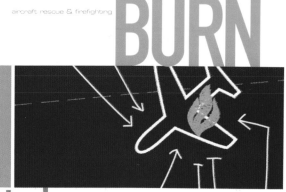

ARFF PROFESSIONALS SHARE THE MOST INSTRUCTIVE LESSONS FROM PLANNED EXERCISES AND, IN ONE CASE, A REAL-LIFE EMERGENCY.

to Learn

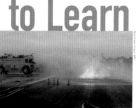

The first hint of a problem was the landing warning light that illuminated as the Boeing 737 lifted off from El Paso International Airport (ELP) at just after 8 p.m. local time. The pilot requested and received permission to return to El Paso immediately.

Upon touchdown, the troublesome landing gear bogie failed, causing the left wing to strike the runway. The plane skidded out of control, left the runway and came to rest in a reservoir. The wing damage ruptured the fuel tank inside. Fuel began spilling into the water, which was as much as four feet deep in places due to recent rainstorms. The fuel quickly caught fire.

BY SEAN BRODERICK

Rescuers were on the scene almost immediately; their trouble began soon after. The dirt road leading into the reservoir had been washed away by the same storms that raised the water level. The unstable ground at the scene surprised responders, causing the second aircraft rescue and firefighting (ARFF) vehicle to reach the scene to "roll over" the first one, ELP ARFF Captain Antonio Silva explained.

The challenges forced rescuers to make some quick decisions. The first: the remaining ARFF units couldn't be committed into the reservoir, so hoses had to be pulled with the trucks sitting some distance from the accident scene.

The good news is that ELP ARFF and emergency-response officials learned quite a bit from the scenario. Even better news is that nobody was hurt, nor was anything damaged in the incident—because it never happened.

The early November 2004 "accident" was a tabletop exercise for some 100 people from 40 agencies, led by ELP. Silva presented the exercise to fulfill FAA's requirement that, once every 12 months, Part 139 airports review their emergency-response plans. ELP's detailed tabletop exercise went beyond what FAA requires (14 CFR 139.325 dictates that airports "review the [emergency] plan," but practicing it is not required), but such approaches typically yield very positive results.

Such is the case with ELP. Silva said the lessons learned for all involved were "extensive." Several stood out to ELP's

ARFF team, including the importance of knowing airport terrain and how elements like excessive rain can alter that terrain; the importance of having enough structural units on standby when an Alert 2 (aircraft reporting major problem) is issued, so that responders are prepared if the situation escalates to an Alert 3 (aircraft accident); and the need to for structural unit members to understand the challenges, including patient extraction, with responding to an incident in the reservoir.

Dealing with casualties is one of the most challenging parts of emergency response to prepare for. Even the most detailed tabletop exercise can't give rescuers a sense of the conditions and difficulties they will encounter when real bodies are waiting at the site of an airport emergency, said San Francisco International Airport (SFO) held its annual air crash field exercise in September 2004. Some of the more significant lessons underscored during that event dealt with handling casualties, SFO Manager, Emergency Operations & Planning William Wilkinson said.

Establishing "positive perimeter control" around an accident site is key. Wilkinson explained, "Ambulatory persons evacuating the aircraft will tend to keep going as far and as fast as they can from the crash," he said. "This means they might end up in areas where they cannot be found quickly and removed under controlled circum-

2_____

aircraft rescue & firefighting

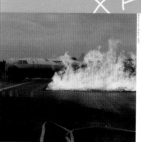

lessons learned come from training exercises, including tabletop exercises and the live emergency drills that Part 139 airports must periodically do. But airports have emergencies, and when they do, ARFF units get to implement what they know—and learn from it.

In 1996, a Southwest Airlines Boeing 737 en route to southern Florida was the target of a bomb threat via a note found onboard during the flight. The Southwest crew opted to get the plane to the closest airport, and was cleared to Pensacola Regional (PNS). FAA officials alerted PNS's ARFF units that an inbound 737 was in trouble and to prepare for an emergency landing. An Alert 2 was issued.

"We had little time to gather additional information before the aircraft was on final approach," recalled PNS ARFF Captain Marty Sasse. "I staged the ARFF vehicles at the appropriate locations and requested additional structural fire units from outside the airport."

The plane landed and the pilot taxied to a remote part of the airfield. ARFF units, still unsure of what the emergency was, closed in. Only after the ARFF vehicles were near the aircraft did Sasse learn that the emergency was a possible bomb.

Law enforcement officials arrived quickly and discussions ensued over how to proceed, with different parties holding different views. ARFF rescuers wanted to get people off the plane as fast as possible. Since the scene was nowhere near a jet bridge, that would have meant deploying slides. But the Southwest captain wanted air stairs brought out to the aircraft instead.

The decision was made to supply air stairs, and 45 minutes after the plane stopped and shut down its engines, the stairs were in place. Law-enforcement officials boarded the aircraft and soon declared the threat a hoax.

In the post-incident debriefs, PNS discussed several lessons learned. Getting as much detail as possible as quickly as possible on an inbound aircraft that has declared an emergency is key, since some emergencies—like onboard fires, for instance—call for immediate intervention by ARFF units, while others—like bomb threats—require ARFF units to stay out of harm's way until it is clear they are needed. The lessons learned from the incident combined with the more intensive focus industry-wide on dealing with terrorist threats in the aftermath of 9/11 helped PNS beef up its procedures.

Morristown Municipal Airport (MMU) in New Jersey recently bolstered its ARFF capabilities and preparedness in a much different way. As part of its mandated tri-annual live fire exercise scheduled for the fall, MMU arranged

stances." This in turn could present several problems, including a delay in getting needed treatment to injured but mobile passengers.

Wilkinson also noted that rescuers must do a better job of ensuring commonly used supplies are at hand, even before specific equipment needs have been established. For instance, during the drill, it soon became apparent that backboards were needed to remove patients from the airplane. Precious time was lost while the request for backboards went down the line to the support area and the boards came forward. "Any such simple predictable supply item could correspondingly be pushed forward," Wilkinson said. "If they are not needed then they will be returned to medical stock during clean-up."

Yet another lesson learned for SFO dealt with clearing patients from the incident site, Wilkinson said. When moving passengers to safe locations, rescuers must be diligent to ensure that so-called "Green" (cleared) patients don't mix with "Yellow" (contamination possible) patients by ensuring that Greens go through triage to confirm their status before being handed over to transportation. "Absent such positive confirmation a Yellow could mix with the Greens only to be discovered when symptoms manifest themselves and cause a crisis," he said.

Fortunately, since large-scale, on-airport emergencies like plane crashes and structural fires are rare, many ARFF

PERFECT PRACTICE

Firefighters are well aware of the importance of practice — not only the procedures they rely on, but also the tools they use. Airport Professional Services (APS) has developed a training aid for use with firefighting aids that ARFF unit members find indispensable: piercing tools.

APS's Penetration Aircraft Skin Trainer (PAST) has a curved steel base that holds rectangular sheets of aluminum skin. The skin, shaped like an airplane fuselage, serves as a target for everything from handheld tools to boom-mounted penetrators, like Crash Rescue's Snozzle. The PAST's advantages, according to APS: the system provides "realistic, hands-on" penetration training by allowing firefighters to practice on aircraft-like targets. And because the panels are replaceable, the PAST doesn't wear out like other common penetration-training aids, such as old buses or aircraft fuselages, do after multiple sessions.

PASTs have been delivered to several airports, including the Bloomington-Normal, Illinois; Chicago Midway and Kansas City International. The product is the brainchild of APS founder Gary Schott, a four-decade ARFF veteran and fire chief of a Midwestern airport. PAST is priced at $5,995 and comes with four aluminum panels.

For more, see www.aps-llc.org.

to bring in a mobile fire trainer from West Virginia University. MMU officials decided to invite firefighters from non-ARFF units that are part of the airport's mutual aid agreement, explained MMU fire chief Doug Reighard. During the planning, officials were a bit surprised to discover that few of the mutual-aid firefights had no ARFF training, and that New Jersey had no recognized ARFF training. "This was the perfect opportunity to not only get out mutual aid [firefighters] trained but to put ARFF on the map in New Jersey," Reighard said.

MMU, with help from the New Jersey Division of Fire Safety (NJDFS), led the development of a state ARFF program, using Virginia's Department of Fire Programs product as a guide. In August, once the program was approved, MMU and the Morris County Fire Academy began classroom work for the mutual-aid firefighters. Coursework consisted of airport and aircraft familiarizations, ARFF firefighter safety and the MMU emergency plan.

On October 19, MMU officials—armed with state approval to do live-fire training at a non-sanctioned state facility—closed MMU's cross-wind runway and set up the mobile trainer. During the next four days, three classes of about 30 firefighters each worked with the mobile trainer.

The tri-annual exercise took place on the night of October 22. The scenario: a Dassault Falcon 2000 business jet and a single-engine Piper aircraft collide over the

airport, causing the jet to crash at the approach end of Runway 31 and the smaller aircraft to hit an office building just off airport grounds. The disastrous scenario tested two major elements in MMU's response plan: dealing with a major on-airport incident and testing the mutual-aid plan by requiring some responders that would normally show up for the on-airport accident to handle the off-airport accident.

"The crash site on the airport grounds was an absolute success due to the realism and the recent training of the mutual aid fire units," Reighard said. "We found that the mutual aid was extremely interested in what goes on at the airport. I believe they finally felt like part of the team rather than being an outsider."

Another lesson that MMU's most recent drill underscored is one that Reighard, who has been involved in three such exercises at MMU and evaluated several more, knows all too well as a veteran of large-scale tests: they require coordination with and support from myriad organizations. Among key participants in the MMU drill that "weren't being tested were Suburban Propane, which donated some 4,000 gallons of propane to burn during the on-airport trials, and Morristown High School, which supplied the crash "victims." In other words, much like running an airport, holding a successful disaster drill means getting significant cooperation from the local community. Said Reighard: "The major contributors made it all possible."

2_____
DESIGN FIRM
Pensaré Design Group
Washington, (DC) USA
PROJECT
Airport Magazine
CREATIVE DIRECTOR
Mary Ellen Vehlow
DESIGNER
Amy E. Billingham

DESIGN FIRM
New York Magazine
New York, (NY), USA
CLIENT
New York Magazine
DESIGN DIRECTOR
Luke Hayman

THE BIG

AT 50, I WAS FIRED. IT WAS AWFUL. I LIVED. LEARNING TO EMBRACE **FAILURE** IN A CITY FUELED BY SUCCESS.

BY JAMES ATLAS

THE YEAR I TURNED 50 I was fired from a job. I hadn't been doing well in the job. I didn't have my heart in it, and it showed. I wasn't making a significant contribution. I was superfluous. It was just a matter of time.

Anxious about my performance, I had already gone to see my boss once. "I don't feel encouraged," I said to him. "I'm not invited to meetings, I'm not given assignments." He was new to the job; I had flourished under the previous boss, who had hired me and given me a lot of responsibility.

...otographs by Katherine Wolkoff

ART DIRECTOR
Chris Dixon
PHOTO DIRECTOR
Jody Quon
DESIGNER
Chris Dixon
PHOTOGRAPHERS
Katherine Wolkoff, James Atlas

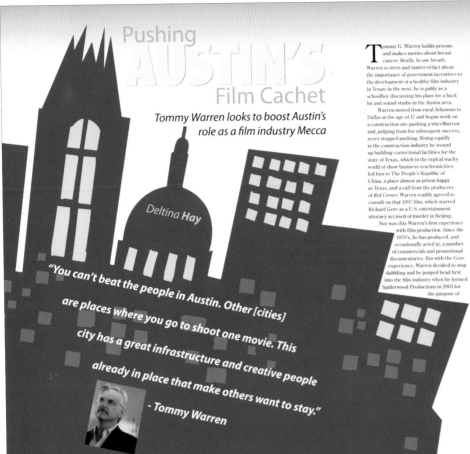

Pushing AUSTIN'S Film Cachet

Tommy Warren looks to boost Austin's role as a film industry Mecca

Deltina Hay

"You can't beat the people in Austin. Other [cities] are places where you go to shoot one movie. This city has a great infrastructure and creative people already in place that make others want to stay."

— Tommy Warren

Tommy G. Warren builds prisons and makes movies about breast cancer. Really. In one breath Warren is stern and matter-of-fact about the importance of government incentives to the development of a healthy film industry in Texas; in the next, he is giddy as a schoolboy discussing his plans for a back lot and sound studio in the Austin area.

Warren moved from rural Arkansas to Dallas at the age of 17 and began work on a construction site pushing a wheelbarrow and, judging from his subsequent success, never stopped pushing. Rising rapidly in the construction industry he wound up building correctional facilities for the state of Texas, which in the typical wacky world of show business synchronicities led him to The People's Republic of China, a place almost as prison happy as Texas, and a call from the producers of *Red Corner*. Warren readily agreed to consult on that 1997 film, which starred Richard Gere as a U.S. entertainment attorney accused of murder in Beijing.

Nor was this Warren's first experience with film production. Since the 1970's, he has produced, and occasionally acted in, a number of commercials and promotional documentaries. But with the Gere experience, Warren decided to stop dabbling and he jumped head first into the film industry when he formed Spiderwood Productions in 2003 for the purpose of producing *The Inner Circle*, since picked up by Porchlight Entertainment for worldwide distribution. The film looks at the singular challenges faced by a woman and her loved ones in the shadow of a mastectomy. It stars Michael O'Keefe and Beth Broderick.

Warren got his feet wet on a number of different levels while making *The Inner Circle*. He is credited for the "behind the scenes" production, and supervised the music. "We used two of the Grammy-winning Los Lonely Boy's titles in this feature, as well as the talents of William Stromberg, who was nominated for a Grammy this year."

With *The Inner Circle* in distribution throughout the world, Warren is now off to other projects. In addition to writing and co-producing both a comedy and reality show, he is developing a television series with editor and director Fred Toye (*Alias, Taken*).

Warren shines with boyish enthusiasm discussing the creative challenges he faced in making *The Inner Circle*, but he becomes CEO serious when he turns to the topic of business. "[Texans] have a romance with film and music, and the general public does not quite understand the depth of this business or how big the film and music industry could be in terms of economic development. My goal is to enhance the existing efforts for filmmaking in Texas, especially in the Austin area." To that end, Warren plans to develop "a back lot" off the Colorado River "where filmmakers can have a known location large enough to allow different forms of landscaping, including water, for shooting movies." The Spiderwood lot will be located on 163 acres within the required Screen Actors Guild 30-mile commuting limit. Spiderwood Productions also has plans to build a sound studio that "can be used to test and experiment with new methods for improving the quality of movies while reducing costs and production time."

Warren says that Austin is already an attractive location for many filmmakers.

Tommy G. Warren behind the scenes of *The Inner Circle*

"Other states may offer better tax and monetary incentives," he says "but the fact that there are trained crews, film stages, and back lot acreage, makes the Austin area a much better deal for movie making. Austin also has post-production studios to complete the work, and getting permits to shoot is simple."

Austin is also an example of how government and communities can work together to strengthen economic development around creative industries.

Warren points out that, "the Texas Film Commission has been around a long time and helps bring film production into the state. The Austin Film Society has also been a moving force in the region for the movie industry. And the local government has been very active in promoting the film, music, and gaming industries by supporting such entities such as Austin Studios."

In addition, the University of Texas and Austin Community College both have programs that regularly add experienced people to the entertainment industries, therefore building a solid future for radio, TV, and film in the area. "When there's a pool of properly trained crews, it will always help bring in the economic benefits of the entertainment industry. And ACC is exploring the possibility of an Entertainment and Digital Arts Institute that will combine the efforts of private businesses in the entertainment industry to foster a stronger internship program. All of this combined effort is teamwork that will bring more business to the area."

With all of this going for Austin, it is no wonder Warren is willing to take such a risk on the area. "Besides," he says, "you can't beat the people in Austin. Other states are places where you go to shoot one movie. This city has a great infrastructure and creative people already in place that make others want to stay."

For more information on Tommy G. Warren or Spiderwood Productions, visit *www.spiderwoodproductions.com*. ◎

SUMMER 2005

1 _____

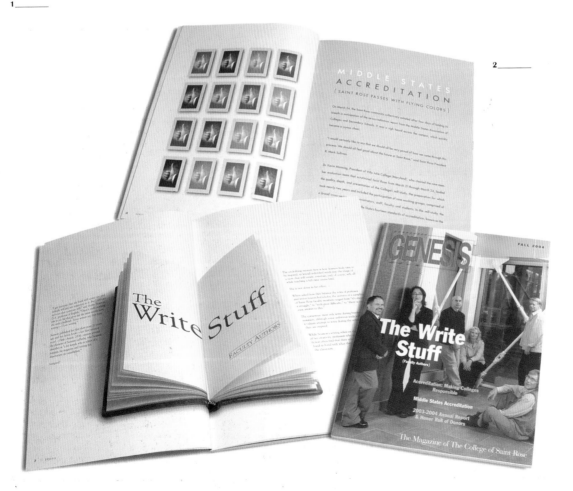

2 _____

1 _____

DESIGN FIRM
TAMAR Graphics
Waltham, (MA) USA

CLIENT
Creative Pulse Magazine

ART DIRECTOR, DESIGNER
Tamar Wallace

ILLUSTRATOR, DESIGNER
Christopher Hay

COPYWRITER
Deltina Hay

2 _____

DESIGN FIRM
The College of Saint Rose
Albany, (NY) USA

PROJECT
Genesis Magazine

ART DIRECTOR
Mark Hamilton

DESIGNER, ILLUSTRATOR
Chris Parody

COPYWRITER
Renee Isgro Kelly

DIRECTOR OF PUBLIC RELATIONS
Lisa Haley Thomson

PHOTOGRAPHERS
Paul Castle Photography,
Luigi Benincasa,
Tom Killips

PRINTER
Brodock Press, Inc.

3_____

3_____
DESIGN FIRM
Riordon Design
Oakville, (Ontario) Canada
CLIENT
Riordon Design
ART DIRECTOR
Ric Riordon
DESIGNER
Alan Krpan
ILLUSTRATORS
Jeff Elliot, Dan Wheaton
PHOTOGRAPHERS
Ric Riordon, Alan Krpan,
photos.com, Getty Images

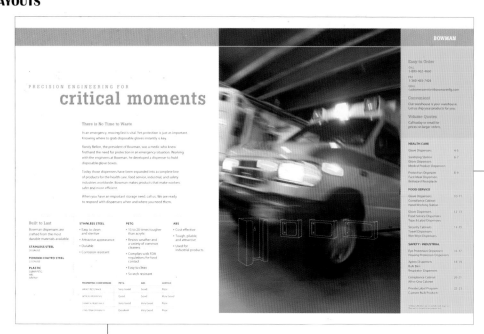

BOWMAN

PRECISION ENGINEERING FOR
critical moments

There is No Time to Waste

In an emergency, moving fast is vital. Yet protection is just as important. Knowing where to grab disposable gloves instantly is key.

Randy Bellon, the president of Bowman, was a medic who knew firsthand the need for protection in an emergency situation. Working with the engineers at Bowman, he developed a dispenser to hold disposable glove boxes.

Today those dispensers have been expanded into a complete line of products for the health care, food service, industrial, and safety industries worldwide. Bowman makes products that make workers safer and more efficient.

When you have an important storage need, call us. We are ready to respond with dispensers when and where you need them.

Easy to Order

Convenient
Our warehouse is your warehouse. Let us ship your products for you.

Volume Quotes
Call today or email for prices on larger orders.

Built to Last
Bowman dispensers are crafted from the most durable materials available.

STAINLESS STEEL

STAINLESS STEEL
• Easy to clean and sterilize
• Attractive appearance
• Durable
• Corrosion resistant

PETG
• 15 to 20 times tougher than acrylic
• Resist weather and a variety of common cleaners
• Complies with FDA regulations for food contact
• Easy to clean
• Scratch resistant

ABS
• Cost effective
• Tough, pliable, and attractive
• Used for industrial products

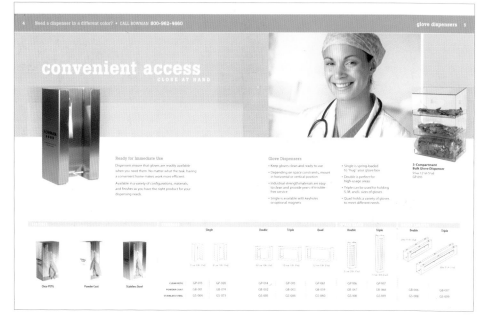

CALL BOWMAN 800-962-4660 · Need a dispenser in a different color?

glove dispensers

convenient access
CLOSE AT HAND

Ready for Immediate Use

Dispensers ensure that gloves are readily available when you need them. No matter what the task, having a convenient home makes work more efficient.

Available in a variety of configurations, materials, and finishes so you have the right product for your dispensing needs.

Glove Dispensers
• Keep gloves clean and ready to use
• Depending on space constraints, mount in horizontal or vertical position
• Industrial-strength materials are easy to clean and provide years of trouble-free service
• Single is available with keyholes or optional magnets

3-Compartment Bulk Glove Dispenser

Clear PETG Powder Coat Stainless Steel

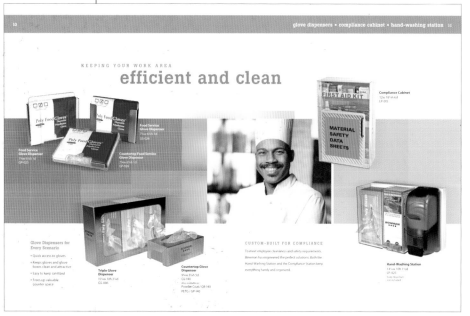

glove dispensers • compliance cabinet • hand-washing station

KEEPING YOUR WORK AREA
efficient and clean

Compliance Cabinet

Glove Dispensers for Every Scenario
• Quick access to gloves
• Keeps gloves and glove boxes clean and attractive
• Easy to keep sanitized
• Frees up valuable counter space

CUSTOM-BUILT FOR COMPLIANCE
To meet employee cleanliness and safety requirements, Bowman has engineered the perfect solutions. Both the Hand-Washing Station and the Compliance Station keep everything handy and organized.

Triple Glove Dispenser

Countertop Glove Dispenser

Hand-Washing Station

1 ____
DESIGN FIRM
belyea
Seattle, (WA) USA
PROJECT
Bowman
CREATIVE DIRECTOR
Ron Lars Hansen
PRODUCTION MANAGER
Sheri-Lou Stannard
DESIGNER
Nick Johnson

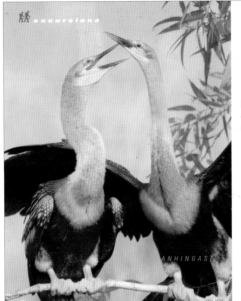

excursions

Winging It

Florida's national parks offer a unique opportunity for birdwatchers, as dozens of species migrate to warmer climates.

BY CONNIE TOOPS

Southern Florida's Everglades region—consisting of marshes, estuaries, and subtropical forests—is unlike any other ecosystem. Lush ferns, clasping vines, graceful cypress trees, and salt tolerant mangroves flourish in the warm, humid climate. Wildlife ranges from vibrant butterflies to stealthy panthers, but birds—with their sporting flamboyant colors, strange shapes, or curious behaviors—are the region's celebrated ambassadors. Bird watchers flock to south Florida to discover rarities found nowhere else in the country. Everglades and Dry Tortugas national parks and Big Cypress National Preserve, all designated by the American Bird Conservancy as Globally Important Bird Areas, provide excitement for novice or experienced birders.

More than 350 bird species have been documented in Everglades National Park. Nearly two-thirds of them migrate north in summer or south in winter to find abundant food or proper nesting conditions. Autumn and spring are great times to observe migrant warblers, tanagers, and buntings in forested or brushy habitats. Sandpipers, plovers, and yellow-legs hug the coasts or seek protected marshes as they traverse the Florida peninsula. Hawks and falcons follow the flocks, dining on the weak and the unwary.

South Florida is famous for sheer numbers of birds that bring panache to the flat landscape. At dawn, flocks of ibises and herons leave roosts in the cypress trees and fly in undulating lines above the wet prairies. Egrets crowd coffee-colored ponds in the mangroves, gracefully plucking minnows as they dance across the water. Groups of white pelicans dip and bob like synchronized swimmers as they encircle schools of fish in the tidal estuaries. Anhingas perch near feeding alligators to dry their wings, lending a prehistoric appearance to the scene.

The Everglades region today is a shrinking zone of wilderness surrounded by a human population growing at twice

Bird-watchers flock to south Florida to discover rarities found nowhere else.

the national average. Half the original Everglades wetlands have been drained. Urban sprawl, air pollution, agricultural runoff, and exotic species have adversely affected native wildlife. Where south Florida was initially explored in the late 1800s, approximately 2 million wading birds resided in what is now Everglades National Park. A century later, scientists estimated 2,200 wading birds nested there. Only by tempering human proliferation, protecting the remaining intact habitat, and promoting reversal to reconnect fragmented natural areas will this extraordinary ecosystem continue to delight birds and birders for centuries to come.

Everglades National Park

One of the most reliable spots to observe birds in Everglades National Park is the Anhinga Trail, a half-mile boardwalk that explores meandering Taylor Slough. Beginning birders can study at close range great blue, little blue, and tricolored herons, great and snowy egrets, and white ibises, the colors of their bills, legs, and feathers distinguish them from one another. Anhingas and cormorants—large birds that fish underwater, then drape themselves in nearby trees to dry—abound here. Purple gallinules saunter across the pond lilies, flaunting turquoise feathers and candy-corn beaks. Don't be surprised if a vocal red-shouldered hawk grabs a lizard or large grasshopper while you're watching.

The 38-mile park road to Flamingo winds through sawgrass, pinelands, hardwood hammocks, and mangroves. Short self-guiding trails access each habitat and are worth exploration to add flycatchers, warblers, vireos, towhees, sparrows, and, perhaps, owls to your list. Many of these birds also appear near pine-shaded campsites at Long Pine Key. From the Flamingo campground, scan Florida Bay for bald eagles (about 30 pairs live in the park), pelicans, roseate spoonbills, gulls, and terns. Also watch for black skimmers, sleek birds whose beaks slice the water to

detect submerged prey. Eco Pond, located between the Flamingo lodge-restaurant complex and the campground, is another superb birding locale.

Small kites, endangered species that feed almost exclusively on large aquatic snails, are sometimes seen along Tamiami Trail (U.S. 41) near the Shark Valley entrance to the park. As with most birding spots, early morning is a great time for viewing. Shark Valley visitors hike, bicycle, or ride a tram along a 15-mile loop to view alligators, deer, and flocks of wading birds; observe tails and night-calling limpkins also inhabit the area. Wood storks sometimes shuffle through shallow water, flicking their wings to herd minnows toward outstretched beaks.

Big Cypress National Preserve

Big Cypress National Preserve encompasses 2,400 square miles of terrain northwest of Everglades National Park. Nearly 180 species of birds have been observed in the park's cypress strands, sawgrass marshes, and pine forests. Herons and egrets scatter into the slough during the summer rainy season. They concentrate around remaining pools of water as wetlands dry up during winter and spring.

Tamiami Trail, Alligator Alley (I-75), and Florida Route 29 cross the preserve, offering brief glimpses of anhin-

SIDETRIP:
Dry Tortugas National Park

For an unforgettable birding experience far from the beaten path, consider visiting Dry Tortugas National Park. Seven sandy islands surrounded by azure waves lie 70 miles west of Key West. Discovered by Ponce de Leon in 1513, the islands had no fresh water but their sea turtle (tortugas) translated into meat for hungry sailors. Fort Jefferson, a huge but never-completed brick fort, dominates Garden Key. Overnight camping is permitted on its beach, but visitors must bring all of their own food, water, and supplies.

Access to the park is gained via ferry, seaplane, or private vessel. Observant birders traveling by boat may see seafaring terns, shearwaters, tropicbirds, and gannets en route. The Tortugas lie on an avian flyway that links South America and Caribbean regions to the United States. Each spring and autumn migrant songbirds drop in, especially if unfavorable winds buffet their journey. Birders gather around the only fresh water—a fountain on the fort's parade ground—to be rewarded by close-up views of thirsty warblers, vireos, orioles, tanagers, and buntings.

Each spring, more than 80,000 sooty terns and 5,000 brown noddies settle onto Bush Key. Rookeries are closed to visitors, but the top of Fort Jefferson provides great views through binoculars. The incessant chatter and whirring of wings that accompany the terns' flight is unforgettable. Oceangoing frigatebirds that nest on Long Key are truly magnificent when they soar in formation over the fort's ramparts.

If you've never visited or birded in such a remote location, join a tour group and let the leaders handle transportation and bird identification. All you'll need are sunscreen and binoculars to savor a once-in-a-lifetime experience. All you'll need are sunscreen and binoculars to savor a once-in-a-lifetime experience.

Travel Essentials

In south Florida, warm humidity prevails much of the year. In the summer months, thunderstorms are frequent and mosquitoes are abundant, and midwinter cold fronts will put a temporary chill in the air. In addition to binoculars and bird guides, bring drinking water, sunscreen, and insect repellant. You'll find bird checklists for each park at www.nps.gov/cia/NPSbirds.html.

A multitude of motels, campgrounds, restaurants, and outdoor supply stores are located in gateway communities of Homestead, Everglades City, Naples, Miami, and Key West. For information about park facilities and activities, check the following sources:

EVERGLADES
www.nps.gov/ever
305-242-7700

FLAMINGO LODGE, RESTAURANT, AND MARINA
amfac.worldres.com
239-695-3101

SHARK VALLEY TRAM TOURS
305-221-8455

BIG CYPRESS
239-695-1201

BISCAYNE
www.nps.gov/bisc
305-230-7275

BOAT TOURS
305-230-1100

DRY TORTUGAS
www.nps.gov/drto
305-242-7700

FERRY SERVICES

SEAPLANES OF KEY WEST
www.seaplanesofkeywest.com
800-950-2359

SUNNY DAYS CATAMARANS
www.drytortugasferry.com
800-236-7937

YANKEE FLEET
www.yankeefreedom.com
800-634-0939

BIRDING TOURS
www.southfloridabirding.com

South Florida is famous for birds that bring panache to the flat landscape.

gas, cormorants, belted kingfishers, and waders fishing in roadside canals. These thoroughfares have few safe pullouts, but alternate routes provide leisurely wildlife viewing. Loop Road (S.R. 94) is a 26-mile unimproved route through cypress and sawgrass that parallels U.S. 41. Ask a park ranger or a local for the latest conditions; as portions may flood during high water. Tree Snail Hammock Nature Trail, located eight miles from the eastern end of Loop Road, offers a self-guided walk through a hammock frequented by great crested flycatchers, white-eyed vireos, and barred owls.

Turner River (C.R. 839) and Birdon (C.R. 841) gravel roads combine for a 17-mile swing through the preserve near Ochopee. Here former canals are plugged with earthen dams, returning water to the marshes through culverts under the roads. The resulting wet habitat hosts green, little blue, and tricolored herons, great and snowy egrets, white ibises, wood storks, elegant sandhill cranes, and common moorhens.

A visitor center on Tamiami Trail provides information about camping within the preserve, as well as access to 31 miles of the Florida Trail, which passes through pinelands where dwarf and endangered red-cockaded woodpeckers and wild turkeys reside. If you plan to

hike this trail, be prepared for submerged sections during the summer.

Biscayne National Park

Southeast of Miami, several narrow islands divide shallow Biscayne Bay from deeper Atlantic waters. Dense subtropical vegetation blankets the largest of these keys. Prop-rooted mangroves and graceful coconut palms line the shore, giving Biscayne National Park a distinctly Caribbean ambiance. Less than 5 percent of the park protrudes above the sea. Beneath the waves lies North America's northernmost coral reef.

Visitors can sample Biscayne's nearly 225 bird species by boat or from a trail. Ospreys hover over the bay, diving to impale prey with sharp talons. Brown pelicans cruise above the waters, plunging to gulp fish into expandable throat pouches. Reddish egrets and an unusual white form of the great blue heron ply the mudflats, while yellow-crowned night herons hug the shoreline searching for crabs. Cormorants, herons, and egrets nest on the Arsenicker Keys at the southern end of the park. Last year, it was host to the first North American sighting of a red-legged honeycreeper, a dazzling blue migrant eating bird from tropical America.

Tour boats depart the Convoy Point visitor center east of Homestead for Elliott Key and snorkeling on the reef. A short mainland trail accesses bayside vegetation and a jetty frequented by seabirds. Birders usually explore trails on Elliott Key by foot, searching for Caribbean specialties such as black-whiskered vireos, gray kingbirds, or white-crowned pigeons. But adventurers can spend the night camping near the harbor, being lulled to sleep by trilling screech owls or the plight of a million mosquitoes.

Connie Toops is a freelance nature writer and photographer based in Marshall, NC. She is a contributing editor for Birder's World magazine and author of The Florida Everglades.

DESIGN FIRM
Pensaré Design Group
Washington, (DC) USA

PROJECT
National Parks Magazine,
Florida Excursions

CREATIVE DIRECTOR
Mary Ellen Vehlow

DESIGNER
Amy E. Billingham

HUF HAUS

THEIR DISTINCTIVE LOOKS — BLACK, WHITE AND GLASS — COUPLED WITH MODERN DESIGN AND CONSTRUCTION METHODS NEVER CEASES TO AMAZE PEOPLE AND ATTRACT BOTH ADMIRERS AND CRITICS. EVEN WITH CRITICS, THE POPULARITY OF HUF HAUS IS GROWING AND SO BRUCE R WILLAN TAKES A LOOK AT WHAT MAKES THESE HOMES SO SPECIAL AND DESIRABLE IN A MODERN WORLD.

DIAMONDS and MICKEY MOUSE from Sotheby's and super-rich Louis Vuitton must travel for a while one has just about everything already

TIMELESS TRAVEL is just as seductive and every bit as romantic and mysterious. AFFORDABLE ART for every taste and budget — where to find it

EXCLUSIVE APARTMENTS PROPERTIES AND VILLAS FOR SALE AROUND THE GLOBE

THE WORLD'S MOST DESIRABLE PROPERTY AND LIFESTYLE

HOMES AWAY FROM HOME

SEPTEMBER 2005 ISSUE 20 PRICE £3.90

Huf Haus
Superb Homes from German designers and engineers of excellence for contemporary 21st century living

ISSN 1741-9646 £3.90

BRAZIL | SPAIN | SOUTH AFRICA | DUBAI | ITALY | FRANCE | MALTA | PORTUGAL | CARIBBEAN

1 ——

Affordable Art

So, just where do you get decent art that not only gives you pleasure but at the same time doesn't require a second mortgage? Robert Anderson finds the best places to buy affordable art...

It is not easy finding works of art that are inexpensive. The auction houses like Sotheby's and Christies rarely have works of note that most of us can afford. The galleries of Mayfair are similarly pricey. But there are alternatives, and if you can place a little faith in the unknown you're bound to find something you like to fill that wall space at a price that you can afford.

For one, try the London Affordable Art Fair. The Affordable Art Fair (AAF) is the leading showcase in the UK for contemporary art under £2,500. The fair was launched in London in 1999 and now takes place biannually in London and annually in Bristol and New York, with affiliate fairs in Sydney and Melbourne.

Since 1999 the contemporary art market has seen extraordinary growth and the Affordable Art Fairs have also boomed, with annual sales rising from £3m in 1999 to £6.5m last year. An average of

one in four visitors buy at the fair and many return year on year. With six UK fairs under its belt, the Affordable Art Fair is established as an important and popular step on the art buying ladder, making the purchase of buying and collecting original art a reality.

HOW IT STARTED
In 1996 Will Ramsay, the founder of the AAF, opened Will's Art Warehouse in Parsons Green to bridge the public's increasing interest in contemporary art and the London gallery scene. He recognised the need for an approach that made people feel comfortable about buying art, however little they know about it, and conceived a gallery that is relaxed and un-intimidating. By concentrating on relatively unknown artists not carrying a premium for reputation, he was able to offer works from £50 -£2,500 and give buyers access

to a stable of over 150 artists. This fair proved to be a winning formula.

HOW IT HAS GROWN
The response to Will's Art Warehouse encouraged Will to take his approach to the next level and in October 1999 he launched the first Affordable Art Fair. Over a period of four days, 45 galleries descended on the marquee in Battersea Park to offer contemporary artwork (original paintings, prints, photographs and sculpture) for under £2,500. Over 10,000 visitors, ranging from first-time buyers to budding collectors, took advantage of the ease of buying, breadth of choice, affordable prices and user-friendly approach at this inaugural event. The fair grew to be so popular that in 2002 Will launched a second annual fair in Battersea — the Spring Collection. In order to ensure that visitors enjoy a totally different spectrum of art at the spring

and autumn fairs, no artist can be shown at more than one of the fairs each year.

THE FUTURE
Following the successful expansion of the Affordable Art Fair in England, Will has launched an AAF in New York and associate fairs in Sydney and Melbourne. The fairs appear to be satisfying the increasing public demand for education about contemporary art and Will hopes to continue expansion in both the United Kingdom and abroad — so watch this space!

This year the Affordable Art Fair returns to Battersea Park, London from 20 to 23 October 2005 with its Autumn Collection. Around 125 galleries will be exhibiting paintings, sculpture, photographs and original prints, all priced at under £3,000. This year visitors can also view garden sculpture as well as the Recent Graduate Exhibition, showcasing artists tipped for the top.

So what do you get for your money at the Affordable Art Fair? Well, in addition to broadening the reach of art and welcoming new buyers, the fair also attracts seasoned collectors on the lookout for bright new artists through the Recent

Graduates exhibition. This is a rich hunting ground for emerging talent as it showcases the cream of the 2005 art school graduates. Previous graduates showcased at AAF include Sam Herbert, whose work is collected by Charles Saatchi, and Damian Roach, who has subsequently been given shows at Tate Britain and the Venice Biennale.

But this is not the only venue for art on a budget. There are many towns and villages around the UK which host art trails and fairs all year round. Or how about trying the Internet? Yes, the Internet is filled to the cosmic edges with art for sale. Veda Bowles, the former South African nurse who set up and co-founded Kaleidoscope Arts — which holds exhibitions and runs the sculpture demonstration area at the Autumn Affordable Art Fair in London — markets and sells her work through galleries, exhibitions and the Internet. Her work of late has been inspired by softly rounded fruits and their intimation of fertility and association with the female figure. Her latest work consists of 'fruits' ranging in size from ten to 70cm. She works primarily in bronze with wonderful and unusual patinas, though sometimes she works in resin, porcelain and glass.

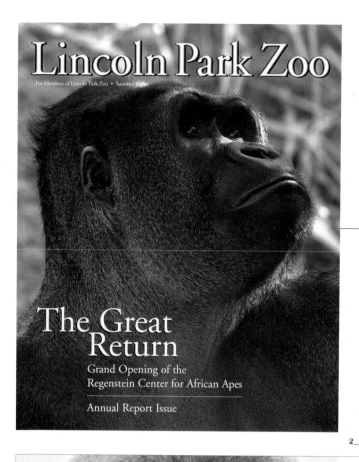

Lincoln Park Zoo

For Members of Lincoln Park Zoo • Summer 2004

The Great Return

Grand Opening of the
Regenstein Center for African Apes

Annual Report Issue

2_____

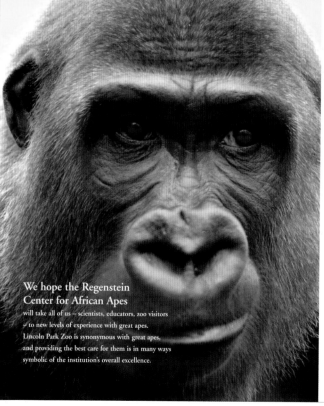

We hope the Regenstein
Center for African Apes
will take all of us – scientists, educators, zoo visitors
– to new levels of experience with great apes.
Lincoln Park Zoo is synonymous with great apes,
and providing the best care for them is in many ways
symbolic of the institution's overall excellence.

[perspective] ————— A Letter From President and CEO Kevin J. Bell

Big Dreams, Big Commitments

In many ways, the opening of the Regenstein Center for African Apes is a dream come true, not only for me but for the entire staff of Lincoln Park Zoo and the city of Chicago.

Our previous great ape house, which was state of the art when it opened in 1976, was an excellent facility for nearly three decades and could have continued to be a comfortable home for our animals for many more years. But as we studied the animals' needs and behaviors and discussed the zoo's long-term goals for conservation and education, we thought: If we're going to dream about providing the best environment for our animals and an unmatched experience for our visitors, let's do it right.

Let's go all the way.

So here we are today with a new home for great apes that may be the finest such facility in the world. It is the culmination of years of hard work and commitment from the staff and the generous people of the greater Chicago community, who provided the encouragement and the funds necessary to transform a vision into reality.

The Regenstein Center for African Apes (RCAA) will provide apes with the mental and physical stimulation they require, plenty of fresh air and sunlight, and spacious naturalistic indoor and outdoor habitats that will foster behavior similar to that of animals in the wild. All of this was made possible thanks to the incomparable philanthropic spirit of the Regenstein Foundation.

The opening of RCAA comes at a time when we are making a major commitment to the study of ape conservation. It's what we have been talking about for the last 20 years: Doing more than exhibiting animals.

We want to understand as much as possible about all the animals in our collection and share that information with our members and visitors. This building and the Lester E. Fisher Center for the Study and Conservation of Apes are huge steps in advancing our mission.

It was natural to name the Fisher Center for Dr. Fisher, given his lifelong commitment to the study of apes. The zoo is known internationally for what Les did in setting up the old ape house, collecting original data, helping create the *Otto Zoo Gorilla* film and cataloging medical information, much of which nobody had done before.

The new ape house will also help us provide innovative educational programming about chimpanzees and gorillas. They are probably the most popular animals we've ever had, or ever will have, at the zoo. There's no question that we identify with apes and are endlessly fascinated by their behavior because of their closeness to human traits.

I have never forgotten my own first experience with gorillas. When I was living in New York and going to college, I worked at the Bronx Zoo in the summers. One summer there were two young gorillas who were being reared not by their mother but by a human foster mother who worked at the zoo. The zoo's goal was to get the gorillas back to being independent from humans. I spent seven days a week from 6 in the morning till 7 at night, May through August, working with them. It was quite an experience.

We hope RCAA will take all of us – scientists, educators, zoo visitors – to new levels of experience with great apes. They are, after all, a significant chapter in the zoo's history, going back to the days of Bushman, Sinbad, Otto, Frank and the rest of the gang. Lincoln Park Zoo is synonymous with great apes, and providing the best care for them is in many ways symbolic of the institution's overall excellence.

We recognize too that there has been a shift in the thinking of our visitors and our supporters, who want more than just to see the animals in their exhibits. At RCAA, we hope visitors will read the science and education graphics and learn more about the animals. Then maybe they will follow up with a visit to our website and learn about our Africa/Asia Field Conservation Fund, which supports projects in that part of the world, or the Fisher Center, which specifically supports chimpanzee and gorilla studies in the wild, or about our many other conservation and education programs. We know a large segment of our visitors are schoolchildren, of course, and it's our responsibility to provide them with the resources that they can take advantage of.

As our membership continues to grow – it is now at an all-time high – we plan to continue improving how we care for animals and housing them in modern facilities, while leading the way in the development of conservation and education programs.

Maybe someday we'll see the number of members, as well as visitors, double. As we learned with the opening of Regenstein African Journey last spring and now with the Regenstein Center for African Apes, anything is possible when you dream big.

Kevin J. Bell
Kevin J. Bell
President and CEO

SUMMER 2004 3

1_____

DESIGN FIRM
Circa 77 Design
Gateshead, England

PROJECT
Homes Away From Home

EDITOR
Bruce Willan

PUBLISHER
i2Media

2_____

DESIGN FIRM
Lincoln Park Zoo
Chicago, (IL) USA

PROJECT
African Ape Issue
Summer 04

DESIGNER
Peggy Martin

PHOTOGRAPHER
Greg Neise

41

STATE
OF THE
PARKS®

STATE OF THE PARKS® Program

[body text illegible]

CONTENTS

REPORT SUMMARY

[body text illegible]

FORT BOTTOM CABIN—SHELTER FOR BANDITS?

[body text illegible]

ARCHAEOLOGY—VANISHED TREASURES: PROGRAM CRITICAL TO RESOURCE PROTECTION

[body text illegible]

NATIONAL PARKS SERVICE IMPACT LEVELS

MODERATE IMPACT: *[body text illegible]*

SEVERE IMPACT: *[body text illegible]*

HISTORIC STRUCTURES: 97 PERCENT OF STRUCTURES SUFFERING MODERATE TO SEVERE IMPACTS

[body text illegible]

THE PARK HAS A WELL-DEVELOPED ARCHIVAL PROGRAM. ADMINISTRATIVE AND HISTORIC RECORDS HAVE BEEN PROCESSED, APPROPRIATELY HOUSED, AND HAVE FINDING AIDS TO HELP RESEARCHERS.

ARCHIVAL AND MUSEUM COLLECTIONS—PARK NEEDS ITS OWN CURATOR

[body text illegible]

HISTORY—ADMINISTRATIVE HISTORY PROJECT UNDER WAY

[body text illegible]

This collection of pots and gourds, called the Danoff Collection, was removed in the early 1980s from land that later became part of the park. In 2002, it was returned to the park and is now part of the museum collection.

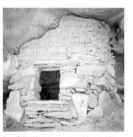

Ancestral Puebloans left behind granaries, rock art, and other evidence of their lives in the canyon country.

HOW TO PRESERVE YOUR HERITAGE

- Cultural sites and artifacts are irreplaceable. Please observe the following guidelines when visiting sites in Canyonlands and other national parks.

- View sites from a distance. Ancient walls crumble easily. Never enter structures or human-made enclosures of Canyonlands, as your movements may damage the foundation or other structural elements.

- Leave things where they lie. Resist the temptation to collect artifacts and allow future visitors the joy of discovery. Also, archaeologists can determine a great deal from the presence and location of artifacts.

- Enjoy rock art with your eyes only. Photographs and petroglyphs should not be touched as the oils in human skin will destroy them. Never spoil cultural sites or natural features with modern graffiti.

—NPS web site

1

DESIGN FIRM
Pensaré Design Group
Washington, (D.C.) USA

PROJECT
National Parks Conservation
Association Resource Assessments

CREATIVE DIRECTOR
Mary Ellen Vehlow

DESIGNERS
Yihong Hsu,
Amy E. Billingham

THE WEEK

APRIL 6 – 13

HIGH PRIORITY

THEATER	MOVIES	RESTAURANTS	ART	NIGHTLIFE
'DOUBT' TRANSFERS TO BROADWAY	THE CHRISTOPHER GUEST FILM SERIES AT MOMA	SHAKE SHACK REOPENS IN MADISON SQUARE PARK	TAKASHI MURAKAMI AT THE JAPAN SOCIETY	SONIC YOUTH AT NORTHSIX

MOVIES

EDITED BY SARA CARDACE

NEW THIS WEEK

THE BIG PICTURE ★
Christopher Guest's hilarious comedy about a young film-maker (Kevin Bacon) who gets co-opted by the system flopped when it came out in 1989; MoMA's Guest retro-spective offers a chance to remedy this crime. The film features not only the sharpest satire of the director's career, but also sterling bits from Martin Short, JT Walsh, and even Teri Hatcher. (1 hr. 40 mins.; PG-13) *Opens 4/11.*

DAVID HOCKNEY: THE COLORS OF MUSIC
British-born artist David Hockney has produced lauded stage designs and costumes for almost a dozen major operas over the past 30 years. Maryte Kavaliauskas's documentary explores his creative process and flamboyant personality. (1 hr. 25 mins.; NR) *Opens 4/6.*

EROS
This three-part anthology about eroticism and desire showcases the work of three of modern cinema's most well-known auteurs: Wong Kar Wai, Steven Soder-bergh, and Michelangelo Antonioni. Each director crafts a distinct exploration of the titular subject. (1 hr. 48 mins.; R) *Opens 4/8.*

FEVER PITCH
Drew Barrymore and Jimmy Fallon star in this romantic comedy about a schoolteacher and a businesswoman who meet and fall in love, only to have their burgeoning rela-tionship imperiled by his love for the Boston Red Sox. The Farrelly brothers direct. (1 hr. 38 mins.; PG-13) *Opens 4/8.*

GUARDING EDDY
Scott McKinsey's indie drama follows the relationship be-tween a young, developmentally disabled man and the failed NBA hopeful he meets in a homeless shelter. Brian Presley and Kiko Ellsworth star. (1 hr. 36 mins.; NR) *Opens 4/8.*

KUNG FU HUSTLE
In this madcap Chinese action-adventure flick, a young wannabe gangster named Sing makes his way through the Shanghai underworld, encountering a cast of shady char-acters and kung fu masters along the way. Stephen Chow stars and directs. (1 hr. 35 mins.; R) *Opens 4/8.*

MAJOR DUNDEE ★
Sam Peckinpah's epic Western, featuring Charlton Hes-ton as a cavalry major chasing after a band of Apaches, was hacked to pieces by its studio back in 1965. It's now been nearly restored and finally makes some sense. The direc-tor's characteristic blend of violence and elegiac machismo is in full force. (2 hrs. 16 mins.; PG-13) *Opens 4/8.*

THE PLOT AGAINST HARRY ★
In Michael Roemer's 1969 gem, a small-time numbers man leaves prison and tries to reincorporate into the legit life with his estranged family. Thanks to its understated brand of comedy, this film sat unreleased for twenty years, then appeared briefly in 1989. It's been a cult item ever since. (1 hr. 21 mins.; NR) *Opens 4/6.*

SAHARA
Matthew McConaughey and Penélope Cruz star in this epic drama, which follows explorer Dirk Pitt as he em-barks on a treasure hunt in the wilds of northern Africa. Breck Eisner directs. (2 hrs. 4 mins.; PG-13) *Opens 4/8.*

WINTER SOLSTICE
Indie talent Anthony LaPaglia stars in this familial dra-ma as a soft-spoken gardener sadly standing by as his relationship with his two sons slowly disintegrates. Things start to turn around after the arrival of an en-lightening neighbor (Allison Janney). (1 hr. 30 mins.; R) *Opens 4/8.*

NOW PLAYING

THE AVIATOR ★
Martin Scorsese returns to form with this Howard Hughes biopic in which Leonardo DiCaprio stars. Gwen

NYMETRO.COM
FOR MOVIE-THEATER LISTINGS,
SHOWTIMES, AND EXPANDED REVIEWS,
VISIT NEW YORK *MAGAZINE ON THE WEB.*

ABOUT THESE LISTINGS Where indicated, these synopses are condensed from reviews by Ken Tucker and Peter Rainer; the remainder are by Logan Hill, Bilge Ebiri, and *New York*'s editors. Stars (★) denote recommended releases, ranging from best-of-the-year picks to worthy curios to flawed movies with one outstanding element.

Typography by John Fulbrook

2_____

DESIGN FIRM
New York Magazine
New York, (NY), USA

CLIENT
New York Magazine

DESIGN DIRECTOR
Luke Hayman

ART DIRECTOR
Chris Dixon

PHOTO DIRECTOR
Jody Quon

DESIGNER
Steve Motzenbecker

ILLUSTRATOR
Adam Larson

TYPOGRAPHY
John Fulbrook

2_____

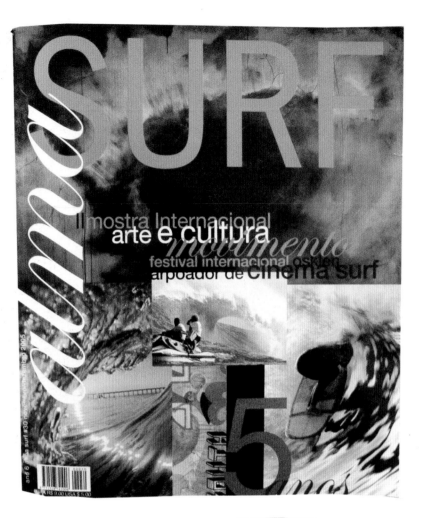

DESIGN FIRM
Mike Salisbury LLC
Venice Beach, (CA) USA
PROJECT
Surf
CREATIVE DIRECTOR
Mike Salisbury
ART DIRECTOR
Gustavo Morais

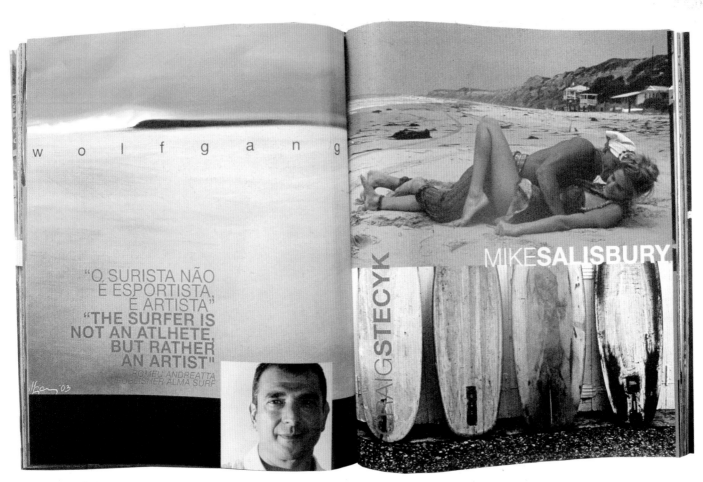

w o l f g a n g

"O SURISTA NÃO
É ESPORTISTA,
É ARTISTA"
"THE SURFER IS
NOT AN ATLHETE,
BUT RATHER
AN ARTIST"
ROMEU ANDREATTA
PUBLISHER ALMA SURF

CRAIGSTECYK

MIKE SALISBURY

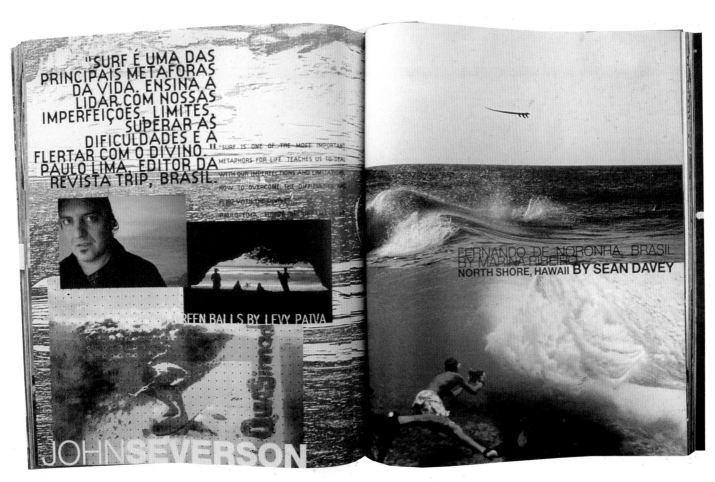

"SURF É UMA DAS
PRINCIPAIS METAFORAS
DA VIDA. ENSINA A
LIDAR COM NOSSAS
IMPERFEIÇÕES, LIMITES,
SUPERAR AS
DIFICULDADES E A
FLERTAR COM O DIVINO.
PAULO LIMA, EDITOR DA
REVISTA TRIP, BRASIL.

"SURF IS ONE OF THE MOST IMPORTANT
METAPHORS FOR LIFE. TEACHES US TO DEAL
WITH OUR IMPERFECTIONS AND LIMITATIONS,
HOW TO OVERCOME THE DIFFICULTIES AND
FLIRT WITH THE DIVINE.
PAULO LIMA, EDITOR OF TRIP MAGAZINE, BRAZIL"

GREEN BALLS BY LEVY PAIVA

FERNANDO DE NORONHA, BRASIL
BY MARINA RIBEIRO
NORTH SHORE, HAWAII BY SEAN DAVEY

JOHN SEVERSON

47 Park Street
A return to elegant living

1 _____

Food

C AV iAR EM pTOR

Tim Haywood

Interiors

Interiors

Number one fan

Charlotte Wilkins

46

1 _____
DESIGN FIRM
Circa 77 Design
Gateshead, England
PROJECT
Homes Away From Home
EDITOR
Sasha Wilkins
PUBLISHER
i2Media

numero 1 | anno 2 | gennaio 2005

Diplomazia Commerciale

RIVISTA TRIMESTRALE
DEL CLUB DEGLI ADDETTI
COMMERCIALI CIVILI
AMBASCIATE ESTERE IN ITALIA

Speciale
America Latina

Club degli Addetti
Commerciali in Italia

La parola al Ministro: Jacek Socha, Polonia	L'ultimo erede di Marco Polo	Il Ministero delle Attività Produttive informa: notizie dalle D.G.

Diplomazia Commerciale · SPECIALE AMERICA LATINA · SPECIALE AMERICA LATINA · Diplomazia Commerciale

Intervista all'Ambasciatore del Perù in Italia, Harold Forsyth

Perù
Occasioni d'investimento tra l'Oceano e le Ande

INTERVISTA DI RICCARDO GEFTER

Turismo, pesca, e risorse minerarie.
L'ambasciatore del Perù in Italia S.E. Harold Forsyth presenta i settori strategici del suo paese e illustra i rapporti con il resto del mondo.

Harold Forsyth
Ambasciatore
del Perù in Italia

14

numero 1 | anno 2 | febbraio 2005

numero 1 | anno 2 | febbraio 2005

15

2

Diplomazia Commerciale · SPECIALE AMERICA LATINA · SPECIALE AMERICA LATINA · Diplomazia Commerciale

Intervista all'Ambasciatore Synesio Sampaio Goes, Console Generale del Brasile in Italia.

Brasile
La sfida dello sviluppo omogeneo in un territorio vastissimo

INTERVISTA DI RICCARDO GEFTER

L'obiettivo è aggregare valore ai diversi anelli della catena produttiva, dalla materia prima al design, al marketing finale di prodotto, passando per un necessario adeguamento delle infrastrutture del paese.
La produttività del comparto agro-alimentare, trainata dalla crescente domanda cinese, fa il pari con la crescita dell'industria di beni ad alto contenuto di tecnologia. Motore e guida del processo di integrazione economica in America Meridionale, il Brasile di Lula è oggi uno degli attori più dinamici del sistema internazionale.

20

numero 1 | anno 2 | febbraio 2005

numero 1 | anno 2 | febbraio 2005

21

2

DESIGN FIRM
designation Studio für Visuelle Kommunikation
Klagenfurt, Austria

PROJECT
Diplomazia Commerciale

DESIGNER
Jürgen G. Eixelsberger

A REPORT FROM THE AMERICAN ACADEMY OF MICROBIOLOGY

MARINE MICROBIAL DIVERSITY:
THE KEY TO EARTH'S HABITABILITY

AMERICAN
SOCIETY FOR
MICROBIOLOGY

DESIGN FIRM
Pensaré Design Group
Washington, (D.C.) USA
PROJECT
American Society for Microbiology
Marine Diversity Report
CREATIVE DIRECTOR
Mary Ellen Vehlow
DESIGNER
Lauren Emeritz

This report is based on a colloquium, sponsored by the American Academy of Microbiology, held April 8-10, 2005, in San Francisco, California.

The American Academy of Microbiology is the honorific leadership group of the American Society for Microbiology. The mission of the American Academy of Microbiology is to recognize scientific excellence and foster knowledge and understanding in the microbiological sciences. The Academy strives to include underrepresented scientists in all its activities.

The American Academy of Microbiology is grateful for the generous support of The Gordon and Betty Moore Foundation.

The opinions expressed in this report are those solely of the colloquium participants and may not necessarily reflect the official positions of our sponsors or the American Society for Microbiology.

A REPORT FROM THE AMERICAN ACADEMY OF MICROBIOLOGY

MARINE MICROBIAL DIVERSITY:
THE KEY TO EARTH'S HABITABILITY

JENNIE HUNTER-CEVERA, DAVID KARL, AND MERRY BUCKLEY

cope with the conditions or by creating barriers to keep the harsh conditions out of their cells.

In cold environments, psychrophilic bacteria cope with the conditions by maintaining flexible membranes and by circulating natural antifreeze compounds throughout the cell. In extremely hot areas of the oceans, hyperthermophilic microbes use subtle changes in their proteins to maximize the number of stabilizing salt bridges and ion pairings that keep enzymes together in the heat. Reverse gyrase, which allows DNA to maintain its structure during replication at high temperatures, is another unique enzyme used by hyperthermophiles.

In areas of high salt concentrations, many halophiles have adapted by altering their proteins, making them acidic, and hence, resistant to the protein-scattering effects of high salt concentrations. Other halophiles circulate osmolytes, small organic molecules that prevent water loss to the highly salty surroundings outside the cell.

The marine environment presents an unparalleled opportunity for studying life in extreme environments. Nowhere else on earth do so many different environmental conditions exist in such compact areas. The oceans are home to extremely high pressures and to the highest temperatures of any aquatic system. Deep sea brines, which have high concentrations of both salts and heavy metals, are singular habitats where life thrives despite the difficulties. Because of these diverse habitats, the oceans are unique with respect to the challenges posed to life and with respect

to the wealth of biological diversity that has arisen to cope with those challenges.

IMPACTS OF HUMAN-INDUCED CHANGE ON THE CYCLING OF ELEMENTS IN THE OCEANS

Since the industrial revolution, vast quantities of many important bioelements have been taken from relatively inert or inaccessible sources and released into the planet's air, soil, and water. Inputs to the environment on this scale directly and indirectly impact the oceans, and atmospheric inputs of greenhouse gases have induced rapid climate change. As world populations climb and resource exploitation soars, environmental inputs and climate change are accelerating at an alarming rate. Some significant alterations in the microbial communities of the oceans, and, therefore, in the global cycling of the bioelements, are anticipated in the wake of these escalating changes.

The impacts of global temperature changes resulting from climate changes will be felt by microbial enzyme systems. Different enzyme systems have different temperature optima, so microecological processes in a given area may be depressed or stimulated depending on the nature of the local temperature change (up or down) and the optima of the enzyme systems involved. These changes are not predictable, since the optimum temperature for enzymes are not easy to decipher from an organism's habitat.

In some areas of the world, climate change has resulted in a decrease in rainfall. In Saharan Africa, a decline in rainfall combined with human activities has led to desertification of many areas and encouraged an increase in wind-born dust, resulting in an increase in the deposition of African dust in the oceans. The metals carried in this dust, including iron, are likely to impact marine microbial communities and the cycles they carry out that sustain the biosphere. (As a side note, in China's Gobi Desert, irrigation and other land use practices have actually decreased the size of selected deserts. This has led to a decrease in dust deposition, and could cause iron limitation in the marine waters where dust and the iron it carries is otherwise deposited.)

Human inputs of nitrogen to the oceans, which comprise roughly

half of the total nitrogen inputs, are impacting the global cycling of nitrogen in both known and unknown ways. For example, nitrogen pollution has had an impact on nitrous oxide cycling in coastal systems, apparently resulting in a net increase in nitrous oxide production. Nitrogen-burdened, oxygen-depleted coastal regions account for only 2% of the ocean surface area, but these regions contribute about 20% of the nitrous oxide the oceans release to the atmosphere. The concentration of nitrous oxide in the atmosphere is increasing at an accelerating rate, and it is not clear how this trajectory will change with global climate change. It is likely that escalating nitrogen inputs will continue to perturb and transform the nitrogen cycle and that nitrous oxide emissions from the oceans will continue to climb.

Because of their rapid growth rates and metabolic flexibility, marine microbes could possibly serve as a buffer that helps dampen large scale changes resulting from human-induced modifications of the oceans. There is a great deal of uncertainty about how well this dampening effect works in practice, however. It may be that marine microbes have a certain, buffering capacity, but when it is exceeded conditions will decline precipitously.

The consequences of global climate change and human inputs of bioelements to the oceans are potentially disastrous. Temperature increases can have an indirect effect on the acid-

ity of ocean water, and thus, on the marine habitat. The solubility of carbon dioxide increases with temperature, and dissolved carbon dioxide combines with water to form carbonic acid (H_2CO_3) which subsequently dissociates into H^+ and HCO_3^-. These materials lower the pH of the water. The concentration of carbon dioxide from human sources is also on the rise. Hence, a decrease in the pH of seawater is expected to

THE CONSEQUENCES OF GLOBAL CLIMATE CHANGE AND HUMAN INPUTS OF BIOELEMENTS TO THE OCEANS ARE POTENTIALLY DISASTROUS

echo the global warming trend and ongoing increases in carbon emissions. Ocean acidification will have a direct impact on corals. They are expected to grow more slowly and become more fragile under these circumstances, decreasing the ability of coral reefs to act as protective island barriers even as storm intensity increases because of climate change.

Climate change may also bring about big changes in the stratification of the oceans, reducing mixing and reducing the output of marine fisheries.

pmg's

GREATER
SOUTH
SOUND

HOME
& GARDEN
A LIFESTYLE MAGAZINE

Discover
Poulsbo

SPA
BATHROOMS
• Fresh ideas
• Newest products

$4.95

COASTAL COOKOUT
Host a beach party in your backyard.

CRAMPED QUARTERS?
Get more space without add-ons.

pampered pets

LUXE PRODUCTS AND
SPECIAL SERVICES FOR FIDO.

SPRING / SUMMER 2004

PLUS: Rhododendrons, Northwest bed and breakfasts, growing mint,
Steilacoom's 150th anniversary and much more.

premiermedia.net

DESIGN FIRM
Premier Media Group
Tacoma, (WA) USA
PROJECT
Home & Garden Magazine
ART DIRECTOR
Dallas Drotz

coastal cookout
Host a Beach Party in Your Backyard

When the sun finally makes its appearance, it's time to celebrate—
Pacific Northwest style! Throw a backyard beach party with a
nautical theme and delectable seafood dishes, and pay homage to
Washington's beautiful coast and rich maritime history.

BY LINDA KAMINSKI, EMILY WINARD,
AND STACIE MAGELSSEN | PHOTOGRAPHY BY JEFF HOBSON

the invitations

Keep the invitations simple. Using Word
or a similar word processing program,
set the document's size to four inches
wide and six inches high. Create a
thin royal blue border; use the same
color for the invitation's wording,
which should be in a sans serif font
such as Arial. Using strong glue, affix
a small sea star to the top left corner.
Wrap a thin strand of jute ribbon
around the invitation two or three
times, knotting it on the backside and
cutting off any extra length. Because
the sea star is bulky and fragile, it
could break when going through the
post office's machines if placed in a
standard envelope. To ensure it arrives
in one piece, place the invitation in an
envelope and then place the envelope
in a bubble mailer, available at any post
office or mail center.

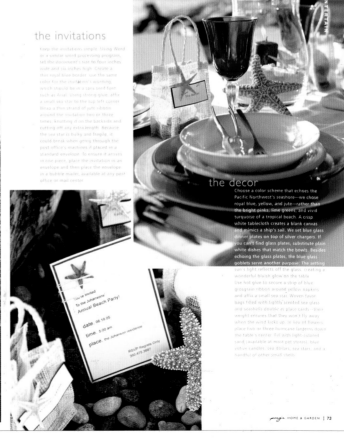

the decor

Choose a color scheme that echoes the
Pacific Northwest's seashore—we chose
royal blue, yellow, and jute—rather than
the bright pinks, lime greens, and vivid
turquoise of a tropical beach. A crisp
white tablecloth creates a blank canvas
and mimics a ship's sail. We set blue glass
dinner plates on top of silver chargers. If
you can't find glass plates, substitute plain
white dishes that match the bowls. Besides
echoing the glass plates, the blue glass
goblets serve another purpose: The setting
sun's light reflects off the glass, creating a
wonderful bluish glow on the table.
Use hot glue to secure a strip of blue
grosgrain ribbon around yellow napkins
and affix a small sea star. Woven favor
bags filled with lightly scented sea glass
and seashells double as place cards—their
weight ensures that they won't fly away
when the wind kicks up. In lieu of flowers,
place two or three hurricane lanterns down
the table's center. Fill with light-colored
sand (available at most pet stores), blue
votive candles, sea dollars, sea stars, and a
handful of other small shells.

*You're invited
to the Johansons'
Annual Beach Party!*

date: 06.19.05

time: 5:00 pm

place: the Johanson residence

RSVP Regrets Only
360.475.9887

the drinks

Place bottled water and an assortment of alcoholic and nonalcoholic drinks in a large galvanized tub filled with ice. Serve dry white wine instead of red. Before the meal begins, pass around glasses of hard lemonade to the adults.

Hard Minted Lemonade

1 1/3 cups sugar
1 cup fresh mint leaves
2 lemons, sliced
2 cups vodka
2 cups fresh lemon juice
2 cups club soda

In a large pitcher mix sugar, mint leaves, and sliced lemon. Add vodka and lemon juice. Let stand for 30 minutes. Stir to dissolve sugar. Chill for 30 minutes. Add club soda and serve over ice. Add fresh mint and lemon wedges for garnish.

The Menu

DRINK
Hard Minted Lemonade

APPETIZER
Mussels in Lemon Cream

MAIN COURSES
Garlic Roasted Crab
Tuscan Bread
Shrimp Caesar with Spicy Croutons

DESSERT
Frosted Sugar Cookies

Garlic Roasted Crab
(MAKES APPROXIMATELY 6 SERVINGS)

8 tablespoons unsalted butter
8 tablespoons extra-virgin olive oil
2 tablespoons minced garlic
6 Dungeness crabs, cooked, cleaned, and cracked
4 tablespoons freshly squeezed lemon juice
1/2 cup finely chopped parsley
Salt and pepper to taste

Preheat oven to 500 degrees. Heat butter, olive oil, and garlic in a medium-sized saucepan over medium-high heat until butter is melted. Place crab on a large cookie sheet and pour butter-olive oil mixture over the top of the crab. Season with salt and pepper. Transfer to the oven and roast until garlic turns light brown and crab is heated through, approximately 12 minutes, tossing once halfway through. Transfer contents of the pan into a large, warm serving bowl. Add lemon juice and parsley and toss. Serve with clarified butter if desired.

Instead of using individual crab crackers, consider placing a large cracker on each end of the table for your guests to share. We used beautiful exotic wood crab crackers we found from a local company on the Olympic Peninsula. Not only are these crab crackers functional (they crack crab quickly and without a lot of the mess associated with smaller crackers), they are gorgeous to look at.

Mussels in Lemon Cream
(MAKES APPROXIMATELY 6 SERVINGS)

2 tablespoons unsalted butter, softened
3 tablespoons minced garlic
1 tablespoons minced green onions
2 1/2 tablespoons finely chopped fresh parsley
2 teaspoons freshly squeezed lemon juice
1 15-ounce can diced tomatoes
1/2 lemon
1 1/2 pounds mussels (about 30)
1/2 cup dry white wine
1/4 cup heavy cream
Salt and pepper to taste

In a bowl, stir butter, 1 tablespoon of garlic, green onion, 1 tablespoon of the parsley, lemon juice, and salt and pepper to taste; set aside. Cut lemon into 4 wedges and remove seeds. Scrub mussels and remove beards. In a heavy 4-quart saucepan melt butter mixture over moderate heat. Add lemon wedges and remaining garlic and cook, stirring 30 seconds. Add mussels and cook, stirring, 1 minute. Add wine, cream, and salt and pepper to taste. Simmer, covered, until mussels are opened (about 5 minutes). Discard mussels that haven't opened. Stir in diced tomatoes and remaining parsley. Garnish with diced, seeded tomato and finely chopped parsley.

*FOR THE SHRIMP CAESAR SALAD, SPICY CROUTONS, AND FROSTED SUGAR COOKIES RECIPES, SEND AN EMAIL TO DANA@PREMIERMEDIA.NET AND PUT "RECIPES" IN THE SUBJECT LINE.

putting down roots
choosing and caring for landscape trees

BY PAMELA KOCK
PHOTOGRAPHY BY MELISSA MUNSON AND THOMASINA ROSS

A graceful Japanese maple punctuates the Chase Garden's lovely alpine meadow in spring.

W hen it comes to home landscaping, trees provide much more than vertical appeal. They soften stark edges and make houses feel like homes. Well-placed trees reduce the need for air conditioning in the summer and heating in the winter by providing shade and windbreaks. Trees also remove air pollutants, produce the oxygen we breathe, and combat global warming by removing carbon dioxide from the air and lowering our usage of fossil fuels.

BUILD IT

BUILD IT

Just in time for summer backyard fun!
An easy to construct picnic table project that you can build family memories around. After you make your table send us a picture of your project and we may place it on our web site. Visit RealDadMagazine.com for the details.

Materials
The materials used for this project are standard 1 x 6-in. (for the seats and table top) and 1 x 3-in. boards (for legs, seat supports, table supports and braces).

Note: Actual dimensions of 1x 6-in. timbers are approximately 3/4-in. x 5-1/2-in. due to the timber dressing or planing of production. 1 x 3-in. timbers typically measure 3/4 x 2-3/4-in.

Untreated pine is ideal for indoor applications. If the table is to be left outside, choose a timber that has a natural resistance to decay (doesn't rot easily) in preference to a pressure-treated timber. The chemicals in some pressure-treated woods can make for a potentially dangerous eating surface. Redwood is an excellent and elegant choice. Your local timber supplier can advise you of available options.

The Fasteners used are 1-1/2-in. deck or wood screws. A 1-lb. box of all-purpose wood screws should be sufficient for this job.

Tools
Tools needed include:

- Power Drill
- Circular Saw
- Square
- Tape Measure

JUNE/JULY 2005 ·11· REAL DAD MAGAZINE

TAKE 'EM
FISHIN'

TOP 10 TIPS:

1. **Start small.** Smaller fish are often more abundant, easier to find and easier to catch. Kids think "catching" when adults say "fishing" – going after smaller fish usually means more catching. Use small hooks and add a bobber for more action and greater success.

2. **Go where the action is.** Check with local bait and tackle stores or look up the local fish and wildlife agency in your phone book to find well-stocked fishing spots for ideal first-outing destinations. There are likely one or two only a short drive from your front door.

3. **Get kids their own equipment.** They'll appreciate the experience all the more with their own equipment. Rod and reel combos for kids can be purchased for about $15 at your local sporting goods store. These affordable packaged sets are great for those new to the sport.

4. **Use live bait.** Earthworms, crickets, minnows and other live bait are often the most productive, and collecting them is half the fun.

5. **Keep it short and sweet.** Limit the time you'll be on the water. Leave while enthusiasm's high, before the kids start to get antsy. If you end the day on a high note, they'll be hooked on coming back.

6. **Focus on fun.** Put the kids first. Remember, there's a world of difference between "taking them fishing" and the kids "going fishing with you." Concentrate on their experience and save your casts for another day.

7. **Brush up on the basics.** If you haven't been fishing in a while, the internet is a great source for information. The public service website www.TakeMeFishing.org is a great place to start.

8. **Be safe.** If you're going to have your kids in a boat on the water, make sure everyone wears snug-fitting personal flotation devices at all times. Bring plenty of water to keep hydrated on hot days, and don't forget the sun block.

9. **Let them be captain for the day.** If you're fishing from a boat, take time to teach your kids the basics of how a boat works. You might even teach him how to steer.

10. **Don't forget your camera.** Of course you'll want to capture the moment your child catches his or her first fish. Don't let this memory be the

Did you know that fishing and boating have their own national celebration week? Neither did we. June 4-12 is National Fishing & Boating Week and actor Dean Cain, star of the television series, "Lois and Clark: The New Adventures of Superman," is the honorary chairperson of this year's celebration. Cain, an avid fisherman, grew up fishing with his father. "Fishing has always been a big part of my life," he says, "and I'm having a great time teaching my son, who always looks forward to the next time I take him fishing."

This summer may be the perfect time to take your daughter or son fishing. To help you have fun on the water and have fun with your kids, we've included some tips on taking kids fishing. Fish with Cain and dads across the nation during National Fishing & Boating Week, and show your child a whole new world of adventure. To learn more about boating and fishing visit www.TakeMeF

REAL DAD MAGAZINE ·20· JUNE/JULY 2005

1

READ, READ: books for childre

Books are a great way to spend time with your children, to foster their imagination, and to open new worlds for them. Reading with your child, even your newborn, is an activity every father should relish.

Want to know what kids are reading?
DIANE MANGAN, Category Director of Children's books at Borders Books and Music, has furnished a list of a few of the top selling children's titles available at Borders.

Baby (0–18 months)	Toddler (18–36 months)	Preschool (3–4 years)	Read Together (4–6 years)	Learn to Read (4–7 years)	Read to Myself (7–9 years)	Independent Reader (8–12 years)
1. Goodnight Moon by Margaret Wise Brown	1. Goodnight Moon by Margaret Wise Brown	1. Tails by Matthew Van Fleet	1. Green Eggs and Ham by Dr. Seuss	1. Animal Antics: Now I'm Reading by Nora Gaydos	1. Summer of the Sea Serpent by Mary Pope Osborne	1. The Bad Beginning, the First (A Series of Unfortunate Events) Lemony Snicket
2. Very Hungry Caterpillar by Eric Carle	2. Happy Baby Colors by Roger Priddy	2. Clap Your Hands: Elmo Puppet by Joseph Ewers, Illustrator	2. The Lorax by Dr. Seuss	2. The Cat in the Hat Cooking with the Cat by Bonnie Worth	2. Top-Secret Personal Beeswax: A Journal by June B. (and Me!) by Barbara Park	2. Tale of Despereaux by DiCamillo
3. Brown Bear, Brown Bear, What Do You See? by Bill Martin, Jr.	3. Happy Baby Animals by Jo Douglass and Neville Graham	3. Ten Little Ladybugs by Melanie Gerth	3. Go, Dog. Go! by P.D. Eastman	3. Dora's Picnic: Ready to Read Series by Christine Ricci	3. June B., First Grader: Boo & I Mean It by Barbara Park	3. Inkheart by Cornelia
4. Pat the Bunny by Dorothy Kunhardt	4. Cheerios Play Book by Lee Wade	4. Elmo's Play Day: Plush Sound Set by Publications International	4. The Sneetches and Other Stories by Dr. Seuss	4. Playful Pals: Level 1 by Nora Gaydos	4. Captain Underpants and the Big, Bad Battle of the Bionic Booger Boy, Part 2: The Revenge of the Ridiculous Robo-Boogers by Dav Pilkey	4. The People Room, Be the Second (A Series of Unfortunate Events) Lemony Snicket
5. Snuggle Puppy by Sandra Boynton	5. Elmo's Big Lift & Look Book by Alan Ross	5. Disney Animals Friends Mover Theater: Storybook and Projector by Sarah Heller	5. Are You My Mother? by P.D. Eastman	5. Amelia Bedelia: 40th Anniversary Collection by Peggy Parish	5. June B. Jones's First Boxed Set Ever! by Barbara Park	5. Harry Potter Limited Box Set (Books 1-5) Rowling

REAL DAD MAGAZINE ·24· APRIL/MAY 2005 APRIL/MAY 2005 ·25· REAL DAD MA

CLASSICAL MUSIC

New Music, With Training Wheels
James Levine and the Boston Symphony ease their audience out of the standard repertory.
BY PETER G. DAVIS

APPARENTLY CONDUCTORS LIKE to teach as much as they enjoy entertaining people or simply showing off, since nearly all orchestral concerts nowadays have some sort of instructive premise. James Levine has not yet spent a full season as the Boston Symphony's new music director, but he is already giving his audiences plenty of what he thinks is good for them, especially new music. No doubt many listeners object to taking their medicine, but that hardly keeps Dr. Levine from vigorously administering fresh doses. The orchestra's latest visit to Carnegie Hall offered new scores by two of Levine's favorite contemporaries—John Harbison and Charles Wuorinen, both born in 1938—and in between was Stravinsky's severe and tersely compressed twelve-tone *Movements for Piano and Orchestra*, a late work completed in 1959. The Brahms Second Symphony came last—not exactly a sweetmeat, but in this context definitely a spoonful of sugar.

That said, only ears averse to the prospect of hearing new music of any kind would have been offended by this invigorating concert. Harbison's *Darkbloom: Overture for an Imagined Opera* is a positively gorgeous seven-minute curtain-raiser, woven from an assortment of thematic strands that throb with a mysterious lyrical power quite unlike anything I've heard from this composer. The "imagined opera" in this case was to be based on Nabokov's *Lolita*, a project Harbison abandoned after the subject matter began to strike him as untenable in today's climate. Too bad, since he was clearly responding to something in the material with unusual urgency.

Wuorinen's new work is a three-movement piano concerto, the fourth such piece in this composer's huge catalogue. It was composed to order for Levine and

BOSTON SYMPHONY ORCHESTRA
JAMES LEVINE, CONDUCTOR.
PETER SERKIN, PIANO. CARNEGIE HALL.

ORCHESTRA OF SAINT LUKE'S
"POSTCARD FROM PRAGUE."
DONALD RUNNICLES, CONDUCTOR.
IVAN MORAVEC, PIANO. CARNEGIE HALL.

Peter Serkin, who warmed up for it by playing Stravinsky's *Movements* with grace and precision. He then threw himself enthusiastically into Wuorinen's new score, which, without losing its intellectual rigor for a moment, generates a compellingly theatrical play of light and dark moods, all created through a delicious blend of instrumental sonorities, lucid organizational clarity, and clever manipulation of the keyboard's coloristic resources. A virtuoso pianist is required, of course, and Serkin has exactly what it takes to make this concerto glitter.

As for Levine, he gives every impression of being rejuvenated by his new association. In any case, it was high time for him to put some distance between himself and the crazy politics of the Metropolitan Opera after all these years and take over a major American orchestra, where he can settle down and make music without extramusical distractions. That already seems to be happening in Boston, and perhaps this exceptionally gifted musician will fulfill himself at last.

"POSTCARD FROM PRAGUE" was the theme of Donald Runnicles's recent concert with the Orchestra of Saint Luke's at Carnegie Hall. Even though he wasn't Czech, Mozart dominated the proceedings, and why not? He was admired in Vienna, but they loved him in Prague, and the composer wrote some of his noblest scores for that city's discerning audiences, two of them back-to-back in 1786: Symphony No. 38 and Piano Concerto No 25. The former was given a spruce, musically alert performance, but the concerto had a special glow, thanks to Ivan Moravec's exquisitely tailored playing of the solo part.

The two authentic Czech scores on the program are both rarities. The three excerpts from Janáček's *Idylla* for strings had in fact never before been played in Carnegie Hall, and it's a pity the whole suite wasn't offered. This music predates most of the tougher Janáček we usually hear, but that distinctively life-affirming voice is unmistakable in these charming evocations of Moravian country life. A ballet featuring amorous kitchen utensils, Martinů's saucy *La Revue de Cuisine* for six instruments actually leaves Prague far behind as it embraces the jazz-soaked music scene in Paris, where the composer was living and working during the twenties. This is most definitely a postcard from France. Its witty message may have a heavy Czech accent, but that doesn't really matter—some composers seem to feel comfortably at home anywhere, Martinů in Paris no less than Mozart in Prague. ∎

Illustration by Sean McCabe

2_____

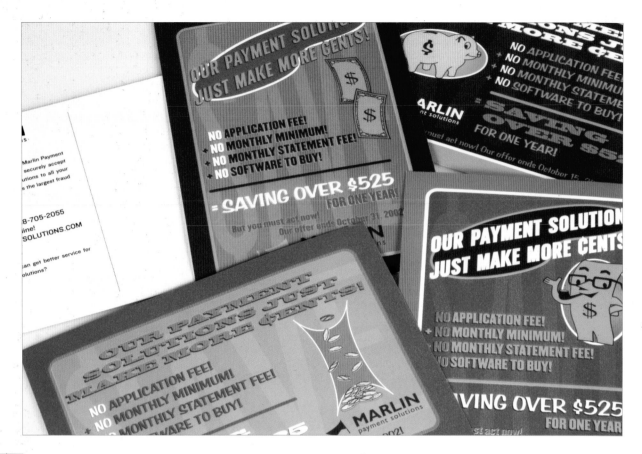

1 _____

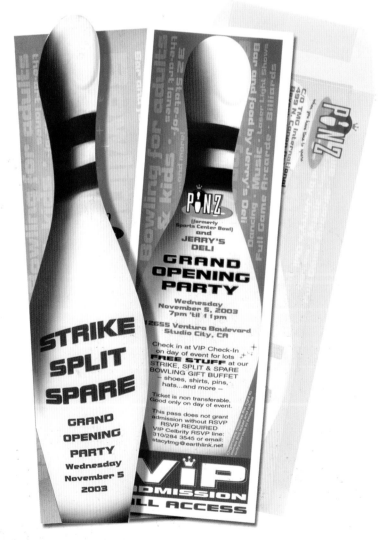

2 _____

1 _____
DESIGN FIRM
maycreate
Chattanooga, (TN) USA
CLIENT
Marlin Payment Solutions
CREATIVE DIRECTOR, PHOTOGRAPHER
Brian May
ART DIRECTOR, DESIGNER
Grant Little
COPYWRITER
Kristina Kollar
PRINTER
Creative Printing

2 _____
DESIGN FIRM
Greenlight Designs
North Hollywood, (CA) USA
CLIENT
TMG Marketing for PINZ Bowling
CREATIVE DIRECTOR
Tami Mahnken
SENIOR DESIGNER
Melissa Irwin
DESIGNER
Shaun Wood
PHOTOGRAPHER
Darryl Shelly

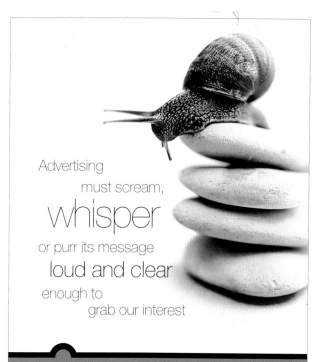

Advertising
must scream,
whisper
or purr its message
loud and clear
enough to
grab our interest

(j)(w)(d)

BRAND 3 EFFORTS

THE REAL KEY TO MARKET LEADERSHIP IS PERCEIVED QUALITY. BECAUSE QUALITY IS DRIVEN BY PERCEPTION, BRANDING IS A KEY ISSUE IN ATTAINING AND KEEPING MARKET LEADERSHIP. THE POWER THAT SIMPLY COMES FROM BEING A LEADER GIVES A BRAND ALL SORTS OF OTHER ADVANTAGES, FROM BARGAINING POWER WITH DISTRIBUTION TO A GENERAL AURA OF QUALITY.

529.8833 (j)(w)(d) 372.5355

QUALITY MARKETING MATERIALS

THE REAL Key TO MARKET LEA

HIGH OCTANE

MARKETING MATERIALS

(j)(w)(d)

3_____

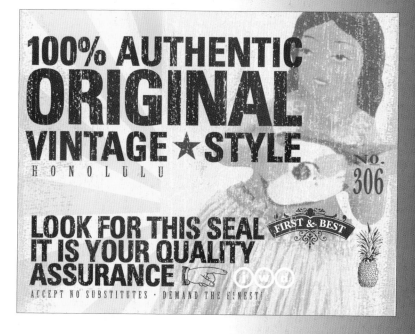

100% AUTHENTIC
ORIGINAL
VINTAGE ★ STYLE
HONOLULU

NO. 306

LOOK FOR THIS SEAL
IT IS YOUR QUALITY
ASSURANCE

FIRST & BEST

(j)(w)(d)

ACCEPT NO SUBSTITUTES · DEMAND THE FINEST!

3_____
DESIGN FIRM
John Wingard Design
Honolulu, (HI) USA
CLIENT
John Wingard Design
ART DIRECTOR, DESIGNER
John Wingard

DIRTWORKS™ PC
LANDSCAPE ARCHITECTURE
200 PARK AVENUE SOUTH
NEW YORK, NEW YORK 10003

NEW Projects

NEW Photos

NEW Information

Company News

Dirtworks invites you to look
at their updated web site.

www.dirtworks.us

TEL 212-529-2263 FAX 212-505-0904
EMAIL INFO@DIRTWORKS.US

1_____

Your favorite sports teams!
Sold-out concerts! Black-tie award shows!
OW YOU CAN BE THERE LIKE NEVER BEFORE!

Go. See. Do. More.
Welcome to GES!

**Why settle for just seeing the stars when
you can get treated like one?**

• The connection you need...and no excessive markups

• The freedom to cherry-pick the events you most want to see

• Personal concierge service: golf, dinner and travel arrangements, too

• A one-of-a-kind employee benefit they'll actually use and rave about

**Why take sky-high ticket
prices sitting down?**

2_____

YOU ARE CORDIALLY INVITED
TO DO WHATEVER
THE HELL YOU WANT.

1_____
DESIGN FIRM
Acme Communications, Inc.
New York, (NY) USA
PROJECT
Dirtworks Postcard
DESIGNERS
Kiki Boucher,
Andrea Ross Boyle

2_____
DESIGN FIRM
JUNGLE 8/creative
Los Angeles, (CA) USA
CLIENT
Green Entertainment Services
CREATIVE DIRECTOR,COPYWRITER
Scott Silverman
DESIGNERS
Lainie Siegel, Gracie Cota

WINE SPECTATOR's

bring your own
Magnum Party
in Napa

Marvin R. Shanken, Editor & Publisher, WINE SPECTATOR
Cordially invites you to attend our annual

bring your own
Magnum Party
in Napa

on the occasion of the Napa Valley Wine Auction

Wednesday, June 2, 2004 • 6:30 pm
Tra Vigne • 1050 Charter Oak Avenue • St. Helena

Buffet Dinner and Dancing

We look forward to seeing you...

Thomas Matthews, Executive Editor • **Kim Marcus,** Managing Editor
Harvey Steiman, Editor at Large • **James Laube,** Senior Editor
Daniel Sogg, Associate Editor • **Tim Fish,** Associate Editor
MaryAnn Worobiec, West Coast Tasting Coordinator
Miriam Morgenstern, V. P., Associate Publisher • **Cynthia McGregor O'Donnell,**
V.P., Managing Director, West Coast • **Connie McGilvray,**
Senior V.P., Administration/Advertising Sales and Services • **Lindsey Hall,**
West Coast Account Manager • **Paulette Williams,** Director, Event Marketing

3 _____

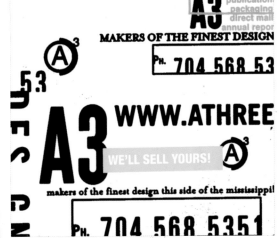

3 _____
DESIGN FIRM
M. Shanken Communications, Inc.
New York, (NY) USA
PROJECT
Napa Magnum Party
ART DIRECTOR, DESIGNER
Chandra Hira
ILLUSTRATOR
Claire Fraser/Imagezoo

4 _____
DESIGN FIRM
A3 Design
Charlotte, (NC) USA
CLIENT
A3 Design
DESIGNERS
Alan Altman,
Amanda Altman,
Steven McGinnis

4 _____

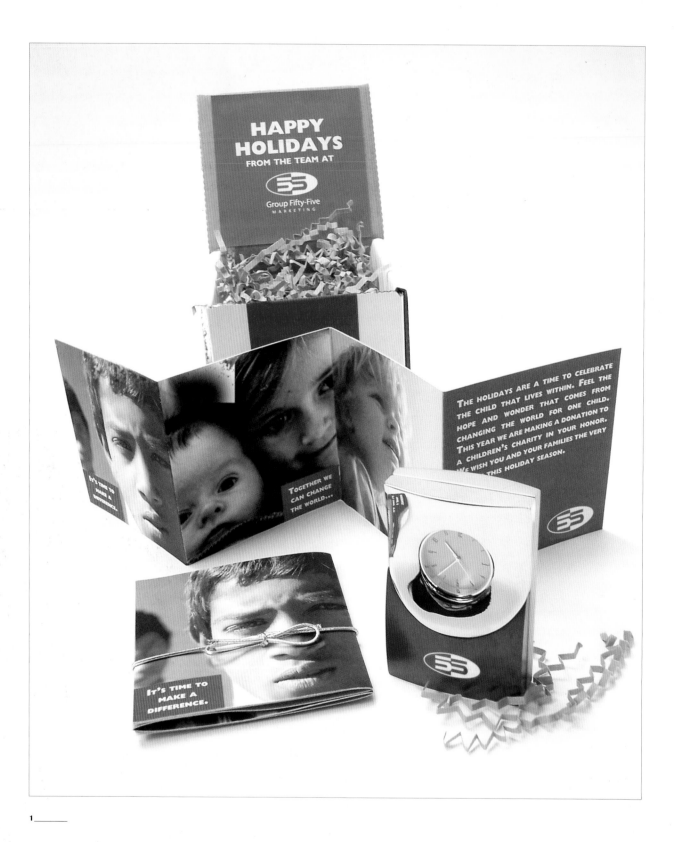

1_____

2_____

1_____

DESIGN FIRM
Group 55 Marketing
Detroit, (MI) USA

PROJECT
Group 55 Holiday Card 2005

ART DIRECTOR, DESIGNER, COPYWRITER
Jennifer Rewitz

2_____

DESIGN FIRM
A3 Design
Charlotte, (NC) USA

PROJECT
E-sert card

DESIGNERS
Alan Altman,
Amanda Altman,
Eric Formanowicz

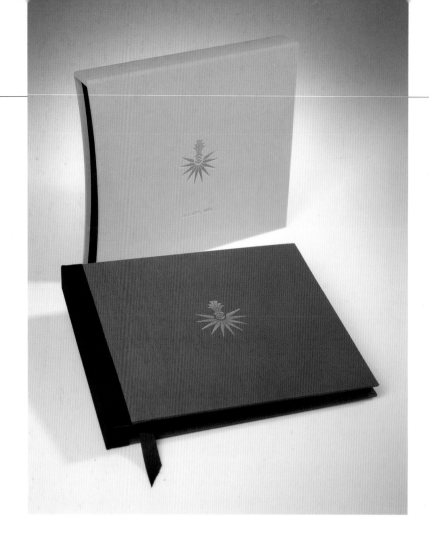

DESIGN FIRM
Riordon Design
Oakville, (Ontario) Canada
CLIENT
Carlson Marketing Group
PROJECT
The Scotia Capital
Invitation to the Carlu
DESIGNERS
Shirley Riordon,
Tim Warnock,
Dan Wheaton

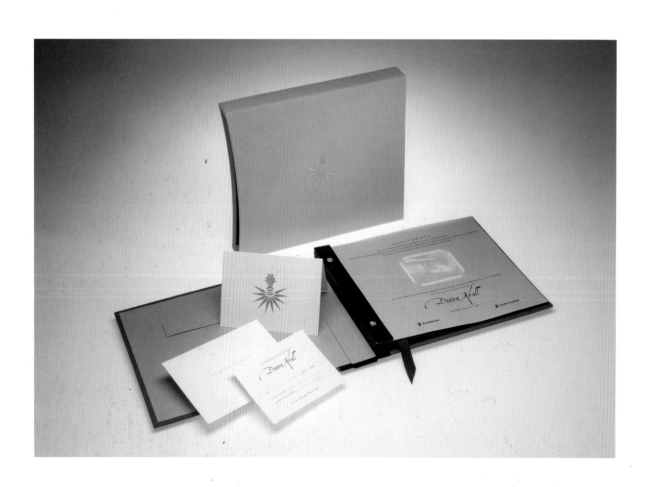

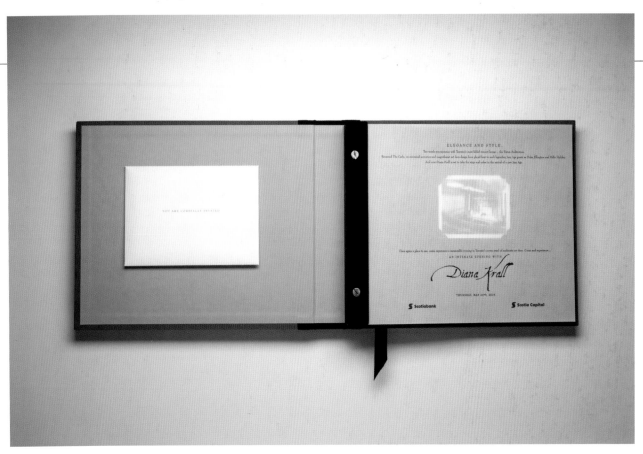

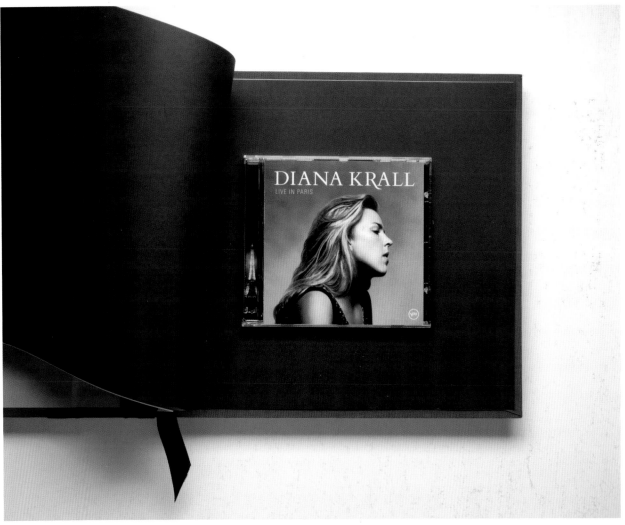

1_____

2_____

3_____

Sonja Foshee *photographer*

Individual and group portraits are an **investment in your family, preserving the memories of a lifetime.** Sonja Foshee produces **creative, memorable portraits** by spending time with her clients and **beautifully capturing** their style and personality in her images.

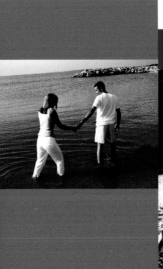

CHILDREN'S PORTRAITS **COLOR ENHANCED PORTRAITS** **SENIOR PORTRAITS** **FAMILY PORTRAITS** **BLACK & WHITE PORTRAITS**

4_____

1_____
DESIGN FIRM
Jill Lynn Design
Jersey City, (NJ) USA
CLIENT
The Atlanta Literary Festival
ART DIRECTOR, DESIGNER
Jill Balkus

2_____
DESIGN FIRM
atomz i! pte ltd
Singapore
CLIENT
Economic Development Board
ART DIRECTOR
Albert Lee
DESIGNER
Lam Oi Ee
COPYWRITER
Kestrel Lee

3_____
DESIGN FIRM
MC Creations Design Studio, Inc.
Hicksville, (NY) USA
CLIENT
MC Creations
Design Studio, Inc.
DESIGNERS
Michael Cali,
Cynthia Morillo

4_____
DESIGN FIRM
little bird communications
Mobile, (AL) USA
PROJECT
Sonja Foshee Portraits Card
DESIGNER
Diane Gibbs
PHOTOGRAPHER
Sonja Foshee

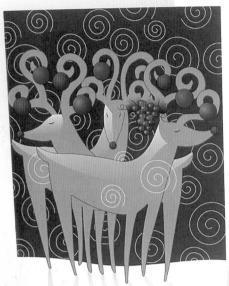

May the
Spirit Of The Season
Be With You
All Year!

Group 55 Marketing

Catch the Holiday Spirit!

1_____

Fully integrated accounting software with powerful Web and analytic capabilities.

With Envision, you're no longer chained to your desk when providing services for your clients. Staff working offsite can securely enter timesheets, submit expenses, and perform other personnel and project management functions via the Internet. The results? *Increased client satisfaction. Enhanced revenue. Lower costs.*

Envision is fully integrated, so your entire organization can easily access hundreds of up-to-the-minute financial reports with extensive drill-down analytic capabilities.

Choose **Small Business, Standard,** or **Enterprise Edition.** Conversion is easy, with full support. All components are included, and no additional seat license fees!

Visit our website for details and receive your FREE gift:
www.envisionaccounting.com/engineering.html

"Envision Accounting met and

exceeded our expectations . . .

(It) gives us the tools we need

to determine the health of

our business, and to ensure

that we are keeping our

projects profitable."

— **TERRY M. STULC**
PRESIDENT
TRINDERA ENGINEERING, INC.

E n v i s i o n
ACCOUNTING MADE EASY

13809 212th Drive N.E.
Woodinville, WA 98072

Prsrt Std
US Postage
PAID
Blaine, WA
Permit No. 106

2_____

**To obtain your free book, complete our short online survey. Offer applies exclusively to recipients of this postcard, one request per company, please. ©2005 Envision*

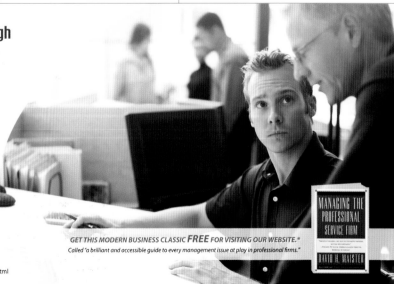

Discover Breakthrough Accounting Software Designed to Enhance Your Profitability

Developed specifically for **engineers** and other **professional service firms,** Envision is packed with advantages that other accounting packages either don't have or charge too much for.

E n v i s i o n
ACCOUNTING MADE EASY

www.envisionaccounting.com/engineering.html

*GET THIS MODERN BUSINESS CLASSIC **FREE** FOR VISITING OUR WEBSITE.**
Called "a brilliant and accessible guide to every management issue at play in professional firms."

MANAGING THE
PROFESSIONAL
SERVICE FIRM

DAVID H. MAISTER

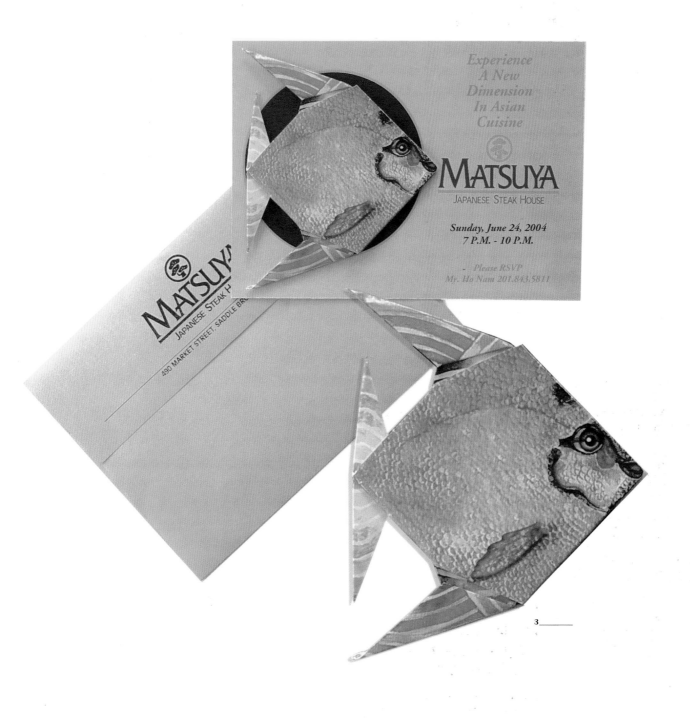

1_____
DESIGN FIRM
Group 55 Marketing
Detroit, (MI) USA
PROJECT
Group 55 Holiday Card 2004
DESIGNER, ILLUSTRATOR
Jeannette Gutierrez
COPYWRITER
Catherine Lapico

2_____
DESIGN FIRM
Ray Braun Design
Seattle, (WA) USA
PROJECT
Envision Postcard
CREATIVE DIRECTOR
Ray Braun
DESIGNER
Dave Simpson
COPYWRITER
Al Lefcourt

3_____
DESIGN FIRMS
Stephen Longo Design Associates and
Media Consultants
West Orange, (NJ) USA
CLIENT
Matsuya Japanese Restaurant
DESIGNER
Stephen Longo
COPYWRITER
Harvey Hirsch

ECHO IS

A THROBBING METROPOLIS

SLIGHTLYFUTURISTIC

UNMISTAKABLE URBAN

EXPERIENCE DAVIDOFF

ECHO

WEDNESDAY, MAY 21ST, 2003

SOME BAR

99 STREET ADDRESS @ CROSS AVENUE

COCKTAILS FROM 6.00 - 9.00 PM

RSVP 212.123.4567

DESIGN FIRM
Über, Inc.
New York, (NY) USA

PROJECT
ECHO Invitation

DESIGNER
Herta Kriegner

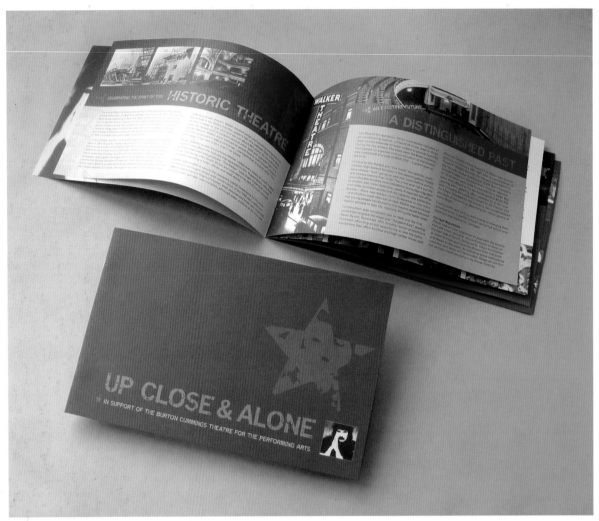

1_____

BLACK FRIDAY

Friday, November 25, 2005 6:30 a.m.–10:00 a.m.

Beauty Blowout at New York New York

Voted "Best in Frederick" for Ten Years

301.695.7777

808 Toll House Ave.
Frederick, MD 21701

new york | new york
HAIR SALON | DAY SPA

2_____

3_____

DYLAN

1_____
DESIGN FIRM
Velocity Design Works
Winnipeg, (Manitoba) Canada
PROJECT
Up Close & Alone
(Burton Cummings)
CREATIVE DIRECTOR, ART DIRECTOR, DESIGNER
Lasha Orzechowski

2_____
DESIGN FIRM
Octavo Designs
Frederick, (MD) USA
CLIENT
New York New York Salon and Day Spa
ART DIRESTOR, DESIGNER
Sue Hough

3_____
DESIGN FIRM
Wet Paper Bag Visual Communication
Crowley, (TX) USA
CLIENTS
Bonita & Lewis Glaser
DESIGNER, ILLUSTRATOR, COPYWRITER
Lewis Glaser
INSPIRATIONAL GURU
Milton Glaser
STUDIO
Wet Paper Bag Visual Communication

69

ENTERTAINER –
captivating & witty

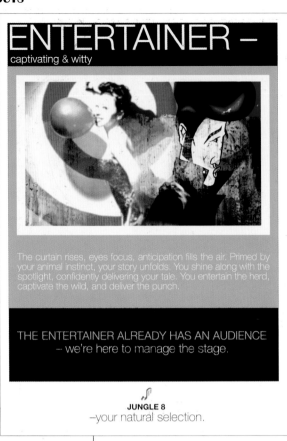

The curtain rises, eyes focus, anticipation fills the air. Primed by your animal instinct, your story unfolds. You shine along with the spotlight, confidently delivering your tale. You entertain the herd, captivate the wild, and deliver the punch.

THE ENTERTAINER ALREADY HAS AN AUDIENCE
– we're here to manage the stage.

♫
JUNGLE 8
–your natural selection.

FIRESTARTER –
– provocateur of innovation

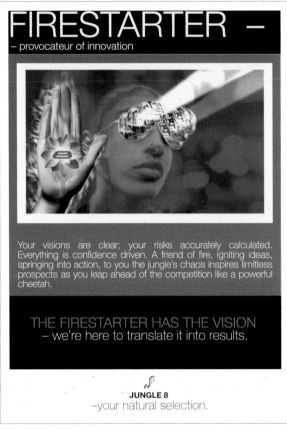

Your visions are clear; your risks accurately calculated. Everything is confidence driven. A friend of fire, igniting ideas, springing into action, to you the jungle's chaos inspires limitless prospects as you leap ahead of the competition like a powerful cheetah.

THE FIRESTARTER HAS THE VISION
– we're here to translate it into results.

♫
JUNGLE 8
–your natural selection.

JUGGLER –
keeping it all going

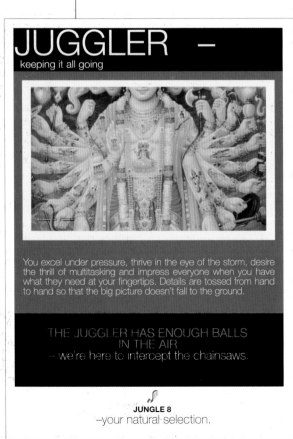

You excel under pressure, thrive in the eye of the storm, desire the thrill of multitasking and impress everyone when you have what they need at your fingertips. Details are tossed from hand to hand so that the big picture doesn't fall to the ground.

THE JUGGLER HAS ENOUGH BALLS IN THE AIR
-- we're here to intercept the chainsaws.

♫
JUNGLE 8
–your natural selection.

KING OF THE BEASTS –
proud & strong

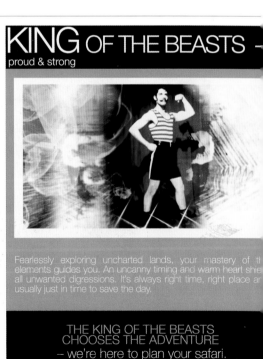

Fearlessly exploring uncharted lands, your mastery of the elements guides you. An uncanny timing and warm heart shield all unwanted digressions. It's always right time, right place and usually just in time to save the day.

THE KING OF THE BEASTS CHOOSES THE ADVENTURE
-- we're here to plan your safari.

♫
JUNGLE 8
–your natural selection.

SHAMAN –
spiring with imagination

takes a special person to create something out of nothing and uide one's team with ideals subtler than the jungle mists. tructure is ceaselessly challenged by all forces of nature, but e person's magic can protect the way that things best get one.

THE SHAMAN HAS A
PHILOSOPHY THAT WORKS
– we're here to amplify the preaching.

JUNGLE 8
–your natural selection.

MASTERMIND –
strategist extraordinaire

You are rich with ideas, inspired by brilliance, comforted by genius. Your mind moves strategically, calculating the next 10 moves with an unnoticed ease. With you, the job is done before the morning sun warms the ground, and the birds begin to sing.

THE MASTERMIND HAS IT
ALL FIGURED OUT
– we're here to support your strategy.

JUNGLE 8
–your natural selection.

LOVER –
– giver and provider

You are found providing support, soothing doubts and majestically guiding every jungle creature toward their ultimate habitat. Your gifts serve as your navigational tool in the wild landscape. You possess the gift of multi-level communication and a heart more precious than gold.

THE LOVER NURTURES EVERY CREATURE
– we're here to build your arc.

JUNGLE 8
–your natural selection.

SWINGER –
suave & debonair

There you go, swinging from vine to vine with back-to-back projects and demanding deadlines. An adventurous spirit propels you. Your high-octane wit coupled with fearless confidence keeps you flying through the air with the greatest of ease.

THE SWINGER NEEDS A SAFETY NET,
– we're down here when you need us.

JUNGLE 8
–your natural selection.

DESIGN FIRM
JUNGLE 8/creative
Los Angeles, (CA) USA
CLIENT
JUNGLE 8, LLC
CREATIVE DIRECTORS, DESIGNERS
Lainie Siegel, Heyward Bracey
COPYWRITER
Mat Gleason

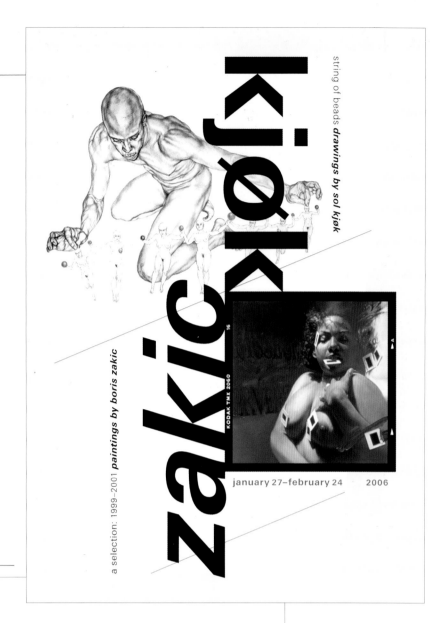

string of beads *drawings by sol kjøk*

kjøk

a selection: 1999–2001 *paintings by boris zakic*

zakic

KODAK TMX 2060 16

january 27–february 24 2006

1_____

exploring the concept of transportation in works of design and fine art

T R A N S *transportation design*

N O V E M B E R *11*–D E C E M B E R *9* 2005

MANIFEST
CREATIVE RESEARCH GALLERY AND DRAWING CENTER

2_____

the KODES team at the CAD Research Center and CDM Technologies, Inc. wishes you a joyous holiday season.

ICODES

3_____

1_____
DESIGN FIRM
kristincullendesign
Cincinnati, (OH) USA
CLIENT
Manifest Creative Research Gallery
and Drawing Center
DESIGNER
Kristen Cullen

2_____
DESIGN FIRM
elf design
Belmont, (CA) USA
PROJECT
Kodes Christmas Card
DESIGNER, ILLUSTRATOR
Erin Ferree

3_____
DESIGN FIRM
Barbara Spoettel
New York, (NY) USA
CLIENT
Auster Bar,
Augsburg, Germany
ART DIRECTOR, ILLUSTRATOR
Barbara Spoettel

1_____

1_____
DESIGN FIRM
Barbara Spoettel
New York, (NY) USA
CLIENT
Peter and Ilona Kowaltschik
ART DIRECTOR, ILLUSTRATOR
Barbara Spoettel

2_____

2_____
DESIGN FIRM
EdgeCore
Cedar Falls, (IA) USA
CLIENT
Gateway Hotel &
Conference Center
ART DIRECTOR
Joe Hahn
COPYWRITER
Ruth Goodman
ACCOUNT EXECUTIVE
Scott Stackhouse

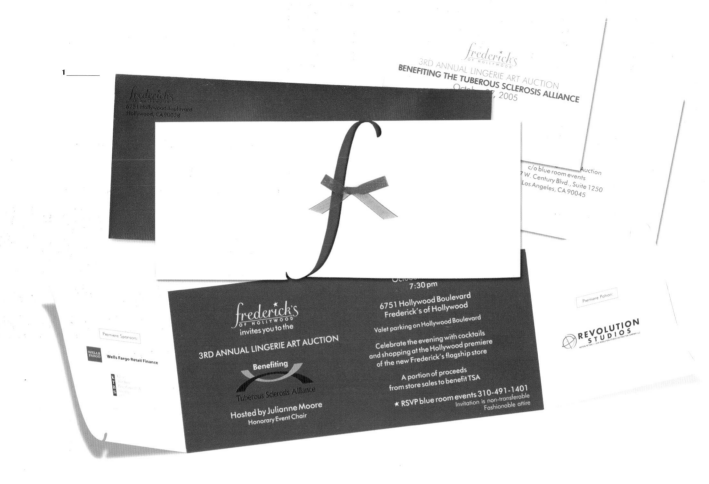

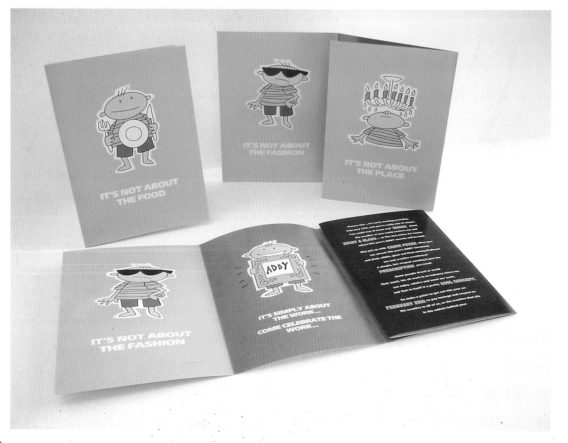

1 _____

DESIGN FIRM
Greenlight Designs
North Hollywood, (CA) USA
CLIENT
Jennifer Lowitz, Frederick's
CREATIVE DIRECTORS
Tami Mahnken,
Darryl Shelly
SENIOR DESIGNER
Melissa Irwin
DESIGNER
Shaun Wood

2 _____

DESIGN FIRM
Gutierrez Design Associates
Ann Arbor, (MI) USA
CLIENT
Ann Arbor Ad Club
DESIGNER, ILLUSTRATOR
Jeannette Gutierrez
COPYWRITER, CONCEPT
Joanne Bandoni

November 10-12, 2005 • San Jose, CA

"This year's spectacular 10th anniversary conference event will build and strengthen the global community of coaches by providing inspiration, community, connection, education and enjoyment! "

We expect 1500 international attendees which include experienced:

- *Personal and Life Coaches*
- *Executive and Business Coaches*
- *Corporate, Organization and Internal Coaches*
- *ICF Credentialed Coaches*

As well as:

- *Those interested in coaching as a business resource*
- *Those interested in coaching as a career choice*
- *And many others!*

Visit www.coachfederation.org for online registration and more information

CATCH THE FIRE!
Early bird registration ends August 31

International Coach Federation®
2365 Harrodsburg Rd.
Suite A325
Lexington, KY 40504
Phone: 1-888-423-3131

RETURN SERVICE REQUESTED

PRSRT STD
U.S. POSTAGE
PAID
LEXINGTON, KY
PERMIT NO. 850

Be Inspired — *Light the Fire*

International Coach Federation®
10th Annual
Conference

November 10-12, 2005
San Jose, California
USA

Honoring the Past — Celebrating the Present — Realizing Our Future

SAN JOSE

S A V E T H E D A T E f o r I C F !

International Coach Federation®

3_____

READ
Every
Day

The Story of READ! 365

READ

With a Child For a Child.™

READ! 365

3_____

DESIGN FIRM
JL Design
Plainfield, (IL) USA

PROJECT
International Coach Federation Card

DESIGNERS
JL Design

4_____

DESIGN FIRM
Desbrow
Pittsburgh, (PA) USA

CLIENT
Read! 365

DESIGNERS
Kimberly Miller,
Jason Korey

4_____

77

1_____

1_____
DESIGN FIRM
Group 55 Marketing
Detroit, (MI) USA
PROJECT
Group 55 Marketing
Self Promotion
ART DIRECTOR, DESIGNER
Jeannette Gutierrez
COPYWRITERS
Catherine Lapico, Jeannette Gutierrez

2_____
DESIGN FIRM
TD2, S.C.
Mexico City, Mexico
CLIENT
Nestlé Food Services Mexico
DESIGNER
Liliana Ramírez,
Adalberto Arenas

2_____

3_____

DESIGN FIRM
M. Shanken Communications, Inc.
New York, (NY) USA
PROJECT
Market Watch Magazine E-Card
ART DIRECTOR
Chandra Hira
DESIGNER
Terrence Janis

3_____

WINE SPECTATOR's

sonoma
BRING YOUR OWN
MAGNUM
PARTY 2004

Marvin R. Shanken,
Editor & Publisher, WINE SPECTATOR

Cordially invites you to attend our

sonoma
BRING YOUR OWN
MAGNUM
PARTY 2004

Tuesday, June 1, 2004 ▪ 6:30 pm ▪ Dry Creek Kitchen
Hotel Healdsburg ▪ 25 Matheson Street ▪ Healdsburg, California

Buffet Dinner and Dancing

We look forward to seeing you...

Thomas Matthews, Executive Editor ▪ **Kim Marcus,** Managing Editor
Harvey Steiman, Editor at Large ▪ **James Laube,** Senior Editor
Daniel Sogg, Associate Editor ▪ **Tim Fish,** Associate Editor
MaryAnn Worobiec, West Coast Tasting Coordinator
Miriam Morgenstern, V. P., Associate Publisher ▪ **Cynthia McGregor O'Donnell,**
V.P., Managing Director, West Coast ▪ **Connie McGilvray,**
Senior V.P., Administration/Advertising Sales and Services ▪ **Lindsey Hall,**
West Coast Account Manager ▪ **Paulette Williams,** Director, Event Marketing

1_____

2_____

C1N Streaming Communications

On October 1st a new day in streaming

▸ Combining best of breed technology with streaming media expertise,
provides solutions for all your online communications needs. From
most complex streaming media applications to the simple task
delivering your message, our process provides cost effective solutions
move your business forward.

▸ Contact Information

Sales
1(866) 589-0826
sales@c1n.com

Web
www.c1n.com

lutions that move
our business forward >> n

1_____
DESIGN FIRM
M. Shanken Communications, Inc.
New York, (NY) USA
PROJECT
Sonoma Magnum Party Invitation
ART DIRECTOR, DESIGNER, ILLUSTRATOR
Chandra Hira

2_____
DESIGN FIRM
maycreate
Chattanooga, (TN) USA
CLIENT
Channel 1 Now
CREATIVE DIRECTOR, ART DIRECTOR, DESIGNER
Brian May
COPYWRITER
Christina Kollar
PRINTING
Creative Printing

Belém do Pará, Belém de Nazaré!

DIZEM QUE O CÍRIO DE NAZARÉ É O NATAL DOS PARAENSES. DIZEM QUE A CHUVA TEM HORA PARA CAIR EM BELÉM, MAS QUASE NUNCA CHOVE NA HORA DO CÍRIO. A MÃE DE JESUS, AQUI, SE CHAMA NAZARÉ. E BELÉM É ONDE JESUS NASCEU. COINCIDÊNCIAS. MAS SERÁ QUE TODAS ESSAS COINCIDÊNCIAS SÃO, DE FATO, COINCIDÊNCIAS?

Feliz Círio de dezembro, o 2º Natal do ano.

Mendes
POR COINCIDÊNCIA, A AGÊNCIA
DO CÍRIO DE NAZARÉ

3_____

4_____

3_____
DESIGN FIRM
Mendes Publicidade
Belém, Brazil
PROJECT
Mendes Christmas Card
DESIGNERS
Oswaldo Mendes,
Maria Alice Penna,
Luiz Braga

4_____
DESIGN FIRM
Velocity Design Works
Winnipeg, (Manitoba) Canada
PROJECT
Pixel Album
DESIGNERS
Velocity Design Works

1_____
DESIGN FIRM
Shelly Prisella Graphic Design
Lauderdale-By-The-Sea, (FL) USA
PROJECT
Sant Meera Postcard
DESIGNER
Shelly Prisella

2_____

DESIGN FIRM
Octavo Designs
Frederick, (MD) USA
CLIENT
Frederick Festival of the Arts
ART DIRECTOR, DESIGNER
Sue Hough
ILLUSTRATOR
Mark Burrier

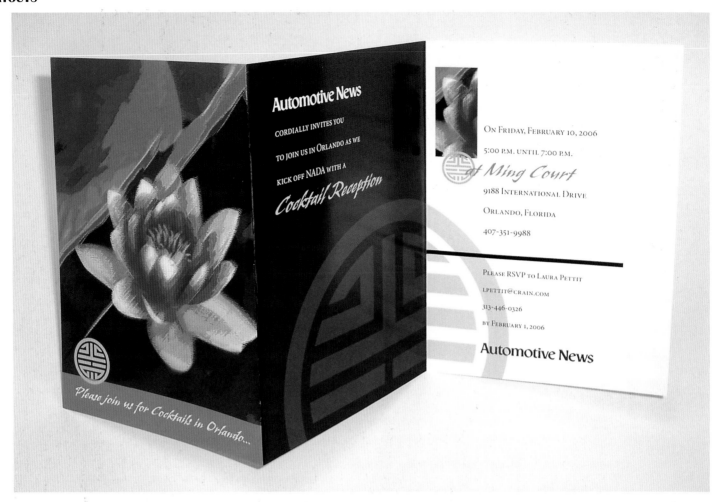

1 _____

2 _____

Tel: 516.681.1007 ■ P.O. Box 8080, Hicksville NY 11802 ■ www.mccreations00.com

1 _____
DESIGN FIRM
Gutierrez Design Associates
Ann Arbor, (MI) USA
CLIENT
Automotive News
DESIGNER
Jeannette Gutierrez

2 _____
DESIGN FIRM
MC Creations Design Studio, Inc.
Hicksville, (NY) USA
CLIENT
MC Creations Design Studio, Inc.
DESIGNERS
Michael Cali, Cynthia Morillo

84

WIR FREUEN UNS IN DER PARFÜMERIE
NAEGELE UNSERE KLEINE INNENSTADT-
DEPANDANCE ZU ERÖFFNEN. ZU EINEM
PREVIEW AM 17. SEPTEMBER LADEN WIR SIE
HERZLICH EIN. BEGINN IST UM 20 UHR.

MAGNOLIA BONBON
IN DER PARFÜMERIE NAEGELE

PHILIPPINE-WELSER-STR. 26
86150 AUGSBURG

TELEFON 0821-3447150

3 _____

4 _____

DER
KLEINE LUXUS
ZWISCHEN-
DURCH

magnolia
bonbon

JULY/AUGUST **MARKET WATCH**

ANNUAL **TEQUILA** ISSUE!

TEQUILA CATEGORY REPORT:
• Bartender Roundtable
 Discusses What's Hot
• Super-Premiums Lead
 Category Growth

LEAD FEATURE:
Supreme Court Ruling
on Direct Shipping of Wine

PLUS:
• A Look At The Pinot Noir Craze
• Retro Cocktails - Brown Spirits
• Bonus Distribution: Texas Package
 Store Convention, July 31-Aug. 2

ADVERTISING CONTACTS:

Diane Leech, V.P./Associate Publisher
e-mail: dleech@mshanken.com

Tiffany Kendall, Account Manager
e-mail: tkendall@mshanken.com
Tel. 212-684-4224
Fax: 212-779-3334

Dana Pellegrini,
West Coast Account Manager
e-mail: dpellegrini@mshanken.com
Tel. 707-963-7764
Fax: 707-963-0415

SPACE CLOSING: JUNE 16 · MATERIALS DUE: JUNE 23

3 _____
DESIGN FIRM
Barbara Spoettel
New York, (NY) USA
CLIENT
Magnolia Restaurant,
Augsburg, Germany
ART DIRECTOR, DESIGNER
Barbara Spoettel

4 _____
DESIGN FIRM
M. Shanken Communications, Inc.
New York, (NY) USA
PROJECT
Market Watch Magazine E-Card Promo
Tequila Issue
ART DIRECTOR
Chandra Hira
DESIGNER
Terrence Janis

Private Moments
© 2002- *Sharon DeLaCruz*

Bath Woman
Sharon DeLaCruz
© 2002

Artistic Moments
Sharon DeLaCruz
© 1987- reprinted 2002

© 2002 - Sharon DeLaCruz

Flower in the Desert

ARTiST
Sharon DeLaCruz
Welcome !
www.mycreativemoments.com

DESIGN FIRM
CRMultimedia
Chicago, (IL) USA

CLIENT
Quilt Designs

CREATIVE DIRECTOR
Sharon DeLaCruz

TECHNICAL DIRECTOR
William Barrett

PHOTOGRAPHERS
Michelle McClendon, James Smestad,
Kenneth Warner, Paul Skelley

Michael • Elizabeth
July 23, 2005

Michael Campos Y Elizabeth Tobias

SATURDAY THE TWENTY THIRD OF JULY, 2005 AT 6:30 IN THE EVENING
ceremony and reception
THE SPANISH KITCHEN 826 N. LA CIENEGA AVE. WEST HOLLYWOOD

cuban cocktail attire optional / menu includes vegetarian and vegan dishes

For details, hotel information and gift registry,
please visit elizabethtobias.com/wedding
or email mikeandelizabeth@gmail.com

Michael Campos Y Elizabeth Tobias

SATURDAY THE TWENTY THIRD OF JULY, 2005 AT 10:00 IN THE EVENING
champagne, cake & rhumba
THE SPANISH KITCHEN 826 N. LA CIENEGA AVE. WEST HOLLYWOOD

·cuban cocktail attire optional·

For details, hotel information and gift registry,
please visit elizabethtobias.com/wedding
or email mikeandelizabeth@gmail.com

DESIGN FIRM
JUNGLE 8 / creative
Los Angeles, (CA) USA
CLIENT
Elizabeth Tobias &
Michael Campos
CREATIVE DIRECTOR, DESIGNER
Lainie Siegel
PHOTOGRAPHER
Elizabeth Tobias

1_____

2_____

1_____
DESIGN FIRM
Mendes Publicidade
Belém, Brazil
PROJECT
"Eita verão Magazan"
DESIGNERS
Oswaldo Mendes,
Marcelo Amorim,
Walda Marques

2_____
DESIGN FIRM
Greenlight Designs
North Hollywood, (CA) USA
CLIENT
Debbie Mink, MGM
CREATIVE DIRECTORS
Tami Mahnken,
Darryl Shelly
SENIOR DESIGNER
Melissa Irwin
DESIGNER
Shaun Wood

3_____

affairs to remember

"Diva in a Box™ hair extensions can make any occasion memorable" — chris gill

Diva in a Box™ (temporary hair extension) | www.divainabox.com

Diva in a Box™

model: brooke (student) | photography miler hung | hair chris gill and brad bykkonen | make up: calvin brockington (smash box) | stylist eve hamilton | wardrobe www.vintagemartini.com

3_____
DESIGN FIRM
Peterson Ray & Company
Dallas, (TX) USA
PROJECT
Nordstrom ad for Diva in a Box
CREATIVE DIRECTOR, DESIGNER,
COPYWRITER, PHOTOGRAPHER
Miler Hung

1

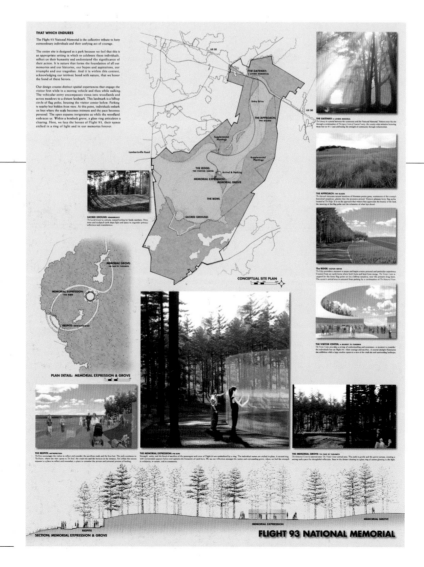

1
DESIGN FIRM
Jeremy Schultz
West Des Moines. (IA) USA
CLIENT
Regency Homes
DESIGNER
Jeremy Schultz

2
DESIGN FIRM
Acme Communications, Inc.
New York, (NY) USA
PROJECT
Flight 93 Competition
DESIGNERS
Kiki Boucher,
David Kamp,
Jamie Meunier,
Aras Ozgun,
Michael Rubin

B&W
Bowers & Wilkins

WORLD LEADERS OF INTEGRATED & UPGRADEABLE HIGH-DEFINITION BIG SCREENS, PLASMA DISPLAYS, LCD PANELS. OUR NetCommandTM TECHNOLOGY PUTS YOU IN CONTROL.

- 181 Channel tuner
- built-in speaker/subwoofer combination Digital receiver to HDTV LT-3050 30" LCD HD *Upgradeable TV.*
$4499.99 Before Savings.

- 181 Channel tuner
- built-in speaker/subwoofer combination
- Perfect Color Control System (individual control over each color)
- Upgradeable with the HD-5000 Digital receiver to HDTV LT-3050 30" LCD HD *Upgradeable TV.*
$4499.99 Before Savings.

- 181 Channel tuner
- built-in speaker/subwoofer combination
- Perfect Color Control System (individual control over each color)
- Upgradeable with the Digital receiver to HDTV LT-3050 30" LCD HD *Upgradeable TV.*
$4499.99 Before Savings.

FINE-TUNE YOUR ROOM'S ACOUSTICS

Every surface in your room has an effect on the sound before it reaches you—that's why we carry and install acoustical materials designed to control or minimize these effects.

Acoustic foam is great for correcting the most common problems in listening environments, no matter what your room's shape or size, and it comes in varying shapes that provide a range of absorption qualities and design possibilities.

Fabric-wrapped treatments provide you with the best possible acoustics without adversely affecting the décor of the room. They are made of either fiberglass or mineral wool wrapped in acoustically transparent fabric, and are specifically engineered to absorb sound energy. We then mount the panels in the correct configuration to fine-tune your room's acoustics.

BDI

WORLD LEADERS OF INTEGRATED & UPGRADEABLE HIGH-DEFINITION BIG SCREENS, PLASMA DISPLAYS, LCD PANELS. OUR NetCommandTM TECHNOLOGY PUTS YOU IN CONTROL.

- 181 Channel tuner
- built-in speaker/subwoofer combination
- Upgradeable with the HD-5000 Digital receiver to HDTV LT-3050 30" LCD HD *Upgradeable TV.*
$4499.99 Before Savings.

- 181 Channel tuner
- built-in speaker/subwoofer combination
- Perfect Color Control System (individual control over each color)
- Upgradeable with the Digital receiver to HDTV LT-3050 30" LCD HD *Upgradeable TV.*

- 181 Channel tuner
- built-in speaker/subwoofer combination
- Perfect Color Control System (individual control over each color)
- Upgradeable with the HD-5000 Digital receiver to HDTV LT-3050 30" LCD HD *Upgradeable TV.*
$4499.99 Before Savings.

3 _____

4 _____

10431 Planters View Drive
Charlotte, NC 28278
Telephone 704. 227. 9722

Planters Walk...pool, cabana, sidewalks and a playground with 2, 3 and 4 bedroom, 2 & 1/2 bath homes starting from the 160's. Minutes to Lake Wylie and easy access to I-77 and 485.

Tuesdays to Saturday 11 to 6
Sundays and Mondays 1 to 6
www.mulvaneyhomes.com

imaginethis.

planterswalk

www.mulvaneyhomes.com

Now imagine that they were free. Didn't cost a thing!

A home that comes with Stainless Steel appliances including a side by side refrigerator, stainless steel smooth top range and hood, microwave, dishwasher and to top it all off, granite countertops!

Come by and meet **Heather Brown** at Planters Walk. Ask Heather about your FREE housewarming present, and your free Designer kitchen valued at over $6,000.00. There are only a few of these designer kitchen homes available so hurry in today!

Designer Kitchen package available for a limited time only, subject to change without notice. Actual kitchen may vary from photos.

3 _____
DESIGN FIRM
Ellen Bruss Design
Denver, (CO) USA
CLIENT
Fidelity
CREATIVE DIRECTOR
Ellen Bruss
DESIGNER
Charles Carpenter

4 _____
DESIGN FIRM
A3 Design
Charlotte, (NC) USA
PROJECT
Mulvaney Homebuilders of Charlotte Ad
DESIGNERS
Alan Altman, Amanda Altman, Eric Formanowicz

93

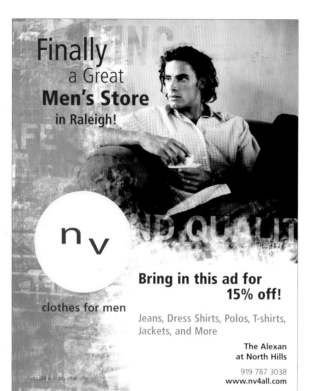

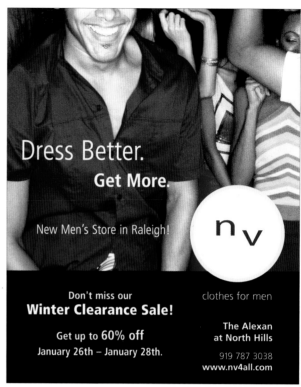

1 ____

2 ____

1 _____
DESIGN FIRM
Little Bird Communications
Mobile, (AL) USA
DESIGNER
Diane Gibbs

2 _____
DESIGN FIRM
Jeremy Schultz
West Des Moines. (IA) USA
PROJECT
Iowa Stars Campaign
DESIGNER
Jeremy Schultz

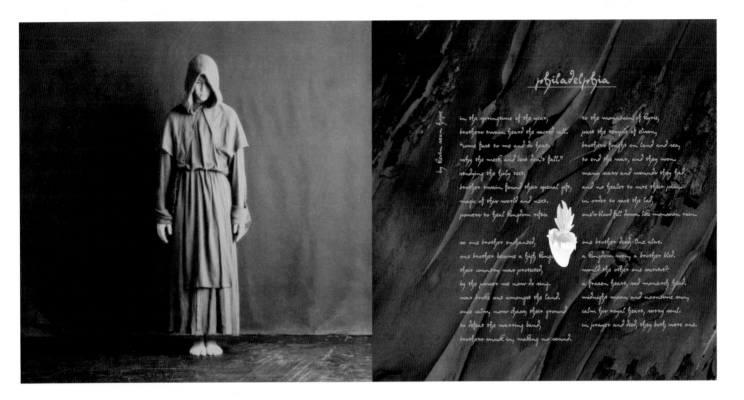

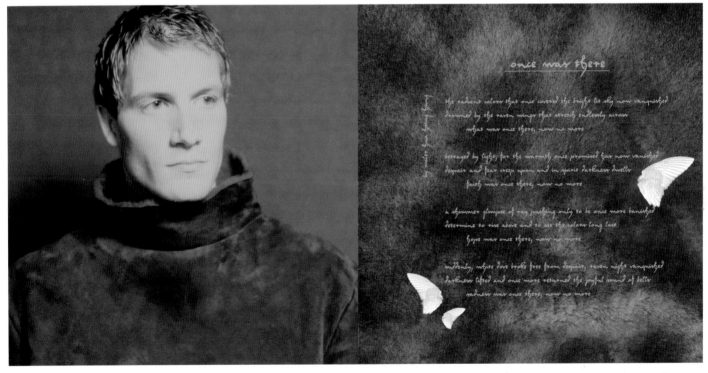

3_____

DESIGN FIRM
Peterson Ray & Company
Dallas, (TX) USA
CLIENT
Book of BE
CREATIVE DIRECTOR, DESIGNER
Miler Hung
COPYWRITER
Kevin Sean Hope
PHOTOGRAPHER
Lee Emmert

You can't teach them to play it safe. Sterilise your pets

You can't teach them to play it safe. Sterilise your pets

1_____

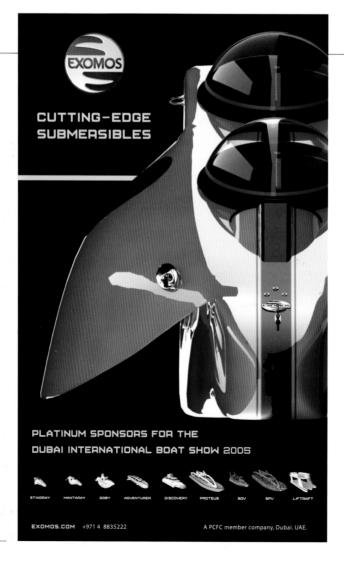

2_____

4 _____

O LIBERAL

Um jornal que teve a coragem de fazer
do seu nome uma declaração de princípios.
Reiterada há 59 anos.

Unama
UNIVERSIDADE
DA AMAZÔNIA
Educação para o desenvolvimento da Amazônia.

3 _____

3 _____
DESIGN FIRM
Mendes Publicidade
Belém, Brazil
PROJECT
"O Liberal…"
DESIGNERS
Oswaldo Mendes,
Maria Alice Penna

4 _____
DESIGN FIRM
maycreate
Chattanooga, (TN) USA
CLIENT
Jeffrey's Flowers
CREATIVE
Brian May

WHY?

WYE!

! Here is some dummy text that describes the features of this undergarment ! And it's advantages and some more copy dummy text here ! There is some dummy text that describes the features of this under garment and more ! It's advantages and some more copy herehere is some dummy text describes ! The features of this under garment and it's advantages and some ! More copy herehere is some dummy text that describes the features of this under garment and it's advantages and some more copy here.

This Is The Tag Line For The Products

here is some text that describes the features

garment here is some dummy text that describes the features

of this under garment

here is some dummy text that describes the features of this under

garment here is some dummy text

describes the features of this under garment here is some more

dummy text that describes

the features of this under garment

describes the features of this under garment here is some more

WYE!

This Is The Tag Line For The Products

here is some text that describes the features

garment here is some dummy text that describes the features

of this under garment

here is some dummy text that describes the features of this under

garment here is some dummy text

describes the features of this under garment here is some more

dummy text that describes

¿YHW

WYE!

WYE!
This is the Product Tagline

DESIGN FIRM
Über, Inc.
New York, (NY) USA
PROJECT
WYE Presentation
DESIGNER
Herta Kriegner

WYE!

Here is some dummy text that describes the features of this under garment and it's advantages and

Some more copy here here is some dummy text that describes the features of this

Under garment and it's advantages and some more copy here here is some dummy text that describes the features of this under garment and it's advantages and some more

Copy here here is the some dummy text that describes the features of this under garment and it's the advantages and there is some more copy on this line here is some dummy text that describes

WYE! undergarment comes in 3 shapes:

thong

bikini

panty

WHY?

WYE!
This is the tagline

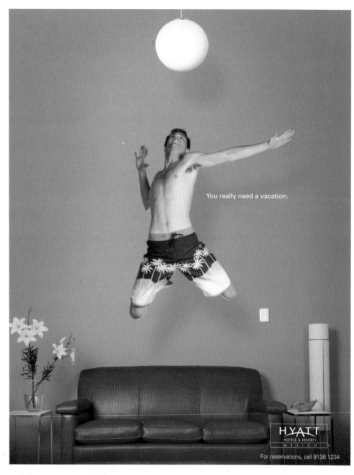

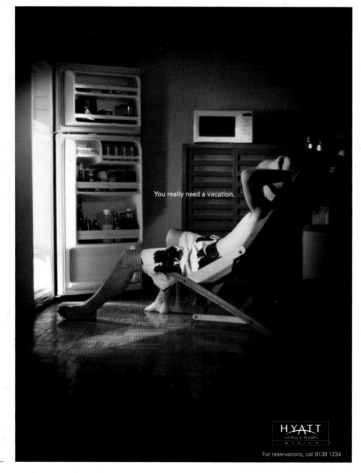

1_____

1_____
DESIGN FIRM
021 Communicaciones
Mexico City, Mexico
CLIENT
Hyatt
CREATIVE DIRECTOR
Gabriel Flores
ART DIRECTORS
Dahian Rau,
Paco Gutierrez,
Mariana Ortiz,
Vladimir Nabor
COPYWRITERS
Gabriel Flores,
Veronica Trujillo,
Angel Martinez

2_____
DESIGN FIRM
**Glitschka Studios/
Prejean Lobue**
Salem, (OR) USA
CLIENT
EasyClosets.com
CREATIVE DIRECTOR
Von R. Glitschka
ART DIRECTOR
Brent Pelloquin
COPYWRITER
Glen Gauthier

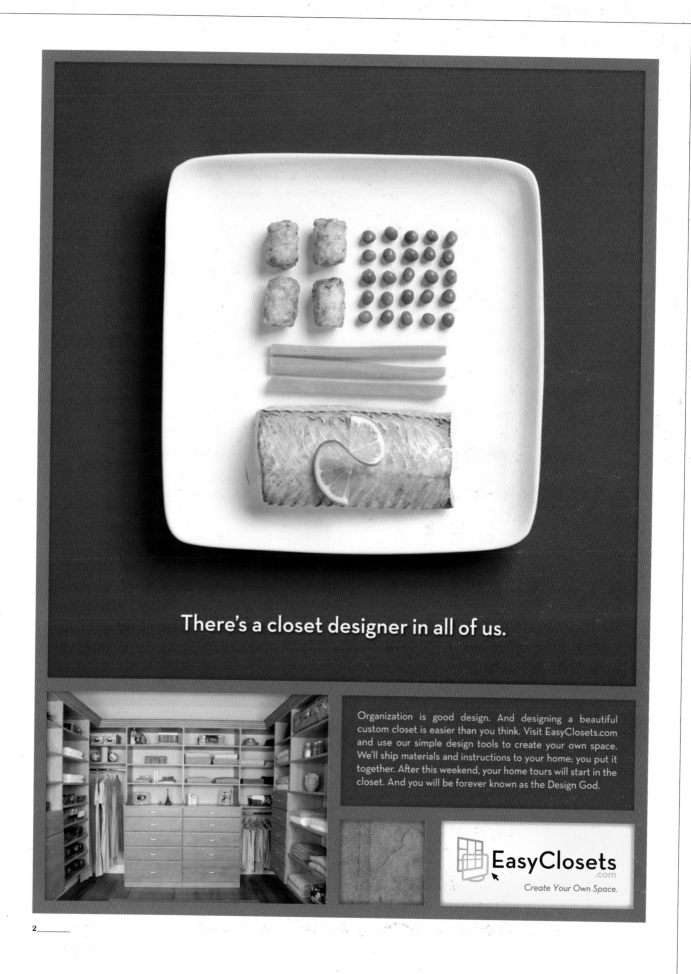

There's a closet designer in all of us.

Organization is good design. And designing a beautiful custom closet is easier than you think. Visit EasyClosets.com and use our simple design tools to create your own space. We'll ship materials and instructions to your home; you put it together. After this weekend, your home tours will start in the closet. And you will be forever known as the Design God.

EasyClosets.com

Create Your Own Space.

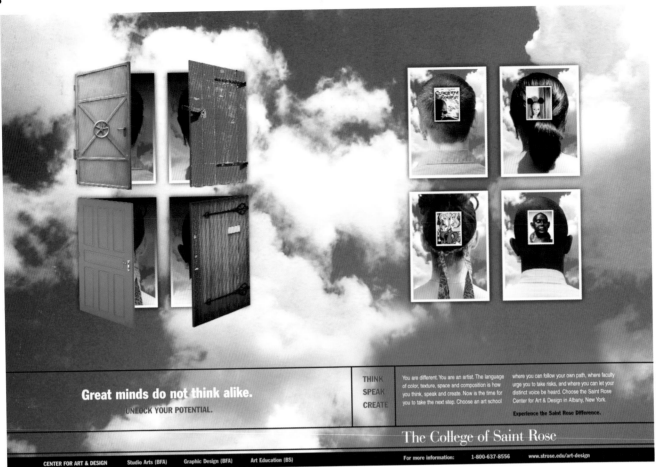

Great minds do not think alike.
UNLOCK YOUR POTENTIAL.

THINK
SPEAK
CREATE

You are different. You are an artist. The language of color, texture, space and composition is how you think, speak and create. Now is the time for you to take the next step. Choose an art school where you can follow your own path, where faculty urge you to take risks, and where you can let your distinct voice be heard. Choose the Saint Rose Center for Art & Design in Albany, New York.

Experience the Saint Rose Difference.

The College of Saint Rose

CENTER FOR ART & DESIGN Studio Arts (BFA) Graphic Design (BFA) Art Education (BS)

For more information: 1-800-637-8556 www.strose.edu/art-design

1 _____

Even the best need
help sometimes...

?

MindSights™
Facilitated Thinking Environment

MindSights™ is
an interactive series of
softBooks acting like a:

• **Consultant-in-a-Box**
 *producing out-of-the-box
 innovative thinking.*

• **Problem Solver**
 *identifying unseen obstacles
 and handles complexities.*

• **Decision Maker**
 *utilizing the right tools to achieve
 certainty and clarity.*

• **Teacher and Tutor**
 *asking the right questions that
 lead to the right answers.*

• **Personal Coach**
 *facilitating mastery of change-adept
 thinking and creativity.*

• **Skilled Meeting Facilitator**
 *defining purpose and develops
 action plans and results.*

• **Project Manager**
 *guiding project activities
 and team thinking.*

For more information and to order
your copy of *MindSights*™ visit:

www.nthdegreesoft.com
Enter code CPM0510 for 10% off

MindSights™ is a trademark of Nth Degree Software.
© 2005, Nth Degree Software, Greenfield, WI.

2 _____

1 _____
DESIGN FIRM
The College of Saint Rose
Albany, (NY) USA
PROJECT
Center for Art & Design Ad
ART DIRECTOR
Mark Hamilton
ILLUSTRATOR
Chris Parody
COPYWRITERS
Mark Hamilton, Lisa Haley
Hamilton

2 _____
DESIGN FIRM
TAMAR Graphics
Waltham, (MA) USA
CLIENT
Nth Degree Software
DESIGNER
Tamar Wallace
PHOTOGRAPHER
Alan McCredie

EMTEK PRODUCTIONS, INC.

Tel | 1.800.356.2741 | 1.800.428.4889 | 1.626.961.0413 |
Fax | 1.800.577.5771 | 626.336.2812 |

Brass Accessories

Flush Bolts

Product Code:

▸ 8501 | 6" Brass Flush Bolt, Square Corners with Strike and Screws

▸ 8502 | 6" Brass Flush Bolt, Radius Corners with Strike and Screws

Finish:

Polished Brass
Antique Brass
French Antique Brass
Oil Rubbed Bronze
Satin Nickel
Pewter
Polished Chrome

List Price
$10.50

Casement Window Latches

Side Surface Mortise

Product Code:

▸ 8700 | Casement Window Latch with Side Mount Strike and Screws

▸ 8701 | Casement Window Latch with Surface Mount Strike and Screws

▸ 8702 | Casement Window Latch with Mortise Mount Strike and Screws

Finish:

Polished Brass
Antique Brass
French Antique Brass
Oil Rubbed Bronze
Satin Nickel
Pewter
Polished Chrome

List Price
$7.50

Addendum H - 2004

3_____

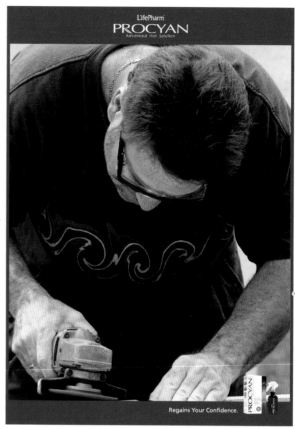

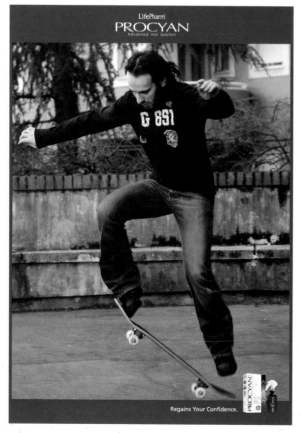

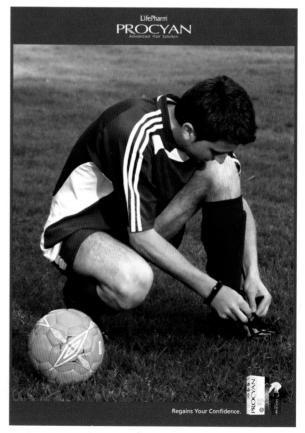

1 _____

1

DESIGN FIRM
Lifepharm Pte Ltd
Singapore

CLIENT
Lifepharm Pte Ltd

DESIGNER
Bernard Chia

2

DESIGN FIRM
**Planet Ads and
Design Pte Ltd**
Singapore

CLIENT
Fiat

DESIGNERS
Hal Suzuki,
Michelle Lauridsen

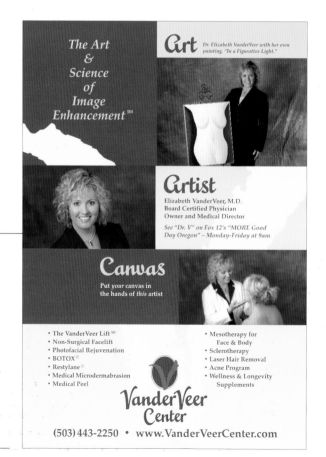

1_____

1_____
DESIGN FIRM
30sixty Advertising+Design
Los Angeles, (CA) USA
CLIENT
Beyond The Bell
CREATIVE DIRECTOR
Henry Vizcarra
ART DIRECTORS
David Fuscellaro,
Pär Larsson

2_____
DESIGN FIRM
Greenlight Designs
North Hollywood, (CA) USA
CLIENT
Joey Monteiro, Lions Gate Films
CREATIVE DIRECTORS
Tami Mahnken,
Darryl Shelly
SENIOR DESIGNER
Melissa Irwin
DESIGNER
Shaun Wood

2

109

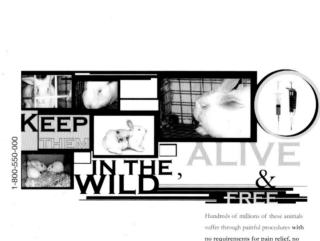

1_____

DESIGN FIRM
Didem Carikci Wong
Istanbul, Turkey
PROJECT
Peta Ads
CREATIVE DIRECTOR,
ART DIRECTOR, DESIGNER
Didem Carikci Wong

2_____

DESIGN FIRM
Morningstar Design, Inc.
Frederick, (MD) USA
PROJECT
Dan Ryan Builders New
Homes Guide
CREATIVE DIRECTOR, DESIGNER
Misti Morningstar
PHOTOGRAPHERS
Shaun Campbell,
Stewart Brothers

3_____

DESIGN FIRM
The College of Saint Rose
Albany, (NY) USA
PROJECT
Saint Rose Music Ad
ART DIRECTOR
Mark Hamilton
COPYWRITERS
Mark Hamilton,
Lisa Haley Thomson

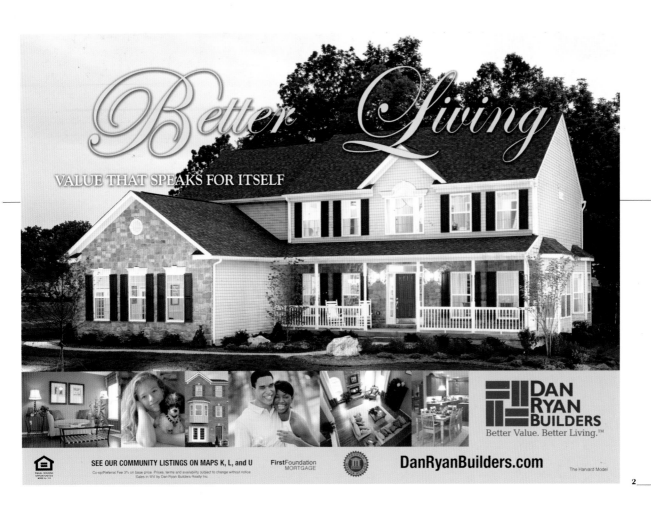
2_____

3_____

LISTEN

COMPOSE

PERFORM

Musicians are artists. The synergy of rhythm, melody and harmony is how they listen, compose and perform—and transform our souls through sound. Encourage the musicians in your life to choose a music program in which they will be urged to express their individuality, experiment with new media and exceed boundaries.

Saint Rose offers bachelor's degrees in music education and music industry, and master's degrees in music education, piano pedagogy, jazz studies and music technology.

Experience the Saint Rose Difference.

The College of Saint Rose

MUSIC EDUCATION (B.S. & M.S. in Ed.) **MUSIC INDUSTRY (B.S.)** **MUSIC (M.A.)** For more information: 1-800-637-8556 www.strose.edu/music

1_____

2_____

1_____
DESIGN FIRM
Imagine
Manchester, England
PROJECT
PPS* Ad
ART DIRECTOR, DESIGNER
David Caunce

2_____
DESIGN FIRM
Terri DeVore
Hewitt, (TX) USA
PROJECT
Mad Hatter Ad
DESIGNER
Terri Devore

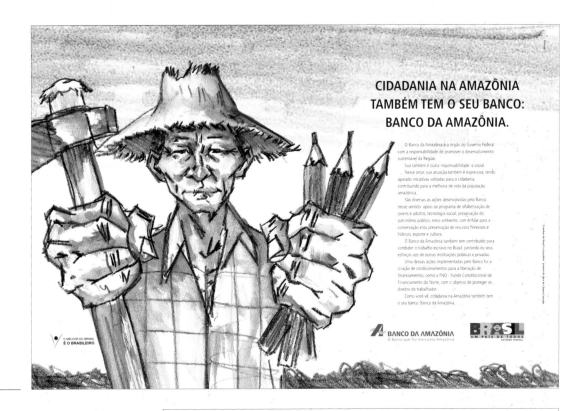

3_____

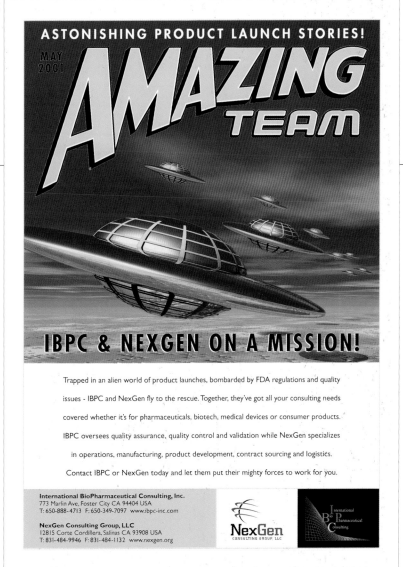

3_____
DESIGN FIRM
Mendes Publicidade
Belém, Brazil
PROJECT
Cidadania na Amazonia
também tem o seu banco
DESIGNERS
Oswaldo Mendes,
Dalmiro Freitas,
Marcel Chaves,
Cássio Tavernard

4_____
DESIGN FIRM
Sandy Gin Design
San Carlos, (CA) USA
PROJECT
NexGen Trade Ad
DESIGNER
Sandy Gin

4_____

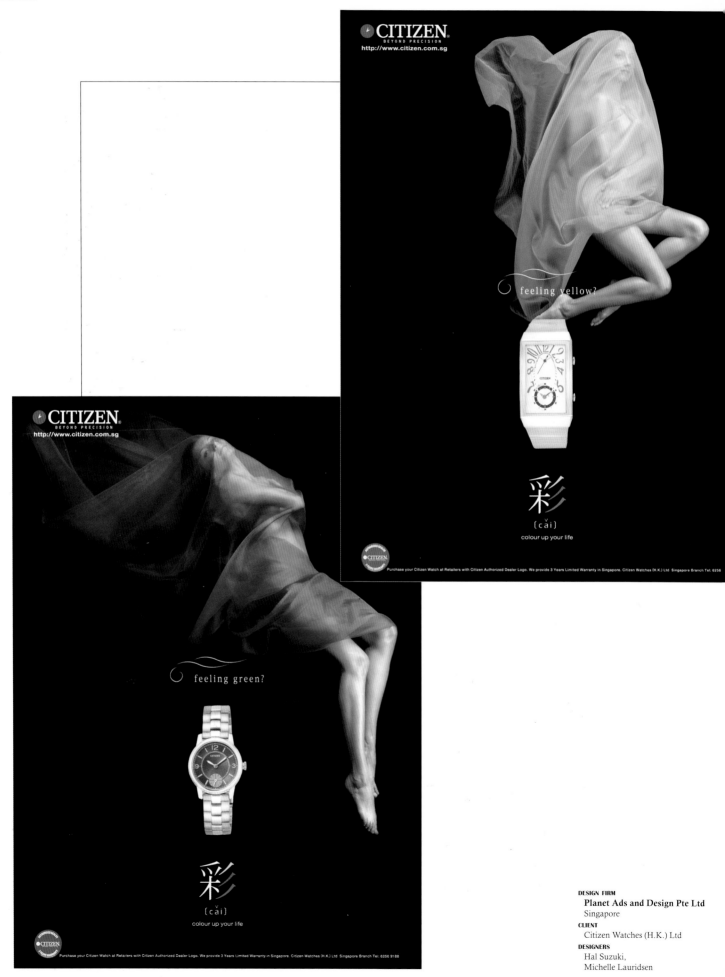

DESIGN FIRM
Planet Ads and Design Pte Ltd
Singapore
CLIENT
Citizen Watches (H.K.) Ltd
DESIGNERS
Hal Suzuki,
Michelle Lauridsen

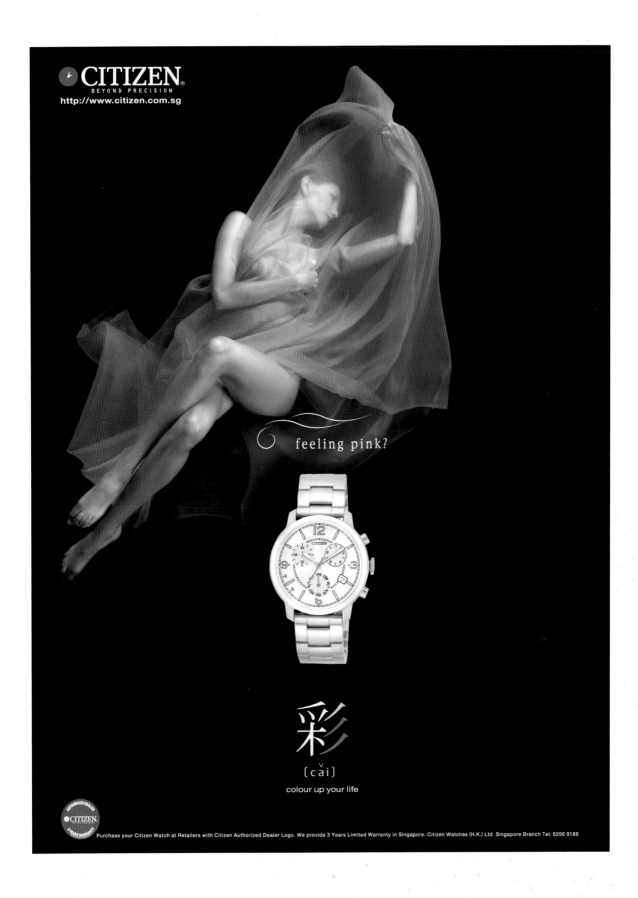

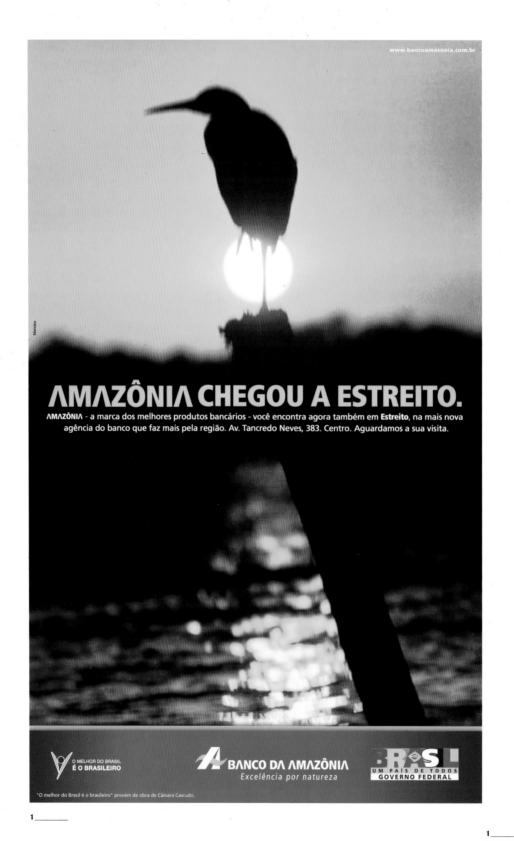

1_____
DESIGN FIRM
 Mendes Publicidade
 Belém, Brazil
PROJECT
 Amazônia chegou a Estreito
CREATIVES
 Oswaldo Mendes,
 Marcelo Amorim

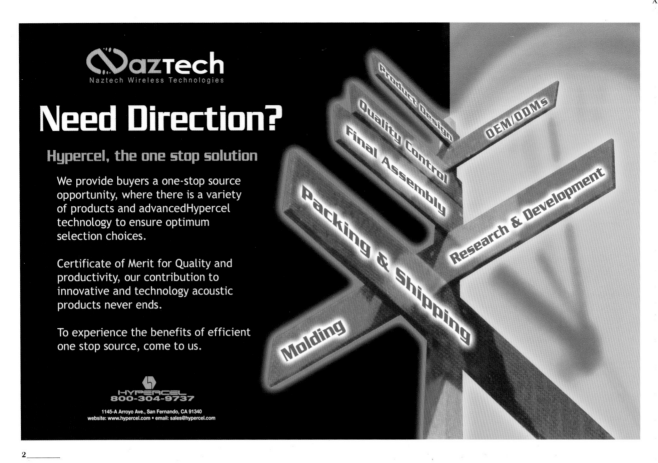

2_____

3_____

How can you tell the grape...

from the not-so-grape?

There are more than 500 wines tasted and rated
in each issue of WINE SPECTATOR.

Subscribe to *Wine Spectator* today! • Visit **www.winespectator.com** or call **1-800-752-7799**

There are good days...

and then there are grape days!

Know the difference. Subscribe to WINE SPECTATOR.
We taste and rate over 500 wines every issue.

Subscribe to *Wine Spectator* today! • Visit **www.winespectator.com** or call **1-800-752-7799**

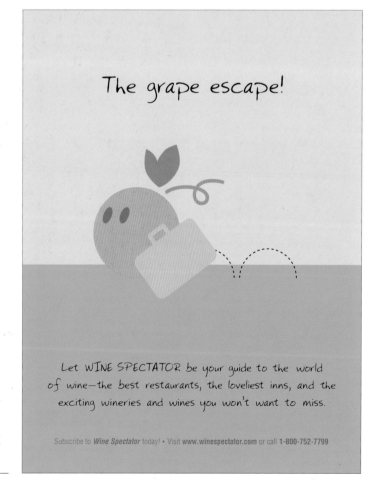

The grape escape!

Let WINE SPECTATOR be your guide to the world
of wine—the best restaurants, the loveliest inns, and the
exciting wineries and wines you won't want to miss.

Subscribe to *Wine Spectator* today! • Visit **www.winespectator.com** or call **1-800-752-7799**

1_____

1_____
DESIGN FIRM
M. Shanken Communications, Inc.
New York, (NY) USA
PROJECT
Wine Spectator Subscription ads
ART DIRECTOR
Chandra Hira
DESIGNER
Michelle Hair-Masi
COPYWRITER
Laura Zandi

2_____
DESIGN FIRM
Greenlight Designs
North Hollywood, (CA) USA
CLIENT
Michael Now, DEJ
CREATIVE DIRECTOR
Tami Mahnken
SENIOR DESIGNER
Melissa Irwin
DESIGNER
Shaun Wood
PHOTOGRAPHER
Darryl Shelly

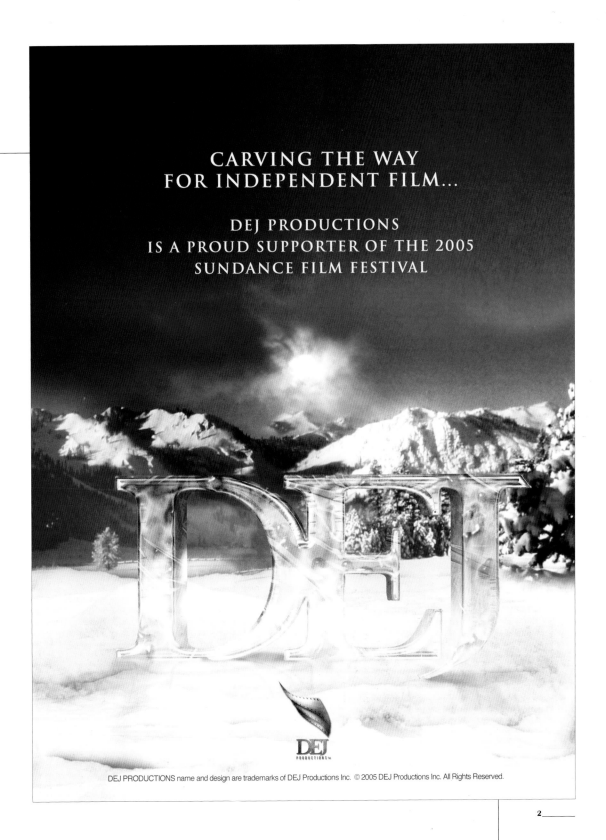

2

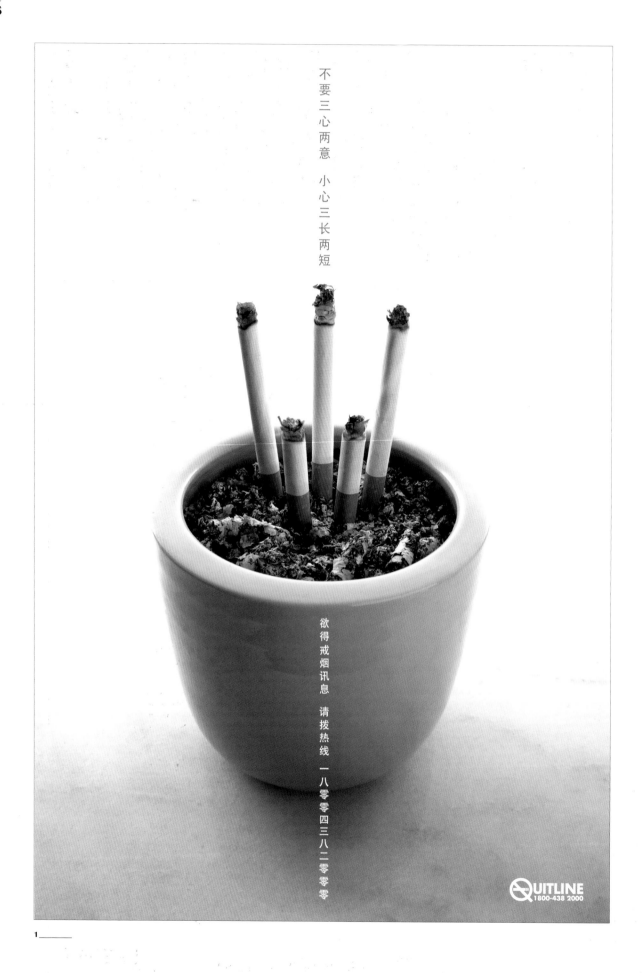

2_____

As published in the Times Union 1/31/05

SOMETIMES IT'S A GOOD THING TO HAVE OTHER PEOPLE TALKING ABOUT YOU...

Anyone can use an ad to talk about their organization. Use big stirring words and fancy language.

But, we know readers of the Capital Region are smarter than that. So, instead of using this ad to

talk about ourselves, we thought we would share a few comments from some of the organizations

and publications that recognized Saint Rose this past year as one of the Northeast's premier

colleges and truly one of the Capital Region's remarkable jewels.

Last spring, the College received **unconditional re-accreditation by the Middle States Commission on Higher Education**. It is rare for a college to receive its 10-year re-accreditation with no recommendations—but we did. In its report, the visiting team of evaluators cited the "tone of confidence and openness that permeates the College at all levels and fosters an atmosphere of student-centered efficiency and academic excellence." The team also commended the faculty for its "dedication and commitment to the intellectual and human development of each student." Students testified that they felt a genuine personal concern, which is why Saint Rose is so special to them.

The graphic design program at The College of Saint Rose has been named among the nation's best by a leading organization in the field of visual communications. The Art Directors Club of New York (ADC) has selected Saint Rose as one of the 'top graphic design schools in the country.' Saint Rose was the only college in the Capital Region, and one of only two in upstate New York, invited to send students to the ADC's 2004 Student Portfolio Review. According to the ADC, the portfolio review was limited to "100 students who will represent the cream of the crop from the top design schools in the country."

Saint Rose was named one of the **top 60 colleges in the North by U.S. News and World Report magazine** in its "Universities—Master's" category. The rank places the College in the top tier of schools that, according to the publication, "offer a full range of undergraduate and master's programs." U.S. News and World Report considered peer assessment, student retention, faculty resources, student selectivity, financial resources and alumni giving in formulating the rankings.

After two years of assessment, all of the College's education-related programs have achieved **national accreditation under the performance-oriented standards of the National Council for Accreditation of Teacher Education (NCATE)**. NCATE is the nation's premier accrediting body for schools and colleges of teacher education. In its assessment, the NCATE team of evaluators was particularly impressed by the extent to which the College reaches out to local schools and agencies to offer its talent, expertise and passion for community service. Also, the examiners were singularly impressed with the student-centered nature of the College's programs and the degree to which the faculty assists students in reaching their academic and personal goals.

An engaged urban campus in the heart of Albany sponsored by The Sisters of Saint Joseph of Carondelet. www.strose.edu

The College of Saint Rose

3_____

1_____

DESIGN FIRM
atomz i! pte ltd
Singapore
PROJECT
Health Promotion Board Ad
ART DIRECTOR, DESIGNER
Albert Lee
COPYWRITER
Kestrel Lee

2_____
DESIGN FIRM
Mendes Publicidade
Belém, Brazil
PROJECT
Banco Da Amazonia Ad
CREATIVES
Oswaldo Mendes,
Maria Alice Penna,
Luiz Braga

3_____
DESIGN FIRM
The College of Saint Rose
Albany, (NY) USA
PROJECT
Saint Rose Image Ad
ART DIRECTOR
Mark Hamilton
COPYWRITERS
Mark Hamilton, Lisa Haley Thomson

1_____

2_____

Remember the surge of

ADRENALINE

you felt the first time you saw it. Now, relive the

RUSH

with this ultimate DVD collection.

The Adventures of Indiana Jones The Complete DVD Movie Collection

Includes all 3 movies, plus a bonus disc featuring over XX hours of never before-seen-materials from the Lucasfilm vaults

Digitally remastered and restored with 5.1 surround sound | A must-have DVD set for your collection

The Adventure Returns November 4th

www.paramount.com/homeentertainment

3_____

3_____

DESIGN FIRM
30sixty Advertising+Design
 Los Angeles, (CA) USA
CLIENT
Paramount Home Entertainment
CREATIVE DIRECTOR
 Henry Vizcarra
ART DIRECTOR
 Pär Larsson

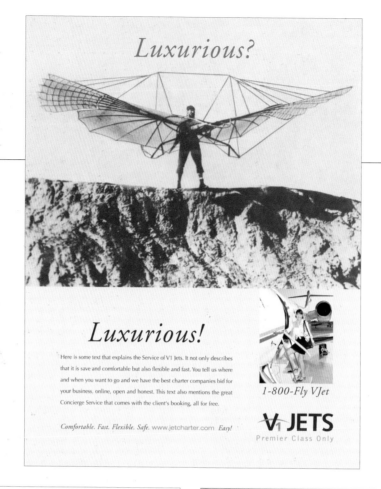

Luxurious?

Luxurious!

Here is some text that explains the Service of V1 Jets. It not only describes that it is save and comfortable but also flexible and fast. You tell us where and when you want to go and we have the best charter companies bid for your business, online, open and honest. This text also mentions the great Concierge Service that comes with the client's booking, all for free.

Comfortable. Fast. Flexible. Safe. www.jetcharter.com *Easy!*

1-800-Fly VJet

V1 JETS
Premier Class Only

He has always enjoyed travelling in his own jet, except now he lets us do the flying...

Here is some text that explains the Service of V1 Jets. It not only describes that it is save and comfortable but also flexible and fast. You tell us where and when you want to go and we have the best charter companies bid for your business, online, open and honest.

V1 JETS
Flying Just For You

Comfortable. Fast. Flexible. Safe. www.jetcharter.com *Easy!*

1-800-Fly VJet

We fly you as soon as you have to go. Premier Class Only.

Here is some text that explains the Service of V1 Jets. It not only describes that it is save and comfortable but also flexible and fast. You tell us where and when you want to go and we have the best charter companies bid for your business, online, open and honest. This text also mentions the great Concierge Service that comes with the client's booking, all for free.

Luxurious. Fast. Flexible. Safe. www.jetcharter.com *Easy!*

V1 JETS
Premier Service. Always.

1-800-Fly VJet

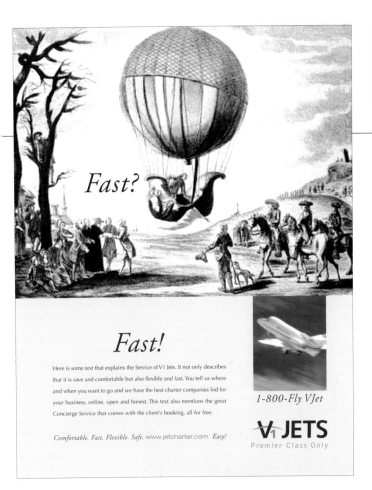

Fast?

Fast!

Here is some text that explains the Service of V1 Jets. It not only describes that it is save and comfortable but also flexible and fast. You tell us where and when you want to go and we have the best charter companies bid for your business, online, open and honest. This text also mentions the great Concierge Service that comes with the client's booking, all for free.

Comfortable. Fast. Flexible. Safe. www.jetcharter.com *Easy!*

1-800-Fly VJet

V1 JETS
Premier Class Only

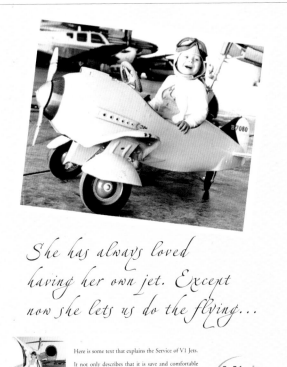

She has always loved having her own jet. Except now she lets us do the flying...

Here is some text that explains the Service of V1 Jets. It not only describes that it is save and comfortable but also flexible and fast. You tell us where and when you want to go and we have the best charter companies bid for your business, online, open and honest.

Comfortable. Fast. Flexible. Safe. www.jetcharter.com *Easy!*

V1 JETS
Flying Just For You

1-800-Fly VJet

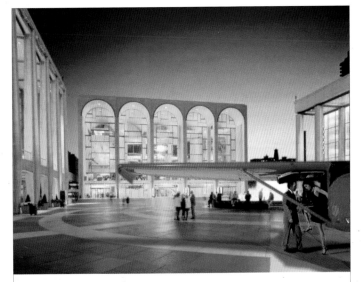

We fly you where you love to be. Premier Class Only.

Here is some text that explains the Service of V1 Jets. It not only describes that it is save and comfortable but also flexible and fast. You tell us where and when you want to go and we have the best charter companies bid for your business, online, open and honest. This text also mentions the great Concierge Service that comes with the client's booking, all for free.

Luxurious. Fast. Flexible. Safe. www.jetcharter.com *Easy!*

V1 JETS
Premier Service Always

1-800-Fly VJet

1_____
DESIGN FIRM
Über, Inc.
New York, (NY) USA
PROJECT
V1 Jets Ad Campaign Presentation
DESIGNERS
Herta Kriegner,
Edita Lintl

2_____

1_____

2_____
DESIGN FIRM
Morningstar Design, Inc.
Frederick, (MD) USA
PROJECT
Morningstar Design Inc.
Dynamite Ad
CREATIVE DIRECTOR, COPYWRITER
Misti Morningstar
DESIGNER
Melissa Neal
ILLUSTRATOR
Rachel Rabat

1_____
DESIGN FIRM
Morningstar Design, Inc.
Frederick, (MD) USA
PROJECT
Vessel Museum ad
DESIGNER
Melissa Neal

Hip Factor #163 Your glasses should never serve as birth control.

EPIC OPTICAL
EYEWEAR PROFESSIONALS

801 Chestnut Street
Hip Downtown • Chattanooga

www.epicoptical.com

RECEIVE 10% OFF
just mention this ad

We understand that not everyone wants really hip, fashionable, cool, up-to-date designer eyewear. But in the off-chance you are one of those people, you should take a look at us.

Call 265-2365 today to set up an appointment or drop by any time and check out the hippest eyewear available in Chattanooga.

3_____

3_____
DESIGN FIRM
maycreate
 Chattanooga, (TN) USA
CLIENT
 Epic Optical
DESIGNER
 Brian May

1_____
DESIGN FIRM
Mendes Publicidade
Belém, Brazil
PROJECT
Estrela de Belém
CREATIVES
Oswaldo Mendes,
Doda Vilhena,
Marcel Chaves

2_____
DESIGN FIRM
Pertmaster
Houston, (TX) USA
PROJECT
AustraliaFlyerPrimavera Ad
DESIGNER
Brooke Browne

3_____
DESIGN FIRM
Mendes Publicidade
Belém, Brazil
PROJECT
Banco Da Amazônia ad
CREATIVES
Oswaldo Mendes,
Dalmiro Freitas,
Marcelo Amorim

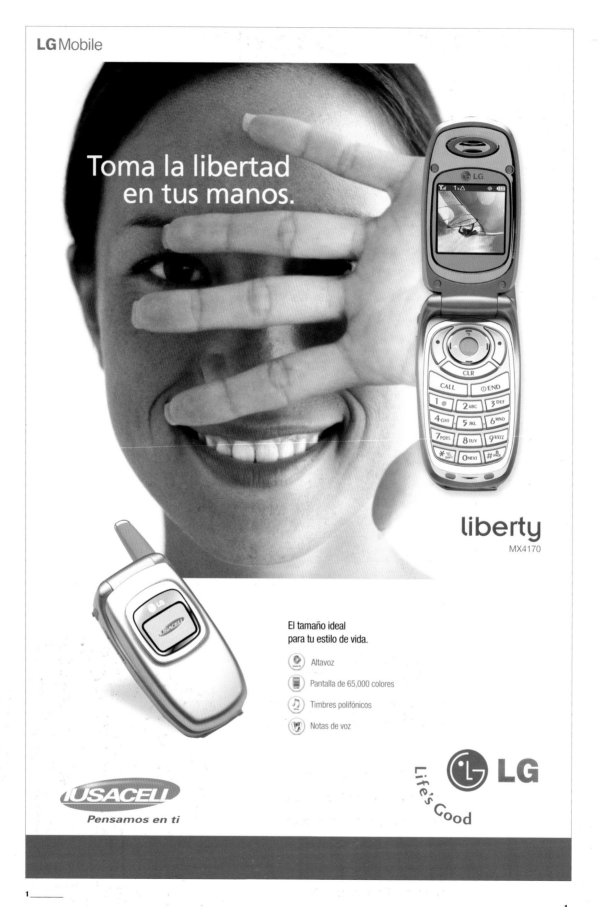

1 _____

DESIGN FIRM
TD2, S.C.
Mexico City, Mexico
CLIENT
LG Electronics
DESIGNER
Gabriela Zamora

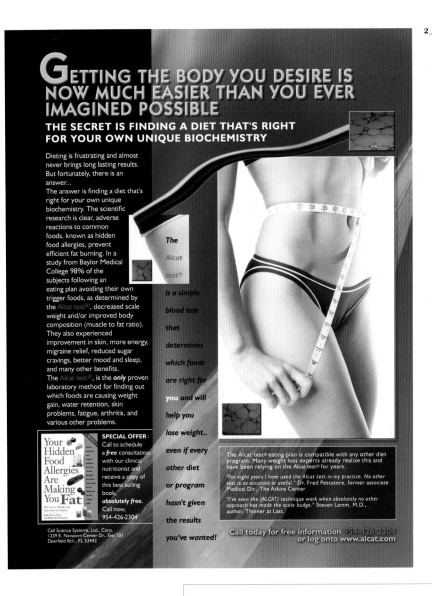

2_____

DESIGN FIRM
Shelly Prisella Graphic Design
Lauderdale-By-The-Sea, (FL) USA

PROJECT
CSS Boca Magazine ad

DESIGNER
Shelly Prisella

3_____

DESIGN FIRM
At First Sight
Ormond, Australia

DESIGNERS
Barry Selleck,
Olivia Brown

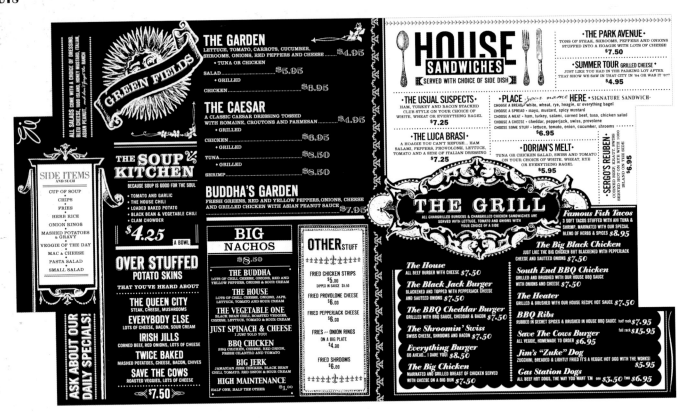

THE GARDEN
LETTUCE, TOMATO, CARROTS, CUCUMBER, SHROOMS, ONIONS, RED PEPPERS AND CHEESE $4.95
• TUNA OR CHICKEN
SALAD $5.95
• GRILLED
CHICKEN $6.95

THE CAESAR
A CLASSIC CAESAR DRESSING TOSSED WITH ROMAINE, CROUTONS AND PARMESAN $4.95
• GRILLED
CHICKEN $6.95
• GRILLED
TUNA $8.50
• GRILLED
SHRIMP $8.50

BUDDHA'S GARDEN
FRESH GREENS, RED AND YELLOW PEPPERS, ONIONS, CHEESE AND GRILLED CHICKEN WITH ASIAN PEANUT SAUCE $7.95

ALL SALADS COME WITH A CHOICE OF DRESSING: BLEU CHEESE, 1000 ISLAND, HONEY MUSTARD, ITALIAN, ASIAN PEANUT.

THE SOUP KITCHEN
BECAUSE SOUP IS GOOD FOR THE SOUL
• TOMATO AND GARLIC
• THE HOUSE CHILI
• LOADED BAKED POTATO
• BLACK BEAN & VEGETABLE CHILI
• CLAM CHOWDER

$4.25 A BOWL

SIDE ITEMS AND SUCH
CUP OF SOUP
CHIPS
FRIES
HERB RICE
ONION RINGS
MASHED POTATOES & GRAVY
VEGGIE OF THE DAY
MAC & CHEESE
PASTA SALAD
SMALL SALAD

OVER STUFFED POTATO SKINS
THAT YOU'VE HEARD ABOUT

THE QUEEN CITY
STEAK, CHEESE, MUSHROOMS

EVERYBODY ELSE
LOTS OF CHEESE, BACON, SOUR CREAM

IRISH JILLS
CORNED BEEF, RED ONIONS, LOTS OF CHEESE

TWICE BAKED
MASHED POTATOES, CHEESE, BACON, CHIVES

SAVE THE COWS
ROASTED VEGGIES, LOTS OF CHEESE

$7.50

ASK ABOUT OUR DAILY SPECIALS!

BIG NACHOS $8.50

THE BUDDHA
LOTS OF CHILI, CHEESE, ONIONS, RED AND YELLOW PEPPERS, ONIONS & SOUR CREAM

THE HOUSE
LOTS OF CHILI, CHEESE, ONIONS, JAPS, LETTUCE, TOMATO & SOUR CREAM

THE VEGETABLE ONE
BLACK BEAN CHILI, ROASTED VEGGIES, CHEESE, LETTUCE, TOMATO & SOUR CREAM

JUST SPINACH & CHEESE
I JUST TOLD YOU!

BBQ CHICKEN
BBQ CHICKEN, CHEESE, RED ONION, FRESH CILANTRO AND TOMATO

BIG JERK
JAMAICAN JERK CHICKEN, BLACK BEAN CHILI, TOMATO, RED ONION & SOUR CREAM

HIGH MAINTENANCE
HALF ONE, HALF THE OTHER $1.00

OTHER STUFF

FRIED CHICKEN STRIPS $5.00
DIPPED IN SAUCE $5.50

FRIED PROVOLONE CHEESE $6.00

FRIED PEPPERJACK CHEESE $6.00

FRIES and ONION RINGS ON A BIG PLATE $4.00

FRIED SHROOMS $6.00

HOUSE SANDWICHES
SERVED WITH CHOICE OF SIDE DISH

• THE USUAL SUSPECTS •
HAM, TURKEY AND BACON STACKED CLUB STYLE ON YOUR CHOICE OF WHITE, WHEAT OR EVERYTHING BAGEL $7.25

• THE LUCA BRASI •
A HOAGIE YOU CAN'T REFUSE... HAM SALAMI, PEPPERS, PROVOLONE, LETTUCE, TOMATO AND A SIDE OF ITALIAN DRESSING $7.25

• THE PARK AVENUE •
TONS OF STEAK, SHROOMS, PEPPERS AND ONIONS STUFFED INTO A HOAGIE WITH LOTS OF CHEESE $7.50

• SUMMER TOUR GRILLED CHEESE •
JUST LIKE YOU HAD IN THE PARKING LOT AFTER THAT SHOW WE SAW IN THAT CITY IN '84 OR WAS IT '87? $4.95

• PLACE your name HERE • SIGNATURE SANDWICH
CHOOSE A BREAD - white, wheat, rye, hoagie, or everything bagel
CHOOSE A SPREAD - mayo, mustard, spicy mustard
CHOOSE A MEAT - ham, turkey, salami, corned beef, tuna, chicken salad
CHOOSE A CHEESE - cheddar, pepperjack, swiss, provolone
CHOOSE SOME STUFF - lettuce, tomato, onion, cucumber, shrooms $6.95

• DORIAN'S MELT •
TUNA OR CHICKEN SALAD, SWISS AND TOMATO ON YOUR CHOICE OF WHITE, WHEAT, RYE OR EVERYTHING BAGEL $5.95

• SERGO'S REUBEN •
CORNED BEEF, KRAUT, SWISS SERVED HOT ON RYE WITH 1000 ISLAND ON THE SIDE $6.95

THE GRILL
ALL CHARGRILLED BURGERS & CHARGRILLED CHICKEN SANDWICHES ARE SERVED WITH LETTUCE, TOMATO AND ONIONS WITH YOUR CHOICE OF A SIDE

The House
ALL BEEF BURGER WITH CHEESE $7.50

The Black Jack Burger
BLACKENED AND TOPPED WITH PEPPERJACK CHEESE AND SAUTEED ONIONS $7.50

The BBQ Cheddar Burger
GRILLED WITH BBQ SAUCE, CHEDDAR & BACON $7.50

The Shroomin' Swiss
SWISS CHEESE, SHROOMS AND BACON $7.50

Everything Burger
GO AHEAD... I DARE YOU! $8.50

The Big Chicken
MARINATED AND GRILLED BREAST OF CHICKEN SERVED WITH CHEESE ON A BIG BUN $7.50

Famous Fish Tacos
3 SOFT TACOS STUFFED WITH AHI TUNA & SHRIMP, MARINATED WITH OUR SPECIAL BLEND OF HERBS & SPICES $8.95

The Big Black Chicken
JUST LIKE THE BIG CHICKEN BUT BLACKENED WITH PEPPERJACK CHEESE AND SAUTEED ONIONS $7.50

South End BBQ Chicken
GRILLED AND BRUSHED WITH OUR HOUSE BBQ SAUCE WITH ONIONS AND CHEESE $7.50

The Heater
GRILLED & BRUSHED WITH OUR HOUSE RECIPE HOT SAUCE $7.50

BBQ Ribs
RUBBED IN SECRET SPICES & BRUSHED IN HOUSE BBQ SAUCE half rack $7.95 full rack $15.95

Save The Cows Burger
ALL VEGGIE, HOMEMADE TO ORDER $6.95

Jim's "Zuke" Dog
ZUCCHINI, BREADED & LIGHTLY FRIED IT'S A VEGGIE HOT DOG WITH THE WORKS! $5.95

Gas Station Dogs
ALL BEEF HOT DOGS, THE WAY YOU WANT 'EM one $3.50 two $6.95

1 _____

The Art of Exceptional Cuisine

● CASUAL CUISINE FOR LUNCH AND DINNER

● SPECIALITY DRINKS ● GREAT WINE SELECTION

● AWARD WINNING BRUNCH SATURDAY AND SUNDAY

Emily Alturo's provides a wonderful ambience and unique dishes that celebrate freshness and flavor. An intimate yet casual dining destination, the Blue Bistro is the proud recipient of the *AAA Four Diamond Award* and rated as one of Florida's Best Places to Dine in Florida by *Florida Trend Magazine.* reservations recommended

Emilio Alturo's
bluebistro

437 North Lake Desitny Drive
Matiland, Florida 32830
Phone: 407.555.2200
Email: bbistro@analogyinc.com
Website: www.bluebistro.com

2 _____

1 _____
DESIGN FIRM
A3 Design
Charlotte, (NC) USA
CLIENT
Jack Masons Bar and Grille
DESIGNERS
Alan Altman,
Amanda Altman

2 _____
DESIGN FIRM
Terri DeVore
Hewitt, (TX) USA
DESIGNER
Terri DeVore

3_____

4_____

3_____
DESIGN FIRM
Velocity Design Works
Winnipeg, (Manitoba) Canada
PROJECT
Wasabi Menu
CREATIVE DIRECTOR, ART DIRECTOR
Lasha Orzechowski
DESIGNERS
Lasha Orzechowski, Rick Sellar
ILLUSTRATOR
Rick Sellar

4_____
DESIGN FIRM
Stephen Longo
Design Associates
West Orange, (NJ) USA
CLIENT
Matsuya Japanese Restaurant
ART DIRECTOR, DESIGNER
Stephen Longo

DESIGN FIRM
Caracol Consultores SC
Morelia, México
CLIENT
Dulces De La Calle Real
ART DIRECTOR
Luis Jaime Lara
DESIGNER
Myriam Zavala
PHOTOGRAPHERS
Luis Jaime Lara, Myriam Zavala

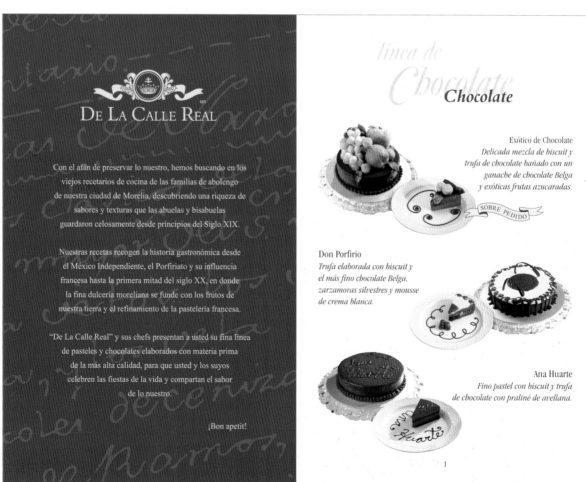

Con el afán de preservar lo nuestro, hemos buscando en los
viejos recetarios de cocina de las familias de abolengo
de nuestra ciudad de Morelia, descubriendo una riqueza de
sabores y texturas que las abuelas y bisabuelas
guardaron celosamente desde principios del Siglo XIX.

Nuestras recetas recogen la historia gastronómica desde
el México Independiente, el Porfiriato y su influencia
francesa hasta la primera mitad del siglo XX, en donde
la fina dulcería moreliana se funde con los frutos de
nuestra tierra y el refinamiento de la pastelería francesa.

"De La Calle Real" y sus chefs presentan a usted su fina línea
de pasteles y chocolates elaborados con materia prima
de la más alta calidad, para que usted y los suyos
celebren las fiestas de la vida y compartan el sabor
de lo nuestro.

¡Bon apetit!

Chocolate

Exótico de Chocolate
*Delicada mezcla de biscuit y
trufa de chocolate bañado con un
ganache de chocolate Belga
y exóticas frutas azucaradas.*

Don Porfirio
*Trufa elaborada con biscuit y
el más fino chocolate Belga,
zarzamoras silvestres y mousse
de crema blanca.*

Ana Huarte
*Fino pastel con biscuit y trufa
de chocolate con praliné de avellana.*

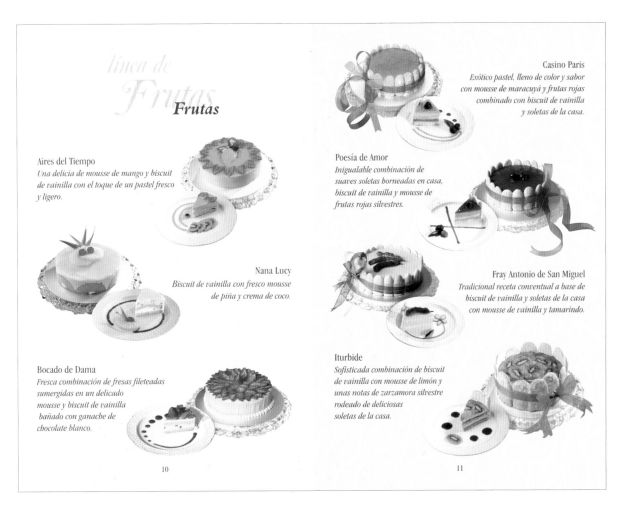

línea de
Frutas

Frutas

Casino Paris
Exótico pastel, lleno de color y sabor con mousse de maracuyá y frutas rojas combinado con biscuit de vainilla y soletas de la casa.

Aires del Tiempo
Una delicia de mousse de mango y biscuit de vainilla con el toque de un pastel fresco y ligero.

Poesía de Amor
Inigualable combinación de suaves soletas borneadas en casa, biscuit de vainilla y mousse de frutas rojas silvestres.

Nana Lucy
Biscuit de vainilla con fresco mousse de piña y crema de coco.

Fray Antonio de San Miguel
Tradicional receta conventual a base de biscuit de vainilla y soletas de la casa con mousse de vainilla y tamarindo.

Bocado de Dama
Fresca combinación de fresas fileteadas sumergidas en un delicado mousse y biscuit de vainilla bañado con ganache de chocolate blanco.

Iturbide
Sofisticada combinación de biscuit de vainilla con mousse de limón y unas notas de zarzamora silvestre rodeado de deliciosas soletas de la casa.

10

11

Chocolatería
Fina

Exquisitas piezas artesanales de chocolate belga con relleno de ate de membrillo, pulpa de tamarindo, zarzamora, cacahuate, almendras y otros originales ingredientes de nuestras tradicionales recetas morelianas.

www.delacallereal.com

135

Marketing PR
Sending the
message home

1 _____

...er Heating
...ciency

...I-CON warms 21 million homes in ...the cold weather sets in and offers tips on protection.

Porter Novelli for **The Propane Education and Research Council** uses statistics from the U.S. Department of Energy on households annual energy costs to attract the attention of editors and readers. The artist shows the advantages of using propane to heat homes to save money, add comfort and security.

American Gas Association offers simple steps homeowners can take to make their homes more energy efficient.

HINTS FOR HOMEOWNERS
Protecting Your Home From Cold Weather Invasions

HINTS FOR HOMEOWNERS
Hot Water On Demand

ENERGY SAVING IDEAS
Make Your Home (And Wallet) More Comfortable

Strata-G Communications or **Handyman Connection** offers simple tips homeowners can take to avoid drafts, save energy and have lower heating bills.

HINTS FOR HOMEOWNERS
10 Tips To Heat Up Your Home

Kill the Chill
Simple Tips for Keeping Your Home Toasty and Energy-Efficient This Winter

Vandiver ... **Maytag** offers tips on furnaces for higher energy efficiency, indicating that older furnaces may deliver only 50 to 60 percent efficiency.

HINTS FOR HOMEOWNERS
Tips On Finding The Right Heating Contractor

Godfrey Advertising ... **York Heating and Cooling** offers suggestions from the experts on how to select an HVAC contractor.

Home Maintenance
and Repair

ZINSSER offers ideas on preventing mold and mildew by keeping airflow constant, eliminating moisture, cleaning infected areas and using their brand of mildew-proof paint which is backed by a 5-year guarantee. A help-line is offered for their expert answers to questions about mildew.

Liggett-Stashower for **Loctite** offers tips on home improvement projects for do-it-yourselfers.

HINTS FOR HOMEOWNERS
Preventing Mildew Inside The Home

Fall Into Home Fix-Ups

Home Improvements
Everyday Ideas For Do-It-Yourselfers

Freeman PR for **Rubbermaid Tough Tools** offered do-it-yourselfers tips on identifying the right tools for the job to help make projects easier ...

Home Air
Quality

TVA Productions for **Sanuvox Technologies** helped homeowners to breathe easier with tips to prevent the negative health effects of indoor pollution using an ultraviolet air purifier.

HINTS FOR HOMEOWNERS
How To Clear The Air At Home

YOUR HOME
Central Vacuums Boost Air Quality

Zimmerman Laurent & Richardson for **Beam Industries** points out that central vacuum systems not only make cleaning easier and more convenient, they also remove allergens from the home.

RESPOND REFLECT RENEW The LEGACY GROVES of SOMERSET COUNTY

THE LEGACY GROVES

The concept of *The Legacy Groves* grew from a collective desire to honor and remember those lost on September 11 with a living, growing tribute of trees.

The Legacy Groves of Somerset County are being planted not only in memory of those lost on Flight 93 but also in appreciation of the tide of first responders: the firefighters, emergency personnel, police and other rescue workers who dedicated themselves to aiding others, as well as the volunteers who sustained the community.

Somerset County is an example of volunteerism in America—where mutual caring and trust between community members accomplished so much during those tragic days, and continues today.

WHAT IS A LEGACY GROVE?

The Legacy Groves are a living memorial created with trees to symbolize the continuity of life and reflect hope for the future. Sugar Maples of various sizes and ages are planted in naturalistic groves that offer a quiet place for peaceful reflection for individuals and the community.

WHY THE SUGAR MAPLE?

The Sugar Maple with its vivid autumn foliage is native to Somerset County. Long associated with the area, the abundance of Sugar Maples gave it its traditional maple sugar and syrup industry.

WHERE TO VISIT A GROVE

The Volunteer Firefighters
Training Center

This site honors both the county's first responders and the spirit of volunteerism that was so vital in the immediate days after 9/11.

The Somerset County
Technology Center

A tree nursery created at the Technology Center assures a continuous supply of Sugar Maples for the groves. The school will involve its forestry and horticulture students in the development and care of the trees, strengthening the ties between the community and *The Legacy Groves.*

It is hoped that these first two groves will inspire others throughout the county to create new groves in other locations—whether near a scenic vista, or historic landmark, besides a public building or on private land.

BECOME A PARTNER

There are donor and volunteer opportunities for local and regional organizations. For more information on how you can participate please contact Kiski Basin Initiatives at 814/467-0836.

The USDA Forest Service Living Memorials Project supports *The Legacy Groves* and other projects in the New York City and Washington D.C./Virginia areas. You can visit their website at www.livingmemorialsproject.net.

OUR COMMUNITY CONNECTIONS

The network of community connections continues to grow. Some of those already involved are Somerset County Technology Center, Somerset Garden Club, Garden Club Federation of Pennsylvania, Westsylvania Heritage Corporation, Somerset County Commissioners, Somerset County Volunteer Firemen's Association, National Park Service, Flight 93 Task Force, Penn State University Extension Service, Conemaugh Valley Conservancy, Community Foundation of the Alleghenies, Somerset County Probation Program, and Kiski Basin Initiatives.

RESPOND | REFLECT | RENEW

©2003 Kiski Basin Initiatives
Landscape Architecture: Dirtworks, PC
Brochure Design: ACME Communications, Inc.

2_____

1_____
DESIGN FIRM
Adventium
New York, (NY) USA
DESIGNER
Penny Chuang

2_____
DESIGN FIRM
Acme Communications, Inc.
New York, (NY) USA
PROJECT
Legacy Groves Brochure
DESIGNERS
Kiki Boucher,
Andrea Ross Boyle

1_____

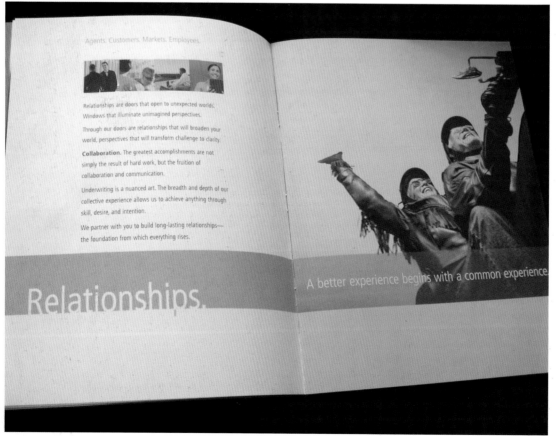

1_____
DESIGN FIRM
Kiku Obata & Company
St. Louis, (MO) USA
CLIENT
Insurance House
DESIGNER
Paul Scherfling

2_____
DESIGN FIRM
substance151
Baltimore, (MD) USA
PROJECT
SUNY Plattsburgh Brochure
DESIGNERS
Ida Cheinman,
Rick Salzman

art

Platts
burgh
State
Univer
sity

ART DEPARTMENT

2

PHOTOGRAPHY

The photography program at Plattsburgh State University offers you a complete spectrum of hands-on creative experiences that take you from the introductory to the advanced level. Advanced courses include black and white prints, color prints, color slides and the view camera. Our emphasis is on developing your individual expressive capabilities. There is a forum for exchanging ideas both in group and single session critiques. You will also learn the essentials of strong portfolio production and presentation, as well as being aware of the aesthetic concerns of other photographers.

9

PHOTOGRAPHY STUDENTS ART WORK

PRINTMAKING

Plattsburgh State University printmaking program strives for an aesthetic balance between process and concept within a informal workshop environment. As an student in printmaking, you will explore various printmaking media, including intaglio, lithography, relief, letterpress and creative bookmaking. Both unique prints, and multiples are produced. While engaging in the creative study of printmaking, you will also investigate the history of the discipline and discuss related critical issues in contemporary art that will assist in your creativity.

10

PRINTMAKING STUDENTS ART WORK

Your visual experiences in Printmaking are supported by trips to museums in the area. Take a printmaking course, either as your art concentration area or simply as an art elective, and you'll be studying in a great facility.

august 2, 2005
denver, colorado

streamsinthedesert
a day-long worship encounter.

DESIGN FIRM
Leslie Rubio
Springfield, (MO) USA
CLIENT
General Council of the Assemblies
of God National Music Department
COPY EDITOR
Tom McDonald

john bevere is the author of many top selling books, including *The Bait of Satan* and *Under Cover*. Known for his loving but confrontational style of writing, John's heart is to see the believer come into an intimate and passionate relationship with God. John's multifaceted ministry includes ministering at conferences and churches both nationally and internationally as well as a weekly television broadcast that airs in over 200 nations. He is a frequent guest of Christian Television programming and many notable Christian publications feature his writings.

terry macalmon is an accomplished songwriter and recording artist. One of his songs, "I Sing Praises" has become a favorite in churches across America and around the world. He has also released numerous live worship CDs that capture intimate worship experiences and include original music as well as the familiar. Terry leads worship all over the world and is very sensitive to the ebb and flow of the Spirit. He makes others comfortable with entering into the Lord's presence. They are then drawn into a place of deeper intimacy with the Lord.

registration information
Registration is required and may be done when registering for General Council or by calling the national Music Department at 417.862.2781, ext. 4130. Tickets are $30 per person and include seminar materials and a box lunch.

schedule
8:00 am	check in
9:00 am	worship in the presence of the Lord
	Terry MacAlmon
10:30 am	teaching: The Bait of Satan
	John Bevere
noon	lunch (box lunch provided)
1:00 pm	table discussion and healing prayers
	topics to be announced
3:00 pm	the holy communion

Financial PR
That works

DESIGN FIRM
Adventium
New York, (NY) USA
PROJECT
Financial PR Brochure
DESIGNER
Penny Chuang

Promote the benefits of your products

Often, NAPS feature stories appear in publications all over the country. What better way to communicate how different types of financial products can meet the needs of different investors?

For example, when Federated Investors wanted the public to know it had acquired the $3.2 billion Kaufman Fund, it released a story that detailed the workings of a growth fund and the strategies the fund's managers had employed over the previous fifteen years. The story also profiled the kind of investors who might be interested in growth funds and finished with a call to action that offered both a toll free number and a Web site.

Federated Investors used a similar approach when it wanted to position its Ultrashort Bond Fund as a suitable alternative to CDs or money market funds. It had NAPS create a feature that explained—in plain English—the arcane world of bonds and how a market that many investors might have once found boring was now offering new opportunities. The feature closed with a succinct description of the potential benefits—a blend of liquidity and stability—the fund offered investors.

Another investment house—Eaton Vance—used an article prepared by NAPS to explain how balancing a portfolio can help manage the liabilities posed by the capital gains tax. In this way, it was able to promote its various bond funds as a solution to that problem.

Investors who are planning for retirement are often faced with other financial challenges as well, such as paying for a college education. TIAA-CREF released a feature that discussed college costs and compared college savings plans. It then used this as an opportunity to describe in detail the specific benefits of the Qualified State Tuition Program offered by its Tuition Financing division. This product makes it possible for an investor to build wealth for college, while deferring tax liabilities.

Money managers at The Enterprise Group of Funds saw a way to promote their family of mutual funds—and develop a relationship with potential investors—by releasing a feature that explained the differences between the Traditional IRA and the Roth IRA. By using a NAPS release to position themselves as financial educators, they were able to describe the unique approach to fund management offered by their products.

Reach investors with special needs

A greater percentage of Americans than ever before are "in the market"—either through investing in individual stocks, bonds and mutual funds or through their retirement plans. As a result, the investing audience is more diverse and companies are constantly searching for ways to capture the attention of these new investors. Using NAPS to distribute a feature article can be an effective way to address the financial needs of different markets.

For example, the Investment Company Institute Education Foundation, a financial trade association, used NAPS to tell the story of a Web site created to serve as a resource for African American investors. The site offers a free investor education workshop aimed at providing online information to investors about building wealth—while maintaining realistic expectations

and encouraging long-term planning. The online workshop features African American investors and finance professionals commenting on their own experience in their effort to reach specific goals, such as a secure retirement or a child's college education. The article closed with a call to action to visit the site.

Prudential wanted to demonstrate it understood the financial challenges facing women today—particularly when it comes to retirement. It called on NAPS to create a feature that highlighted the results of a survey sponsored by Prudential. The study showed that only 50% of the women surveyed knew first-hand about the costs of long-term care and how those costs could affect their retirement and only 58% reported they manage their own 401(k) account. The article also featured comments from two

women executives in the investment industry and urged readers to contact the Prudential Web site for more information.

Increasingly, financial professionals are treating insurance products as key elements of a comprehensive financial plan. When New York Life wanted to reassure individuals who were newly single, through divorce or death, that there were new ways they could still cover the mortgage and pay for their children's education while planing for retirement—it chose NAPS to tell the story and offers tips on how the suddenly single could protect their financial assets.

Attract new investors

A well-placed feature that describes a new product or service can be an effective way to spark the interest of investors—without ever asking for their money. NAPS features are printed in papers that often serve affluent communities—places where such stories can attract the interest of potential investors.

Often, a message of opportunity can be conveyed without ever mentioning the word investment. For example, NAPS prepared a story about a new method for testing resistance to the drugs prescribed to treat HIV—a product with global potential. While the article never mentions that the company, Trugene, is looking for investors, the story does list the company's stock symbol on the NASDAQ exchange, right after its name.

By the same token, releasing stories that highlight new drugs, medical services, energy sources or products can also be an effective way to arouse an investor's interest.

For instance, a feature that started by highlighting the work of actor/director Stephen Furst to promote diabetes awareness also promoted the work of a chain of 115 comprehensive wound treatment centers managed by Curative Health Services. The article included the company's stock symbol, Internet address and a toll-free number.

Foreign firms have also used NAPS to increase investor interest. In one case, a manufacturer of fibers and textiles, plastics, pharmaceutical and other products called Teijin used a NAPS feature to publicize its ventures with American companies such as DuPont. It also promoted its development of an injectable form of medicine to treat E.coli bacterium. The article closed with a call to action that offered the company's Web site.

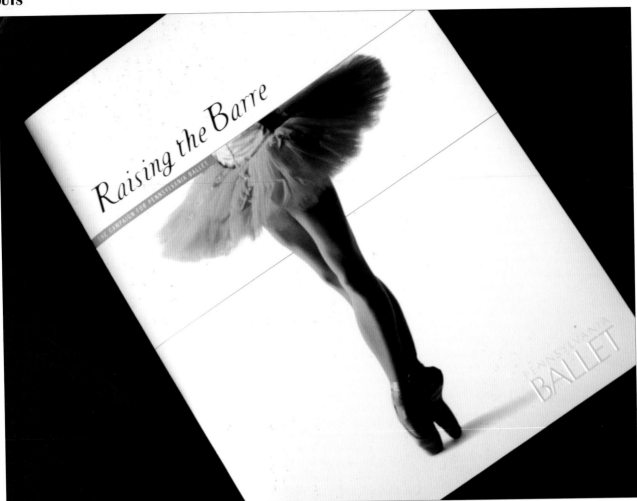

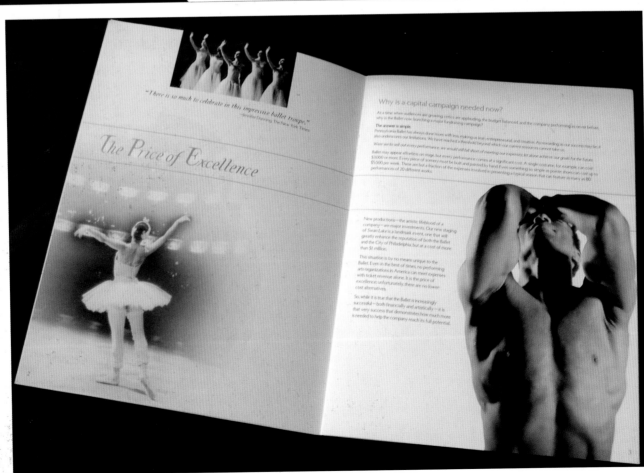

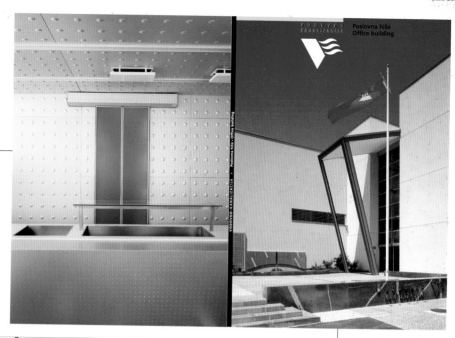

Poslovna hiša
Office building

Nova poslovna palača
javnega podjetja Vodovod–Kanalizacija

arhitekt Andrej Mlakar

2 _____

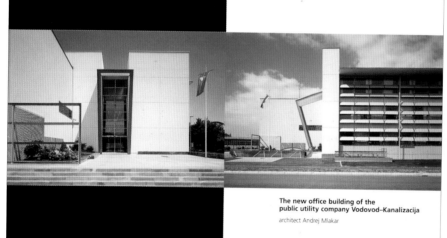

The new office building of the
public utility company Vodovod–Kanalizacija

architect Andrej Mlakar

1 _____

DESIGN FIRM
The Star Group
Cherry Hill, (NJ) USA

CLIENT
Pennsylvania Ballet

DESIGNER
Maria Dileo

2 _____

DESIGN FIRM
KROG, Ljubljana
Ljubljana, Slovenia

CLIENT
Vodovod-Kanalizacija,
Ljubljana

ART DIRECTOR, DESIGNER
Edi Berk

COPYWRITER
Miha Dezman

PHOTOGRAPHER
Miran Kambic

Fasade so oblečene v sodobno obleko iz kamna, betona, kovine in stekla. Manjši trakt je poudarjeno stereometričen, zato so odprtine enakopraven del zvezenega fasadnega ovoja. Večji trakt pa je glede na orientacijo fasad artikuliran na zaprto čelno fasado, ki jo določa poteza avle in vhoda, dve enaki stekleni vzdolžni fasadi, ki jima kovinska senčila dajo lahkotno tehničen, poudarjeno horizontalni značaj, ter servisno zadnjo fasado s čitljivo bazilikalno zasnovo.

The facades are fashioned in contemporary style from stone, concrete, metal and glass. The smaller tract is emphatically stereometric, and the openings are therefore a part of the open-plan facade covering in their own right. The larger tract is articulated with respect to the orientation of the facades to the closed front facade, which is defined by the line of the hall and the entrance, two identical longitudinal glass facades, to which the metal shadows give a gentle technical, emphasised horizontal character as well as a rear service facade with a perceptible basilica design.

145

TOP 2 BOTTOM
BONDED · INSURED
PROFESSIONAL CLEANING

Commercial Cleaning & Janitorial Services
www.top2bottomclean.com

Serving Frederick & Montgomery Counties

1_____

The Experienced Professionals

With years of experience in the commercial cleaning industry, John Giles has grown his family-owned business into one of the most respected in the area. As a hands-on owner, he is involved in every aspect of day-to-day operations and is in constant communication with customers. He oversees the training of each member of his staff, who all share his attention to detail and philosophy of proactive service.

Professional Teams Make Your Business Shine
Fully bonded and insured.

Our teams are hard working, reliable and respectful of your environment, your employees and your customers. Their work is regularly inspected by our management for quality control to ensure your complete satisfaction. We take pride in the appearance of your facility, as if it were our own, and we are always looking for better ways to keep it immaculate.

Day Porter Service

Top 2 Bottom will put one of our staff professionals in your office and at your disposal when you need help, for as long as you need it. Our Day Porters are available monthly, weekly, daily, or on call to assist with everything from special events to routine cleaning chores.

Call 301-834-7908
for a free consultation!

Custom Cleaning Services

Whether you need help for a special occasion or you want someone to worry about day-to-day details like changing light bulbs and stocking cleaning supplies, we handle it all—from Top 2 Bottom! Let us create a custom cleaning plan for your organization.

- General cleaning
- Pre-construction
- Move-in/move-out
- 24-hour emergency cleanup
- On-site day porter service

- Floor stripping, waxing & buffing
- Window washing
- Spring cleaning
- Carpet cleaning

- Spot & stain treatment
- Maintenance options
- Product stocking option
- Exterior trash pickup
- Pressure washing

"Top 2 Bottom does a wonderful job cleaning our 32 private offices, conference rooms, reception area and kitchen. They're extremely responsive, flexible and willing to do little extras. It's as if we have an extra pair of eyes to help us with the appearance of our office suite. They make helpful recommendations such as the addition of a shredder by our copy machine to protect our clients' proprietary information."

Stephanie Bayliss, President
Monarch Executive Suites, LLC

"We had a lot of frustration with cleaning companies in the past, but since we hired Top 2 Bottom, we couldn't be more pleased. It's been a complete turn-around and we are all impressed—not only with the absence of complaints, but because we often hear positive comments. This is an issue that's very important to our members, and we're thrilled with the job Top 2 Bottom has done."

Jim Hall, Director of Facilities & Operations
Frederick County YMCA

"Top 2 Bottom does an excellent job cleaning and maintaining the appearance of our facility, which is approximately 40,000 square feet. Being a food facility, we are under rigid regulations and must pass monthly inspections. Our goal is to always provide a clean environment for our employees and our customers. Top 2 Bottom goes the extra mile to make sure our facilities, hallways, lobbies and employee areas meet these standards. As a vendor, Top 2 Bottom is an important part of our success."

Brian Murray, Assistant Plant Manager
Morningstar Foods

2_____

1_____
DESIGN FIRM
Octavo Designs
Frederick, (MD) USA
CLIENT
Top 2 Bottom
Professional Cleaning
ART DIRECTOR, DESIGNER
Sue Hough

2_____
DESIGN FIRM
The Designquarters
Singapore
CLIENT
NAFA Arts Kindergarten
DESIGNER
Deborah Ang Bee Kuan

UW MEDICINE

report to the community

WINTER 2006

UW Medicine

DESIGN FIRM
belyea
Seattle, (WA) USA
CLIENT
UW Medicine
CREATIVE DIRECTOR
Ron Lars Hansen
SENIOR DESIGNER
Anne Bryant
PRODUCTION MANAGER
Sheri-Lou Stannard

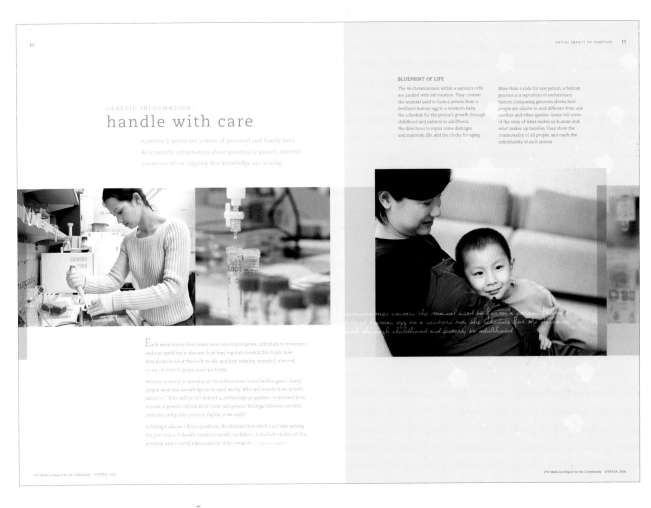

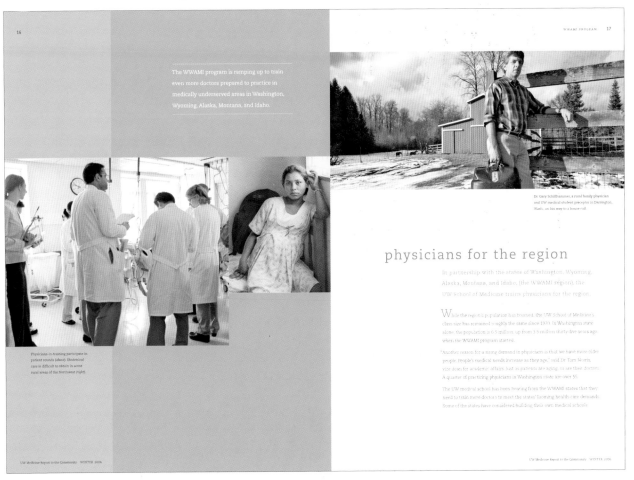

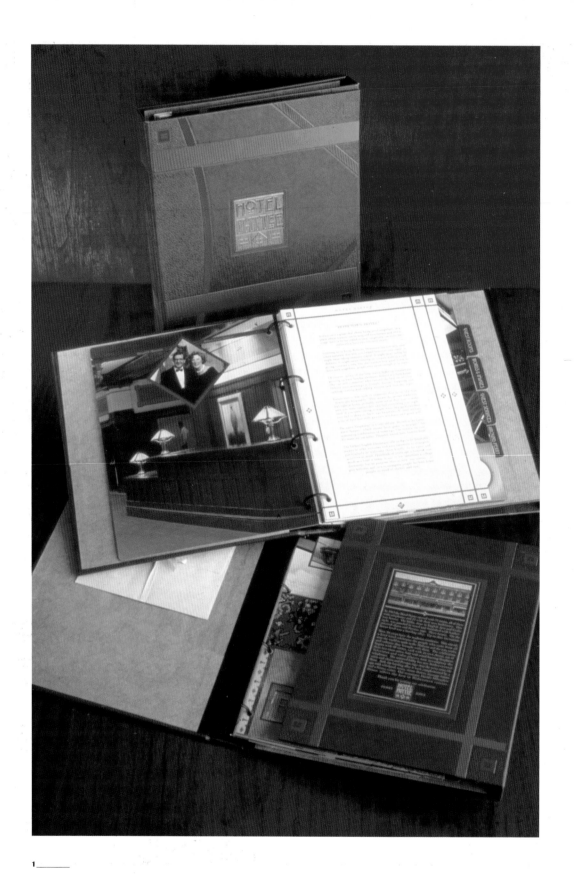

1_____

1_____
DESIGN FIRM
Sayles Graphic Design
Des Moines, (IA) USA
CLIENT
Hotel Pattee
ART DIRECTOR, DESIGNER
John Sayles
PHOTOGRAPHER
John Clark

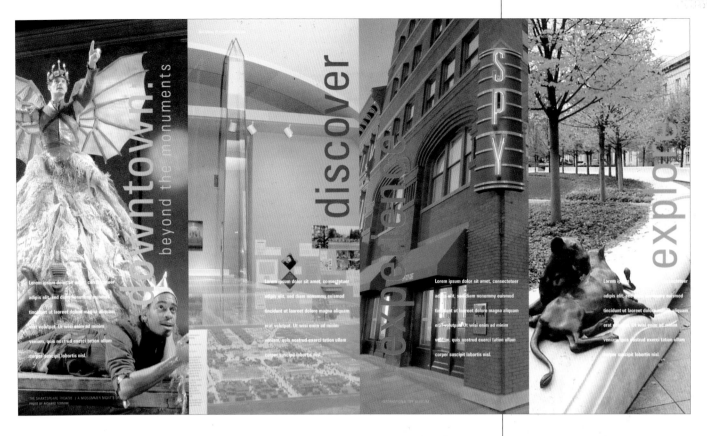

downtown.
beyond the monuments

discover

SPY

explore

THE SHAKESPEARE THEATRE / A MIDSUMMER NIGHT'S DREAM
PHOTO BY RICHARD TERMINE

INTERNATIONAL SPY MUSEUM

THE CHINATOWN ARCH

NATIONAL PORTRAIT GALLERY

museums

International Spy Museum
Espionage-related artifacts chronicle the history of spying. Advanced ticket purchase advised. Last tour begins one hour before closing. Apr–Oct 9–8, Nov–Mar 10–6. M: Gallery Place/Chinatown. 800 F Street NW. 202-393-7798

Lillian and Albert Small Jewish Museum
DC's oldest surviving synagogue building was once home to the Adas Israel Congregation. Donation suggested. Sun–Thurs by appointment. M: Judiciary Square. 701 Third Street NW. 202-789-0900

Marian Koshland Science Museum
New National Academy of Sciences museum explores frontiers of today's scientific research. Daily except Tues, 10–5. M: Gallery Place/Chinatown or Judiciary Square. Sixth and E Streets NW. 202-334-1201

National Archives
The Rotunda reopened on Sept 18, 2004, returning the Constitution, Bill of Rights, and Declaration of Independence to public display. M: Archives/Navy Memorial. 700 Pennsylvania Ave NW. 866-325-7208

National Building Museum
Premier museum of design, architecture, engineering, urban planning, and construction. Mon–Sat 10–5, Sun 11–5. M: Judiciary Square. 401 F Street NW. 202-272-2448

National Gallery of Art
One of the world's finest collections illustrates major achievements in painting, sculpture, decorative arts, and works on paper. Mon–Sat 10–5, Sun 11–6. M: Judiciary Square, Archives/Navy Memorial or Smithsonian. Seventh Street and Constitution Ave NW. 202-737-4215

National Museum of Women in the Arts
The only museum in the world dedicated solely to women's artistic achievements. Mon–Sat 10–5, Sun 12–5. M: Metro Center. 1250 New York Ave NW. 202-783-5000

Sixth & I Historic Synagogue
Newly-restored 1908 synagogue tells the story of Washington's Jewish community. Mon–Thurs 9–5, Fri 9–4. M: Gallery Place/Chinatown. 600 I Street NW. 202-408-3100

NATIONAL MUSEUM OF WOMEN IN THE ARTS

theaters

Ford's Theatre National Historic Site
After Abraham Lincoln was shot at Ford's Theatre, he was carried across the street to Petersen House, where he passed away. National Park Service ranger-led tours. Daily 9–5, except during theater performances. M: Metro Center or Gallery Place/Chinatown. 511 Tenth Street NW. 202-426-6924

GALA Hispanic Theatre
Spanish-language theater dedicated to promoting Latino culture; productions include Golden Age classics and sizzling new musicals. Bilingual headphones available. Sept–June. Performances at the Warehouse Theater; new theater scheduled to open winter 2004-05. M: Mount Vernon Square. 1021 Seventh Street NW. 202-234-7174

National Theatre
Washington's "Broadway type" theatre, with 1,676 orchestra, mezzanine, and balcony seats. M: Metro Center. 1321 Pennsylvania Ave NW. 202-628-6161

The Shakespeare Theatre
Plays by Shakespeare and other classical playwrights, including one free outdoor production each summer. M: Gallery Place/Chinatown or Archives/Navy Memorial. 450 Seventh Street NW. 202-547-1122

Warehouse Theater
Formed in 1994 to showcase emerging artists from DC and beyond. Call for schedule. M: Gallery Place/Chinatown. 1021 Seventh Street NW. 202-782-3933

Woolly Mammoth Theatre Company
Edgy new plays and extensive community outreach programs. Performances at the Kennedy Center, the DC Jewish Community Center, and the Warehouse Theater until their new theater opens in spring 2005. 202-393-3939

galleries and venues

American Immigration Law Center Exhibit Hall
Historic building displays traveling exhibits about our nation's immigrant heritage. Mon–Fri 10–5. M: Metro Center or Gallery Place/Chinatown. 919 F Street NW. 202-742-5608

Canadian Embassy
Gallery showcases Canadian heritage and culture, with art from across the continent. Mon–Fri 9–5. M: Archives/Navy Memorial or Judiciary Square. 501 Pennsylvania Ave NW. 202-682-1740

Flashpoint
Dynamic downtown venue features emerging visual and performing artists. Mon–Sat 10–6, Sun 11–6, with additional hours during shows. M: Gallery Place/Chinatown. 916 G Street NW. 202-315-1305

Gallery of Warehouse
Formed in 1994 to showcase emerging artists from DC and beyond. Call for schedule. M: Gallery Place/Chinatown. 1021 Seventh Street NW. 202-783-3933

Goethe-Institut
Promotes German language and culture through films, exhibits, lectures, and language classes. Mon–Thurs 9–5, Fri 9–3. M: Gallery Place/Chinatown. 812 Seventh Street NW. 202-289-1200

Interdevelopment Bank Cultural Center (IDB)
Forum for outstanding intellectual and artistic manifestations of member countries, with emphasis on Latin America and the Caribbean. Mon–Thurs 11–5. M: Metro Center. 1300 New York Ave NW. 202-623-3774

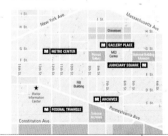

memorials

National Law Enforcement Officers Memorial
Landscaped memorial honors law enforcement officers who have been killed in the line of duty. M: Judiciary Square. E Street between Fourth and Fifth Streets NW. 202-737-3400

U.S. Navy Memorial & Naval Heritage Center
Striking outdoor plaza honors U.S. sea services. Inside are interactive videos, a gift shop, and a free movie at noon daily. Mon–Sat 9:30–5. M: Archives/Navy Memorial. 701 Pennsylvania Ave NW. 202-737-2300

coming soon

Newseum
Scheduled to open at its new location in 2007. Visitors can still enjoy the outdoor version of Today's Front Pages, showing daily newspapers from around the world updated. M: Archives/Navy Memorial. Pennsylvania Ave and Sixth Street NW. 888 NEWSEUM or 703-284-3544

National Portrait Gallery, Smithsonian Institution
Unique collection combines American history, biography, and art; scheduled to reopen July 4, 2006. M: Gallery Place/Chinatown. Eighth and G Streets NW. 202-275-1738, TTY 202-357-1729

Smithsonian American Art Museum
The largest collection of American art in the world; scheduled to reopen July 4, 2006. M: Gallery Place/Chinatown. Eighth and G Streets NW. 202-633-1000, TTY 202-357-1729

DESIGN FIRM
Pensaré Design Group
Washington, (D.C.) USA
PROJECT
Cultural Tourism DC Brochure
CREATIVE DIRECTOR
Mary Ellen Vehlow
DESIGNER
Amy E. Billingham

FORUM MOMENTUM

Fall/Winter 2004

FASHION FORWARD

Experience the newest looks
of The Forum Shops

Greenspun Media Group edition

DESIGN FIRM
Greenspun Media Group
Henderson, (NV) USA

CLIENT
The Forum Shops at Caesars

CREATIVE DIRECTOR
Mami Awamura

PHOTOGRAPHER
Alex Cho

Opposite page: Dolce & Gabbana pink silk chiffon gown with gold sequins, $7,995; St. John victorian web bangle cuff, $245 and lace pendant with blend, $235. Stuart Weitzman clear "Blazing" shoes, $375.

This page: Burberry Prorsum pink tan liquid satin gathered cross over dress, $840. Dior by John Galliano large Tutankamon trucker necklace, $840.

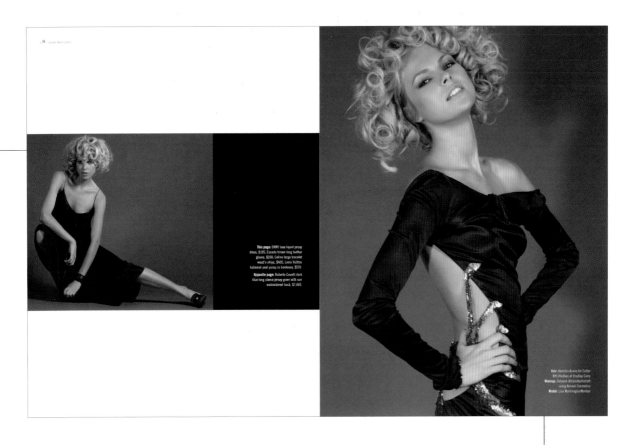

This page: DKNY loose liquid jersey dress, $195. Escada brown long leather gloves, $250. Celine large bracelet wood'o strips, $405. Louis Vuitton balmoral peal pump in bordeaux, $570.

Opposite page: Roberto Cavalli dark blue long sleeve jersey gown with sun embroidered back, $7,440.

Hair: Kenshin Asano for Cutler NYC/Redken at Bradley Curry
Makeup: Deborah Altizio/Kartishoff using Remeni Cosmetics
Model: Lisa Martinaglia/Marilyn

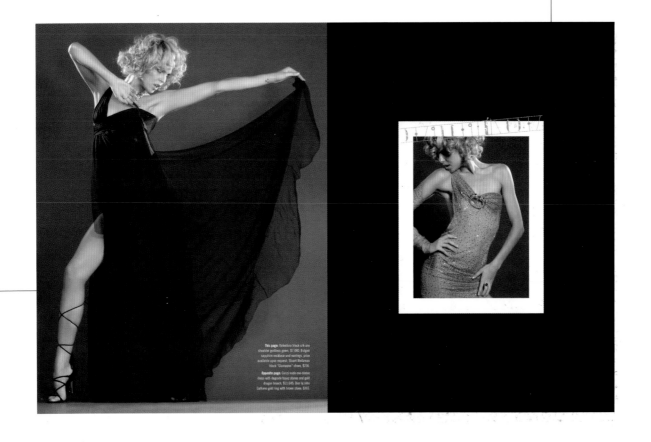

This page: Valentino black silk one shoulder goddess gown, $7,440. Bvlgari sapphire necklace and earrings, price available upon request. Stuart Weitzman black "Glamazon" shoes, $236.

Opposite page: Gucci nude one-sleeve dress with degrade topaz stones and gold dragel brooch, $13,645. Dior by John Galliano gold ring with brown stone, $365.

DESIGN FIRM
 Gouthier Design
 Fort Lauderdale, (FL) USA
PROJECT
 Calvary Chapel Brochure
CREATIVE DIRECTOR
 Jonathan Gouthier
DESIGNER
 Kiley del Valle

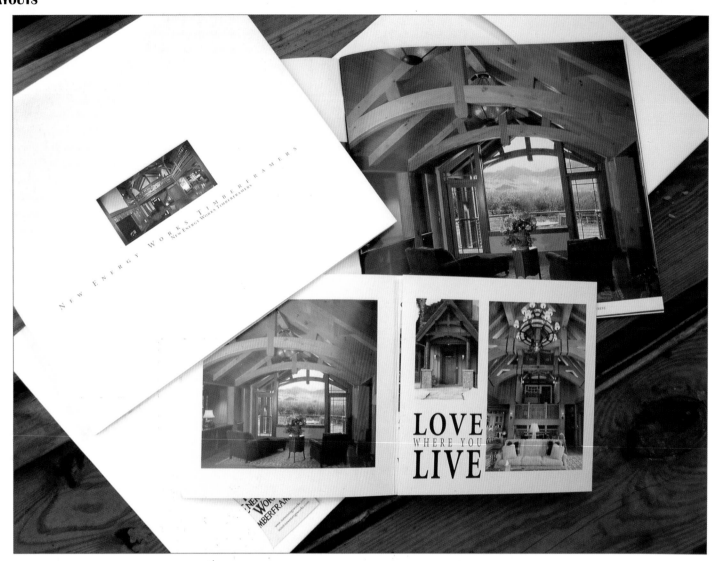

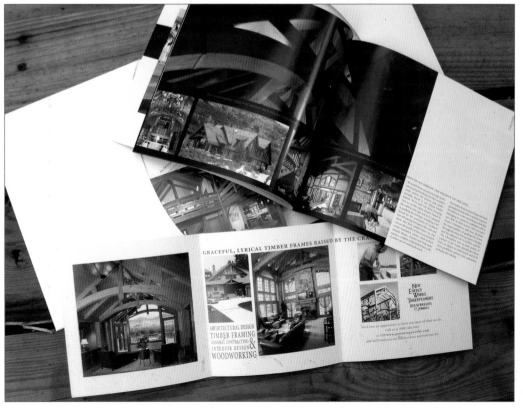

1————

1————
DESIGN FIRM
New Energy Work Marketing Dept.
Farmington, (NY) USA
CLIENT
New Energy Works Timberframers
DESIGNERS
Deanna Varble,
Iain Harrison

It's Your Move.

MAS Monetary Authority
 of Singapore

"You have to be able to see things
beyond the little corner and adopt
a macro perspective."

—James Chia
Associate, Monetary Policy
Investment & Research Group

MAS Graduate Officer Scheme

Up for the Challenge?

MAS welcomes fresh graduates
with little or no working
experience as Associates under
our Graduate Officer Scheme.
We value diversity and look for
outstanding graduates with
well-rounded backgrounds and
personalities, as well as a track
record of excellence in any
field. Our senior officers have
read fields ranging from English
Literature and Geography
to Computer Science and
Electrical Engineering.

Closing date: Mid-December

What it takes.

We're looking for motivated
individuals with strongly
analytical minds, excellent
written and verbal
communications skills,
leadership abilities as well as
team-player qualities. If you have
a keen interest in a central
banking career and believe you
will thrive in a dynamic, rapidly-
changing environment, we
would like to hear from you.

Your Career with MAS.

Graduate Officers are assigned
to a specific department on
appointment. You will receive
training geared toward providing
you with a broad perspective of
the Authority's functions.
A comprehensive training
package will give you a solid
foundation for your career.
Outstanding officers may be
sponsored for postgraduate
studies, either locally or overseas.

Graduate Officer Scheme

Life @ MAS

Career Development

MAS sees your development as an ongoing process. We take a broad approach to training and development,
believing that learning can emerge from many sources and that your personal growth benefits the entire
organisation. You will be given ample opportunities to take a variety of courses, including those in general
management and personal development.

In addition, the MAS Educational Sponsorship Scheme encourages our staff to pursue further studies in any
field relevant to MAS as a whole.

Life @ MAS

2_____
DESIGN FIRM
atomz i! pte ltd
Singapore
PROJECT
Monetary Authority
of Singapore Brochure
DESIGNER
Tomaz Goh
COPYWRITER
John Low

1 _____

1 _____
DESIGN FIRM
M. Shanken Communications, Inc.
New York, (NY) USA
PROJECT
IMPACT Magazine
Brochure
ART DIRECTOR
Chandra Hira
DESIGNER
Terrence Janis

Packaging:

Each **Tool Time Watch®** is packaged in a unique metal gift container reminiscent of an industrial tool case. This eye-catching presentation is constructed from durable plastic and aluminum and makes the perfect finishing touch. The gift box is suitable for home display suggesting a multipurpose use, such as a great place to store loose change.

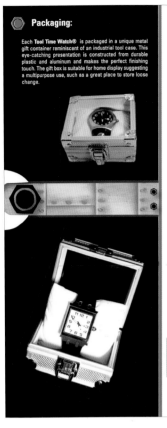

TOOL TIME WATCHES are unmistakably designed for every workingman or woman, tradesman or artisan, sportsman or athlete, professional or weekend tinkerer. Whatever your life demands, **TOOL TIME WATCHES** stand up to the challenge.

The **TOOL TIME WATCH COMPANY** mission is to create a lifelong relationship with our customers by delivering value through our streamlined production of quality watches at a price point that is commensurate with the working person, tradesman, artisan or sportsman budget by providing durable products that stand up to vigorous usage. Every **TOOL TIME WATCH** is designed to provide pride in ownership, offering the quality features, usually found in products that retail well over $1000, at a fraction of the cost.

All **TOOL TIME WATCHES** are built to meet rigid testing standards, assuring dependability time & time again. All styles are:

- tested to 100 hammer slams
- covered by a 5 year warranty
- forged from 316, non-magnetic stainless steel
- technically sound -- precision Citizen engineered
- water resistant to 300 feet
- durable shock absorbent mineral hardened crystal lens
- sturdy & resistant screw-back case

TOOL TIME WATCHES have a FREE LIFETIME battery replacement program*

Consistent reliability delivered with each **TOOL TIME WATCH** we make.

*Purchaser is required to complete and return a warranty card to **TOOL TIME WATCH COMPANY** within 30 days of purchase. During the life of the watch to the original owner to **TOOL TIME WATCHES** will replace the battery free of charge. For battery replacement, the purchaser must send the watch to **TOOL TIME WATCH COMPANY** in a prepaid postal package. Included in the parcel, the owner must provide a check or money order for $4.95 to cover return shipping and handling costs (S&H). **TOOL TIME WATCH COMPANY** will replace the battery, reseal the case and mail back to the customer in a freight-prepaid parcel.

TOOL TIME WATCH COMPANY
5545 Avenida Adobe
Yorba Linda, CA 92887
P: 714 693 4606 • F: 714 693 8451

TOOL TIME WATCHES®
-the essential tool, for work, for life

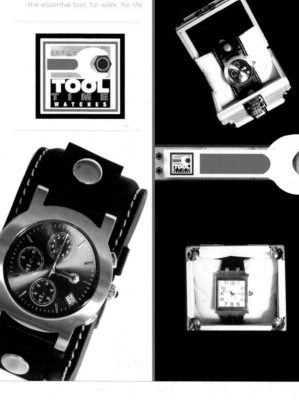

2_____

TOP CROP Model #C100 msrp $249.99
- handsome styling
- forged from 316 stainless steel
- equipped with full chronograph functions
- sturdy iridescent blue face dial, multifunction windows
- robust 100% genuine leather strap
- ample padding between band & watch
- beautifully etched logo
- durable shock absorbent, hardened glass lens
- water resistant to 300 feet
- balanced engineered case protecting precision Citizen mechanism
- blue stone crown detailing

TIMELY CLASSIC Model #C110 msrp $249.99
- sophisticated work watch
- forged from 316 stainless steel
- equipped with full chronograph functions
- elegant iridescent silver face dial, multifunction windows
- robust 100% genuine leather strap
- beautifully etched logo
- durable shock absorbent, hardened glass lens
- water resistant to 300 feet
- balanced engineered case protecting precision Citizen mechanism
- blue stone crown detailing

MULTI EDGE Model #C120 msrp $229.99
- all occasion appropriate
- forged from 316 stainless steel
- equipped with full chronograph functions
- elegant iridescent black & silver face dial, multifunction windows
- robust 100% genuine leather strap
- beautifully etched logo
- durable shock absorbent, hardened glass lens
- water resistant to 300 feet
- balanced engineered case protecting precision Citizen mechanism
- blue stone crown detailing

BOLD & PRECISE Model #C130 msrp $219.99
- unique sophistication
- forged from 316 stainless steel
- equipped with full chronograph functions
- bold iridescent black & silver face dial, multifunction windows
- robust 100% genuine leather strap
- beautifully screened logo
- durable shock absorbent, hardened glass lens
- water resistant to 300 feet
- balanced engineered case protecting precision Citizen mechanism
- blue stone crown detailing

CHALLENGE PROOF Model #D200 msrp $179.99
- sport beautiful, dress appropriate
- forged from 316 stainless steel
- sporty iridescent black & silver face dial, date window
- specialized polyurethane band
- water, paint and most chemical resistant
- beautifully screened logo
- durable shock absorbent, hardened glass lens
- water resistant to 300 feet
- balanced engineered case protecting precision Citizen mechanism
- blue stone crown detailing

FLEX EFFECT Model #D210 msrp $169.99
- strikingly versatile
- forged from 316 stainless steel
- sturdy iridescent black & silver face dial, date window
- genuine leather, fabric & Velcro strap
- beautifully screened logo
- durable shock absorbent, hardened glass lens
- water resistant to 300 feet
- balanced engineered case protecting precision Citizen mechanism
- blue stone crown detailing

CHOICE PLUS Model #D220 msrp $169.99
- impressive style
- forged from 316 stainless steel
- sturdy 100% genuine leather strap
- beautifully screened logo
- durable shock absorbent, hardened glass lens
- water resistant to 300 feet
- balanced engineered case protecting precision Citizen mechanism
- blue stone crown detailing

MIGHTY MUSCLE Model #D230 msrp $179.99
- robust quality
- forged from 316 stainless steel
- sturdy iridescent black & silver face dial, date window
- sturdy 100% genuine leather strap
- beautifully screened logo
- durable shock absorbent, hardened glass lens
- water resistant to 300 feet
- balanced engineered case protecting precision Citizen mechanism
- blue stone crown detailing

FLUID FORCE Model #D240 msrp $179.99
- suited for an active lifestyle
- forged from 316 stainless steel
- sporty iridescent black & silver face dial, date window
- specialized polyurethane band
- water, paint and most chemical resistant
- beautifully screened logo
- durable shock absorbent, hardened glass lens
- water resistant to 300 feet
- balanced engineered case protecting precision Citizen mechanism
- blue stone crown detailing

ALL TIME MASTERY (ATM) Model #D250 msrp $169.99
- simplistic elegance
- forged from 316 stainless steel
- sturdy iridescent black & silver face dial, date window
- specialized polyurethane band
- water, paint and most chemical resistant
- beautifully screened logo
- durable shock absorbent, hardened glass lens
- water resistant to 300 feet
- balanced engineered case protecting precision Citizen mechanism
- blue stone crown detailing

TIME IMPRESSION Model #R300 msrp $129.99
- show stopping style
- forged from 316 stainless steel
- sturdy iridescent white face dial, date window
- specialized polyurethane band
- beautifully screened logo
- durable shock absorbent, hardened glass lens
- water resistant to 300 feet
- balanced engineered case protecting precision Citizen mechanism
- blue stone crown detailing

MODERN EDGE Model #R310 msrp $99.99
- elegantly executed
- designed in Denmark
- forged from 316 stainless steel
- sturdy iridescent black & silver face dial, date window
- beautifully screened logo
- durable shock absorbent, hardened glass lens
- water resistant to 300 feet
- balanced engineered case protecting precision Citizen mechanism
- blue stone crown detailing

TIME BALANCE Model #R320 msrp $119.99
- unique & individual
- forged from 316 stainless steel
- elegant iridescent black & silver face dial, date window
- robust 100% genuine leather strap
- ample padding between band and watch
- beautifully screened logo
- durable shock absorbent, hardened glass lens
- water resistant to 300 feet
- balanced engineered case protecting precision Citizen mechanism
- blue stone crown detailing

GO POWER Model #R330 msrp $109.99
- casually refined
- forged from 316 stainless steel
- stylistic iridescent black & silver holographic checkered pattern face dial
- specialized polyurethane band
- water, paint and most chemical resistant
- beautifully screened logo
- durable shock absorbent, hardened glass lens
- water resistant to 300 feet
- balanced engineered case protecting precision Citizen mechanism
- blue stone crown detailing

SMOOTH FORCE Model #R340 msrp $119.99
- rewarding taste
- forged from 316 stainless steel
- elegant iridescent white & silver face dial
- specialized polyurethane band
- water, paint and most chemical resistant
- beautifully screened logo
- durable shock absorbent, hardened glass lens
- water resistant to 300 feet
- balanced engineered case protecting precision Citizen mechanism
- blue stone crown detailing

TIME PACE Model #R350 msrp $89.99 | TIME STEP* msrp $89.99 Model #R360
- casual elegance
- forged from 316 stainless steel
- sturdy iridescent white & silver face dial
- beautifully screened logo
- durable shock absorbent, hardened glass lens
- water resistant to 300 feet
- balanced engineered case protecting precision Citizen mechanism
- blue stone crown detailing

TIME PACE* specialized polyurethane band, water, paint and most chemical resistant

TIME STEP* robust 100% genuine leather strap

STRONG SHOW Model #R370 msrp $109.99
- durability driven
- forged from 316 stainless steel
- elegant iridescent white & silver face dial
- robust 100% genuine leather strap
- beautifully screened logo
- durable shock absorbent, hardened glass lens
- water resistant to 300 feet
- balanced engineered case protecting precision Citizen mechanism
- blue stone crown detailing

POWER TOUCH Model #P900 msrp $79.99
- promotional item*
- equipped with full chronograph functions
- fitting silver tone dial & face + multifunction windows
- adjustable Velcro band
- manufactured from durable ABS plastic
- beautifully etched logo
- covered by a 1 year warranty

(Only Tool Time Watch ® style that is not made with a stainless steel casing)

Model Name	Model #	MSR	Msp	Cost
TOP CROP	C100	249.99	99.99	44.75
TIMELY CLASSIC	C110	249.99	99.99	44.75
MULTI EDGE	C120	229.99	89.99	41.10
BOLD & PRECISE	C130	219.99	89.99	41.10
CHALLENGE PROOF	D200	179.99	55.99	29.73
FLEX EFFECT	D210	169.99	54.99	29.55
CHOICE PLUS	D220	169.99	54.99	27.90
MIGHTY MUSCLE	D230	179.99	59.99	29.73
FLUID FORCE	D240	179.99	59.99	29.63
ALL TIME MASTERY (ATM)	D250	169.99	59.99	29.90
TIME IMPRESSION	R300	129.99	49.99	24.89
MODERN EDGE	R310	99.99	34.99	16.04
TIME BALANCE	R320	119.99	59.99	31.06
GO POWER	R330	109.99	54.99	26.55
SMOOTH FORCE	R340	119.99	59.99	28.33
TIME PACE	R350	89.99	49.99	22.22
TIME STEP	R360	89.99	49.99	22.22
STRONG SHOW	R370	109.99	54.99	25.55
POWER TOUCH	P900	79.99	24.99	12.98

2_____

M Majestic Wood Floors has been serving the greate
metropolitan area for nearly a decade. Founded i
1996 and striving for perfection ever since, we tre
every job as if it is our only one. We are large eno
to handle any size job, but also small enough to g
each and every one the care and attention that it
deserves. Our products have graced the architect
of many of the district and surrounding area hom
custom designed for each one.

In April of 2003, Majesti
won the National Wood
Floor Association's "Flo
the Year" award in the
members choice expert
division. Since, we have been featured in *"Floor
Covering Weekly"*, *"National Floor Trends"* and
"Hardwood Floors" magazines. We would like the
opportunity to design a floor of the year for you.

■ MAJESTIC WOOD FLOOR

1_____

1_____
DESIGN FIRM
Octavo Designs
Frederick, (MD) USA
CLIENT
Majestic Wood Floors
ART DIRECTOR
Sue Hough
DESIGNERS
Sue Hough, Mark Burrier

2_____
DESIGN FIRM
Mayhem Studios
Los Angeles, (CA) USA
PROJECT
Emtek Brochure
DESIGNER
Calvin Lee

MODERN LEVER & KNOB STYLES

EGG
LEVER

ZURICH
BLUE KNOB

LUZERN
LEVER

EMTEK

2_____

MODERN LEVER & KNOB STYLES

SLEEK, STREAMLINED,

ENERGIZED, THESE

LEVERS CAN BE USED

TO COMPLIMENT

EITHER EURO-MODERN

OR AMERICAN 50'S

DECORATING THEMES.

CONSTRUCTED FROM

SOLID BRASS AND

ETCHED GLASS.

Electra Frost Lever
Polished Chrome

Electra Blue Lever
Satin Nickel

Egg Lever
Satin Nickel

Egg Lever
PVD- Lifetime

Mercury Lever
PVD- Lifetime

Mercury Lever
Oil Rubbed Bronze

Zurich Frost Knob
Polished Nickel

Zurich Blue Knob
Satin Nickel

Orb Knob
Polished Chrome

Orb Knob
PVD- Lifetime

Basel Lever
Satin Nickel

Basel Lever
Polished Nickel

Luzern Lever
Oil Rubbed Bronze

Luzern Lever
PVD- Lifetime

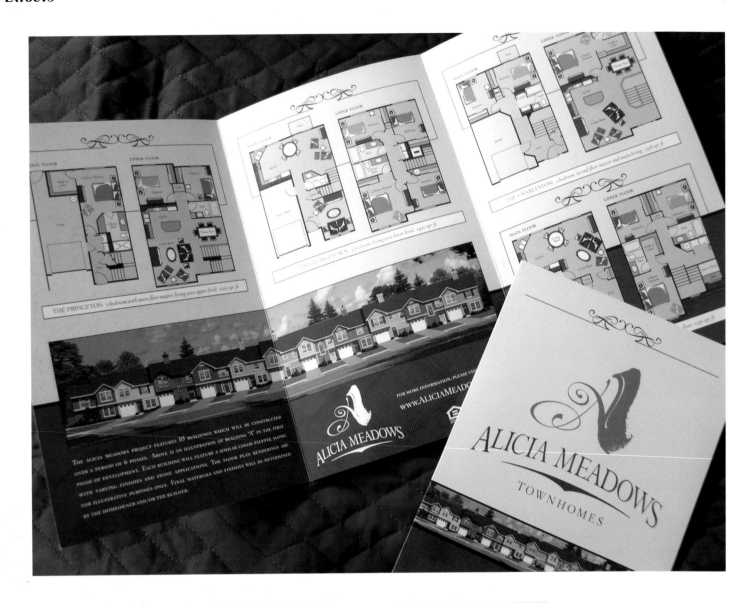

1
DESIGN FIRM
Colin Magnuson Creative
Tacoma, (WA) USA
CLIENT
Alicia Meadows LLC
DESIGNER
Colin Magnuson

2
DESIGN FIRM
Jeremy Schultz
West Des Moines, (IA) USA
PROJECT
The World Food Prize Brochure
DESIGNER
Jeremy Schultz

A "Signature Event":

Bringing the **World** to Iowa, and **Iowa** to the World

A WORLD-CLASS INTERNATIONAL SYMPOSIUM AND LAUREATE AWARD CEREMONY...

- Cutting-edge topics such as Biotechnology, HIV/AIDS, and Global Water Insecurity
- Over 1,900 symposium registrants from 30 countries and as many states

- 60 symposium speakers from India, Kenya, Israel, the West Bank, Ghana, Egypt, United Arab Emirates, Vietnam, China, Canada, Sweden, Great Britain, Switzerland, Ethiopia, Italy, the World Bank, the UN FAO

- Keynote presentations by: Karl-Heinz Funke German Minister of Agriculture; Andrew Natsios, Head of USAID; Head of Chinese Genetic Engineering laboratory, Chen ZuangLiang; Heinz Imhof, Chairman of Syngenta; Catherine Bertini, UN Secretary General's envoy to the Middle East; and Ingo Potrykus, Developer of "Golden Rice"

THE ATTENTION OF WORLD LEADERS...

- UN Secretary General Kofi Annan released a statement congratulating Dr. Pedro Sanchez for his selection as the 2002 World Food Prize Laureate

- Nobel Peace Prize Laureate Mikhail Gorbachev released a statement on the 2002 World Food Prize Symposium and World Food Prize Chrystal Award

- Presidents Jimmy Carter and George H.W. Bush join Council of Advisors

- President Johannes Rau of Germany recognizes 2001 World Food Prize Laureate, Dr. Per Pinstrup-Andersen and calls The World Food Prize the "Nobel Prize" for food and agriculture

- President Ernest Zedillo of Mexico awards 2000 World Food Prize Laureate Evangelina Villegas Mexico's Woman of the Year Award in 2000

WORLD FOOD PRIZE EVENTS AND PROGRAMS WORLDWIDE...

- 2001 World Food Prize Laureate at IFPRI Conference in Bonn, Germany

- 2002 Laureate Announcement at International Horticultural Congress in Toronto

- World Food Prize Laureate Luncheon for United Nations officials at Rainbow Room in New York City featuring Richard Holbrooke and Dan Glickman

- 2002 Laureate video shown at International Soil Science Congress in Bangkok and American Soil Science Association in Indianapolis

- World Food Prize Laureate Statement presented at World Food Summit in Rome

- Senator Elizabeth Dole acknowledged Al Clausi's receipt of Nicholas Appert Award in speech at International Food Technologist Congress in New Orleans

- Dr. Borlaug honored at the Nobel Centennial Celebrations in Oslo

- World Food Prize video shown at ceremony presenting Award for World Understanding and Peace to Dr. Borlaug at Rotary International Convention, Barcelona

- World Food Prize Laureates Pedro Sanchez and M.S. Swaminathan address plenary session at the World Summit on Sustainable Development in Johannesburg, South Africa

- 38 Borlaug-Ruan Interns in Malaysia, China, Brazil, Costa Rica, Trinidad, Ethiopia, Peru, Thailand, Mexico, India, Kenya, Indonesia and the Philippines

The World Food Prize, and its Laureates and Founders have received an increasing amount of attention from national and international media, including significant attention from the following media outlets:

The New York Times

The Economist

Herald Tribune

...ly 15 years ago, then Iowa State ...tors Leonard Boswell and Elaine ...moniak and other leaders in the ...of Iowa came to John Ruan with ...y unique opportunity. Since 1990, ...Ruan Family has supported the giving of The ...ld Food Prize, the world's most award for ...lleviation of poverty, hunger, and starvation.

...only fitting that this Prize has found its home ...e State of Iowa—the home of the greatest ...anitarian and agricultural heroes the world ...ever known.

...reflection of this aspect of Iowa's heritage, The ...ld Food Prize Foundation has worked to cre- ...'signature event" for the state of Iowa, holding ...ts in XX countries on X continents and seek- ...ut connections with key cultural, artistic, edu- ...onal, scientific and historical in the state of Iowa.

...are proud to present to you the result of nearly ...e years of our efforts to expand the reach and ...ct of The World Food Prize Foundation.

...BASSADOR (RET.) DR.

...NNETH M. QUINN

...ESIDENT, THE WORLD ...OD PRIZE FOUNDATION

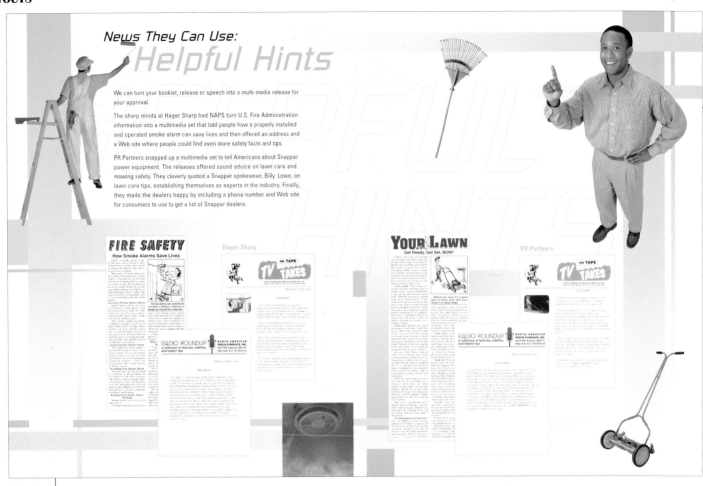

News They Can Use:
Helpful Hints

We can turn your booklet, release or speech into a multi-media release for your approval.

The sharp minds at Hager Sharp had NAPS turn U.S. Fire Administration information into a multimedia set that told people how a properly installed and operated smoke alarm can save lives and then offered an address and a Web site where people could find even more safety facts and tips.

PR Partners snapped up a multimedia set to tell Americans about Snapper power equipment. The releases offered sound advice on lawn care and mowing safety. They cleverly quoted a Snapper spokesman, Billy Lowe, on lawn care tips, establishing themselves as experts in the industry. Finally, they made the dealers happy by including a phone number and Web site for consumers to use to get a list of Snapper dealers.

Create more results by covering more media

Newspapers—from top dailies to weeklies in the wealthy suburbs—will give you 100 to 400 placements per release. Sixteen-hundred dailies and 8,400 weeklies are on our media list. The vast majority of these are not on the wires or typical press mailing lists.

TV talk shows will give you 100 to 150 plus placements for each one-minute VFR. Send us your story with a VNR, B-Roll or color stills for a free proposal. We can supply stock footage if necessary. It's a low-cost way for you to create millions in additional audience for your creative work—by simply giving America's TV stations a chance to use it. We send the story out in any format the TV stations require, including the best broadcast quality tapes, such as Beta-SP and DVC-pros. Stations that run NAPS releases can be found in the top 50 markets, including such major markets as New York City, Los Angeles, Chicago, San Francisco, Boston, Philadelphia, Detroit, Washington D.C, Dallas and Houston and their metropolitan areas, as well as many smaller places. The hundreds of VHF and UHF network affiliates we reach include those of ABC, CBS, Fox and NBC (at least one in each of the top markets) as well as prestigious cable stations, such as A&E.

Radio talk shows will give you 200 to 300 placements per release. We send the stations both a professionally voiced CD and a script that often gets your message delivered by the station's own host or hostess, which can add credibility to your release. Nearly all the radio stations that use NAPS scripts do so during the morning and evening drive time.

Many TV stations report they use NAPS's Consumer Science News, an informative program from experts on health, home, family, food and finances, during local news time, the other half use it during talk shows.

Many of the TV and radio stations use every script we send, often running the entire program as an independent show. That gives your script a better chance of getting broadcast than if you had sent it to the station by itself. The stations find the 30 and 60 second spots particularly convenient to fill in the tight space between commercials, news broadcasts, and other station programming.

We are in constant contact with editors and program directors both on the phone and by test mailings, so we can reach the maximum number of readers, listeners and viewers.

A multimedia release—or several of them—can be a particularly good idea when you want to maximize coverage on a major story or when you're planning an annual program and want to build in really thoroughly, all media coverage quarterly, bi-monthly or monthly.

You save time and money because NAPS provides fast, efficient delivery at low cost.

DESIGN FIRM
Adventium
New York, (NY) USA
PROJECT
Multimedia Brochure
DESIGNER
Penny Chuang

Financial PR:
Show Them The Money—
And You May Get Some

A good many of the nation's 10,000 newspapers are published in the wealthy suburbs where readers have plenty of money to invest, and where many home and small business thrive. Scripts and articles that can help these entrepreneurs, retirees (who often have time and money) and commuters can help the businesses that sent the releases thrive.

That may be why putting its stamp of approval on a set of multimedia releases was a smart move on the part of the U.S. Postal Service. The print release had the logo, popular with editors: Small Business News & Notes. The releases showed how the Post Office can help companies save time and tax dollars and ended with a Web site.

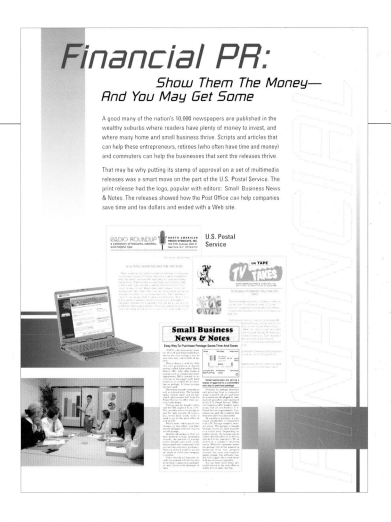

Education:
Live and Learn

Organizations such as the National Pest Management Association and the National Clearinghouse for Professionals in Special Education maximized the reach of their message with sets of multimedia releases.

The NPMA explained what its members were doing to protect school-children from the health and safety risks of having vermin in the classroom. It also publicized its Web site as a way to get information on pest management and on where to find a licensed, trained and qualified pest management professional.

The NCPSE sought to recruit non-traditional applicants to become special ed teachers. The releases explained the need and the benefits and gave a Web site and toll-free phone number for prospective teachers.

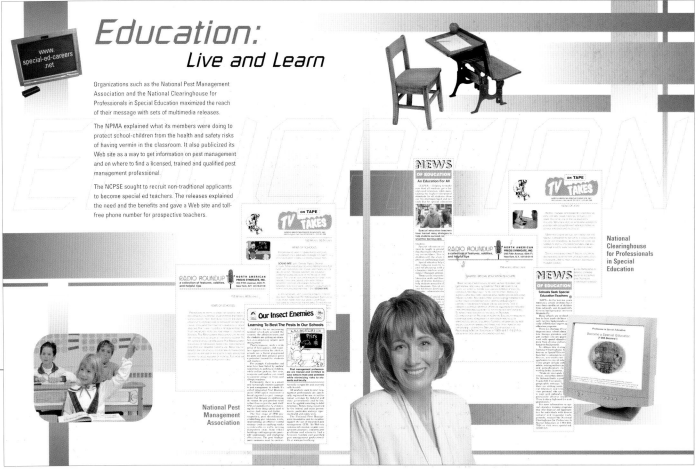

National Pest
Management
Association

National
Clearinghouse
for Professionals
in Special
Education

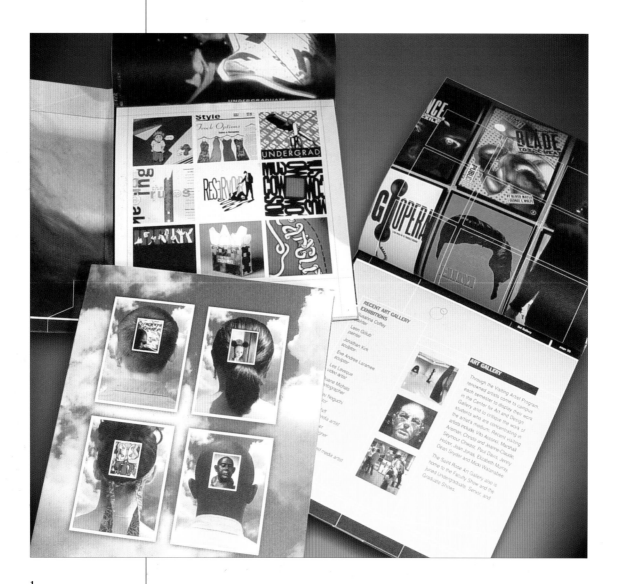

1_____

1_____
DESIGN FIRM
 The College of Saint Rose
 Albany, (NY) USA
PROJECT
 Center for Art & Design Viewbook
ART DIRECTOR
 Mark Hamilton
DESIGNER, ILLUSTRATOR
 Chris Parody
COPYWRITERS
 Mark Hamilton, Lisa Haley Thomson
PHOTOGRAPHERS
 Chris Parody, Paul Castle Photography
PRINTER
 John C. Otto Company, Inc.

2_____
DESIGN FIRM
 Sayles Graphic Design
 Des Moines, (IA) USA
PROJECT
 Principal Financial Group 125th
 Anniversary Brochure
DESIGNER, ILLUSTRATOR
 John Sayles

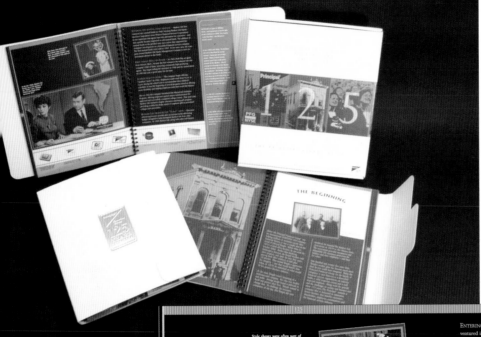

ENTERING THE MUTUAL FUND BUSINESS — Bankers Life first ventured into mutual funds in 1968, forming Bankers Life Equity Services Corporation (now Princor Financial Services Corporation). It was important that agents have this alternative for customers – and they quickly became registered to sell mutual funds. The addition of mutual funds to the product mix was a move that supported the company's development as a diversified financial services company. The first mutual funds were sold in 1969. At the same time, the company created Bankers Life Equity Management Company to serve as investment adviser to the funds.

FIRST FEMALE HALL-OF-FAMER — In 1963, Ruth Day, an agent from Detroit, Mich., became the first woman to be inducted into the company's Hall of Fame, honoring consistently high-producing agents. Day began selling life insurance in 1940 and she earned about $1,500 that year, a good salary for the time.

A GREAT PLACE TO WORK — The company began offering "mothers' hours" in 1966. Employees could work from 9 a.m. to 3 p.m. during the school year to accommodate their children's schedules. It was the beginning of several programs aimed at offering more flexibility and helping employees with their work/life balance.

Also in 1966 the company introduced the Educational Assistance Program, offering employees partial tuition reimbursement for approved and successfully completed college courses. That same year, Bankers Life initiated a higher education matching gift program, providing a dollar-for-dollar match of employee gifts to accredited colleges and universities.

BANKERS LIFE SPONSORS THE "TODAY" SHOW — Television advertising became possible after an increase in the advertising budget, designed to help distinguish Bankers Life from other companies. In 1968, Bankers Life, along with other well-known

Style shows were often part of the women's stags (socials). Here, an employee displays a hat she constructed to win a prize at the event.

In the late 1960s, Bankers Life became one of the sponsors of the "Today" show. Barbara Walters and Hugh Downs hosted the show.

Did You Know?

Earl Rosell, an agent in Billings, Mont., was featured in a movie with Dustin Hoffman in 1970. The movie, "Little Big Man," was filmed on Rosell's ranch.

In the 1950s and 1960s, The Bankers Life was a big draw for young women – many just out of high school. Many of these young women came from small towns outside of Des Moines. They'd arrange for housing in Des Moines during the week, returning home on the weekends. On Fridays, they'd drop their suitcases in the lobby and pick them up at the end of the day before heading out of town. At the time, these young women were known as "Bankers Life girls."

In 1956 the company approved a mortgage loan for a home to be built in Pacific Palisades, Calif., for Ronald and Nancy Reagan.

In the 1960s, only supervisors had phones on their desks. If an employee had a phone call from outside, the employee picked up the message from the receptionist at lunch time.

Marble and bronze paperweight developed to commemorate the 100th anniversary, 1979 | Cloisonne pin with the Principal Financial Group logo, circa 1960s | The Bankers Life fabric patch, circa 1970s | The Principal fabric patch, 1980s | Stamp dispenser, 1940s | Ad in the television viewers' guide for the 2000 Olympics | Sign hung in the offices of client companies offering group insurance from Bankers Life in the 1940s

1946 – 1970

BUILDING MOMENTUM

Although cumbersome, the company's first computer, the IBM® 650, offered great efficiencies.

The post-World War II era was one of steady growth for Bankers Life Company, surpassing the $2 billion life insurance in force mark in 1954. Technology was changing the ways companies did business; television was changing the way companies advertised. And, in 1954, Bankers Life took time out to celebrate its 75th anniversary.

The quarter century from 1946 to 1970 was a time to define the company — to take some calculated risks, but mostly to solidify the operations and build on the company's strengths. This was a time when the company would focus on small and medium-sized

businesses — a focus that would remain important. It also introduced mutual funds to customers during this period.

During those 25 years, Bankers Life Company had four presidents at its helm. Navigating the company through these post-war years, these presidents were able to effect consistent company growth. Employee numbers increased, creating the need to add onto the home office and add another building. And the company increased flexibility to help employees balance their work and home lives.

Maryland Food Stamp Nutrition Education

Evaluation Report

Fiscal Year 2005

DESIGN FIRM
The University of Maryland
Cooperative Extension
Columbia, (MD) USA
CLIENT
The University of Maryland
Cooperative Extension—
Food Stamp Nutrition Education Program
DESIGNER
Trang Dam

FSNE
changes
lives

Achievements and Recommendations

In fiscal year 2005, we made several innovative efforts to increase the efficiency and utility of the program evaluation. First, in response to concern over the formatting of the pre/post behavior change evaluation tool, the evaluation team tested modifications to the format in two program sites. This testing revealed reduced error among participants completing the evaluation, and the new format was adopted for use. Second, new evaluations were collected for teacher trainings and Color Me Healthy programs. Third, Elaine A. Anderson, Ph.D. and Marta McClintock-Comeaux, MSW, conducted a meta-evaluation of the program to examine program planning, implementation, and outcomes over the last four years. Dr. Anderson provided recommendations for future FSNE programming. Fourth, educators moved to full-scale use of consent forms and participant tracking. These evaluation achievements, along with the many positive impacts made by educators and program staff, have increased the effectiveness of FSNE each year.

In reflecting upon evaluation results for fiscal year 2005 and the program meta-evaluation, several challenges and opportunities for improvement emerge. First, a major limitation of the pre/post behavior change evaluations is that program staff are unable to determine whether people's intentions to change behavior translate into actual behavior change. Second, the match between program goals and objectives and the evaluation techniques used to determine success need to be strengthened. Third, some evaluation techniques and formatting need to be better suited to participants' abilities to address evaluation questions. Fourth, as the sources and quantity of evaluation data increase, the time constraints for analyzing data have become more burdensome for evaluation staff. Finally, the collection and tracking of consent forms from adult participants completing pre/post behavior change evaluations have become burdensome to educators.

In order to address these emerging problems, we have proposed the following improvements for fiscal year 2006 and 2007 program evaluation. The evaluation staff will conduct post-lesson interviews with participants

Maryland Food Stamp Nutrition Education Evaluation Report • Fiscal Year 2005

Of 142,443 total FSNE participants, 103,485 were adults, 34,727 were youth, and 4,231 were agency staff or teachers.

Evaluation Project Overview

The 2005 program evaluation includes analyses of contact data, pre/post behavior change quantitative data, qualitative data, and quantitative data from the *WalkWays* program. Participant contact data was collected via the Maryland Cooperative Extension Reporting System. Pre/post behavior change quantitative data was collected through the use of a standardized question bank, measuring the extent to which learners indicate an intention to change specific behaviors. Intent to change responses were used as a proxy measure for pre-post evaluation methods. Consent forms were collected for each adult participant who provided pre/post behavior change data (see Appendix G). Qualitative data in the form of stories, photographs, newspaper articles, and educator reports were collected and analyzed for themes. Quantitative data from WalkWays program participants was collected in the form of walking logs that recorded each participant's stage of change for engaging in physical activity before and after the program, as well as their steps per week throughout the duration of the program.

In this report, program and participant data are presented, as are recommendations from a program meta-analysis. Program evaluation achievements, areas in need of strengthening, and evaluation plans for fiscal year 2006 are included. County data is available to each county for their program planning and reporting purposes. County data includes project summaries, participant demographics, and pre/post behavior change data. Recommendations to strengthen program implementation and evaluation also are included.

Maryland Food Stamp Nutrition Education Evaluation Report • Fiscal Year 2005

Are you ready for Group 55 Marketing to

rock your
message?

Smart Marketing. Fresh Ideas.
313.875.1155 | group55.com

329 Fisher Building | 3011 West Grand Boulevard | Detroit, MI 48202
2710 Brooklyn Avenue | Windsor, Ontario Canada N9H 2L2

Group Fifty-Five Marketing

DESIGN FIRM
Group 55 Marketing
Detroit, (MI) USA
PROJECT
Group 55 Marketing
Corporate brochure
ART DIRECTOR, DESIGNER
Heather Sowinski
COPYWRITERS
Catherine Lapico,
Jeannette Gutierrez,
David Horowitz, Dave Warner

Smart Marketing never forgets your company's values, mission, and core competencies. It builds an image firmly oriented in your company's unique personality, and expresses that personality in a campaign that's both memorable... and compelling.

Group 55 Marketing finds your company's true north... and stays true to it.

"FROM DAY ONE, GROUP 55 GRASPED OUR UNIQUE PARTNERSHIP-DRIVEN BUSINESS STRATEGY AND SERVICE CULTURE. FROM START TO FINISH, THEY HAVE MANAGED PROJECTS EFFICIENTLY, CONFIDENTLY, AND WITHIN BUDGET. WE ESPECIALLY APPRECIATE THEIR ADAPTABILITY, AVAILABILITY, AND CREATIVITY."

LINDA DESIMONE,
CORPORATE COMMUNICATIONS MANAGER,
AMERISURE INSURANCE.

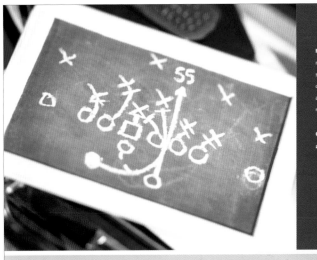

Fresh Ideas are seldom safe and predictable. It sometimes takes a bold move to break through the clutter. And, the freshest ideas are based on solid strategies. At Group 55, we start with a careful assessment of your company, your industry, and the marketplace. Then, we envision, explore, and innovate... to create a hard-driving campaign that carries your message home.

Group 55 Marketing outlines an innovative, strategy-based approach... to help you reach your goals.

"GROUP 55 HAS BEEN A PLEASURE TO WORK WITH. THEY ACTUALLY 'LISTEN' TO THE CLIENT, THEN CREATE SOMETHING NEW AND EXCITING THAT GETS RESULTS! THE QUALITY AND DELIVERY OF THE WORK HAS BEEN EXCEPTIONAL."

DIANE PACZAS
MARKETING DIRECTOR
BECK COMPANIES

Smart Marketing sweats the details...from exceptionally thorough research, to finding the most effective vehicle to reach your audience. Smart marketing asks the right questions... to create a campaign with muscle, where each element works hard on many different levels to communicate your company's message.

Group 55 Marketing. We're about performance. And results. And we never forget the most important number of all... your bottom line.

"GROUP 55 CREATED AN OUTSTANDING CAMPAIGN FOR US, AND POTENTIAL CLIENTS HAVE ACTUALLY CALLED US TO SAY HOW IMPRESSED THEY ARE. GROUP 55'S ABILITY TO DELIVER GREAT WORK IS MATCHED BY THEIR ATTENTION TO DETAIL, AND TIMELY COMMUNICATION. THEY'RE ALWAYS 'ON', ALWAYS THINKING. I FEEL OUR ACCOUNT HAS THEIR FULL ATTENTION."

BERND RONNISCH
PRESIDENT
RONNISCH CONSTRUCTION GROUP

greater
than
the
sum

SELECTIONS FROM
THE CRAIG ROBINS COLLECTION OF CONTEMPORARY ART

as a collection, the contemporary art acquired by miami-based developer craig robins defies neat categorization. combining a cutting edge outlook with unusual range and depth, robins has selected impressive works by many of the brightest names in contemporary art. but it is immediately clear that this collector is responding in a very personal way to pieces that speak on both emotional and formal levels. ranging from minimal and serene to politically charged and arousing, the robins collection covers a spectrum of aesthetic interests.

university GALLERY

cover art: PAUL MCCARTHY / **pot head**, silicon rubber, 33.5"x42"x48"

1_____

2_____

1_____
DESIGN FIRM
Connie Hwang Design
Gainesville, (FL) USA
PROJECT
Greater Than the Sum
Exhibition Brochure
DESIGNER
Connie Hwang
COPYWRITER
Amy Vigilante

2_____
DESIGN FIRM
**Hornall Anderson
Design Works**
Seattle, (WA) USA
CLIENT
Boullioun Aviation Services
DESIGNERS
Jack Anderson,
Katha Dalton,
Ryan Wilkerson,
Belinda Bowling

3_____
DESIGN FIRM
Kiku Obata & Company
St. Louis, (MO) USA
CLIENT
McCormack Baron Salazar
DESIGNER
Rich Nelson

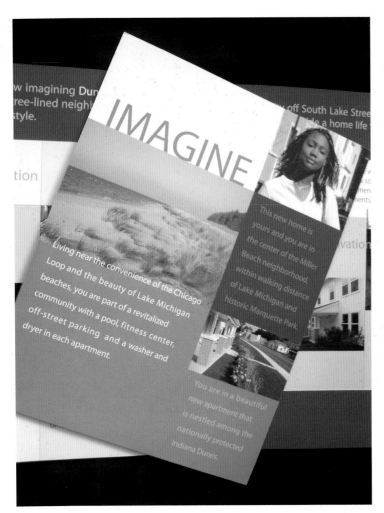

IMAGINE

Living near the convenience of the Chicago Loop and the beauty of Lake Michigan beaches, you are part of a revitalized community with a pool, fitness center, off-street parking and a washer and dryer in each apartment.

This new home is yours and you are in the center of the Miller Beach neighborhood, within walking distance of Lake Michigan and historic Marquette Park.

You are in a beautiful new apartment that is nestled among the nationally protected Indiana Dunes.

3_____

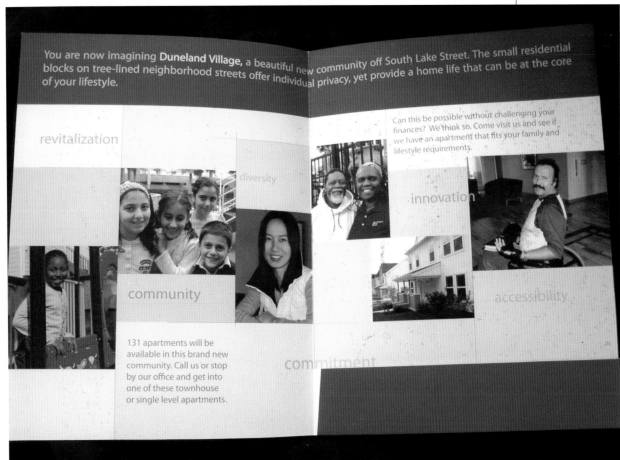

You are now imagining **Duneland Village,** a beautiful new community off South Lake Street. The small residential blocks on tree-lined neighborhood streets offer individual privacy, yet provide a home life that can be at the core of your lifestyle.

revitalization

diversity

Can this be possible without challenging your finances? We think so. Come visit us and see if we have an apartment that fits your family and lifestyle requirements.

innovation

community

accessibility

131 apartments will be available in this brand new community. Call us or stop by our office and get into one of these townhouse or single level apartments.

commitment

DESIGN FIRM
Maurius Fahrner Design
New York, (NY) USA
CLIENT
Jakob Juergensen
Immobilien GmbH
ART DIRECTOR
Marius Fahrner
ILLUSTRATOR
Barbara Spoettel

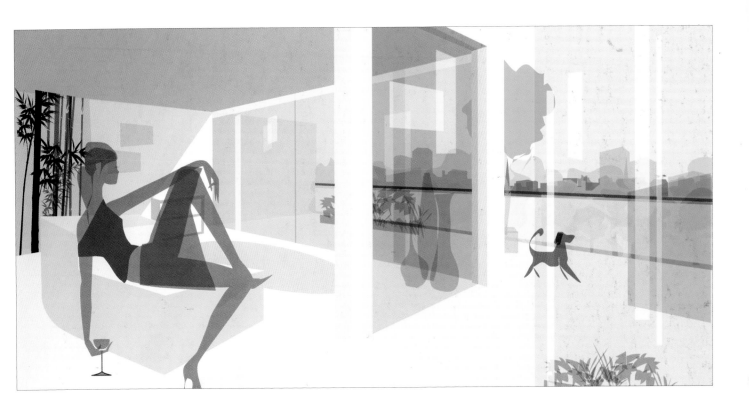

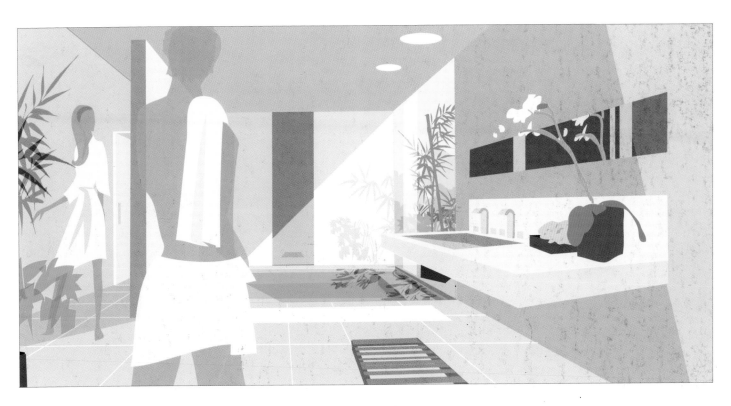

1_____

1_____
DESIGN FIRM
Audra Buck Design
Birmingham, (AL) USA
ART DIRECTOR, DESIGNER
Audra Buck

2_____
DESIGN FIRM
Corel Marketing Services & Epoxy
Ottawa, Canada
CLIENT
Corel Painter IX

2

DESIGN FIRM
Riordon Design
Oakville, (Ontario) Canada
CLIENT
Unite Productions
ART DIRECTOR
Shirley Riordon
DESIGNERS, ILLUSTRATORS
Dawn Charney, Shirley Riordon

We have some of the
best picks for you this Fall.

Please come and join us!

You will not be able to just pick one.

Golden Knights vs. the Syracuse Orange
Saint Rose and Syracuse Meet on the Court

Monday, October 31, 5 pm (Alumni Party), 7 pm (Tip-Off), $30
Syracuse University Carrier Dome

There's

no place like... the Dome, of course!

Don't miss the action when The College of Saint

Rose Golden Knights tip off against the Syracuse University

Orange in an exhibition basketball game at the famous Ca

Dome. Plus, the pre-game Alumni Party at Darwin's Rest

and Bar is back by popular demand, so warm up before the ga

your favorite game day munchies and, if you wish, enjoy refre

at the cash bar. For just $30 per person, your ticket includ

trip bus transportation between Albany and Syracuse, th

Party, and game admission. Bus departs from Saint

at 2:30 pm. Estimated time for bus to return

the College is 11:30 pm.

Dinner and a Movie on Madison Avenue
A Special Installment of *Free Your Mind Fridays*

Friday, November 18, 5 pm (Dinner), 7 pm (Movie)
$12 adults & $8 children 12 and under

5 pm, Dinner, Carl E. Touhey Forum, Thelma P. Lally School of Education
7 pm, Movie Feature, Madison Theater, 1036 Madison Avenue

The College of Saint Rose and our favorite neighbor, the

Madison Theater, are delighted to bring you *Dinner and a Movie*

on Madison Avenue, a fun and inexpensive treat that

will delight your whole family. Our chefs will prepare a

traditional spaghetti dinner for you to enjoy, and then it's

just a hop, skip and jump to the new and

improved Madison Theater for the high-

ly anticipated and family-friendly fea-

ture, *Chicken Little* (or another featured film of your choice).

1 _____

1 _____
DESIGN FIRM
The College of Saint Rose
Albany, (NY) USA
PROJECT
Fall Events Brochure
ART DIRECTOR
Mark Hamilton
ILLUSTRATOR
Chris Parody
COPYWRITERS
Meredith Rose,
Jamie Hicks
DIRECTOR OF PUBLIC RELATIONS
Lisa Haley Thomson
PRINTER
Ansun Graphics Inc.

You need to make decisive choices about manufacturing, contract vendor selection and quality assurance systems. We can help you achieve competitive advantage in supply chain development and management whether you are a new company or well established. Stay within your corporate objectives, available budget and manpower with NexGen's guidance on how to set up or streamline the production planning process.

Specialties

With our many years of expertise we can assist your organization in areas such as:

· Operations
· Manufacturing
· Product Launches
· Product Development
· Contract Sourcing
· Regulatory Compliance

Company Overview

NexGen Consulting Group ...eading provider of consulting services and resources ...otech, pharmaceutical and consumer health product ...tries for development, materials management, ...facturing and logistics.

...en has the experience to help your ...ss manage its business.

...ition you to take advantage of the path ...ention to marketability so you can focus ...reative course of your discovery.

Our track record includes small niche markets for biotech drugs, through worldwide venues for some of the largest and most well-known consumer health care products. We have the experience and expertise to guide you along the crucial steps for adoption and utilization of your product.

Contact Us

Contact us today for more information on how we can help your company achieve its goals in today's competitive marketplace.

Call 831-484-9946 or

visit us at www.nexgen.org

e-mail info@nexgen.org

2_____

3_____

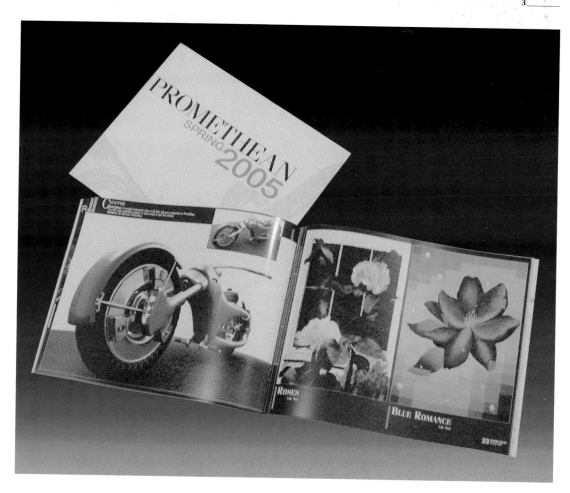

2_____
DESIGN FIRM
Sandy Gin Design
San Carlos, (CA) USA
PROJECT
NexGen Brochure
DESIGNER
Sandy Gin
PHOTOGRAPHERS
Eyewire,
Artville

3_____
DESIGN FIRM
CCM
West Orange, (NJ) USA
CLIENT
County College of Morris
ART DIRECTOR
Stephen Longo
DESIGNER
German Salazar
EDITORS
Jorawer Singh,
Trebor Ricadela,
Elizabeth Bacon

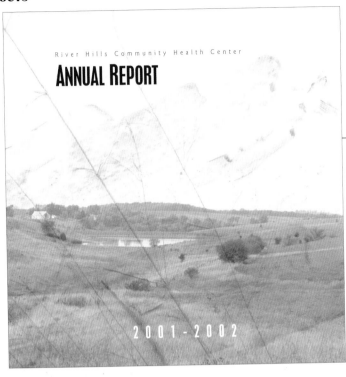

River Hills Community Health Center

ANNUAL REPORT

2001 - 2002

②

EXECUTIVE DIRECTOR'S REPORT

IN JANUARY 2002, it was my distinct pleasure to accept the invitation of River Hills Board of Directors to fill the position of Executive Director of River Hills Community Health Center, Inc. After working practically my entire career in hospital and clinic administration, I find the move to community health center management both challenging and personally rewarding.

River Hills fulfills a mission that is both unique and critically necessary to the well-being of the community.

In this report you will read about the history of community health centers and their contributions. You will also read about River Hills. It is with great pleasure that I share this report about our "first year" with you and that you find it informative and share in our pride of River Hills.

River Hills Community Health Center **BOARD OF DIRECTORS** Fiscal Year 2001

Gordon Aistrope, Chairman	Rich Johnson, Treasurer	Tom Lazio, Secretary	Patricia Cervantes
Cindy Leedom	Bill Linstrom	Sister Irene Munoz	Darlene Peta

1 _____

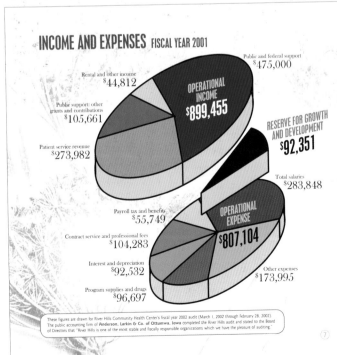

INCOME AND EXPENSES FISCAL YEAR 2001

Rental and other income
$44,812

Public and federal support
$475,000

Public support: other grants and contributions
$105,661

OPERATIONAL INCOME
$899,455

Patient service revenue
$273,982

RESERVE FOR GROWTH AND DEVELOPMENT
$92,351

Total salaries
$283,848

Payroll tax and benefits
$55,749

OPERATIONAL EXPENSE
$807,104

Contract service and professional fees
$104,283

Interest and depreciation
$92,532

Other expenses
$173,995

Program supplies and drugs
$96,697

These figures are drawn for River Hills Community Health Center's fiscal year 2002 audit (March 1, 2002 through February 28, 2002). The public accounting firm of **Anderson, Larkin & Co. of Ottumwa, Iowa** completed the River Hills audit and stated to the Board of Directors that "River Hills is one of the most stable and fiscally responsible organizations which we have the pleasure of auditing."

⑦

1_____

DESIGN FIRM
Jeremy Schultz
West Des Moines, (IA) USA

PROJECT
River Hills Community Health
Center 2002 Annual Report

DESIGNER
Jeremy Schultz

2_____

DESIGN FIRM
Evenson Design Group
Culver City, (CA) USA

PROJECT
Yokohama Ref Guide

CREATIVE DIRECTOR
Mark Sojka

ART DIRECTOR
Stan Evenson

DESIGNER
Melanie Usas

1_____

"WE HAVE MORE EXPERIENCE TREATING BRAIN TUMORS THAN ANY OTHER MEDICAL CENTER
IN THE PACIFIC NORTHWEST. MORE THAN 200 BRAIN TUMOR SURGERIES AND
50 PITUITARY TUMOR SURGERIES ARE PERFORMED HERE EVERY YEAR."

– DR. DAN SILBERGELD

xcellence in

Science Education

Bachelor of Science degree programs:
 Biology 7-12
 Chemistry 7-12
 Earth Scince 7-12
 Applied Technology Education

Master of Science in Education:
 Applied Technolgy Education

2_____

Real World
Experience in
Tech Valley

- The Medical Technology 3+1 Program combines three years at Saint Rose with a one-year internship and specialization at Rochester General Hospital or Berkshire Medical Center Hospital;
- Biology/cytotechnology students complete a one-year clinical internship at Albany School of Pharmacy; and
- Through a joint program with the Albany-Colonie Regional Chamber of Commerce, business majors gain valuable, professional work experience by interning with local Chamber-affiliated organizations.

2_____
DESIGN FIRM
The College of Saint Rose
Albany, (NY) USA
CLIENT
The College of Saint Rose
ART DIRECTOR, DESIGNER
Chris Parody
COPYWRITERS
Lisa Haley Thornson,
Renee Isgro Kelly
PHOTOGRAPHERS
Paul Castle Photography,
Gary Gold Photography,
Jupiter Images Corp.
PRINTERS
John C. Otto Company, Inc.

1_____
DESIGN FIRM
Ray Braun Design
Seattle, (WA) USA
CLIENT
UW Medical Center—Neurology
CREATIVE DIRECTOR
Ray Braun
DESIGNER
Dave Simpson
PHOTOGRAPHER
Janet Schukar

1_____

1_____
DESIGN FIRM
maycreate
Chattanooga, (TN) USA
CLIENT
NextLec Corporation
CREATIVE DIRECTOR, ART DIRECTOR,
PHOTOGRAPHER
Brian May
DESIGNERS
Brian May, Grant Little
COPYWRITER
Chuck Crowder
PRINTER
Jones Printing

Where is Slovenia?
This is usually the first question asked when putting forward Slovenian wines. A bit of surrounding information and a basic map will provide you with the answer. At the crossroads of Western and Central Europe, Slovenia rests, with Austria to the north, Italy to the west, Hungary in the east and Croatia to the South. A short stretch of the Adriatic Sea shapes Slovenia's beautifully picturesque, rocky coastline. The Julian Alps ascend along the Italian and Austrian borders, with wooded hills and fertile fields prevailing as one moves south and east, as the lush and verdant valleys roll west toward the sea.

Why haven't I heard about Slovenian wine before?
Slovenia is a very little country with a population of only two million people. Compared to most wine exporting nations, they just don't produce a lot.

Does Slovenia have a tradition of winemaking?
Slovenia is home to the oldest continuously producing vine in Europe - it is over four hundred years old.
Indeed, it is no surprise that Slovenian vineyards have been producing high quality wine for many years.
This tradition has been carried on by a new generation of private winemakers, who creates their own unique and distinctive techniques that rival the best wine found anywherein the world.

Wines From SLOVENIA

Editor
TOMAŽ SRŠEN

WINES FROM SLOVENIA

Gorenjska
Pokhmaru
Primorje

SLOVENIA
The Wine Country
AT THE SUNNY SIDE
of the
ALPS

Basic facts:
All vineyards:	*24,200 ha*
Total annual production:	*98,000,000 L*
Average annual consumption per capita:	*41 L*

Slovenia has always been *the crossroads between* north and south, east and west; travellers brought viticultural knowledge from all the prominent viticultural nations. Accordingly, French, Italian, and German influences are evident both in the growing and production of wines as well as in the terminology. Varietal wines are predominantly named after the grape, while blended wines frequently carry the name of the producing region; the terminology for high-quality and predicate wines is similar to the German.

7

2_____

Primorje
Podravje
Posavje

Winegrowing
Regions
OF
SLOVENIA

Tree winegrowing regions:
Primorje:	*6,500 ha (16,200 acres)*
Podravje:	*10,200 ha (25,600 acres)*
Posavje:	*7,500 ha (18,700 acres)*

Vitis vinifera can only be *cultivated in climate* zones where the average yearly temperature is between 14-15 °C and cannot grow, much less produce quality wine in areas with a yearly average below 10 °C. These climatic conditions are only achieved between 30 °N and 50 °N in the northern hemisphere and 30 °S and 50 °S in the southern hemisphere, and even there only in regions where the summer heat is moderated by proximity to the sea or other large bodies of water. The vine may grow closer to the equator, but the resulting grape would only accumulate abundant sugar and pigments with aromatics and acids too scarce for production of quality wine. Further north and south, the temperatures are simply too low, the summers too short, and the spring frosts too severe for the gentle shoots.

29

2_____

DESIGN FIRM
KROG, Ljubljana
Ljubljana, Slovenia
CLIENT
Ministry for Agriculture, Forestry and Food of the Republic of Slovenia
ART DIRECTOR, DESIGNER
Edi Berk
EDITOR
Tomaz Srsen

Makers of Hawaii's Finest Ukuleles Since 1916

1

Aloha Kakou!

Welcome to Kamaka Hawaii, Inc., makers of Hawaii's finest ukuleles, and the home of the original Pineapple Ukulele! Kamaka Hawaii was established in 1916 in the Territory of Hawaii, and is a family-owned and operated business. The Kamaka family has been dedicated to building skillfully-handcrafted ukuleles for nearly a century. The heritage of ukulele making at Kamaka Hawaii is preserved by second and third generation Hawaiian luthiers, as well as the many talented craftsmen at the Kakaako factory in Honolulu.

A tradition of excellence is the foundation of Kamaka Hawaii's reputation. Kamaka ukuleles are world-renown, and possess a lasting, rich tone that cannot be duplicated. The process of making a Kamaka ukulele is an art that involves design, redesign, and experimentation to produce instruments with the tonal and playing characteristics required by professional and amateur musicians alike. Many of the techniques used today have evolved from practices developed by founder Sam Kamaka Sr. This ensures consistency in quality, resulting in ukuleles that are often handed down to future generations and cherished as valued family heirlooms.

Kamaka ukuleles begin as rough Hawaiian koa lumber, and are meticulously hand built into exquisite musical instruments enjoyed by ukulele players and audiences across the globe. The Kamaka name is synonymous with superior Hawaiian craftsmanship, and Kamaka ukuleles are world-class instruments enjoyed by everyone from elementary school beginners to professional musicians.

The Kamaka Story

Shortly after the turn of the century, Samuel Kaiаlilili Kamaka began crafting koa ukuleles from the basement of his Kaimuki, Hawaii home. In 1916, he formed his one-man shop, "Kamaka Ukulele and Guitar Works," and soon established a solid reputation for making only the highest quality ukuleles.

In 1921, Kamaka Ukulele established a shop at 1814 South King Street. In the mid-20s, Sam Kamaka laid out a pattern for a new oval-shaped ukulele body. His friends remarked that it looked like a pineapple, so one of Sam's artist friends painted the front to duplicate the tropical fruit. A few years later in 1928, Sam Kamaka patented the design. Thus began the original Pineapple Ukulele, which produced a resonant, mellow sound distinct from the traditional figure-eight. The Pineapple Ukulele became an instant success worldwide, and continues to be Kamaka's signature ukulele to this day.

During the 30s, Sam Sr. introduced his two sons, Samuel Jr. and Frederick, to the craft of ukulele-making, even though the boys were only in elementary school. In 1945, the business was reorganized as "Kamaka and Sons Enterprises." Sam Jr. and Fred Sr. were then drafted into the Army, and after serving in WWII, both brothers attended college on the GI bill. After graduating from Washington State University, Fred Sr. began a career in the Army, while Sam Jr. earned a masters degree and went on to pursue a doctorate in entomology at Oregon State University.

In 1952, Sam Sr. went into semi-retirement and hauled his equipment to his Lualualei Homestead farm in Waianae. When he became seriously ill the following year, Sam Jr. abandoned his studies and moved back to Hawaii to care for his father. Sam Sr. died in December 1953, after hand-crafting koa ukuleles for over 40 years.

Immediately following Sam Sr.'s death, Sam Jr. put aside his personal career aspirations to continue the family business. Building on the knowledge he had picked up from his father, Sam Jr. restored the factory at the previous 1814 S. King Street location. Five years later in 1959, the company expanded to its current location at 550 South Street.

Kamaka and Sons incorporated in 1968 and became "Kamaka Hawaii, Inc." After retiring from the Army in 1972, Fred Sr. joined the business as its general manager. Along the way, Sam Jr.'s sons, Chris and Casey, also got involved with the company as did Fred Sr.'s son, Fred Jr. The sons now play major roles at Kamaka Hawaii, Inc.: Chris is the production manager, Casey crafts the custom orders, and Fred Jr. is the business manager. Other young family members are also helping with the business, carrying the Kamaka tradition into the fourth generation.

As the Kamaka legacy moves forward, it is important to reflect on what has made the company endure. The guiding philosophy at Kamaka Hawaii has always been the candid, but sensible advice handed down from Sam Sr. to sons, grandsons, and now great-grandsons: "If you make instruments and use the family name, don't make junk."

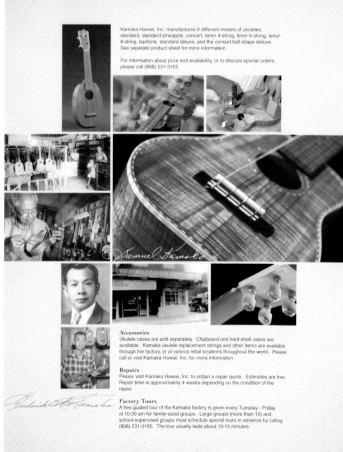

Kamaka Hawaii, Inc. manufactures 9 different models of ukuleles: standard, standard pineapple, concert, tenor 4-string, tenor 6-string, tenor 8-string, baritone, standard deluxe, and the concert bell shape deluxe. See separate product sheet for more information.

For information about price and availability, or to discuss special orders, please call (808) 531-3165.

Accessories
Ukulele cases are sold separately. Chipboard and hard-shell cases are available. Kamaka ukulele replacement strings and other items are available through the factory, or at various retail locations throughout the world. Please call or visit Kamaka Hawaii, Inc. for more information.

Repairs
Please visit Kamaka Hawaii, Inc. to obtain a repair quote. Estimates are free. Repair time is approximately 4 weeks depending on the condition of the repair.

Factory Tours
A free guided tour of the Kamaka factory is given every Tuesday - Friday at 10:30 am for family-sized groups. Large groups (more than 10) and school-supervised groups must schedule special tours in advance by calling (808) 531-3165. The tour usually lasts about 10-15 minutes.

science laboratories

| Data Lab | Colour Lab | Classic Lab |

THREE DISTINCT FURNITURE SYSTEMS FOR THE EVER EVOLVING LABORATORY ENVIRONMENT. OFFERING OUTSTANDING ADAPTABILITY AND ALLOWING THE INCREASING INTEGRATION OF NEW TECHNOLOGIES INTO THE SCIENCE AREA.

design + technology

| design manufacturing | graphic products | textiles | food technology |
| control & systems technology | advanced manufacturing technology | multi-media editing |

PURPOSE DESIGNED FURNITURE FOR ALL AREAS OF DESIGN & TECHNOLOGY. FREE-STANDING AND FITTED SYSTEMS THAT OFFER A CREATIVE YET SAFE CLASSROOM ENVIRONMENT. FURNITURE SYSTEMS FOR USE IN SUCH DIVERSE DISCIPLINES AS FOOD TECHNOLOGY OR DESIGN MANUFACTURING.

design + technology

| design manufacturing | graphic products | textiles | food technology |
| control & systems technology | advanced manufacturing technology | multi-media editing |

1_____

DESIGN FIRM
John Wingard Design
Honolulu, (HI) USA
CLIENT
Kamaka Hawaii
ART DIRECTOR, DESIGNER
John Wingard
PHOTOGRAPHER
Bud Muth

2_____
DESIGN FIRM
Imagine
Manchester, England
PROJECT
Keystage Brochure
ART DIRECTOR, DESIGNER
David Caunce

J.U.i.C.E.

justice by uniting in creative energy

REPLICATION MANUAL

J.U.i.C.E. is a project of Community Partners

DESIGN FIRM
JUNGLE 8 / creative
Los Angeles, (CA) USA

CLIENT
Justice by Uniting in
Creative Energy

CREATIVE DIRECTOR
Lainie Siegel

DESIGNERS
Justin Cram,
Amir Tohrani

COPY EDITOR
Lauren Kay

COPYWRITER
Dawn Smith

PRODUCER
Monica X. Delgado

OUR MISSION
The mission of J.U.i.C.E. is to address the root causes of juvenile crime and of youths' need for belonging by providing a safe center run by and for young people, focused on skill building in the arts surrounding hip-hop culture: word, music, art, and dance.

WELCOME, GROUNDBREAKER
We hope this book will serve as a guide, providing you with ideas and inspiration for bringing positive change to your community. Young people in need, a juvenile justice system gone awry, and the power of hip-hop as a creative force have inspired and informed our work. This manual is for anyone interested in learning more about what it takes to create a J.U.i.C.E. site, and about breaking new ground of your own. In this manual, you will find resources, tips, stories, and lessons learned to guide you on your own journey. Here's to you!

Much of the inspiration for J.U.i.C.E. came from activist, organizer, author, and graffiti writer Billy "Upski" Wimsatt, who wrote so eloquently about the importance of the journey to starting your own community organization in his book, "NO MORE PRISONS."

"(When) you walk in and look around you see all types of races, varying from young age to old age, and it's just a comfortable feeling. It's just inviting. It's just like family. Everyone knows each other. As soon as they walk in, everyone introduces themselves to each other, and it's just a pleasant place to be."
–Rawbzilla

J.U.i.C.E.
JUSTICE BY UNITING IN CREATIVE ENERGY

Excerpt from Billy "Upski" Wimsatt's NO MORE PRISONS:

I WANT YOU TO THINK SERIOUSLY ABOUT STARTING AN ORGANIZATION. IT DOESN'T HAVE TO BE A BIG ORGANIZATION. IT COULD JUST BE YOU. THINK ABOUT YOUR SKILLS, RESOURCES, CONNECTIONS, PASSIONS, AND DREAM UP A WAY TO FIGHT EVIL IN YOUR OWN LITTLE PERSONAL AND SPECIFIC WAY. MAKE UP A CLEVER NAME FOR IT. THEN CALL YOUR FRIENDS. GET THEM EXCITED ABOUT IT. IF THEY'RE NOT EXCITED, THEN MAKE SOME NEW FRIENDS WHO ARE. HAVE THEM OVER FOR DINNER. MAKE IT FUN.

AND DON'T SPEND TOO MUCH TIME PLANNING. THE MOST IMPORTANT STEP IS TO START THE ORGANIZATION. LEARN BY DOING. IT WILL PROBABLY FLOP AND THAT'S OKAY. IT'S YOUR FIRST TRY. YOU'LL LEARN AS YOU GO.. I HAVE PROBABLY STARTED A DOZEN ORGANIZATIONS THAT FLOPPED. THAT'S OKAY. I HAD TO FAIL TO LEARN.

...

IT IS DIFFICULT TO GRASP THIS MOMENT IN THE HISTORY OF THE EARTH. THOSE OF US WHO GET IT SOME OF THE TIME—WHO APPRECIATE THE SANCTITY, AND WHO UNDERSTAND OUR POWER IN DETERMINING THE FUTURE—WE HAVE A LOT OF WORK TO DO.

"I've been in hip-hop for about a year now and before that I was into, I mean I wasn't getting into trouble but I didn't know who I was. I was into drugs. I did drugs and just followed whoever I was hanging with. Opportunities like this, like what J.U.i.C.E. provides, they just do so much for the children. And just being part of the hip-hop culture, it's opened so many doors for me and it's closed the ones I don't want to ever open again."

– Jackie, J.U.i.C.E. participant

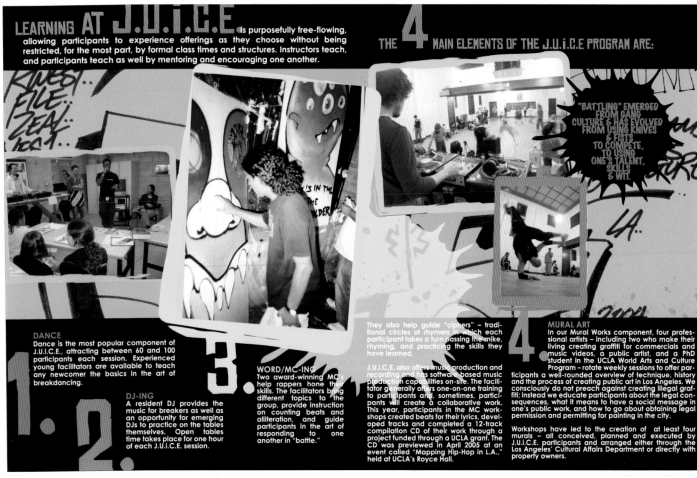

LEARNING AT J.U.i.C.E

is purposefully free-flowing, allowing participants to experience offerings as they choose without being restricted, for the most part, by formal class times and structures. Instructors teach, and participants teach as well by mentoring and encouraging one another.

THE 4 MAIN ELEMENTS OF THE J.U.i.C.E PROGRAM ARE:

"BATTLING" EMERGED FROM GANG CULTURE & HAS EVOLVED FROM USING KNIVES & FISTS TO COMPETE, TO USING ONE'S TALENT, SKILLS & WIT.

1. DANCE
Dance is the most popular component of J.U.i.C.E., attracting between 60 and 100 participants each session. Experienced young facilitators are available to teach any newcomer the basics in the art of breakdancing.

2. DJ-ING
A resident DJ provides the music for breakers as well as an opportunity for emerging DJs to practice on the tables themselves. Open tables time takes place for one hour of each J.U.i.C.E session.

3. WORD/MC-ING
Two award-winning MC's help rappers hone their skills. The facilitators bring different topics to the group, provide instruction on counting beats and alliteration, and guide participants in the art of responding to one another in "battle."

They also help guide "ciphers" – traditional circles of rhymers in which each participant takes a turn passing the mike, rhyming, and practicing the skills they have learned.

J.U.i.C.E. also offers music production and recording and has software-based music production capabilities on-site. The facilitator generally offers one-on-one training to participants and, sometimes, participants will create a collaborative work. This year, participants in the MC workshops created beats for their lyrics, developed tracks and completed a 12-track compilation CD of their work through a project funded through a UCLA grant. The CD was previewed in April 2005 at an event called "Mapping Hip-Hop in L.A.," held at UCLA's Royce Hall.

4. MURAL ART
In our Mural Works component, four professional artists – including two who make their living creating graffiti for commercials and music videos, a public artist, and a PhD student in the UCLA World Arts and Culture Program – rotate weekly sessions to offer participants a well-rounded overview of technique, history and the process of creating public art in Los Angeles. We consciously do not preach against creating illegal graffiti; instead we educate participants about the legal consequences, what it means to have a social message in one's public work, and how to go about obtaining legal permission and permitting for painting in the city.

Workshops have led to the creation of at least four murals – all conceived, planned and executed by J.U.i.C.E. participants and arranged either through the Los Angeles' Cultural Affairs Department or directly with property owners.

assembling a **board of directors**

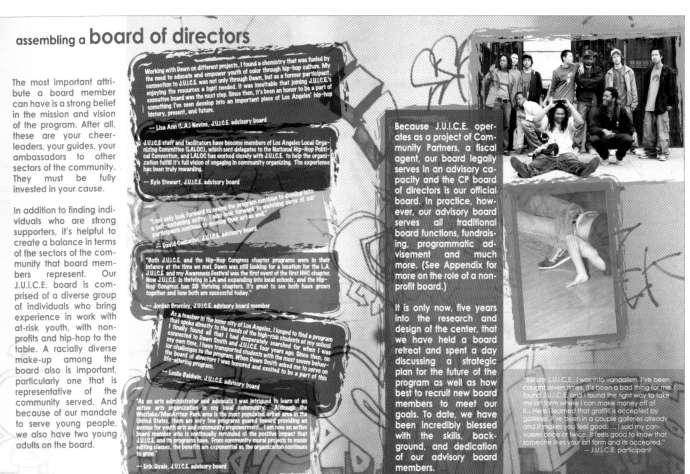

The most important attribute a board member can have is a strong belief in the mission and vision of the program. After all, these are your cheerleaders, your guides, your ambassadors to other sectors of the community. They must be fully invested in your cause.

In addition to finding individuals who are strong supporters, it's helpful to create a balance in terms of the sectors of the community that board members represent. Our J.U.i.C.E. board is comprised of a diverse group of individuals who bring experience in work with at-risk youth, with non-profits and hip-hop to the table. A racially diverse make-up among the board also is important, particularly one that is representative of the community served. And because of our mandate to serve young people, we also have two young adults on the board.

Working with Dawn on different projects, I found a chemistry that was fueled by the need to educate and empower youth of color through hip-hop culture. My connection to J.U.i.C.E. was not only through Dawn, but as a former participant, enjoying the resources a b-girl needed. It was inevitable that joining J.U.i.C.E.'s executive board was the next step. Since then, it's been an honor to be a part of something I've seen develop into an important piece of Los Angeles' hip-hop history, present, and future.

-- Lisa Ann (L.A.) Nevins, J.U.i.C.E. advisory board

J.U.i.C.E. staff and facilitators have become members of Los Angeles Local Organizing Committee (LALOC), which sent delegates to the National Hip-Hop Political Convention, and LALOC has worked closely with J.U.i.C.E. to help the organization fulfill it's full vision of engaging in community organizing. The experience has been truly rewarding.

-- Kyle Stewart, J.U.i.C.E. advisory board

"I not only look forward to seeing the program continue to develop into a self-sustaining entity. I also look forward to watching some of our participants continue to develop their art as well."

-- David Camacho, J.U.i.C.E. advisory board

"Both J.U.i.C.E. and the Hip-Hop Congress chapter programs were in their infancy at the time we met. Dawn was still looking for a location for the L.A. J.U.i.C.E. and my Awareness Festival was the first event of the first HHC chapter. Now J.U.i.C.E. is thriving in LA and expanding into local schools, and the Hip-Hop Congress has 28 thriving chapters. It's great to see both have grown together and how both are successful today."

-- Jordan Bromley, J.U.i.C.E. advisory board member

As a teacher in the inner city of Los Angeles, I longed to find a program that spoke directly to the needs of the high-risk students at my school. I finally found all that I had desperately searched for when I was connected to Dawn Smith and J.U.i.C.E. four years ago. Since then, on my own time, I have transported students with the most severe behavior challenges to the program. When Dawn Smith asked me to serve on the board of directors I was honored and excited to be a part of this life-altering program.

-- Leslie Baldwin, J.U.i.C.E. advisory board

"As an arts administrator and advocate I was intrigued to learn of an active arts organization in my local community. Although the Westlake/MacArthur Park area is the most populated urban area in the United States, there are very few programs geared toward providing an avenue for youth arts and community empowerment... I am now an active board member who is continually reminded of the positive impact that J.U.i.C.E. and its programs have. From community mural projects to music editing classes, the benefits are exponential as the organization continues to grow."

-- Erik Qvale, J.U.i.C.E. advisory board

Because J.U.i.C.E. operates as a project of Community Partners, a fiscal agent, our board legally serves in an advisory capacity and the CP board of directors is our official board. In practice, however, our advisory board serves all traditional board functions, fundraising, programmatic advisement and much more. (See Appendix for more on the role of a nonprofit board.)

It is only now, five years into the research and design of the center, that we have held a board retreat and spent a day discussing a strategic plan for the future of the program as well as how best to recruit new board members to meet our goals. To date, we have been incredibly blessed with the skills, background, and dedication of our advisory board members.

"Before J.U.i.C.E. I was into vandalism. I've been caught seven times. It's been a bad thing for me. I found J.U.i.C.E. and I found the right way to take my art form where I can make money off of it...Here I learned that graffiti is accepted by galleries. I've been in a couple galleries already and it makes you feel good. ... I sold my canvasses once or twice. It feels good to know that someone likes your art form and its accepted."
-- J.U.i.C.E. participant

191

1 _____

1 _____

DESIGN FIRM
Imagine
Manchester, England

PROJECT
Beer Barons Brochure

ART DIRECTOR, DESIGNER
David Caunce

1990 | The Art Education programs move from the College of Education to the Department of Art.

1992 | Professor Brian Slawson launches Ligature, the annual student-run design event.

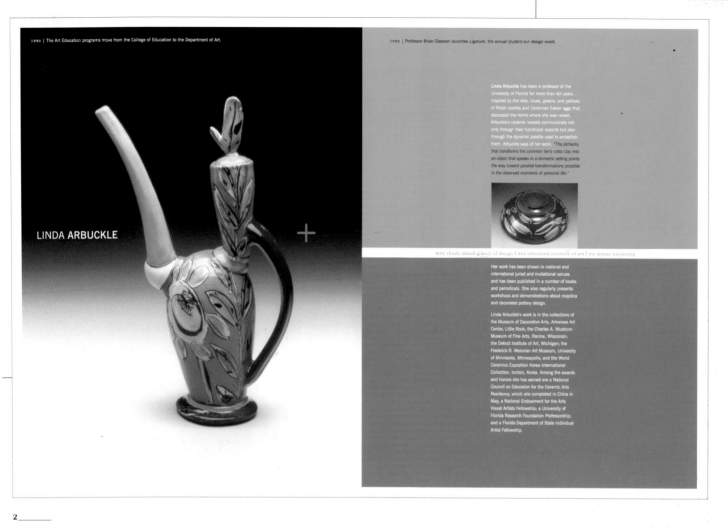

LINDA ARBUCKLE

Linda Arbuckle has been a professor at the University of Florida for more than ten years. Inspired by the reds, blues, greens, and yellows of Polish textiles and Ukrainian Easter eggs that decorated the home where she was raised, Arbuckle's ceramic vessels communicate not only through their functional aspects but also through the dynamic palette used to embellish them. Arbuckle says of her work, "The alchemy that transforms the common terra cotta clay into an object that speaks in a domestic setting points the way toward parallel transformations possible in the observed moments of personal life."

MFA rhode island school of design | BFA cleveland institute of art | BA miami university

Her work has been shown in national and international juried and invitational venues and has been published in a number of books and periodicals. She also regularly presents workshops and demonstrations about majolica and decorated pottery design.

Linda Arbuckle's work is in the collections of the Museum of Decorative Arts, Arkansas Art Center, Little Rock; the Charles A. Wustrum Museum of Fine Arts, Racine, Wisconsin; the Detroit Institute of Art, Michigan; the Frederick R. Weisman Art Museum, University of Minnesota, Minneapolis; and the World Ceramics Exposition Korea International Collection, Inchon, Korea. Among the awards and honors she has earned are a National Council on Education for the Ceramic Arts Residency, which she completed in China in May; a National Endowment for the Arts Visual Artists Fellowship; a University of Florida Research Foundation Professorship; and a Florida Department of State Individual Artist Fellowship.

2_____

3_____

2_____

DESIGN FIRM
Connie Hwang Design
Gainesville, (FL) USA

PROJECT
UF School of Art + Art History
Capability Brochure

DESIGNERS
Connie Hwang,
Maria Rogal

3_____

DESIGN FIRM
Barbara Spoettel
New York, (NY) USA

CLIENT
Mobile Cook, Munich, Germany

ART DIRECTOR, DESIGNER, PHOTOGRAPHER
Barbara Spoettel

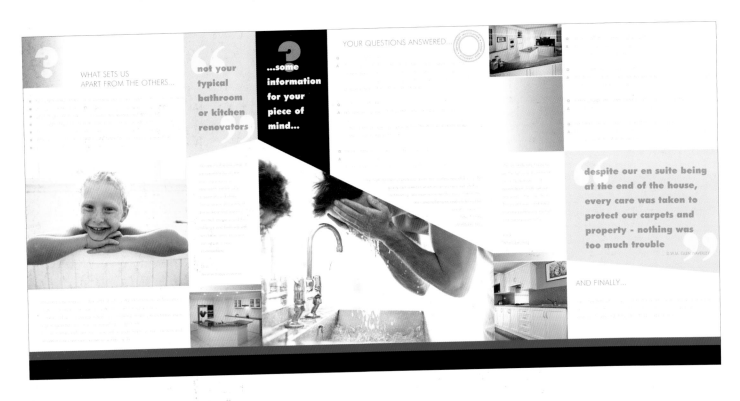

1_____

DESIGN FIRM
At First Sight
Ormond, Australia
DESIGNERS
Barry Selleck,
Olivia Brown

2_____

DESIGN FIRM
Adventium
New York, (NY) USA
DESIGNER
Penny Chuang

Internet

Building Audience For A Web Site

Hundreds of PR executives now publicize Web sites the way great PR firms introduce a new product:

1. Cover the mass media that now use releases: 10,000 newspapers, 1,000 TV stations and 6,500 radio stations.

2. Create 50 to 100 million or more in circulation and audience.

3. Build awareness of reasons to visit—what your site offers.

4. Report to management with not only clips and broadcast usage reports, but also colorful usage maps so management can see from all those dots how PR is succeeding.

5. See which releases got the most coverage so next year you can do more of what worked best.

Cover All The Media

The mass media are delightfully responsive to releases about Web sites because the Internet is huge and growing.

The Internet is competing with schools for student time, with business and government for office time, and with TV big time, costing millions of viewer hours daily.

Newspapers and radio aren't being hit hard because newspapers have retail ads and helpful features that are hugely popular, and the public can listen to the radio while doing something else.

So all the media—10,000 newspapers, 1,000 TV stations and 6,500 radio stations that use releases—are wide open to releases about what's available on your Web site.

Fifty Million Plus

Getting massive circulation and audience is increasingly easy because media that use releases have so much to give.

Newspapers offer you 137 million in circulation. The 1,500 dailies have 58 million, and weeklies—mostly in the wealthy suburbs—are up to 79 million and growing.

With each NAPS-distributed release for the newspapers, you'll also be on the Internet at no extra charge.

Radio is heard by 150 million Americans on an average day—and if you multiply that by the number of days in a year, you may feel an incentive to do a radio release monthly or at least quarterly.

TV now reaches nearly everyone. TV talk shows on 1,000 stations, including those in major markets, are pleased to receive one-minute taped features that are helpful and informative for their viewers.

Build Awareness

You'll hit different broadcasters than those who use VNRs. News shows use VNRs but talk shows welcome our one-minute tape features. "Selling by sample" is a popular technique for sharply increasing Web site hits: give samples in other media—newspapers, radio, and TV—of what's available on your Web site.

Making Management Happy

PR treasure maps—with placements shown by color dots on maps NAPS will send you—show management where you have created golden opportunities.

One clipping may look pretty much like another but when management sees hundreds of dots on a map—with the dots clustered around the major markets because that's where most newspapers and broadcasters operate—management can see at a glance how successful your PR work has been.

NAPS gives you computer-generated usage maps showing the results of each release to the mass media. You also receive colorful bar charts, graphs and CDs that delight management.

What Mass Media Offers You...

Newspapers

The 1,500 dailies with 58 million circulation—and 8,500 weeklies with 79 million mostly in the wealthy suburbs—will give you 100 to 400 placements per release.

Four releases will get over 1,000 placements, a monthly series of 12 will get over 2,500, and what's important isn't the clippings but the people you reach.

The top 500 newspapers are certainly the most important, but a release to all 10,000 papers gets three times as much circulation as a release to only 500.

Some of your additional circulation will be from top-500 dailies because departmental editors are swamped but feature and Sunday editors are hungry for material. When you cover all 10,000 newspapers, your release distribution includes feature and Sunday editors.

Some of your pick-up is likely to come from downsized former editors who now freelance special sections from home for major newspapers. These freelancers receive CD-ROMs and diskettes at home from NAPS—and often phone NAPS for "special order" diskettes when a new assignment comes in.

You get more from departmental editors because they are swamped with work, swamped with releases. Releases that arrive on CDs have an edge with many busy editors.

Weeklies offer quality readership because they go to upscale suburban homeowners Newspapers flourish where readers have the money to buy from advertisers.

Nearly all major PR firms and departments send releases to the 10,000 newspapers by using NAPS because:

1. You get more results if you cover the 10,000 newspapers than if you don't.

2. NAPS will save you money on distribution. With each paper, you'll go to NAPS contacts who use releases. Editors welcome releases as a useful source. NAPS has six people on the phones to media keeping track of who are the best editors to cover.

3. NAPS will send you your clippings not just from the outside clipping services but also from the big NAPS clipping bureau that reads suburban newspapers.

4. NAPS covers all 10,000 newspapers (not the 3,000 covered by some "we do the same as NAPS" services). sends costly CDs, not just cheap repro proofs, uses First Class to top dailies, covers NAPS contacts, not names from a directory, and sends you clips from outside services plus the NAPS clipping bureau.

5. NAPS will save you time. Based on your information, NAPS will write releases that will get massive pick-up. Or if you have a release ready to go, NAPS may suggest editing to increase pick-up without requiring another clearance.

While some PR people send an important release to a few hundred newspapers and go home hoping that pick-up will be good, hundreds of top PR firms and departments now send a set of four or more releases

TV Talk Shows

While news shows use VNRs, talk shows are eager for our one-minute taped VFRs (video feature release).

If you want to consider doing a TV release, give NAPS information and we can prepare a suggested release.

At no cost or obligation, NAPS will write a proposed release for you. Once you approve copy, we will use your color graphics, VNR, B-roll or our own stock footage to produce a one-minute VFR which, when you approve, will be sent to 1,000 stations.

You will have 100 to 150+ placements per release. If your release is on health, technology or travel, you'll have more than 150 placements per release. One advantage of covering TV is that marketing executives love it. The 100 largest national advertisers spend over seven dollars on TV for every dollar they spend on newspapers.

Another advantage of covering TV is cost efficiency. If you already have a VNR, B-Roll or color stills in your file, you can create millions in additional audience for your creative work by simply giving America's TV stations a chance to use it.

The biggest advantage of covering talk shows, whether or not you're doing a VNR, is that by informing additional millions of Americans, you'll more fully attain the objectives of your program.

It's inexpensive, and hundreds of top PR firms and departments use NAPS with pleasure. You're safe with NAPS. Send us your VNR, B-Roll or color stills. No cost or obligation for a NAPS proposal—and you'll love your results if you approve.

*VFR is a registered-mark of North American Precis Syndicate, Inc.

Radio

A one-minute radio script—about 140 to 150 words—will get pick-up by 400 to 500+ stations.

Your usage report will include audience data, a colorful usage map, plus the bar charts and pie charts that make management happy—especially marketing executives who love to quantify what results PR is producing for them.

Radio is terrific for reaching homemakers and motorists, and sometimes you get two-in-one: a homemaker in her car on the way to the shopping center.

The same skills that make you successful in newspapers will make you even more successful with radio because radio needs more material and receives much less. Radio is hungry for helpful information.

A radio release to 6,500 stations goes out in the form of paper scripts, CDs or both, depending on what each broadcaster prefers. You'll reach NAPS contacts, users, not names from a list, and you're guaranteed complete satisfaction with the results of each release or another one free.

Radio is heard by more than 150 million Americans on an average day. So pervasive and persuasive is radio that it bills more ad dollars each year than all consumer magazines combined.

If you're willing to consider covering radio, send NAPS information and we'll gladly send you proposed scripts—no cost or obligation for the proposal—that will bring you excellent results.

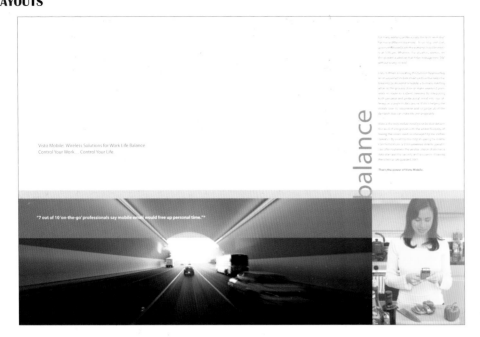

Visto Mobile: Wireless Solutions for Work Life Balance.
Control Your Work ... Control Your Life.

balance

"7 out of 10 'on-the-go' professionals say mobile email would free up personal time."*

1_____

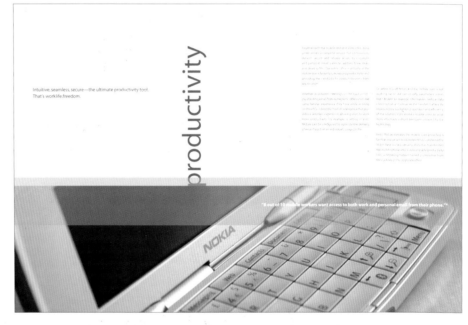

productivity

Intuitive, seamless, secure—the ultimate productivity tool.
That's worklife.freedom.

"8 out of 10 mobile workers want access to both work and personal email from their phone."*

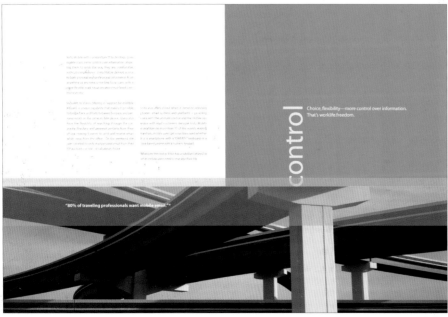

control

Choice, flexibility—more control over information.
That's worklife.freedom.

"80% of traveling professionals want mobile email."*

1_____
DESIGN FIRM
Visto Marketing
Redwood Shores, (CA) USA
CREATIVE MANAGER, LEAD DESIGNER
Todd Laur
COPYWRITER
Suzanne Panoplos
PHOTOGRAPHERS
Michael Sexton Photography,
Todd Laur

2_____
DESIGN FIRM
William Berry Campaigns, Inc.
Sacramento, (CA) USA
CLIENT
Committee for Yes on Measure C
CREATIVE DIRECTOR
William Berry
DESIGNER
Mike Wyman
(Wyman Designs)

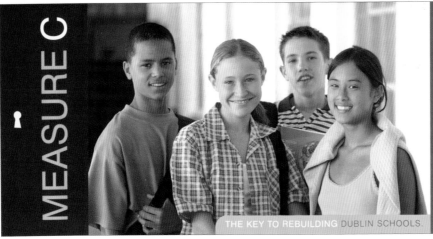

2_____

3_____

3_____

DESIGN FIRM
Mayhem Studios
Los Angeles, (CA) USA

DESIGNER
Calvin Lee

197

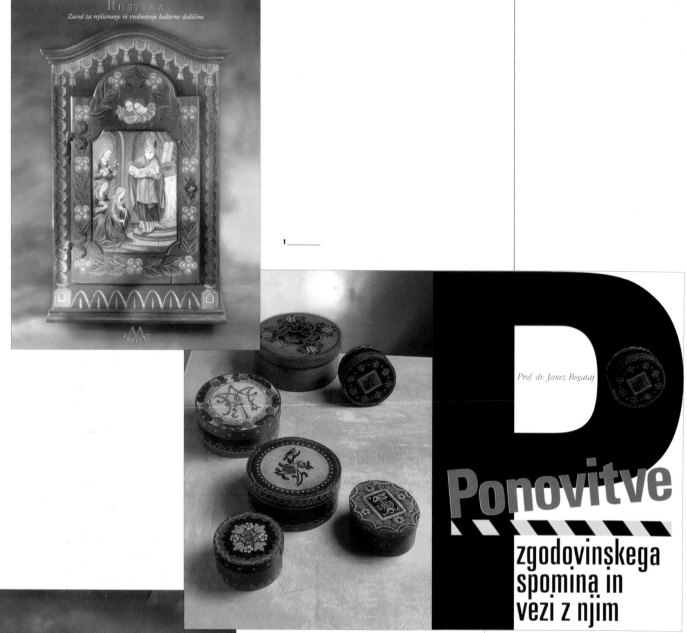

1 _____

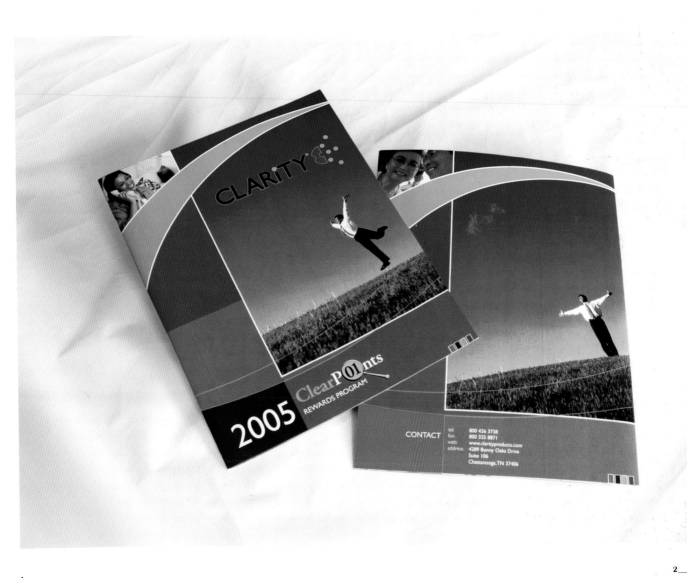

1
DESIGN FIRM
KROG, Ljubljana
Ljubljana, Slovenia
CLIENT
Gallery Rustika, Ljubljana
ART DIRECTOR, DESIGNER
Edi Berk
COPYWRITERS
Janez Bogataj, Adrian Loos
PHOTOGRAPHERS
Boris Gaberscik, Janez Puksic

2
DESIGN FIRM
maycreate
Chattanooga, (TN) USA
CLIENT
Clarity Products
CREATIVE DIRECTOR, ART DIRECTOR,
DESIGNER, PHOTOGRAPHER
Brian May

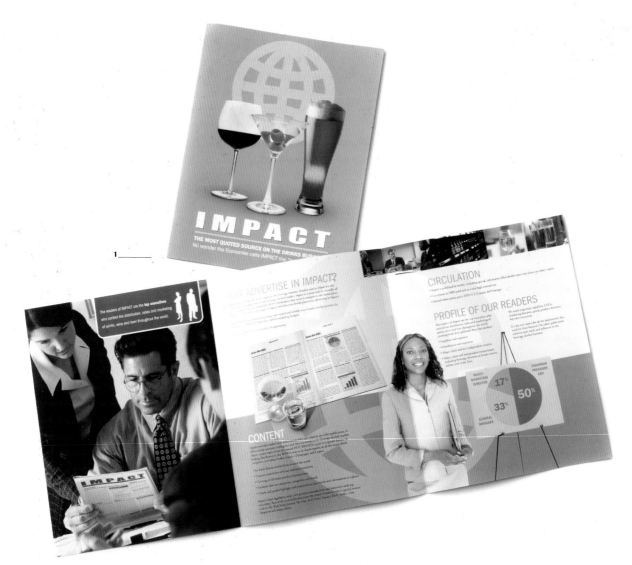

1 _____

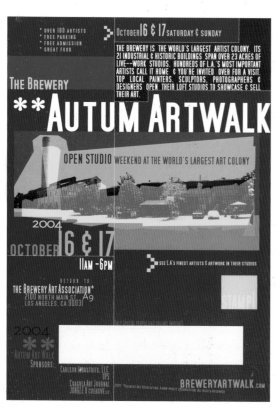

2 _____

1 _____

DESIGN FIRM
**M. Shanken
Communications, Inc.**
New York, (NY) USA

PROJECT
Impact Marketing
Seminar Brochure

ART DIRECTOR
Chandra Hira

DESIGNER
Terrence Janis

2 _____

DESIGN FIRM
JUNGLE 8 / creative
Los Angeles, (CA) USA

CLIENT
Brewery Art Association

DESIGNER
Lainie Siegel

COPYWRITER
Mat Gleason

CORPORATE SOLUTIONS

EXECUTIVE RECRUITMENT SOLUTIONS

Corporate Solutions, the executive search and management consultancy for the construction industry was established nearly 30 years ago. Following re-branding in 1998, Corporate Solutions has defined itself as a discreet and confidential service providing total recruitment for **Senior Management** and **Board Directors** throughout the construction industry.

EXECUTIVE SEARCH PROCESS

RETAINED ASSIGNMENTS

ADVERTISING & SELECTION

ADDITIONAL CONSULTANCY SERVICES

INDUSTRY SECTORS

3 _____
DESIGN FIRM
Jo Mew Creative
London, England
PROJECT
CS Brochure
DESIGNER
Jo Mew

1_____

1_____
DESIGN FIRM
 Evenson Design Group
 Culver City, (CA) USA
PROJECT
 Vistamar Viewbook
ART DIRECTOR
 Stan Evenson
DESIGNER
 Mark Sojka
PHOTOGRAPHER
 Anthony Nex

2_____
DESIGN FIRM
 JL Design
 Plainfield, (IL) USA
DESIGNER
 JL Design

WHEELS

VICTORY WHEELS, INC

NASCAR Officially Licensed IndyCar SERIES

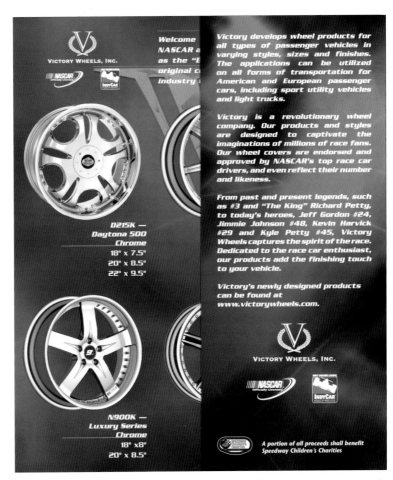

Welcome [...] NASCAR a [...] as the "E [...] original c [...] industry [...]

Victory develops wheel products for all types of passenger vehicles in varying styles, sizes and finishes. The applications can be utilized on all forms of transportation for American and European passenger cars, including sport utility vehicles and light trucks.

Victory is a revolutionary wheel company. Our products and styles are designed to captivate the imaginations of millions of race fans. Our wheel covers are endorsed and approved by NASCAR's top race car drivers, and even reflect their number and likeness.

From past and present legends, such as #3 and "The King" Richard Petty, to today's heroes, Jeff Gordon #24, Jimmie Johnson #48, Kevin Harvick #29 and Kyle Petty #45, Victory Wheels captures the spirit of the race. Dedicated to the race car enthusiast, our products add the finishing touch to your vehicle.

Victory's newly designed products can be found at www.victorywheels.com.

VICTORY WHEELS, INC.

NASCAR Officially Licensed IndyCar SERIES

A portion of all proceeds shall benefit Speedway Children's Charities

D215K —
Daytona 500
Chrome
18" x 7.5"
20" x 8.5"
22" x 9.5"

N900K —
Luxury Series
Chrome
18" x8"
20" x 8.5"

2

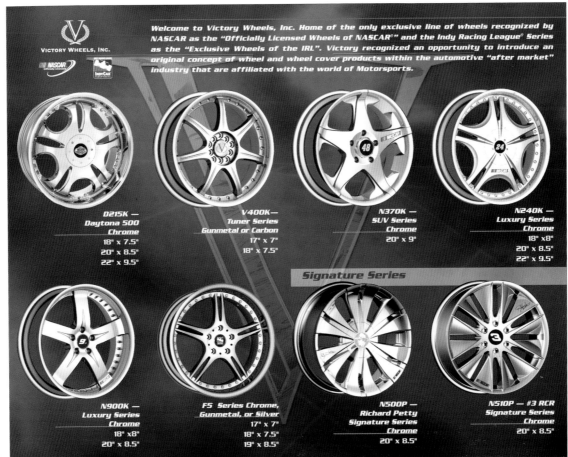

Welcome to Victory Wheels, Inc. Home of the only exclusive line of wheels recognized by NASCAR as the "Officially Licensed Wheels of NASCAR®" and the Indy Racing League® Series as the "Exclusive Wheels of the IRL". Victory recognized an opportunity to introduce an original concept of wheel and wheel cover products within the automotive "after market" industry that are affiliated with the world of Motorsports.

D215K —
Daytona 500
Chrome
18" x 7.5"
20" x 8.5"
22" x 9.5"

V400K—
Tuner Series
Gunmetal or Carbon
17" x 7"
18" x 7.5"

N370K—
SUV Series
Chrome
20" x 9"

N240K —
Luxury Series
Chrome
18" x8"
20" x 8.5"
22" x 9.5"

Signature Series

N900K —
Luxury Series
Chrome
18" x8"
20" x 8.5"

F5 Series Chrome,
Gunmetal, or Silver
17" x 7"
18" x 7.5"
19" x 8.5"

N500P —
Richard Petty
Signature Series
Chrome
20" x 8.5"

N510P — #3 RCR
Signature Series
Chrome
20" x 8.5"

Fusion of
luxury and inspiration

The core vision of the community is centered on exceptional form, design, materials, and world-class service. Luxury will drive Bahrain Bay's success, providing an experience that is differentiated, attracts premium value and builds loyalty.

Where the night comes alive

When night falls, Bahrain Bay comes alive with orchestrated energy. Light shows illuminate the sky, while music filters through the air from cafés and fine restaurants. The exciting atmosphere, bustling with diners, visitors and residents is further charged by live cultural events on the promenade, dramatic fountains and stunning views of the water and of the Manama skyline.

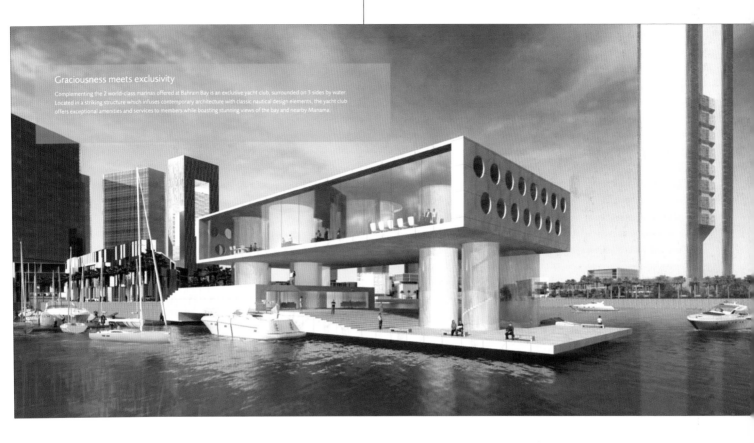

Graciousness meets exclusivity

Complementing the 2 world-class marinas offered at Bahrain Bay is an exclusive yacht club, surrounded on 3 sides by water. Located in a striking structure which infuses contemporary architecture with classic nautical design elements, the yacht club offers exceptional amenities and services to members while boasting stunning views of the bay and nearby Manama.

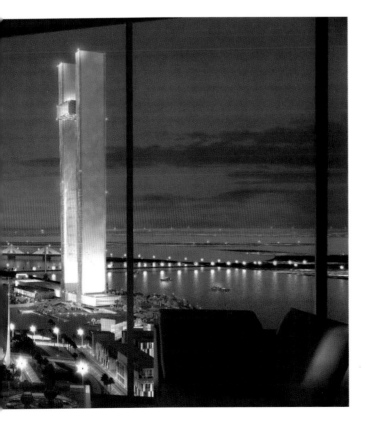

DESIGN FIRM
FutureBrand
Brand Experience
New York, (NY) USA
PROJECT
Bahrain Bay Brochure
CREATIVE DIRECTOR
Diego Kolsky
DESIGNERS
Cheryl Hills, Mike Williams,
Brendan Oneill, Tom Li
COPYWRITER
Stephanie Carroll
DIRECTOR OF VISUALIZATION
Antonio Baglione
VISUALIZATION ARTIST
Oliver de la Rama

Hot Stuff

Group Fifty-Five Marketing

1

Are You Ready To Kick It Up A Notch?

Has your company's image grown stale on the shelf? Want to step up your marketing efforts...and increase sales? Convinced your marketing dollars could work harder... and achieve more measurable results?

We Know How to Spice Up Your Marketing!

At Group 55, we'll take your company to the next level. We know how to create a powerful brand image, from corporate and product identity to print, radio, tv and web. And we base everything we do for you on rock-solid strategy... and in-depth research.

Brace Yourself For Red Hot Results!

We're ready...to learn everything about you, your customer, and your competition. Then, we'll zero in on the unique benefits and personality of your company's product...and drive your message home. And when your message hits home, your sales go up.

Call us! We have the recipe for the results you want.

Now that's Hot!

Group Fifty-Five Marketing
Fresh ideas. Red hot strategies.

313.875.1155 | group55.com

MARKETING
ADVERTISING
COLLATERAL
TELEVISION
RADIO
INTERACTIVE
EVENTS
PUBLIC RELA

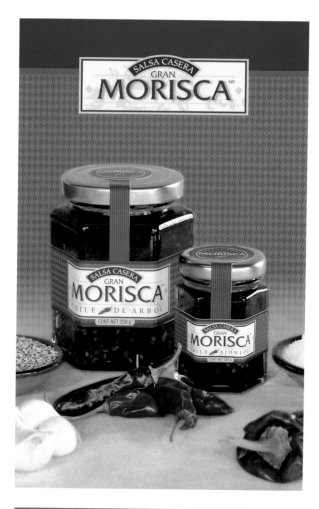

2 _____

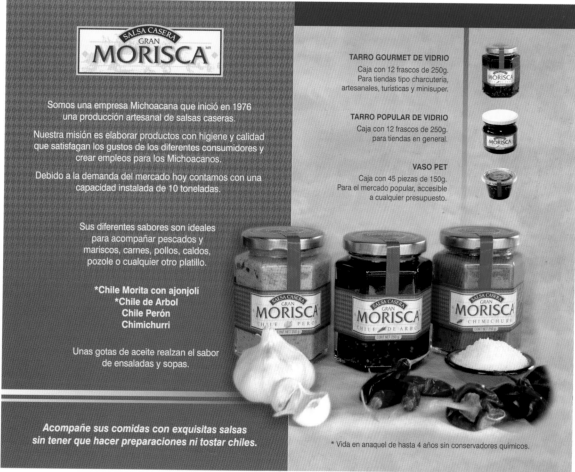

GRAN MORISCA

Somos una empresa Michoacana que inició en 1976
una producción artesanal de salsas caseras.

Nuestra misión es elaborar productos con higiene y calidad
que satisfagan los gustos de los diferentes consumidores y
crear empleos para los Michoacanos.

Debido a la demanda del mercado hoy contamos con una
capacidad instalada de 10 toneladas.

Sus diferentes sabores son ideales
para acompañar pescados y
mariscos, carnes, pollos, caldos,
pozole o cualquier otro platillo.

*Chile Morita con ajonjolí
*Chile de Arbol
Chile Perón
Chimichurri

Unas gotas de aceite realzan el sabor
de ensaladas y sopas.

**Acompañe sus comidas con exquisitas salsas
sin tener que hacer preparaciones ni tostar chiles.**

TARRO GOURMET DE VIDRIO
Caja con 12 frascos de 250g.
Para tiendas tipo charcutería,
artesanales, turísticas y minisuper.

TARRO POPULAR DE VIDRIO
Caja con 12 frascos de 250g.
para tiendas en general.

VASO PET
Caja con 45 piezas de 150g.
Para el mercado popular, accesible
a cualquier presupuesto.

* Vida en anaquel de hasta 4 años sin conservadores químicos.

1 _____
DESIGN FIRM
Group 55 Marketing
Detroit, (MI) USA
PROJECT
Group 55 Marketing
Brochure
ART DIRECTOR, DESIGNER
Jeannette Gutierrez
COPYWRITERS
Catherine Lapico,
Jeannette Gutierrez

2 _____
DESIGN FIRM
**Caracol Consultores
SC**
Morelia, México
CLIENT
Salsas Gran Morisca
ART DIRECTOR
Luis Jaime Lara Perea
DESIGNERS
Myriam Zavala,
Luis Jaime Lara
PHOTOGRAPHER
Luis Jaime Lara

DESIGN FIRM
FutureBrand Brand Experience
New York, (NY) USA
PROJECT
Exomos Brochure
CREATIVE DIRECTOR
Avrom Tobias
DESIGNERS
Mike Williams, Brendan Oneill,
Tom Li, Tini Chen, Phil Rojas
VISUALIZATION DIRECTOR
Antonio Baglione
VISUALIZATION ARTIST
Oliver de la Rama
COPYWRITER
Stephanie Carroll
DIRECTOR OF IDENTITY SYSTEMS
Carol Wolf
PRINCIPAL
Mario Natarelli

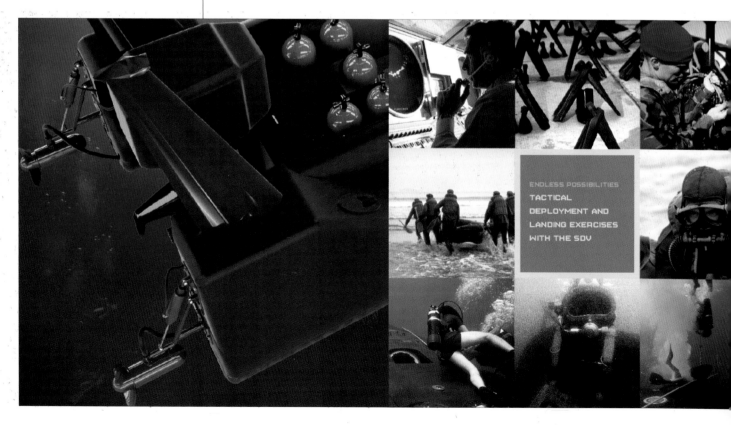

ENDLESS POSSIBILITIES
TACTICAL
DEPLOYMENT AND
LANDING EXERCISES
WITH THE SDV

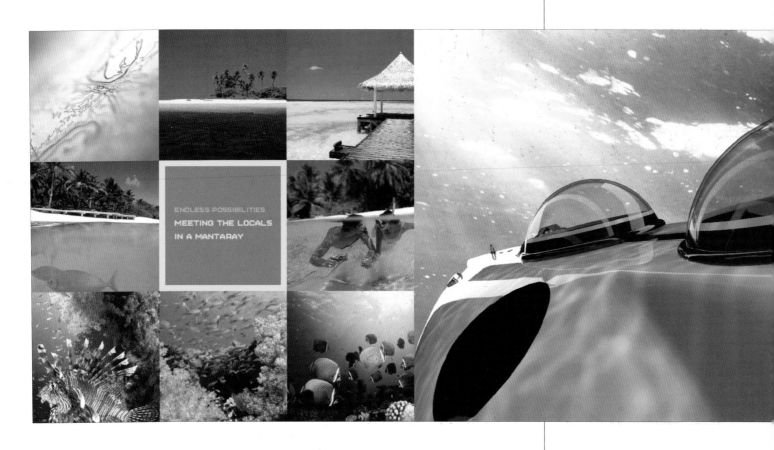

ENDLESS POSSIBILITIES
**MEETING THE LOCALS
IN A MANTARAY**

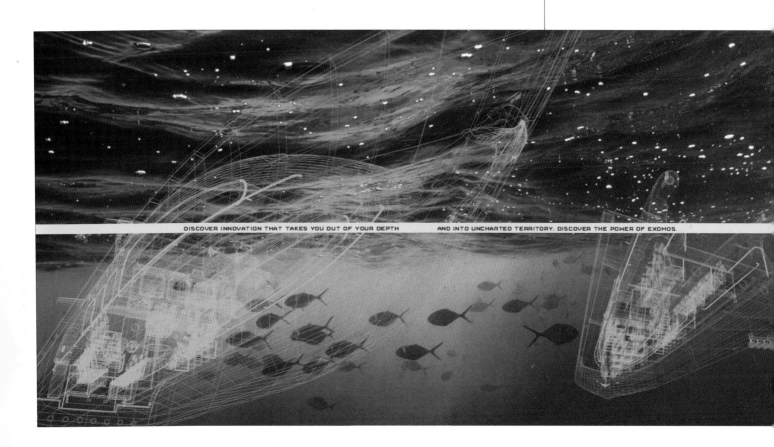

DISCOVER INNOVATION THAT TAKES YOU OUT OF YOUR DEPTH AND INTO UNCHARTED TERRITORY. DISCOVER THE POWER OF EXOMOS.

Tumbleweed Secure Policy Gateway A centralized policy engine applies deep intelligence to securely manage both inbound and outbound communications across the entire extended enterprise.

NEXT-GENERATION INTERNET SECURITY

Traditional solutions secure the network not the content that flows through it.

Tumbleweed secure content management raises the bar.

THE BUSINESS INTERNET: TWIN CHALLENGES

The Internet has revolutionized global business communications, enabling a dramatic increase in the flow of information across the extended enterprise while reducing communication costs, maximizing business efficiencies, and strengthening business relationships. As today's organizations move more and more business-critical communications and processes to the Internet, this revolution brings with it twin challenges.

On the one hand you must protect your enterprise like never before. You must ensure that confidential, proprietary, and sensitive information such as trade secrets, financial reports, customer data, and future product plans are not unintentionally disclosed to parties lacking authorized access. You must be vigilant against the constant threat of viruses and unsolicited e-mail that can bring a network to its knees, directly impacting your bottom line and business goodwill. You must comply with increasing government and industry regulations. And you must reduce your exposure to legal liabilities and fraud through the universal and consistent application of corporate policies and procedures.

On the other hand you must extend your network outward like never before. To realize the full potential of the business Internet, you must increase communication and collaboration with those outside your corporate firewall—extending your reach and visibility to the farthest edges of the network. You must provide high levels of interoperability with partners and customers to streamline business processes and enhance customer service and loyalty. You must maximize business efficiencies by using the Internet for customer bill and statement presentment, partner relationship management, order and forms processing—and more.

1_____

2_____

1_____
DESIGN FIRM
Connie Hwang Design
Gainesville, (FL) USA
PROJECT
Tumbleweed Communications Brochure
DESIGNER
Connie Hwang
COPYWRITER
Jessa Aubin

2_____
DESIGN FIRM
Eben Design
Seattle, (WA) USA
CLIENT
Pepperdogz
ART DIRECTOR, DESIGNER
Dan Meehan
COPYWRITERS
Sean Youssefi, Karen Youssefi

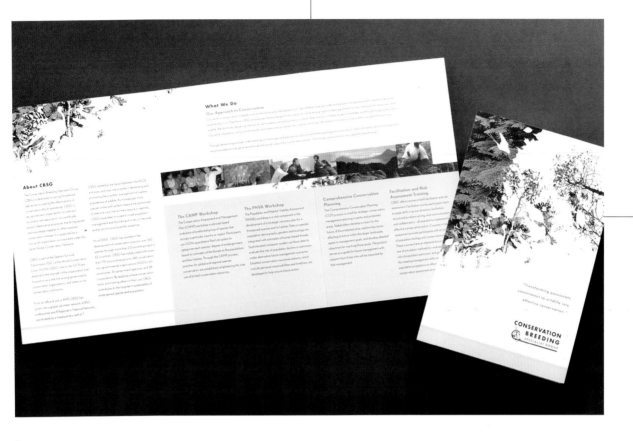

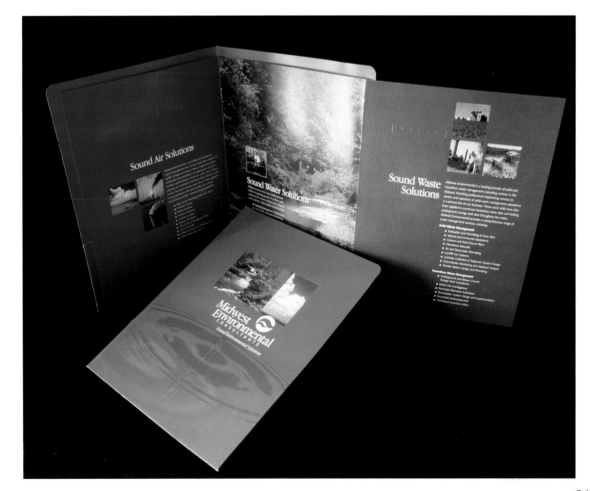

3

4

3

DESIGN FIRM
Evenson Design Group
Culver City, (CA) USA

PROJECT
CBSG Annual and Brochure

ART DIRECTOR
Stan Evenson

DESIGNER
Melanie Usas

4

DESIGN FIRM
Vangel Marketing
Communications
Columbia, (MO) USA

PROJECT
Midwest Environmental
Consultants Brochure

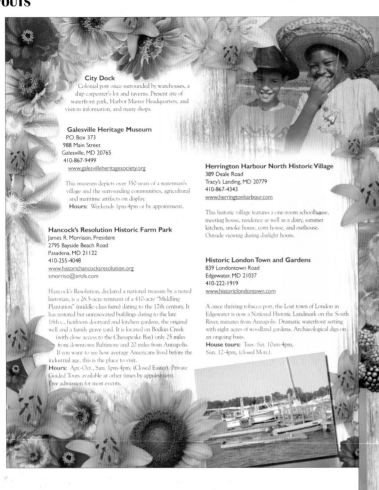

City Dock
Colonial port once surrounded by warehouses, a
ship carpenter's lot and taverns. Present site of
waterfront park, Harbor Master Headquarters, and
visitors information, and many shops.

Galesville Heritage Museum
P.O. Box 373
988 Main Street
Galesville, MD 20765
410-867-9499
www.galesvilleheritagesociety.org

This museum depicts over 350 years of a waterman's
village and the surrounding communities, agricultural
and maritime artifacts on display.
Hours: Weekends 1pm-4pm or by appointment.

Hancock's Resolution Historic Farm Park
James R. Morrison, President
2795 Bayside Beach Road
Pasadena, MD 21122
410-255-4048
www.historichancocksresolution.org
smorriso@erols.com

Hancock's Resolution, declared a national treasure by a noted
historian, is a 26.5-acre remnant of a 410-acre "Middling
Plantation" (middle-class farm) dating to the 17th century. It
has restored but unrenovated buildings dating to the late
18th c., heirloom dooryard and kitchen gardens, the original
well and a family grave yard. It is located on Bodkin Creek
(with close access to the Chesapeake Bay) only 25 miles
from downtown Baltimore and 20 miles from Annapolis.
If you want to see how average Americans lived before the
industrial age, this is the place to visit.
Hours: Apr.-Oct., Sun. 1pm-4pm, (Closed Easter). Private
Guided Tours available at other times by appointment.
Free admission for most events.

Herrington Harbour North Historic Village
389 Deale Road
Tracy's Landing, MD 20779
410-867-4343
www.herringtonharbour.com

This historic village features a one-room schoolhouse,
meeting house, residence as well as a dairy, summer
kitchen, smoke house, corn house, and outhouse.
Outside viewing during daylight hours.

Historic London Town and Gardens
839 Londontown Road
Edgewater, MD 21037
410-222-1919
www.historiclondontown.com

A once thriving tobacco port, the Lost town of London in
Edgewater is now a National Historic Landmark on the South
River, minutes from Annapolis. Dramatic waterfront setting
with eight acres of woodland gardens. Archaeological digs on
an ongoing basis.
House tours: Tues.-Sat. 10am-4pm,
Sun. 12-4pm, (closed Mon.).

Hydromont Berry Farm
Jim and Denise Edelen
8020 Hawthorne Road
La Plata, MD 20646
301-932-0872
www.hydromontberryfarm.com

Enjoy pick-your-own or pre-picked farm fresh strawberries
from three acres of fresh strawberries. Farm products, kids
playgrounds and more. Sunday events for the family.
Hours: May-Mid Jun. 8am-7pm.
Directions: 301 South, right on Route 225
(Hawthorne Road) 3 miles on right.

Linden Farm
Karen Briggs
8530 Mitchell Road
La Plata, MD 20646
301-934-9003
karnbrgs@aol.com

Bed and Breakfast named for the trees that still shade the
house. Linden has been a private residence since its
construction in 1783 and is listed on the National Register of
Historic Places. Horse riding programs for all level students in
hunt-seat, side saddle, stock-seat, driving classes, over fences,
lease program, training and summer camp. At Linden, the
riding program is intended to introduce young people and
adults to the wonderful world of horsemanship.

Serenity Farm Inc.
Frank & Theresa Robinson
6932 Serenity Farm Road
P.O. Box 305, Route 231
Benedict, MD 20612
301-274-3829
Cell: 301-399-1629 or Cell:301-399-1634
Fax: 301-274-9135

Field days, mazes and school tours, Halloween "Kasper's
Castle" for schools, and for public during weekends in October.
Retail/Wholesale: Cattle (hereford), goat (meat),
pig (meat), sheep (meat), jams, jellies, berries
(blackberries, raspberries), field corn, rye, soybeans, hay
(alfalfa-fescue), straw.
Hours: 8am-5pm.
Directions: Seven miles east of Hughesville on north side
of Route 231, Serenity Farm Road.

Oak Hill Farm and Stables
Elmer Curry or Jackie Lynch
3805 Hance Road
Port Republic, MD 20676
410-586-0679

Horse boarding, horseback riding, horse-training lessons.
Retail/Wholesale: Horses (Arabian, thorough bred,
standard-bred), hay (orchard grass mix), beans (snap, lima),
cabbage, cucumbers, eggplant, greens (collards, kale,
mustard, turnip), onions, potatoes (redskin, white),
summer squash, turnips.
Hours: By appointment only.
Directions: Route 4 South to Route 264 (Broomes Island
Road), right on Hance Road, left at fork, watch for Oak Hill
Stables sign on right, turn right to big red barn.

Poplars Farm
Carolyn and Howard Anderson
7141 Old Bayside Road
Chesapeake Beach, MD 20732
410-257-0173, Fax: 301-855-0927

Products: Bass (large mouth), bluegill, catfish
(hybrid striped), pond stocked.
Hours: Please call for reservation.
Directions: Route 260 to Route 261,
right on Old Bayside Road, 1 mile to pond on left.

River View Farm
Donald T. Gott
8515 Mackall Road
St. Leonard, MD 20685
410-586-1240

Field days, open house days.
Products: Cattle (beef), field corn, oats, wheat, hay
(alfalfa), straw.
Hours: Mon.-Sat. 7am-7pm.
Directions: Right on Route 264, 5 miles,
left on Route 265, farm on right.

Stillwater Farm - Pony Express
1600 Emmanuel Church Road
Huntingtown, MD 20639
410-535-1989

Full service party provider. Horses, ponies (for sale),
horse boarding (full or pasture), livestock hauling, pony
parties, moon bounces, company picnics, petting farm,
various inflatables.
Hours: Please call.
Directions: Route 2/4 South, East 2.5 miles on
Plum Point Road, South .75 mile on Emmanuel
Church Road, farm on right.

1_____

WHY CHOOSE **SAINT ROSE?**

REMARKABLE OUTCOMES

Our students are prepared for advanced graduate study in prestigious doctoral programs and medical and law schools. Recent graduates have attended Harvard, Dartmouth and Yale. Other students dive into careers immediately upon graduation. Graduates have landed jobs at Fortune 500 companies, New York City advertising agencies, national television networks and entertainment companies, as well as with federal and state agencies.

ACADEMICS

Our 55 undergraduate majors are all grounded in a comprehensive liberal education curriculum. This ensures that you will be able to tailor a course of study that meets both your personal interests and your career goals.

FACULTY

Saint Rose professors are committed to student-centered teaching, scholarship, research involving undergraduates, and the encouragement of creative endeavors. Our professors do more than teach, they are mentors in your academic, career, and personal growth.

VALUES-BASED EDUCATION

The driving force of the College is our founding values that foster a diverse, caring community and empower faculty, staff, and students to make a difference in the world.

LOCATION

More than 1,100 students live on our campus located in the Pine

TAKE A ROAD TRIP AND VISIT US. WWW.STROSE.EDU/VISITS

Examine new ideas, express yourself,

exceed expectations.

The College of Saint Rose

1 _____
DESIGN FIRM
Rottman Creative Group
Laplata, (MD) USA
PROJECT
TCC
DESIGNERS
Gary Rottman,
Robbie Whetzel

2 _____
DESIGN FIRM
The College of Saint Rose
Albany, (NY) USA
PROJECT
Exceed Expectations Brochure
ART DIRECTOR
Mark Hamilton
DESIGNER
Chris Parody
COPYWRITER
Lisa Haley Thomson
PHOTOGRAPHERS
Paul Castle Photography,
Gary Gold Photography
PRINTER
Brodock Press, Inc.

SUBSTANCE 151 IS A MULTIDISCIPLINARY DESIGN FIRM THAT HELPS ORGANIZATIONS
FULFILL THEIR MISSION BY BREAKING THROUGH THE MARKETPLACE CLUTTER AND
DISTINGUISHING THEMSELVES — STRATEGICALLY AND VISUALLY.

HOW WE DO IT...

1_____

SUBSTANCE 151 IS A MULTIDISCIPLINARY STRATEGIC DESIGN FIRM SPECIALIZING IN
DEVELOPING INNOVATIVE BUSINESS COMMUNICATIONS TOOLS ACROSS PRINT, WEB
AND INTERACTIVE MEDIA.

BESIDES ADDRESSING THE IMMEDIATE NEEDS OF OUR CLIENTS, WE CONTINUE TO SHARE OUR
KNOWLEDGE AND EXPERTISE THROUGH TEACHING, LECTURING, COMMITTEE AND JURY WORK,
SETTING THE STANDARDS OF EXCELLENCE FOR THE GRAPHIC DESIGN DISCIPLINE.

1_____

DESIGN FIRM
substance151
Baltimore, (MD) USA

PROJECT
substance151 Promotional
Brochure

DESIGNERS
Ida Cheinman,
Rick Salzman

2_____

DESIGN FIRM
Riordon Design
Oakville, (Ontario) Canada

CLIENT
Adriana Toncic Interiors

ART DIRECTOR, DESIGNER
Alan Krpan

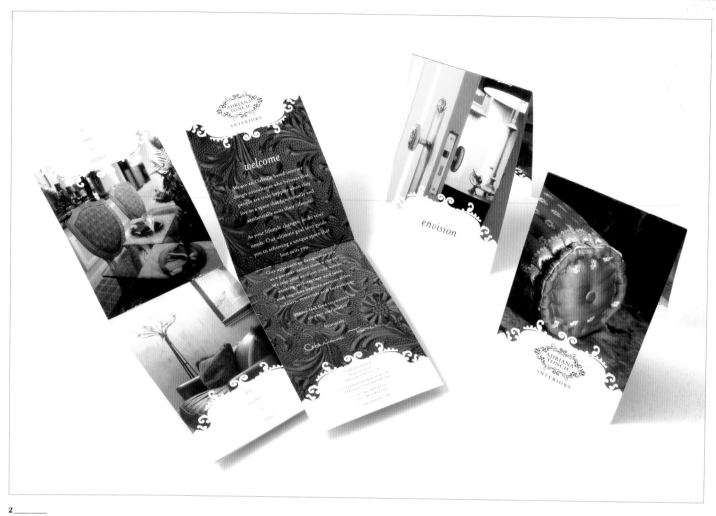

2_____

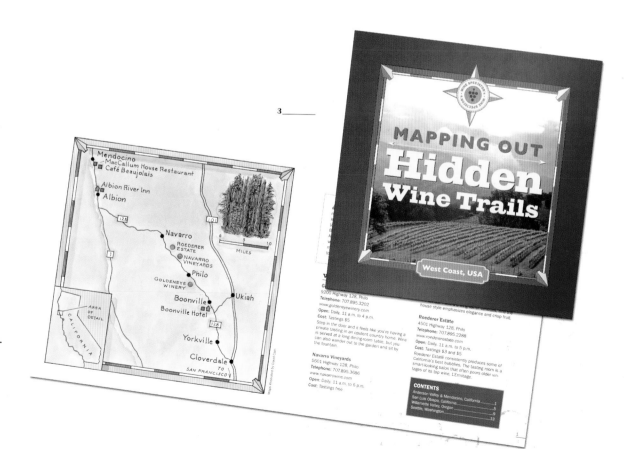

3_____

3_____

DESIGN FIRM
M. Shanken
Communications, Inc.
New York, (NY) USA

PROJECT
Wine Spectator
Promotional

ART DIRECTOR
Chandra Hira

DESIGNER
Cheryl McGovern

ILLUSTRATOR
David Caine

ClarityCap Mixers Road Lily Industrial Estate
Wrexham North Wales United Kingdom LL12 0PJ

Telephone 44 (0)1978 853805 Facsimile 44 (0)1978 653795
Email sales@claritycap.co.uk Web www.claritycap.co.uk

List

PX

The PX range has been designed to provide characteristics midway between our PW and SA capacitors.

Constructed from a 250Vdc(6µm) rated film, this component is spindle wound. It is then given a special heat treatment before it has insulated copper terminals hand soldered to give the best possible connection.

The inherently low dissipation and dielectric absorption factors of polypropylene allied with an excellent mechanical stability results in an extremely detailed sonic performance.

The construction also results in a low self-inductance and ESR (Equivalent Series Resistance) and the devices are highly stable with regard to temperature and frequency.

Tape and resin colours are flexible with options shown on page 14 Unless specified, capacitors won supplied with blue tape and blue

08 / 09

DT

12 / 13

DESIGN FIRM
Imagine
Manchester, England

PROJECT
Exept ClarityCap Brochure

ART DIRECTOR
Tony Wynn

DESIGNER
David Caunce

fference

yCap

nnical details

ance range	See table
ce	±5% standard. Others by request
sion factor	< 0.001 @ 1KHz & 20 ±3°C
sion resistance	≥ 10⁵MΩ·μF(C>330nF); ≥ 3 x 10⁵MΩ (C< 330nF) @ rated voltage & 20 ±3°C
voltage	250Vdc
ic absorption	< 0.1% @ 20 ±3°C
ture range	-55 to +100°C
mental category	55/100/56 to EN 60068 - 1 (IEC 68 - 1)
oltage test	1.5 x rated voltage for 30s. Not to be repeated
n	EN 60068 - 2 - 6 (IEC 68 - 2 - 6) Test Fc 100 to 500 Hz 0.75mm or 98m/s² EN 60068 - 2 - 29 (IEC 68 - 2 - 29) Test Eb 400m/s²: 1000 x 10 bumps

Size chart

CAP(μF)	L	W	T
0.15	20	10	5
0.22	20	11	6
0.33	20	12.5	8
0.47	20	15	10
0.68	20	17	12.5
1.0	30	16	11.5
1.5	30	19	14
2.2	30	22	17.5
3.3	30	26.5	22
4.7	34	27	22.5
6.8	34	32	27
10.0	47	31	26
15.0	47	37	32
22.0	47	44	39
33.0	60	46	41
47	80	54	49

Please note that intermediate capacitance values are available. Contact our sales department for details.

Ordering details

PX 10μ J 250Vdc

Cap Value Tolerance Rated Voltage dc

μF for C≥ 1μF J = 5%
nF for C < 1μF

Outline dimensions (maximum) in mm

Terminations are PVC covered copper wire, length is a minimum of 40mm.
Conductor diameter (ø) is 1mm, sleeved diameter is 2.5mm.

DTAC data

Ohmic Resistance (non-dielectric)
Comparison with standard SA with 5µ metal thickness

The DTAC range is the latest high performance addition to our range. It has been designed to produce the lowest possible resistance within the component, which we believe has a direct relationship to sonic performance.

A narrow 10µm(630Vdc) polypropylene film with a special spray and heat treatment contribute to the exceptional performance of this capacitor. These measures combined with hand soldered M8 male or female terminations ensure that the ESR is greatly improved when compared to the traditional axial leaded components.

The low ESR is particularly relevant in high quality crossover networks, ensuring that loudspeakers perform to their optimum.

Tape and resin colours are flexible with options shown on page 14. Unless specified, capacitors would be supplied with gold tape and black resin.

Technical details

Capacitance range	See table
Tolerance	±5%
Dissipation factor	< 0.001 @ 1KHz & 20 ±3°C
Insulation resistance	≥ 10⁵MΩ·μF @ rated voltage & 20 ±3°C
Rated voltage	630Vdc
Dielectric absorption	< 0.1% @ 20 ±3°C
Temperature range	-55 to +100°C
Environmental category	55/100/56 to EN 60068 - 1 (IEC 68 - 1)
Proof voltage test	1.5 x rated voltage for 30s. Not to be repeated
RMS current rating	Please contact us for information.

Size chart

CAP(μF)	Typ dia (mm)	Min dia (mm)	Max dia (mm)
2.0	38	36	42
3.0	45	43	50
4.0	53	50	57
5.0	59	56	64
6.0	64	60	70
7.0	69	65	75
8.0	73	69	80
9.0	78	73	85
10.0	82	77	90
11.0	86	81	94
12.0	89	85	99
13.0	93	88	102
14.0	97	91	106
15.0	100	95	110
16.0	103	98	113
17.0	106	101	117
18.0	109	103	120
19.0	112	106	123
20.0	115	109	127
21.0	118	112	129
22.0	121	114	133

Ordering details

Please use the full part number, as example shown here.
DTAC 22µ J 630Vdc

Outline dimensions (maximum) in mm

M8 x 1.25

Please note that intermediate capacitance values are available. Contact our sales department for details.

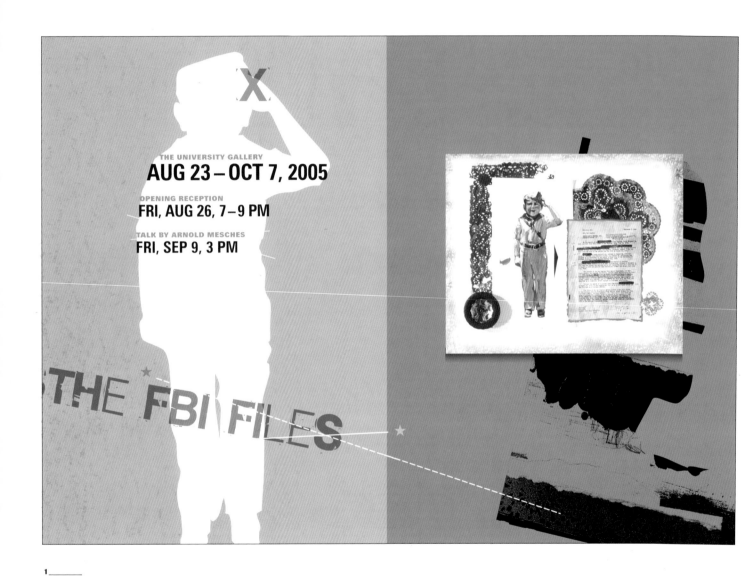

THE UNIVERSITY GALLERY
AUG 23 – OCT 7, 2005

OPENING RECEPTION
FRI, AUG 26, 7 – 9 PM

TALK BY ARNOLD MESCHES
FRI, SEP 9, 3 PM

THE FBI FILES

1_____

1_____
DESIGN FIRM
Connie Hwang Design
Gainesville, (FL) USA
PROJECT
The FBI Files
Exhibition brochure
DESIGNER
Connie Hwang
COPYWRITER
Amy Vigilante

2_____
DESIGN FIRM
University of Maryland Cooperative Extension—
FSNE
Columbia, (MD) USA
CLIENT
The University of Maryland Cooperative Extension—
Food Stamp Nutrition Education
Program
DESIGNERS
Trang Dam, Meredith Pearson, Lisa Lachenmayr

Food Stamp Nutrition
Education Youth Programs

Healthy Food, Fitness and Fun!

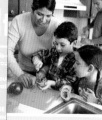

Heal

Cooking healthy foods
(FSNE) can help the you

FSNE is available thro
activity. Food prepara
FSNE youth program.

But that's not all! FSNE
emphasis is on fun, an

Cooking
healthy
foods

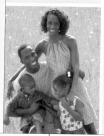

Choosing
low fat
snacks

Becoming
more
active

Here is what some participating collaborators have said about the impact of FSNE programs in their organizations.

"Our students are more willing to try a variety of new foods. They brag about trying foods they had never seen before. It has become an esteem booster!"

"After learning about the food pyramid, children often ask me to help them read the fat content on their milk cartons at lunch and on items they bring for snack."

"A parent of a child in the Color Me Healthy program told me her daughter was going to the grocery store and helping her pick out vegetables and fruits. She said the child told her that she needed to eat all the different colors if she wanted to be healthy."

Contact Information

FSNE educators are available to implement programs in your youth organization. An alternative approach is for educators to "train-the-trainer" to enable your staff to deliver nutrition education programming.

Contact your local Maryland Cooperative Extension office for more information regarding how this innovative program can help your organization's learners develop new skills in healthy eating and physical activity.

Healthy Food, Fitness and Fun!

Cooking healthy foods–choosing low fat snacks–becoming more active–these are some of the skills the Food Stamp Nutrition Education program (FSNE) can help the youth in your organization develop.

FSNE is available throughout the state of Maryland. FSNE provides programs for limited-resource youth that promote healthy eating and physical activity. Food preparation, making healthier choices when eating away from home, and finding ways to be more physically active are all part of the FSNE youth program.

But that's not all! FSNE brings programs to wherever youth are—school classrooms, after-school programs, summer day camps and preschools. The emphasis is on fun, and there is no charge!

Here is what some participating collaborators have said about the impact of FSNE programs in their organizations.

"Our students are more willing to try a variety of new foods. They brag about trying foods they had never seen before. It has become an esteem booster!"

"After learning about the food pyramid, children often ask me to help them read the fat content on their milk cartons at lunch and on items they bring for snack."

"A parent of a child in the Color Me Healthy program told me her daughter was going to the grocery store and helping her pick out vegetables and fruits. She said the child told her that she needed to eat all the different colors if she wanted to be healthy."

Contact Information

FSNE educators are available to implement programs in your youth organization. An alternative approach is for educators to "train-the-trainer" to enable your staff to deliver nutrition education programming.

Contact your local Maryland Cooperative Extension office for more information regarding how this innovative program can help your organization's learners develop new skills in healthy eating and physical activity.

Want your students to eat more fruits and vegetables?

The Color Me Healthy (preschool curriculum) is designed to be integrated into the day's schedule, providing lessons, stories and activities that encourage children to try new fruits and vegetables. Color is key—a sign that there are nutrients in those oranges, bananas, peas and carrots. The leader's guide includes 14 lessons and parent newsletters to help parents reinforce the nutrition and activity messages children are learning in the classroom. FSNE educators will provide curriculum materials and train teachers to implement **Color Me Healthy** in their classrooms.

Wish your students knew more about cooking?

The Pyramid of Snacks curriculum will put kids ages 9-12 in the kitchen, preparing simple, healthy and delicious foods. Experiential learning activities will encourage them to make healthy food choices through games, science experiments and stories. The curriculum is designed to allow flexibility in planning and delivering programs in a variety of settings.

Cooking with Kids is a multicultural nutrition education curriculum that provides hands-on learning activities about culturally diverse foods that are healthy and appealing to children. Activities can be integrated into math, science, social studies, language arts, music and art. This program includes tasting classes and food preparation sessions appropriate for grades K-6.

Do your students get enough physical activity?

JumpSmart is an after-school program that will help students jump into fitness! By forming jump rope clubs, youth develop jump rope skills and create routines to their favorite music. FSNE educators will organize trainings for after-school program staff to become jump rope coaches and to help youth choose healthy foods. FSNE provides all materials including jump ropes, music, videos and leaders' guides at no charge.

Want your students to make healthier choices when eating out?

The Power of Choice curriculum is designed to empower young teens to develop a healthy lifestyle. They will develop skills in reading food labels, making low fat food choices at restaurants, and preparing meals and snacks safely. Activities can be integrated into a variety of settings—in classrooms, after-school programs and day camps.

PRESCRIPTION PRODUCTS

Feinstein Kean Healthcare for Novartis alerted readers about the benefits of EXELON for mild to moderate Alzheimer's disease. A toll-free number and Web site were offered for an "ID.A.D. Resource Kit," containing educational materials such as a video, a memory questionnaire and informational brochures specifically for caregivers.

Health Bulletin

Dorland Sweeney Jones for Merck created an awareness of its physician-respected Web site with credible, independent health information that could help readers to enhance their doctor visits.

Health Bulletin
Burning Questions About Digestive Health

Dorland Sweeney Jones for Eisai, Inc and Janssen Pharmaceutica used a Q&A format to create an awareness of ACIPHEX for GERD, heartburn and acid reflux disease.

HEALTH PR

Techniques of Great PR Teams

DESIGN FIRM
Adventium
New York, (NY) USA
PROJECT
Health PR Brochure
DESIGNER
Penny Chuang

Women's Basketball Star Edna Campbell Inspires Free Electronic Greeting Card For Breast Cancer Patients

Ogilvy for Ortho Biotech Products, marketer of PROCRIT, offered free electronic greeting cards for cancer patients. This innovative campaign demonstrated the company's ongoing commitment to cancer patients and their caregivers. Readers were directed to a Web site for prescribing information and additional information on PROCRIT and anemia.

Children's Health

MCS for MedPointe Pharmaceuticals targeted parents with news of how allergies may affect concentration in the classroom and how OPTIVAR, a prescription eyedrop, can help. Compelling statistics from the NIH on missed school days per year and the negative impact that lost time can have on a child's ability to learn were offered. Parents were encouraged to see an allergist or ophthalmologist for an accurate diagnosis and treatment if their child suffers from nasal allergies.

HEALTH MATTERS

Survey Shows Americans Are Not Taking Heart Disease Risk To Heart

Edelman for Pfizer created an awareness, in English and Spanish, of the Web site for "The Pfizer Journal" by revealing the results of a survey about heart disease.

GOVERNMENT

Ogilvy for Centers for Disease Control (CDC) advised parents about what to do for colds and flu and warned of the risk of antibiotic resistance.

Sniffle Or Sneeze? No Antibiotics Please
CDC Advises Parents About Colds, Flu and Antibiotics

Pointers For Parents
Tips To Help Your Child Become a Strong Reader

Widmeyer for the National Institute for Literacy and the National Institute of Child Health offered tips to help parents help their children to read better. Readers were directed to an informative Web site for more information about the Partnership for Reading program.

SAFETY SENSE
Fire Safety Tips For Your Home

Protecting the Children
Fire-Safe Kids

Hager Sharp for the U.S. Fire Administration, an entity of the Federal Emergency Management Agency (FEMA), offered tips to help reduce fire hazards.

Holiday Hints
Small Steps To Healthier Holidays

Hager Sharp for the NIH for National Diabetes Education Program offered healthy eating tips to diet-conscious people, especially those with type 2 diabetes, designed to enhance holiday party experiences.

Learn what you can do to make the most of your vision.
What you should know about low vision.

The NIH for National Eye Institute offered a free booklet about low vision.

1-877-LOW VISION
(1-877-569-6474)

If you're a businesswoman, and you don't think golf is important to your success . . .

THINK AGAIN!

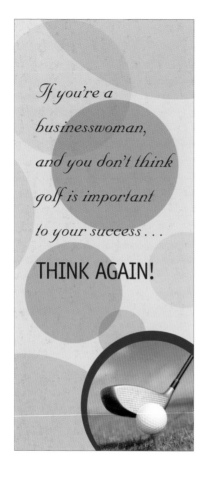

Myths & Realities

Why don't women take advantage of the opportunity golf affords? Because women embrace certain golf myths as realities.

MYTH: To play in a golf business outing, you have to be a good golfer.

FACT: You need minimal golf skills. Mostly, you need to understand golf etiquette, and a few basic rules.

MYTH: Men who play in business outings are good golfers.

FACT: Most people, regardless of gender, are average golfers at best.

MYTH: You have to commit significant time to reach a skill level to play golf for business purposes.

FACT: You need a basic understanding of three things to play golf: 1) Safety on the course 2) How to maintain pace of play throughout a round and 3) Basic golf etiquette. These take hours, not months or years, to learn.

Discover what men have known for years: the powerful

BUSINESS BENEFITS
of golf.

- Develop stronger business relationships.

- Use golf outings as a business tool.

- Build confidence.

- Overcome fear of embarrassment on the golf course.

- Gain an activity for a lifetime.

- Have fun!

Myths & Realities

Why don't women take advantage of the opportunity golf affords? Because women embrace certain golf myths as realities.

MYTH: To play in a golf business outing, you have to be a good golfer.

FACT: You need minimal golf skills. Mostly, you need to understand golf etiquette, and a few basic rules.

MYTH: Men who play in business outings are good golfers.

FACT: Most people, regardless of gender, are average golfers at best.

MYTH: You have to commit significant time to reach a skill level to play golf for business purposes.

FACT: You need a basic understanding of three things to play golf: 1) Safety on the course 2) How to maintain pace of play throughout a round and 3) Basic golf etiquette. These take hours, not months or years, to learn.

Introducing GolfingWomen

Helping women develop the tools they need to use golf for business.

"A Simple Course to Success" — A 4-week, 4-session workshop that combines classroom learning— golf terminology, etiquette and the "must knows" when you entertain clients on the golf course—with practical, on-course instruction.

One-on-one private coaching — Prefer a more private, personalized approach? We'll tailor "A Simple Course to Success" to meet your particular needs.

"Tee Off Tomorrow" — A 1-week, 8-hour intensified cram session to help you quickly get ready to participate in a golf outing or take a client out on the course.

Individual or group golf instruction — The fastest way to sharpen your golf skills, from novice to advanced.

To learn more or to register for upcoming programs, call toll free

1-866-689-8201
www.golfingwomen.com

1

WESPaC Student
Manage Success.

2_____

WESPaC Finance
Manage Success.

1_____
DESIGN FIRM
Adventium
New York, (NY) USA
PROJECT
Golfing Women Brochure
DESIGNER
Penny Chuang

2_____
DESIGN FIRM
Eben Design
Seattle, (WA) USA
CLIENT
WSIPC
(Washington School
Information Processing Cooperative)
ART DIRECTOR
Dan Meehan
DESIGNER
Matthew Grimes
COPYWRITER
Marty Krouse

1_____

2_____

1_____
DESIGN FIRM
Group 55 Marketing
Detroit, (MI) USA
PROJECT
All Seasons Brochure
ART DIRECTOR, DESIGNER
Jeannette Gutierrez
COPYWRITERS
Catherine Lapico, Jeannette Gutierrez
PHOTOGRAPHER
Jerry Beznos

2_____
DESIGN FIRM
Eben Design
Seattle, (WA) USA
CLIENT
Kings-Men Construction
ART DIRECTOR
Dan Meehan
DESIGNER
Matthew Grimes
COPYWRITER
Marty Krouse
PHOTOGRAPHER
Jim Garner

Aviation and tourism generate jobs, create business activity and help drive the regeneration of economies. Planning for the future can be challenging as well as exciting.

3_____

4_____

3_____
DESIGN FIRM
Imagine
Manchester, England
PROJECT
Feather Consulting Brochure
ART DIRECTOR, DESIGNER
David Caunce

4_____
DESIGN FIRM
Dezainwerkz Pte Ltd
Singapore
CLIENT
Air Division
CREATIVE DIRECTOR
Dezainwerkz
ART DIRECTOR
Xavier Sanjiman
PHOTOGRAPHER
Simon Low

imagination is more important than knowledge _Albert Einstein_

and the **ideas can come from anywhere.**

we want to inspire the free thinker, stimulate constructive debate

and **fire the imagination.**

that's how we do things around here.

1 _____

standing still is the fastest way of moving backwards in a rapidly changing world

all things to all people

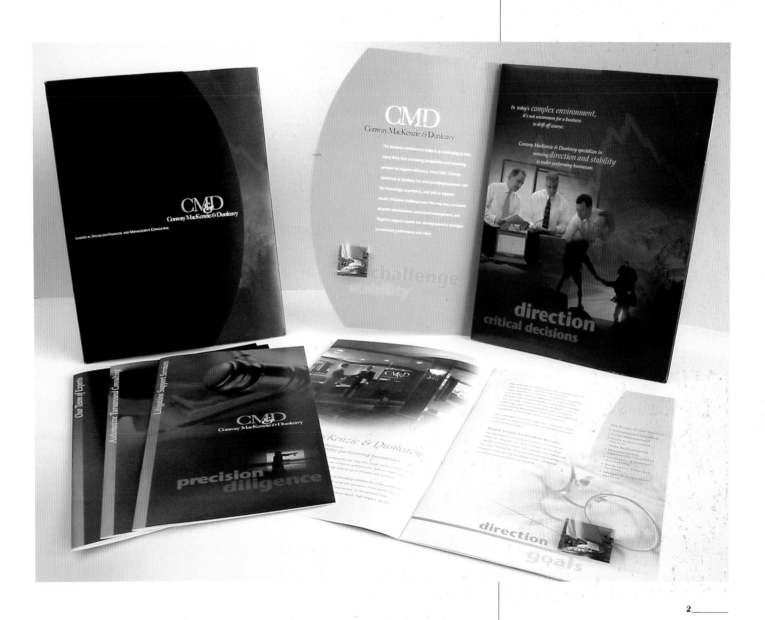

1_____
DESIGN FIRM
Jo Mew Creative
London, England
DESIGNER
Jo Mew

2_____
DESIGN FIRM
Group 55 Marketing
Detroit, (MI) USA
PROJECT
Conway Mackenzie and
Dunleavy Brochure
ART DIRECTOR, DESIGNER
Jeannette Gutierrez
COPYWRITER
David Stewart
PHOTOGRAPHER
Richard Hirneisen

1_____

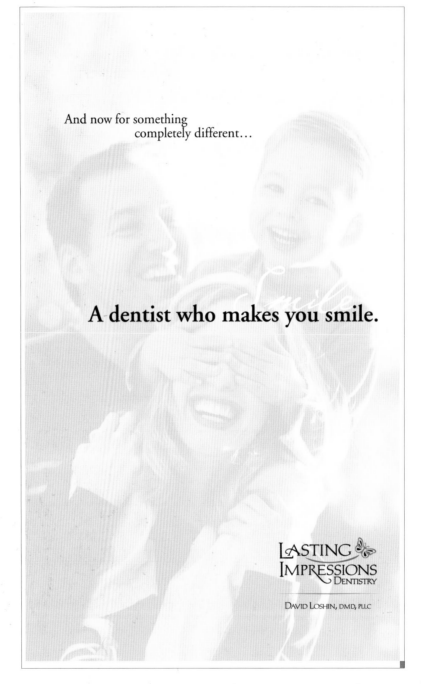

1_____
DESIGN FIRM
Eben Design
Seattle, (WA) USA
CLIENT
Lasting Impressions Dentistry
ART DIRECTOR
Dan Meehan
DESIGNER
Masako Takeda
COPYWRITER
Marty Krouse

2_____
DESIGN FIRM
Liska + Associates
Chicago, (IL) USA
PROJECT
Attorney Street Brochure
ART DIRECTOR
Tanya Quick
DESIGNERS
Danielle Akstein Bear, Tanya Quick
PHOTOGRAPHER
Josh Levine

2

Zoo History

Lincoln Park Zoo is everyone's zoo. Formed in 1868, it is the oldest zoological garden in the country, yet it is also among the most modern – a leader in wildlife conservation and educational outreach. Each year the zoo welcomes 3 million visitors, providing them with remarkable learning experiences, as well as a peaceful park setting.

Since 1995 Lincoln Park Zoo has operated as a private institution with a limited subsidy from the Chicago Park District. With this privatized status, the zoo has refined its approach to operations and the achievement of its mission. The education programs are innovative and effective, reaching increased numbers of visitors; research programs shape operations and animal management issues at zoos across the country and around the world; conservation efforts rank among the top 10 zoos in the country; and the beautiful grounds are in the heart of one of the city's most bustling and vibrant neighborhoods.

res
cons
objectiv
wildlife amb
native environmen
This central philoso
the auspices of *My*
Park Zoo, with the
ber of zoo facilitie
opened May 2003;
which opened July
Family Children's Z

These renovat
significant success
bandry of the ani
enhanced the zoo

Welcome to the
Conservators' Circle
of Lincoln Park Zoo

DESIGN FIRM
Lincoln Park Zoo
Chicago, (IL) USA
PROJECT
Development Brochure
DESIGNER
Peggy Martin
PHOTOGRAPHERS
Greg Neise,
Grant Kessler

ctions
·its

exotic or domestic,
coln Park Zoo rep-
to accomplish our
on and recreation
more than 1,300
ats that reflect their
's highest priorities.
ar precedence under
ampaign for Lincoln
struction of a num-
can Journey, which
er for African Apes,
ening of the Pritzker

ed the zoo's already
d appropriate hus-
collection and have
perience.

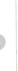

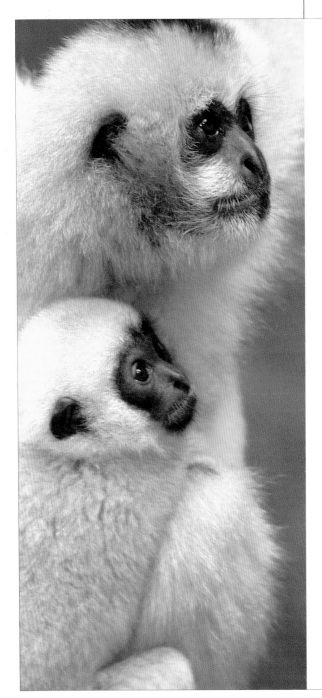

Facts About the Zoo

LINCOLN PARK ZOO IS:

•One of the most visited zoos in the country with an estimated 3 million annual visitors.

•An urban oasis that covers 35 acres in the heart of the city and has more than 1,300 animals in its collection.

•An institution with an operations budget of approximately $19 million.

•One of the oldest zoos in North America, which was created with the gift of two swans in 1868.

•The only American Zoo and Aquarium-accredited, privately managed, free zoo in the nation.

•Home to one of the largest collections of lowland gorillas in the country and one of the most successful captive-breeding programs in the world (more than 47 gorilla births since 1970).

•A world leader in the conservation of endangered species and one of the top 10 zoos in the nation to fund conservation research in the wild.

•Actively involved in more than 35 of the more than 100 Species Survival Plans for threatened and endangered species.

•Host to more than 1.6 million people each year in a variety of education programs on zoo grounds and in the community.

ZOO HOURS

GENERAL (April 1 – Sept. 30): Grounds – 9 a.m. to 6 p.m. Buildings and Farm – 10 a.m. to 5 p.m.; **SUMMER WEEKENDS** (Memorial Day – Labor Day, Saturdays, Sundays and Holidays): Grounds open until 7 p.m., Buildings/Farm open until 6:30 p.m. **WINTER HOURS** (Nov. 1 – March 31): Grounds – 9 a.m. to 5 p.m., Buildings/Farm – 10 a.m. to 4:30 p.m.

DESIGN FIRM
Liska + Associates
Chicago, (IL) USA
PROJECT
56 Pine Brochure
ART DIRECTOR, COPYWRITER
Tanya Quick
DESIGNERS
Tanya Quick,
Fernando Munoz
ILLUSTRATORS
Don Pietache,
Francesco Gianesini
PHOTOGRAPHERS
P. Margonelli, others

56

PINE IN THE MIDDLE OF... Classic and new restaurants: Bayard's · Bridge Cafe · Cabana · Delmonico's · Fraunces Tavern · 14 Wall Street · Il Porto · Les Halles Downtown · Quartino · Rise · Mark Joseph Steakhouse · Steamer's Landing · Stone Street Tavern Vine · Waterstone Grill Over 1,400 retail stores, including: J & R · Century 21 · Borders · J. Crew · Abercrombie & Fitch · The Sharper Image Coach · Gap · Bloomingdale's SoHo Over 100 parks, plazas and open spaces totalling 88 acres of green space: Battery Park · South Street Seaport · Bowling Green City Hall Park Downtown revitalization Wifi Hotspots New York landmarks City Hall · Brooklyn Bridge · American Stock Exchange · Ellis Island Federal Hall · Freedom Tower · Fulton Street Fish Market · NY Stock Exchange · St. Paul's Chapel · Statue of Liberty · Trinity Church · Wall Street · Woolworth Building Water on 3 sides: Ferries · Water Taxis and steps from practically every subway line: A, C, E, N, R, J, M, Z, 1, 2, 3, 4, 5, 6

3 4

...you're out the door. Find more time for yourself and less for your commute when you wake up dowtown.

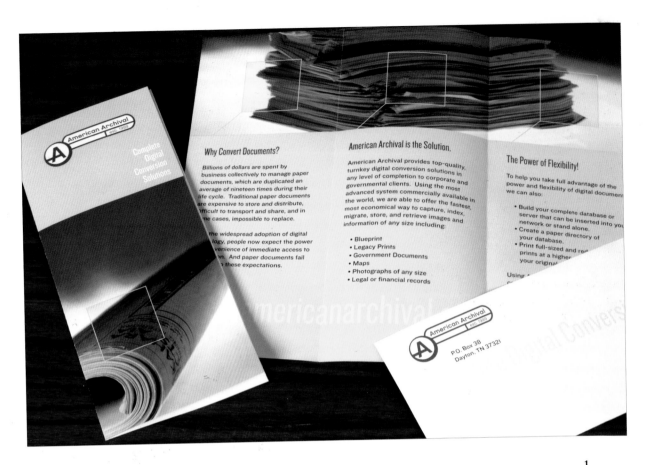

Why Convert Documents?

Billions of dollars are spent by business collectively to manage paper documents, which are duplicated an average of nineteen times during their life cycle. Traditional paper documents are expensive to store and distribute, difficult to transport and share, and in some cases, impossible to replace.

...the widespread adoption of digital ...logy, people now expect the power ...venience of immediate access to ...on. And paper documents fail ...o these expectations.

American Archival is the Solution.

American Archival provides top-quality, turnkey digital conversion solutions in any level of completion to corporate and governmental clients. Using the most advanced system commercially available in the world, we are able to offer the fastest, most economical way to capture, index, migrate, store, and retrieve images and information of any size including:

- Blueprint
- Legacy Prints
- Government Documents
- Maps
- Photographs of any size
- Legal or financial records

The Power of Flexibility!

To help you take full advantage of the power and flexibility of digital documents we can also:

- Build your complete database or server that can be inserted into your network or stand alone.
- Create a paper directory of your database.
- Print full-sized and red prints at a higher your original...

Using...

American Archival
P.O. Box 38
Dayton, TN 37321

1_____

2_____

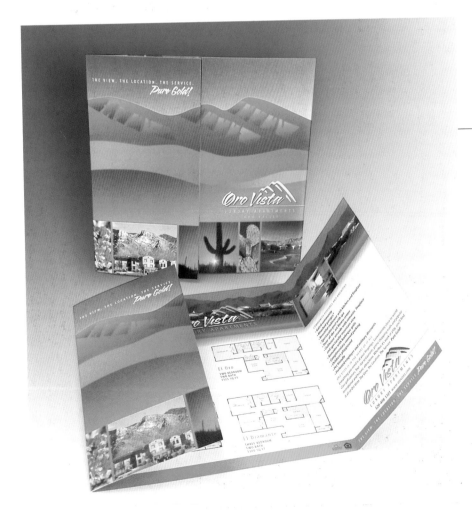

1_____

DESIGN FIRM
maycreate
Chattanooga, (TN) USA

CLIENT
American Archival

CREATIVE DIRECTOR, ART DIRECTOR,
DESIGNER, PHOTOGRAPHER
Brian May

COPYWRITER
Kristina Kollar

PRINTER
Creative Printing

2_____

DESIGN FIRM
Group 55 Marketing
Detroit, (MI) USA

PROJECT
Oro Vista Brochure

ART DIRECTOR, DESIGNER
Jeannette Gutierrez

COPYWRITER
Catherine Lapico

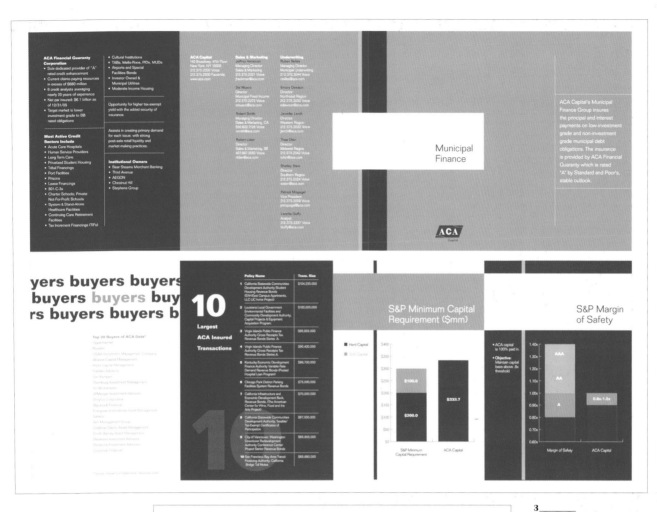

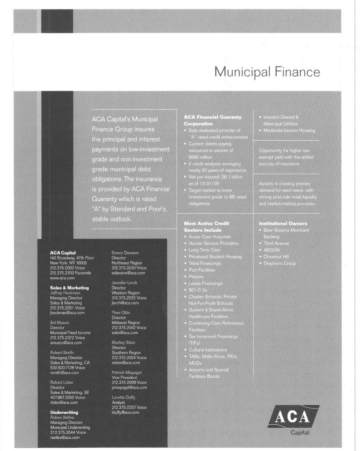

DESIGN FIRM
**Rizco Design &
Communications**
Manasquan, (NJ) USA
PROJECT
ACA Capital Brochure
ART DIRECTOR, DESIGNER
Keith Rizzi

1_____

2_____

3_____

1_____
DESIGN FIRM
Liska + Associates
Chicago, (IL) USA
PROJECT
High Line Brochure
ART DIRECTOR
Tanya Quick
DESIGNER
Meghan Eplett
ILLUSTRATOR
Linda Roy

2_____
DESIGN FIRM
Mayhem Studios
Los Angeles, (CA) USA
PROJECT
Mayhem Studios
Brochure
DESIGNER
Calvin Lee

3_____
DESIGN FIRM
Lebensart Media,
Berlin
Berlin, Germany
CLIENT
Club of Clubs, Munich
ART DIRECTOR
Michael Schickinger
ILLUSTRATOR
Barbara Spoettel

The scientific research is clear, adverse reactions to common foods, known as hidden food allergies, prevent efficient fat burning. In a study from Baylor Medical College 98% of the subjects following an eating plan avoiding their own trigger food, as determined by the **Alcat test**, decreased scale weight and/or improved body composition (muscle to fat ratio). They also experienced improvement in skin, more energy, elimination of migraines, reduced sugar cravings, better mood and sleep, and other benefits.

"The Alcat test...will change the future of medicine."
William G. Crook, author, The Yeast Connection, and many other books.

The **Alcat test** is the **only** proven laboratory method for finding out which foods are causing weight gain, water retention, skin problems, fatigue, arthritis, and various other problems.

WHY WEIGHT?

It is scientifically validated, has been awarded three US patents, and is performed under careful control by only one U.S. Government certified laboratory. The health benefits help ensure that you'll meet your weight goals safely, with less effort than you ever imagined possible, without the feeling of deprivation.

Physicians and scientists now know that caloric restriction alone is not enough. The body is genetically programmed to lower metabolism and conserve energy stores during times of perceived famine. In contrast, the **Alcat test** produces the required improvement to metabolic function necessary for healthy and effective weight loss...fat is burned, energy increases, muscle mass is maintained or even increased...all without caloric restriction!

For more information

on the Alcat Test

please ask your

healthcare professional

The Alcat Test® is a simple, effective blood test that will determine which foods and chemicals YOU need to avoid.

The Alcat test has been proven successful in helping overcome

- Stomach Disorders
- Fatigue
- Migraines
- Asthma
- Skin Disorders
- Aching Joints
- Hyperactivity/ADD
- Obesity
- *And much more...*

The **Alcat test** eating plan is compatible with any other diet program. Many weight loss experts already realize this and have been relying on the **Alcat test** for years.

"For eight years I have used the Alcat test in my practice. No other test is as accurate or useful."
Fred Pescatore, M.D., former associate Medical Dir., The Atkins Center

"I've seen the (ALCAT) technique work when absolutely no other approach has made the scale budge."
Steven Lamm, M.D., author, Thinner at Last

"I have been tested and have been following the rotation diet sent to me for about two weeks. After only three days, the residual inflammation in my hands disappeared. I discontinued my arthritis medication, and the pain free condition continues. What a great relief that is! To say I am impressed would be totally inadequate"
Kathryn P. Noble, M.D., Columbus, OH

"My clients have certainly seen results with your Alcat test. You may not realize how you have improved the quality of life for many people by making this test available."
Registered Dietitian from Massachusetts

The following results were obtained in a study of subjects experiencing food intolerance related health problems (n=353)		
Condition of Subjects	Migraine/headache	95%
	Irritable Colon	87%
	Eczema	94%
	Perennial Rhinitis	95%
	Arthritis	85%
	Asthma	96%
		Experienced Improvement

"I have been using the Alcat test consistently for weight loss, chronic fatigue, depression, arthritis, candidiasis and a host of other diseases and find it an invaluable tool."
Dr. John P. Salerno, formerly of The Atkins Center, Medical Director Salerno Center Rockefeller Center in New York, Medical Consultant Josai Clinic, Tokyo, Japan, Medical Director, Cell Science Systems, Ltd.

"...within just four weeks of taking the test and following the food plan, I lost 5 kilograms (11lbs.), my stuffy nose and throat problem has completely cleared up and I now have tremendously more strength during training."
Christian Mayer, World Champion Skier

"After the Alcat test I have probably 5% more strength and where I would take a rest after workouts in the afternoon I can carry straight through the day with no need or desire to stop for a break. To think that a mundane and harmless food like black pepper could be causing my problems is incredible...but it works! I recommend it to anyone looking for that edge on the competition and for health generally."
Dave Gauder - "Big Dave"
"The strongest man that ever lived"* Holder of 22 Guinness World Strength Records.
*Quote from Strength Athlete magazine.

Each Year Millions of People Start Diets That Don't Work: WHY?

Dieting is frustrating and almost never brings long lasting results...

But fortunately, **there is** an answer.

The answer is finding an eating plan that's right for your own unique biochemistry.

ALCAT
WORLDWIDE

Don't even think about starting a diet without reading this book!

REVISED

Your Hidden Food Allergies Are Making You Fat

How to Lose Weight and Gain Years of Vitality

Rudy Rivera, M.D., and Roger Davis Deutsch

Foods as common as corn, tomatoes, and lettuce may cause cravings that make you overeat. Now a simple test can identify your personal "trigger" foods.

1

1

DESIGN FIRM
Shelly Prisella Graphic Design
Lauderdale-By-The-Sea, (FL) USA

PROJECT
Alcat Worldwide Brochure

DESIGNER
Shelly Prisella

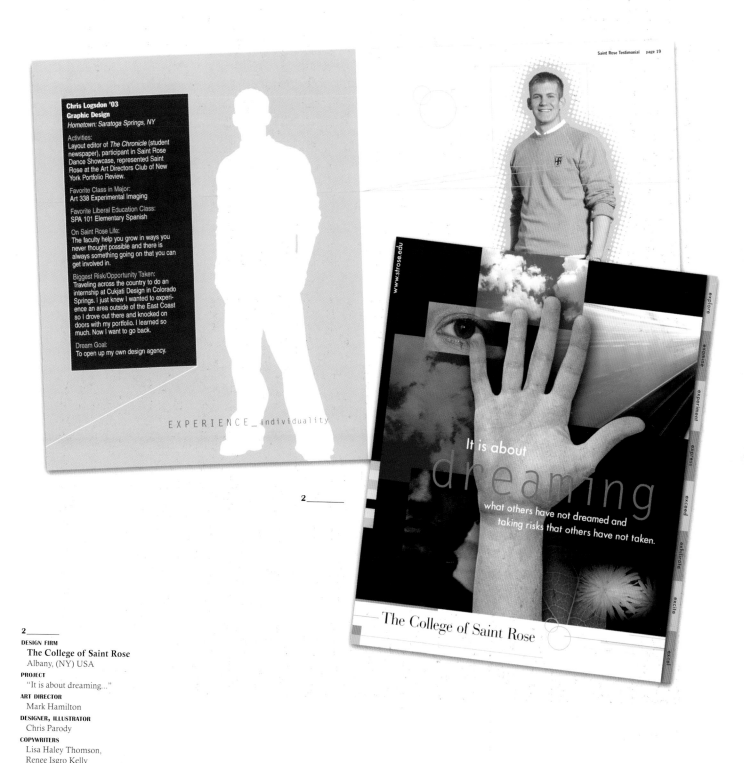

2_____

2_____

DESIGN FIRM
The College of Saint Rose
Albany, (NY) USA
PROJECT
"It is about dreaming..."
ART DIRECTOR
Mark Hamilton
DESIGNER, ILLUSTRATOR
Chris Parody
COPYWRITERS
Lisa Haley Thomson,
Renee Isgro Kelly
PHOTOGRAPHERS
Paul Castle Photography,
Gary Gold Photography
PRINTER
Brodock Press, Inc.

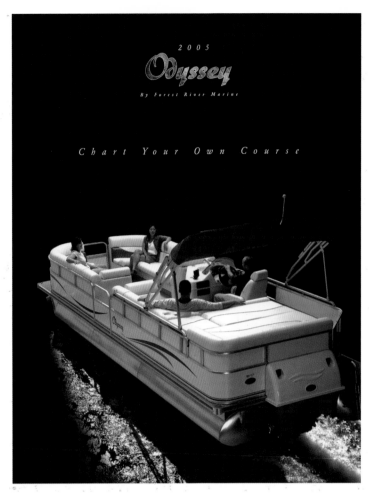

1_____

At Odyssey Boats, we believe it's not just about the boat. It's about where that boat takes you, how it flows beneath your dreams, your goals, your life. How it takes each moment and

turns it into something memorable. When you're on an Odyssey pontoon boat, you're not simply cruising on the water. You're on an adventure. Let your dreams chart your course.

1

DESIGN FIRM
Studio D and
Lassiter Advertising
Fort Wayne, (IN) USA

PROJECT
Odyssey Brochure

CREATIVE DIRECTOR
Michael Earl

ART DIRECTORS
Holly Decker,
Jeremy Culp

PHOTOGRAPHER
Jeff Belli

2

DESIGN FIRM
Velocity Design Works
Winnipeg, (Manitoba) Canada

PROJECT
Velocity Design Works ID

CREATIVE DIRECTOR, ART DIRECTOR, DESIGNER
Lasha Orzechowski

3

DESIGN FIRM
**The Eden Communications
Group**
Maplewood, (NJ) USA

CLIENT
The Eden Communications Group

ART DIRECTOR, DESIGNER
Donna Malik

DESIGN FIRM
Annagram Studio and Design
Richmond, (KY) USA
CREATIVE DIRECTOR
Coda Projects
ART DIRECTOR
Graham Allen
DESIGNER
Kyle Sheldon
ILLUSTRATOR
Christopher Sharp
PRINTER
Host Communications

Inspiration

...Pro surfer Carl Phillip has his
...tion of board care. One visit to his
...longtime Wrightsville Beach, North
...e's...y...other...gets his
...e...of the hardest changing
...break...water monsters...

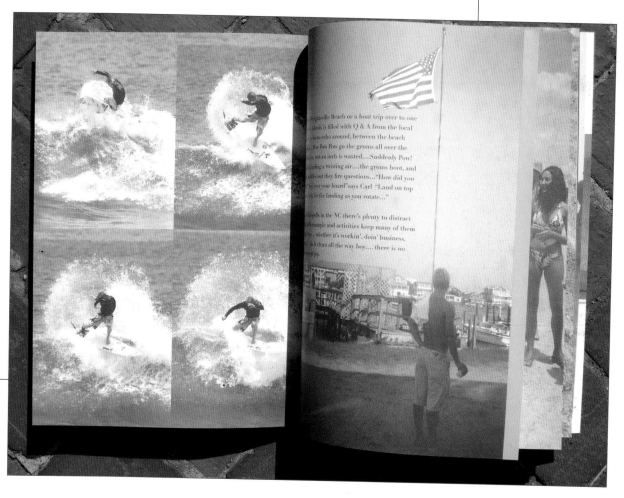

...rightsville Beach or a boat trip over to one
...lands is filled with Q & A from the local
...shots echo around, between the beach
...Pow Pow Pow go the groms all over the
...not an inch is wasted....Suddenly Pow!
... making a twisting air....the groms hoot, and
...les out they fire questions..."How did you
...ge over your board" says Carl "Land on top
...for the landing as you rotate..."

...spells in the NC there's plenty to distract
...example and activities keep many of them
...whether it's workin', doin' business,
...do it clean all the way boy.... there is no
...not joy.

BE A PART OF IT

1_____

www.jiclub.com www.thecosmopolitanclub.com www.thesmallhotelcompany.com www.designhotels.com www.planethotels.com

THE ARRANGEMENT www.club-of...

We promote your events to one or more of our two membership levels. You enjoy increased exposure to a highly attractive target group. In return, our members, on attending your events, enjoy the preferential treatment that they are used to.

WE PROMOTE YOU TO OUR MEMBERS. YOU OFFER OUR MEMBERS THE STANDARD THEY ARE USED TO.

HOW DOES THE CLUB OF CLUBS WORK?

To help you further identify your target group, our membership is broken down into two distinct levels. We can promote your events to one or more of those carefully selected groups according to your requirements.

JUNIOR INTERNATIONAL CLUB™ Its members are between 18 and 35 years old. They are going places and getting there fast. They live busy international lifestyles and need to make sure that time off isn't time wasted. They want to go out to events that combine sophistication and glamour. Membership of the Junior International Club is limited to 3000 with a limited quota for individual countries, and is carefully selected by the committee - ensuring that we will be promoting your events to precisely the people you would like to attend them.

THE COSMOPOLITAN CLUB™ Its members are over 30 years old. They are looking to indulge in the luxuries that their success affords and they don't mind paying for the privilege. They are looking for refinement, sophistication and style, and expect the highest standards from events and parties when they attend them. They are looking for events that they can enjoy personally and where they can entertain professionally. Membership of the Cosmopolitan Club is limited to 3000 with a limited quota for individual countries. Again, membership is carefully vetted by the committee.

THE CLUB OF CLUBS ...we want you to be a part of it.

1_____
DESIGN FIRM
Lebensart Media, Berlin
Berlin, Germany
CLIENT
Club of Clubs, Munich
ART DIRECTOR
Michael Schickinger
ILLUSTRATOR
Barbara Spoettel

ASSOCIATION
OF
PERFORMING
ARTS
OF
INDIA

Mission

Association of Performing Arts of India, is a non-profit organization, founded on June 1998. All our committee members and board of directors are working as volunteers. The goal is to promote Indian classical music and dance through lecture demo and concerts. There are classes given in Sitar, Tabla (Percussion) and Dance. We are located in Pembroke Pines, Florida.

Lakshmi Shankar

Shubha Mudgal

Quotes

Comments from "Music for the Soul" featuring Pt. Vishva Mohan Bhatt
"Balanced artistic program for the listener with traditional Indian style in the first half of the program, and the second half showcased Bhatt's contemporary sensibilities and his influence on the (contemporary) "world music" genre. Unique instrumental sound and great technical ability."
**James Shermer, Grants Director
Broward Cultural Affairs**

Comments from "From Prince To Buddha" by The Shakti Dance Group
"I enjoyed the concert very much. The music and dance were of a very high caliber. I was so pleased to see how many people were in the audience."
**Daniel Lewis, Dean of Dance
New World School of the Arts**

"The percussive beat of the tabla and the distinctive sounds of the sitar can be heard in Broward County this spring and summer thanks to the efforts of the Association of Performing Arts of India."
**Helene Eisenberg Foster -
Cultural Quarterly,
Spring 2001, Volume XIV, Number 2.**

"Though the raga was as long as Beethoven's Ninth Symphony, the musicians maintained audience interest in an unbroken span for 70 minutes, with a fiery virtuosity and provisional flair that was often awe inspiring"
**Lawrence A. Johnson - Concert Review,
Sun Sentinel, June 18, 2001.**

Organizational History

The Association of Performing Arts of India (APAI) was founded in 1998 with the mission to preserve and promote the ancient Indian Classical Music and Dance. Indian Music is the oldest written music in the world. The first evidence of written music, i.e musical notes, comes from the Vedas, Indian sacred documents written more than 4000 years ago.

In spite of such a rich heritage, Indian music, particularly Indian Classical music, while flourishing in India, is still an unknown art in the rest of the world. The primary purpose of APAI is to bring this art to the U.S. The secondary purpose is to educate the South Florida community, young and old, about this art through lecture-demonstrations, classes and concerts. There is a large group of Americans of Indian origin in South Florida, and these people would like to keep in touch with their cultural heritage. There are close to 50,000 Indian Americans from India and close to 50,000 Indian Americans from the Caribbean Islands in South Florida. If one includes other Americans who would want to learn about Indian Music and dance also, there is a large audience who would appreciate and participate in Indian music and dance. Therefore our work is a pioneering effort and hopefully will lead to enriching the cultural scope of all residents of Broward County.

Veena Sahasrabudde

Long Term Goals and Objectives

To present an annual series of Indian classical music and dance concerts for the general public.

To present educational programs for Broward school children to acquaint them to the artistry and cultural traditions of Indian classical music.

To provide opportunities for South Florida residents of Indian heritage to come together to promote and express their cultural heritage.

To offer workshops for musicians (both Indian and non-Indian) to learn Classical Indian musical repertoire and techniques.

To develop a financial support base to sustain and expand APAI activities.

Manju Mehta

Program History

The Association of Performing Arts of India has, since its inception, focused not only on featuring premier caliber artists, but has also sought to expand the scope of its presentations to include classical dance and dance-drama, folk art forms and cross cultural events. The Association's inaugural performance was held on November, 1998 presenting Ustad Rashid Khan, a leading Hindustani vocal artist accompanied by tabla (drums) and the now rarely seen classical Indian fiddle known as the sarangi. Subsequently, the Association succeeded in bringing a diverse variety of high caliber, in some cases, world known artists to our region including instrumental music featuring all of the principal instruments of the Hindustani tradition: sitar, sarod (a fretless multi-stringed lute,) shehnai (the Indian oboe), sarangi (the above mentioned fiddle) and the bamboo flute. Prominent sitarist such as Ustad Shujaat Hussain Khan, a leading exponent of the Imdadkhani gharana and son of the late great Ustad Vilayat Khan, has appeared on our programs here in South Florida, as well as Pt.Vishva Mohan Bhatt, A versatile Guitar performer with a broad repertoire of traditional music, Bhatt received a Grammy Award in 1994 for a joint world music album entitled "A Meeting by the River" created with Ry Cooder. Vocal music has been heavily featured as well, including male and female artists from a number of different gharanas or musical "families" that are exponents of a particular style. These include singer Shubha Mudgal, vocalist on many film soundtracks, Lakshmi Shankar, sister-in-law to Ravi Shankar, as well as featured vocalist on the soundtrack to Richard Attenborough's epic film "Gandhi" and Veena Shastrabuddhe, a one of the most respected singers of the Gwalior gharana. With a view to demonstrating the commonalities of different musical traditions, the Association has twice presented fusion performances melding the musical and dance traditions of flamenco and Indian traditions. We have showcased the flamenco guitar alongside the sarangi and flamenco vocals (cante). At the same time, audiences experienced classical Indian dance (Kathak) side by side with the fiery steps of flamenco.

Shakti Dance Company

The common rhythmic and melodic foundation of these two very different traditions was evident in the performances and the ability of the artists to communicate with little or no rehearsal across language and stylistic barriers was impressive Perhaps the most popular and well-attended events sponsored by the Association are its dance concerts. On three occasions, the Association has presented the Shakti Dance Company, a Bharata Natyam dance company with a full complement of live musicians, including three vocalists, various percussion, violin, flute, and veena (a South Indian long-necked lute). The performances included virtuoso soloists and a full corps of dancers performing three separate works of dance-drama, one based on the Bhagavad-Gita, the others on the life of Buddha and Sant Meera. The Association has endeavored, and succeeded, in presenting variety, cultural diversity and art of the highest artistic integrity and quality without neglecting the very capable dancers, singers and instrumentalists in our own community who have participated and performed in our programs dedicated to local artists. The years since our inception have seen events ranging from small, intimate audiences and community outreach programs such as lecture demonstrations to sold-out houses at larger venues, each program contributing in its own way to furthering communication with our audience.

DESIGN FIRM
Shelly Prisella Graphic Design
Lauderdale-By-The-Sea, (FL) USA
PROJECT
APAI 2005 Brochure
DESIGNER
Shelly Prisella

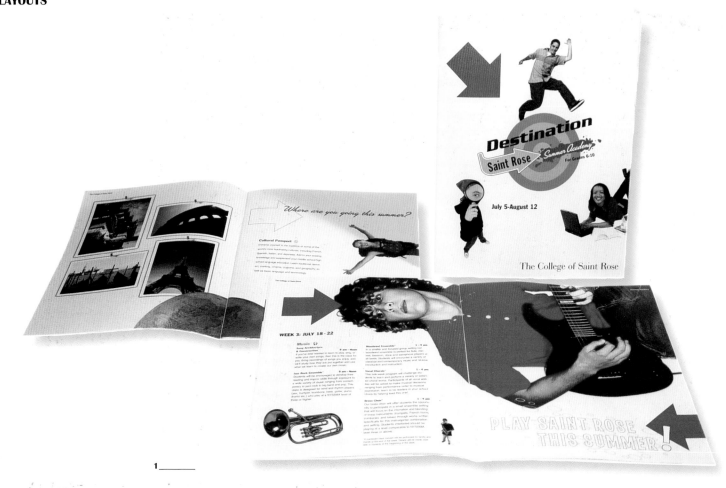

1 _____

1 _____

DESIGN FIRM
The College of Saint Rose
Albany, (NY) USA

PROJECT
Destination Saint Rose
Summer Academy

ART DIRECTOR
Mark Hamilton

ILLUSTRATOR
Chris Parody

COPYWRITERS
John Hunter, Mark Hamilton

PHOTOGRAPHER
Jupiter Images Corp.

PRINTER
Ansun Graphics

2_____

2_____

DESIGN FIRM
Velocity Design Works
Winnipeg, (Manitoba) Canada
PROJECT
Pixel Album
CREATIVE DIRECTOR, ART DIRECTOR, PHOTOGRAPHER
Lasha Orzechowski
DESIGNERS
Lasha Orzechowski, Rick Sellar

3_____
DESIGN FIRM
Vangel Marketing Communications
Columbia, (MO) USA
PROJECT
D&H Drugstore Brochure

3_____

enero

Un gobierno con la gente... un gobierno diferente

2006

Playa de La Manzanilla

diciembre							febrero						
D	L	M	M	J	V	S	D	L	M	M	J	V	S
				1	2	3				1	2	3	4
4	5	6	7	8	9	10	5	6	7	8	9	10	11
11	12	13	14	15	16	17	12	13	14	15	16	17	18
18	19	20	21	22	23	24	19	20	21	22	23	24	25
25	26	27	28	29	30	31	26	27	28				

D	L	M	M	J	V	S
1	2	3	4	5	6	7
8	9	10	11	12	13	14
15	16	17	18	19	20	21
22	23	24	25	26	27	28
29	30	31				

Coordinación
General de
Comunicación Social

2002·2008 Michoacán

Michoacán
un gobierno diferente

junio

Un gobierno con la gente... un gobierno diferente

2006

Paisaje desde Tzintzuntzan

mayo							julio						
D	L	M	M	J	V	S	D	L	M	M	J	V	S
	1	2	3	4	5	6							1
7	8	9	10	11	12	13	2	3	4	5	6	7	8
14	15	16	17	18	19	20	9	10	11	12	13	14	15
21	22	23	24	25	26	27	16	17	18	19	20	21	22
28	29	30	31				23	24	25	26	27	28	29
							30	31					

D	L	M	M	J	V	S
				1	2	3
4	5	6	7	8	9	10
11	12	13	14	15	16	17
18	19	20	21	22	23	24
25	26	27	28	29	30	

Coordinación
General de
Comunicación Social

2002·2008 Michoacán

Michoacán
un gobierno diferente

DESIGN FIRM
Caracol Consultores SC
Morelia, México
CLIENT
Gobierno del Estado
de Michoacán, Mexico
ART DIRECTOR
Luis Jaime Lara Perea
DESIGNER
Luis Jaime Lara
PHOTOGRAPHER
Coordinación General de
Comunicación Social

noviembre

Un gobierno con la gente... un gobierno diferente

2006

Flores de Cempazúchitl

octubre

D	L	M	M	J	V	S
1	2	3	4	5	6	7
8	9	10	11		13	14
15	16	17	18	19	20	21
22	23	24	25	26	27	28
29	30	31				

diciembre

D	L	M	M	J	V	S
					1	2
3	4	5	6	7	8	9
10	11	12	13	14	15	16
17	18	19	20	21	22	23
24		26	27	28	29	30
31						

D	L	M	M	J	V	S
			1		3	4
5	6	7	8	9	10	11
12	13	14	15	16	17	18
19		21	22	23	24	25
26	27	28	29	30		

Coordinación
General de
Comunicación Social

2002·2008 Michoacán

Michoacán
un gobierno diferente

marzo

Un gobierno con la gente... un gobierno diferente

2006

Paracho

febrero

D	L	M	M	J	V	S
		1	2	3	4	
5	6	7	8	9	10	11
12	13	14	15	16	17	18
19	20	21	22	23	24	25
26	27	28				

abril

D	L	M	M	J	V	S
					1	
2	3	4	5	6	7	8
9	10	11	12	13	14	15
16	17	18	19	20	21	22
23	24	25	26	27	28	29
30						

D	L	M	M	J	V	S
			1	2	3	4
5	6	7	8	9	10	11
12	13	14	15	16	17	18
19	20	21	22	23	24	25
26	27	28	29	30	31	

Coordinación
General de
Comunicación Social

2002·2008 Michoacán

Michoacán
un gobierno diferente

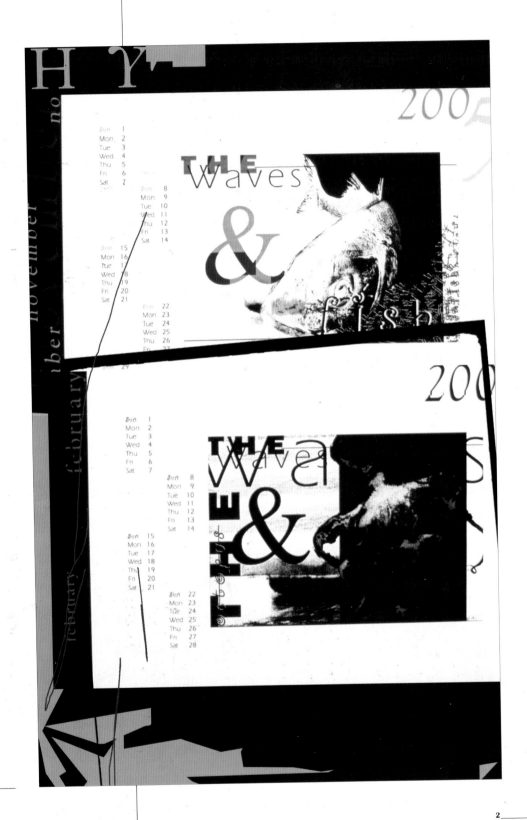

1_____
DESIGN FIRM
Didem Carikci Wong
Istanbul, Turkey
CREATIVE DIRECTOR, ART DIRECTOR, DESIGNER
Didem Carikci Wong

2_____
DESIGN FIRM
Riordon Design
Oakville, (Ontario) Canada
PROJECT
Coloratura Calender
CLIENT
Riordon Design
ART DIRECTOR
Shirley Riordon
DESIGNERS
Dawn Charney, Shirley Riordon

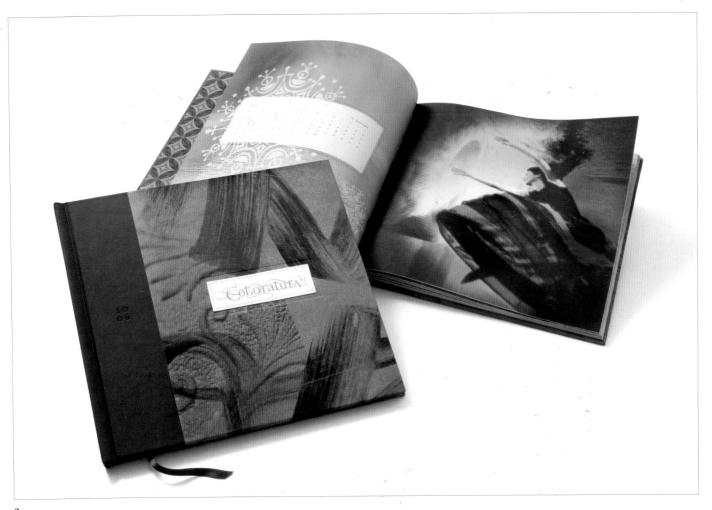

2 _____

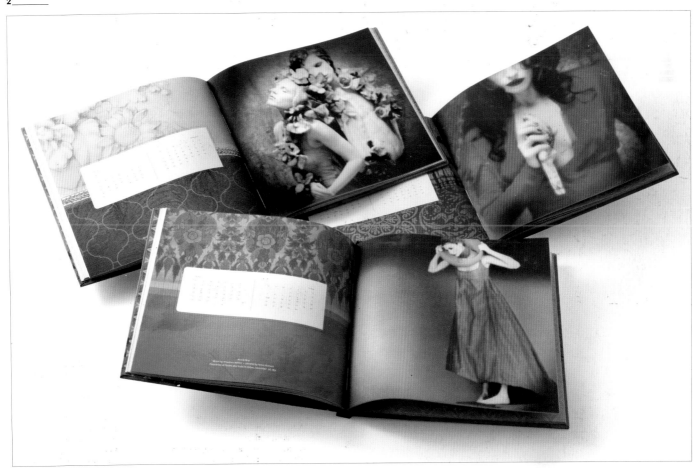

1 _____
DESIGN FIRM
JL Design
Plainfield, (IL) USA
PROJECT
Gigi's Calender
DESIGNER
JL Design

2006

Food Stamp Nutrition Education
2006 Recipe Calendar

S	M	T	W	T	F	S
			1	2	3	4
5	6	7	8	9	10	11
12	13	14	15	16	17	18
19	20	21	22	23	24	25
26	27	28	February is: ■ American Heart Month ■ Potato Lover's Month			

February

2_____

Baked Potato & Toppings
Makes 1 serving

1 baked potato
1 topping
2 tablespoons grated cheese

Potato Toppings
 Chili
 Spaghetti sauce
 Cooked broccoli
 Salsa (add lettuce and tomato for a taco potato)
 Frozen vegetables (cook for 3-4 minutes)

1. Wash potato and pierce with a fork.
2. Microwave on high for about 16 minutes
 (turn over after 8 minutes).
3. Carefully cut open the potato.
4. Top each potato with one of the above toppings.
5. Top with grated cheddar or mozzarella cheese.

■ Add leftover chicken or ground beef to make a well-rounded dinner.
■ Try eating the skin of the potato to boost the fiber in your meal.

2_____

DESIGN FIRM
University of Maryland
Cooperative Extension—FSNE
Columbia, (MD) USA

CLIENT
The University of Maryland
CooperativeExtension—Food
Stamp Nutrition Education Program

PROJECT
FSNE 2006 Recipe Calender

DESIGNERS
Lisa Lachenmayr,
Trang Dam

1_____

1_____
DESIGN FIRM
Coates and Coates
Naperville, (IL) USA
CLIENT
HSBC—North America
ART DIRECTOR, DESIGNER
Carolin Coates

2_____

2_____
DESIGN FIRM
 Maddocks
 Los Angeles, (CA) USA
CLIENT
 Maddocks
CREATIVE DIRECTOR
 Jen Caughey
DESIGNERS
 Jen Caughey, Jonah Levine
PHOTOGRAPHER
 Dave Lauridsen
PRINTING
 B+G Printing

BOSCOE HOLDER'S

Caribbean World of Beauty

2005

1_____

1_____

DESIGN FIRM
All Media Projects Ltd (AMPLE)
Trinidad, West Indies

CLIENT
CLICO (Trinidad) Limited

DESIGNERS
Cathleen Jones,
Patti-Anne Ali,
Boscoe Holder,
Deborah Garraway,
Images Studio, CPPL

Livskraft i 100 år

HYDRO

Jubileumskalender

2005

Respekt. 36.000 fagfolk. Energi. Samarbeid.
Djerve mål. Aluminium. Grenser som flyttes.
Mennesker. Natur. Framsyn. Inspirasjon i 100 år.

Livskraft. På norsk.

2_____

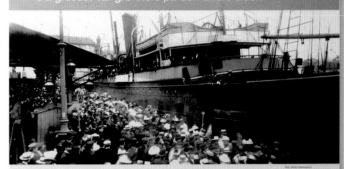

Januar

Da gresset var grønnere på den andre siden

2_____

DESIGN FIRM
KARAKTER Ltd
London, England

CLIENT
Norsk Hydro

DESIGNERS
Clive Rohald,
Kam Devsi,
Mei Wing Chan,
Martin Watkins

1 _____

1_____
DESIGN FIRM
Studio Universal
Rome, Italy
CLIENT
Universal Studios Networks Italy
DESIGNER
Luca Marcucci

2_____
DESIGN FIRM
**All Media Projects Ltd
(AMPLE)**
Trinidad, West Indies
CLIENT
BP Trinidad and Tobago (bpTT)
CREATIVES
Cathleen Jones,
Glenn Forte,
Astra Da Costa,
Josiane Khan,
Abigail Hadeed,
Fazad Mohammed,
Digital Photo Center,
Scrip-J Printers

We are bpTT

2005

bp
Trinidad and Tobago

sunday	monday	tuesday	wednesday	thursday	friday	saturday
					1	2
3	4	5	6	7	8	9
10	11	12	13	14	15	16
17	18	19	20	21	22	23
24	25	26	27	28	29	30

april 2005

Resting yet alert, an iguana
basks in the sun

bp
Trinidad and Tobago

...investing beyond petroleum

2

sunday	monday	tuesday	wednesday	thursday	friday	saturday
				1	2	3
4	5	6	7	8	9	10
11	12	13	14	15	16	17
18	19	20	21	22	23	24
25	26	27	28	29	30	

september 2005

Twin peaks rise majestically from
the tranquil coastline

bp
Trinidad and Tobago

...investing beyond petroleum

sunday	monday	tuesday	wednesday	thursday	friday	saturday
				1	2	3
4	5	6	7	8	9	10
11	12	13	14	15	16	17
18	19	20	21	22	23	24
25	26	27	28	29	30	31

december 2005

Peace and splendour...
Mayaro at sunrise

bp
Trinidad and Tobago

...investing beyond petroleum

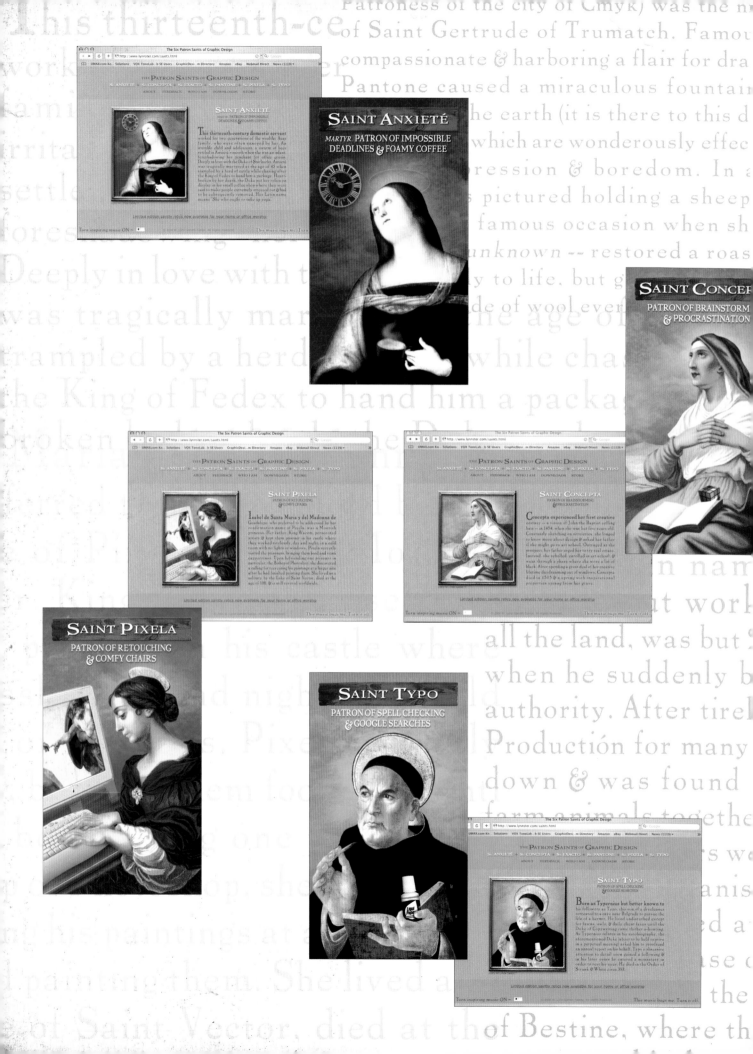

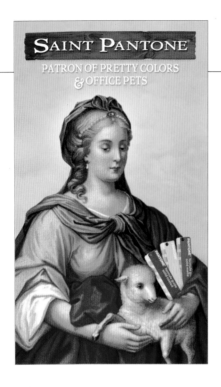

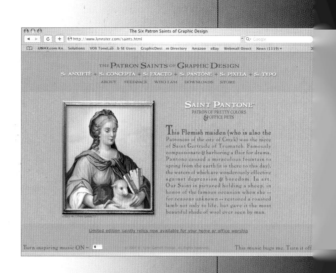

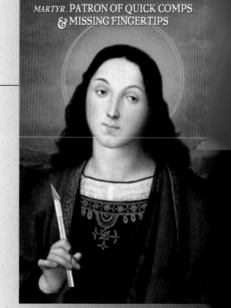

DESIGN FIRM
W. Lynn Garrett Art Direction + Design
San Francisco/Los Angeles, (CA) USA

CLIENT
W. Lynn Garrett Art Direction + Design

DESIGNER, COPYWRITER
W. Lynn Garrett

1_____

1_____

DESIGN FIRM
JUNGLE 8/creative
Los Angeles (CA), USA
CLIENT
Insight Group International
DESIGNER
Lainie Siegel
COPYWRITER
Michael Walsh

2_____

3_____

2_____

DESIGN FIRM
JUNGLE 8/creative
Los Angeles (CA), USA

CLIENT
Pure BodyWork

CREATIVE DIRECTOR
Lainie Siegel

DESIGNER
Justin Cram

COPYWRITER
Scott Silverman

3_____

DESIGN FIRM
JUNGLE 8/creative
Los Angeles (CA), USA

CLIENT
Carsey Werner

DESIGNER
Lainie Siegel

COPYWRITER
Michael Walsh

1

2

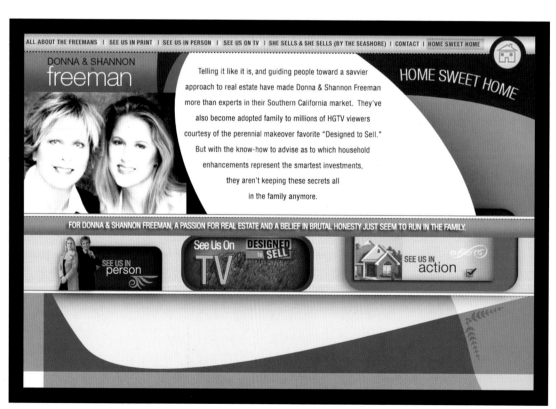

1
DESIGN FIRM
FutureBrand Brand Experience
New York (NY), USA
PROJECT
Riffa Views Website
CREATIVE DIRECTOR
Diego Kolsky
DESIGNERS
Cheryl Hills,
Brendan Oneill,
Tom Li,
Mike Williams
MULTIMEDIA DEVELOPER
Mike Sheehan
COPYWRITER
Stephanie Carroll
DIRECTOR OF VISUALIZATION
Antonio Baglione
VISUALIZATION ARTIST
Oliver de la Rama
PRINCIPAL
Raymond Chan

2
DESIGN FIRM
JUNGLE 8/creative
Los Angeles (CA), USA
CLIENT
Donna & Shannon Freeman
CREATIVE DIRECTOR
Lainie Siegel
DESIGNERS
Justin Cram, Gracie Cota
COPYWRITER
Scott Silverman

OMN*E*SSENCE™

 Using Oils **Catalog** **Home**

WELCOME TO OMNESSENCE

We take pride in offering only the purest essential oils from the world's premium distillers and growers.

What our customers have to say about **OmnEssence**...

"I love these!"

"There is wisdom in these oils."

rose centifolia

How To Order **View The Catalog ▶**

Genuine and Authentic essential oils

Single Oils | Synergistic Blends | Oil Kits | Carrier Oils | Accessories | Publications & Books | Educational Opportunities
How To Use Essential Oils | Catalog (Coming Soon) | How To Order | Product Return Policy | Contact | Downloadable PDF Catalog

© 2002 OmnEssence LLC Website design Octavo Designs

3_____
DESIGN FIRM
Octavo Designs
Frederick, (MD), USA
CLIENT
OmnEssence
ART DIRECTOR
Sue Hough
DESIGNERS
Sue Hough, Mark Burrier

265

1_____

2_____

1_____

DESIGN FIRM
FutureBrand
Brand Experience
New York (NY), USA
PROJECT
Exomos Website
CREATIVE DIRECTOR
Avrom Tobias
DESIGNERS
Tini Chen,
Mike Williams,
Brendan Oneill,
Tom Li
MULTIMEDIA DEVELOPER
Mike Sheehan
COPYWRITER
Stephanie Carroll
DIRECTOR OF VISUALIZATION
Antonio Baglione
VISUALIZATION ARTIST
Oliver de la Rama
IDENTITY SYSTEMS DIRECTOR
Carol Wolf
PRINCIPAL
Mario Natarelli

2_____

DESIGN FIRM
Engrafik
Oslo, Norway
CLIENT
Kisses on Platform 2
CREATIVE DIRECTOR, DESIGNER
Reinert Korsbøen

3 _____

2 _____

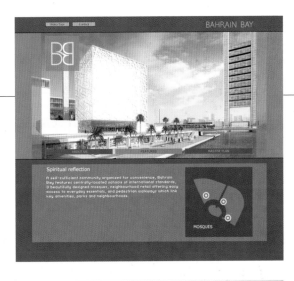

3 _____

DESIGN FIRM
Maurius Fahrner Design
New York, (NY), USA

PROJECT
Elements-Winterhude Website

ART DIRECTOR
Marius Fahrner

ILLUSTRATOR
Barbara Spoettel

4 _____

DESIGN FIRM
FutureBrand
Brand Experience
New York (NY), USA

PROJECT
Bahrain Bay Website

CREATIVE DIRECTOR
Diego Kolsky

DESIGNERS
Mike Williams, Cheryl Hills,
Brendan Oneill, Tom Li

MULTIMEDIA DEVELOPER
Mike Sheehan

COPYWRITER
Stephanie Carroll

DIRECTOR OF VISUALIZATION
Antonio Baglione

VISUALIZATION ARTIST
Oliver de la Rama

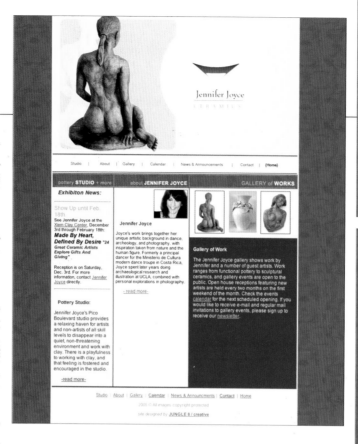

1 _____

2 _____

1 _____

DESIGN FIRM
JUNGLE 8/creative
Los Angeles (CA), USA
CLIENT
Jennifer Joyce
PROJECT
Jennifer Joyce Ceramics
DESIGNERS
Lainie Siegel,
Gracie Cota

3_____

2_____
DESIGN FIRM
**University of Maryland
Cooperative Extension—FSNE**
Columbia, (MD) USA
CLIENT
Mark Hamilton,
Hamilton Photography Inc.
PROJECT
Hamilton Photography Website
DESIGNER
Trang Dam

3_____
DESIGN FIRM
JUNGLE 8/creative
Los Angeles (CA), USA
PROJECT
Korbel Champagne Website
CLIENT
Korbel Media
CREATIVE DIRECTOR, DESIGNER
Lainie Siegel
CREATIVE DIRECTOR
Michael Walsh
PRODUCER
Elizabeth Burtis-Lopez

1_____

2_____

3_____

ROAD RAGE on Texas Highways: No One is Immune
Wednesday, 8:00pm

1_____
DESIGN FIRM
John Wingard Design
Honolulu, (HI), USA
CLIENT
Pearl Hawaii
ART DIRECTOR, DESIGNER
John Wingard

2_____
DESIGN FIRM
Velocity Design Works
Winnipeg, (Manitoba) Canada
PROJECT
Carriere
CREATIVE DIRECTOR, ART DIRECTOR,
DESIGNER
Lasha Orzechowski
PHOTOGRAPHER
Deborah Seguin

3_____
DESIGN FIRM
TAMAR Graphics
Waltham, (MA) USA
PROJECT
Road Rage Billboard
DESIGNER
Tamar Wallace

1 _____
DESIGN FIRM
Imagine
Manchester, England
PROJECT
Beer Barons Banners
ART DIRECTOR, DESIGNER
David Caunce

2 _____
DESIGN FIRM
McMillian Design
Brooklyn, (NY) USA
CLIENT
Buena Vida
ART DIRECTOR, DESIGNER
William McMillian

THE HEART OF A CARING COMMUNITY

Buena♡Vida
Continuing Care and Rehabilitation Center

48 CEDAR STREET • BROOKLYN, NY 11221-3253
(718) 928-3514 • WWW.BUENAVIDACENTER.ORG

3 _____

2 _____

Organic

Wild-Crafted

OMNESSENCE
genuine and authentic essential oils

Vintage

Ethically Farmed

aromatic
HeaLing tm

Educational resources
on the uses of essential oils
for health and well-being

3 _____

DESIGN FIRM
Octavo Designs
Frederick, (MD) USA

CLIENT
OmnEssence/Aromatic Healing

ART DIRECTOR
Sue Hough

DESIGNERS
Sue Hough, Mark Burrier

DESIGN FIRM
Eduard Cehovin
Ljubljana, Slovenia
PROJECT
SK04/Srecko Kosovel
1904 - 2004
DESIGNER
Eduard Cehovin

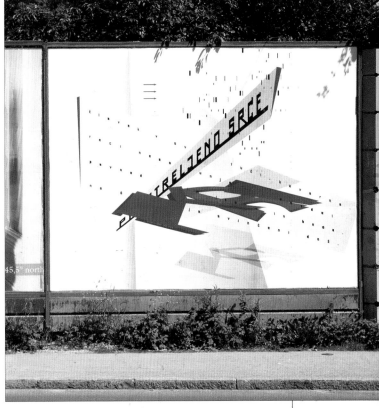

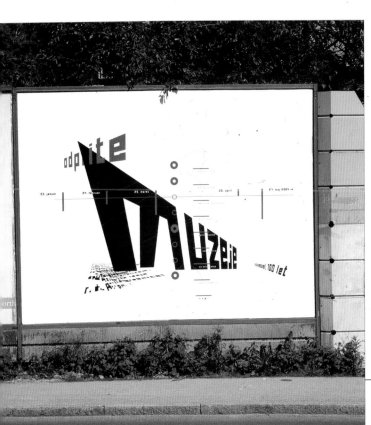

1_____

1_____
DESIGN FIRM
Octavo Designs
Frederick, (MD) USA
CLIENT
Majestic Wood Floors
ART DIRECTOR, DESIGNER
Sue Hough

2_____

2_____
DESIGN FIRM
Sandy Gin Design
San Carlos, (CA) USA
PROJECT
Limelight Networks
Trade Show Banners
CLIENT
Limelight Networks
DESIGNER
Sandy Gin
PHOTOGRAPHER
Digital Vision

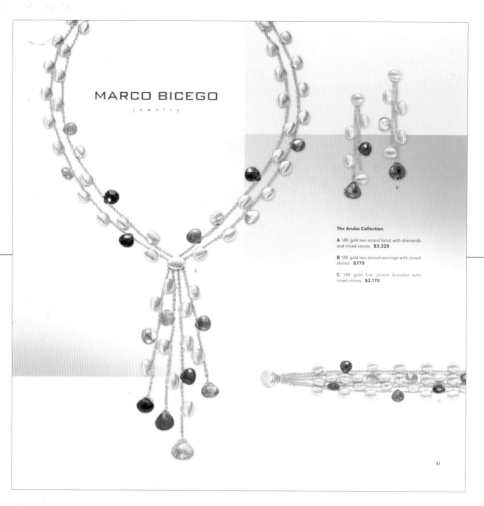

1

1_____

DESIGN FIRM
Ellen Bruss Design
Denver, (CO) USA

CLIENT
Hyde Park

CREATIVE DIRECTOR
Ellen Bruss

DESIGNER
Charles Carpenter

2_____

DESIGN FIRM
Joe Miller's Company
Santa Clara, (CA) USA

CLIENT
Girl Scouts of
San Francisco Bay Area

DESIGNER
Joe Miller

2

3_____

DESIGN FIRM
maycreate
Chattanooga, (TN) USA
CLIENT
Clarity Products
CREATIVE DIRECTOR,
ART DIRECTOR, DESIGNER
Brian May

BRININSTOOL + LYNCH : PROCESS

1_____

1_____
DESIGN FIRM
Liska + Associates
Chicago, (IL) USA
PROJECT
Brininstool + Lynch
Space Exhibition Catalog
ART DIRECTOR
Steve Liska
DESIGNER
Carole Masse
COPYWRITER
Reed Kroloff

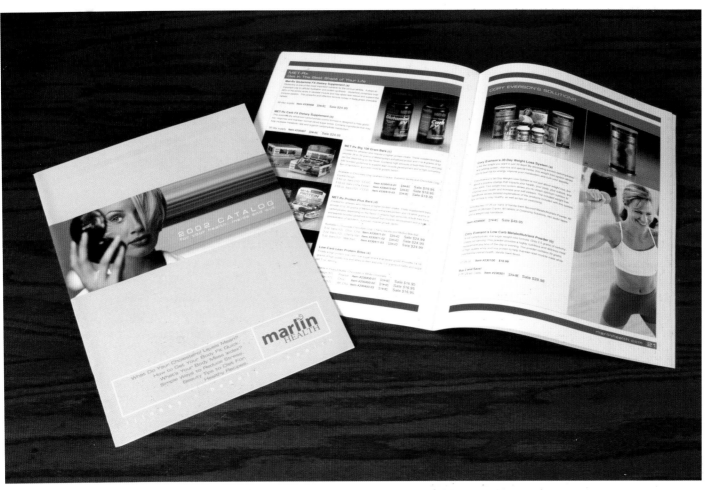

2

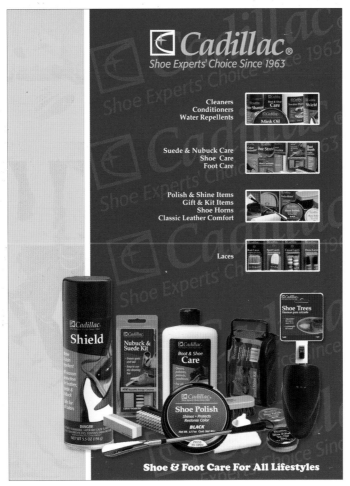

2

DESIGN FIRM
maycreate
Chattanooga, (TN) USA

CLIENT
Marlin Nutritional

CREATIVE DIRECTOR
Brian May

ART DIRECTOR, DESIGNER
Grant Little

PHOTOGRAPHER
Tom Farmer

PRINTER
Creative Printing

3

DESIGN FIRM
Excelda Manufacturing
Brighton, (MI) USA

PROJECT
Cadillac Catalog

DESIGNER
Melissa McIntosh

3

works/san josé

the first quarter-century

DESIGN FIRM
Joe Miller's Company
Santa Clara, (CA) USA
CLIENT
Works/San José
DESIGNER
Joe Miller

1_____

DESIGN FIRM
Excelda Manufacturing
Brighton, (MI) USA
PROJECT
XtremeScents
DESIGNER
Melissa McIntosh

2_____
DESIGN FIRM
Rule29 Creative
Geneva, (IL) USA
PROJECT
Tour Edge Catalog 2006
ART DIRECTOR
Justin Ahrens
DESIGNERS
Justin Ahrens, Josh Jensen
PHOTOGRAPHER
Brian MacDonald

DESIGN FIRM
Studio D
Fort Wayne, (IN) USA
PROJECT
RCI Catalog
CREATIVE DIRECTOR
Michael Earl
ART DIRECTORS
Holly Decker,
Jeremy Culp
CREATIVE
Lassiter Advertising

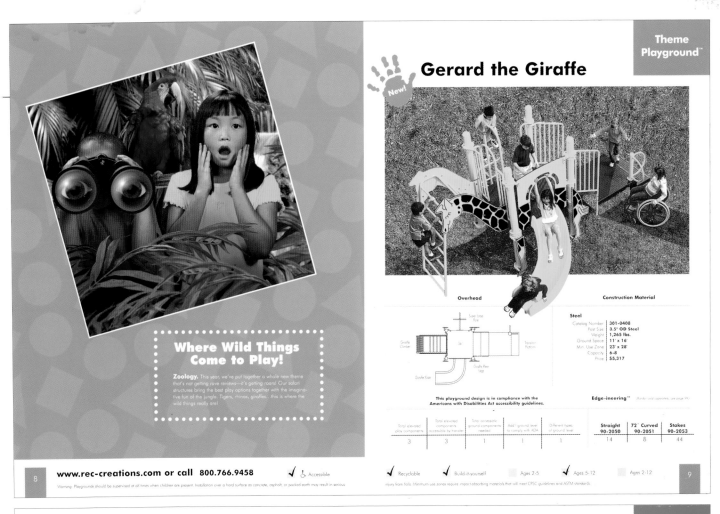

Where Wild Things Come to Play!

Zoology. This year, we've put together a whole new theme that's not getting rave reviews—it's getting roars! Our safari structures bring the best play options together with the imaginative fun of the jungle. Tigers, rhinos, giraffes... this is where the wild things really are!

Gerard the Giraffe

New!

Overhead

Giraffe Climber • Slide Use Zone • Transition Platform • Giraffe Slide • Giraffe Pen Legs

Construction Material

Steel

Catalog Number	301-0408
Post Size	3.5" OD Steel
Weight	1,265 lbs.
Ground Space	11' x 16'
Min. Use Zone	23' x 28'
Capacity	6-8
Price	$5,317

This playground design is in compliance with the Americans with Disabilities Act accessibility guidelines.

Edge-ineering™ (Border sold separately, see page 94.)

Total elevated play components	Total elevated components accessible by transfer	Total accessible ground components needed	Add'l ground level to comply with ADA	Different types of ground level		Straight 90-2050	72" Curved 90-2051	Stakes 90-2053
3	3	1	1	1		14	8	44

www.rec-creations.com or call 800.766.9458

✓ ♿ Accessible

✓ Recyclable ✓ Build-it-yourself ☐ Ages 2-5 ✓ Ages 5-12 ☐ Ages 2-12

Warning: Playgrounds should be supervised at all times when children are present. Installation over a hard surface as concrete, asphalt, or packed earth may result in serious injury from falls. Minimum use zones require impact-absorbing materials that will meet CPSC guidelines and ASTM standards.

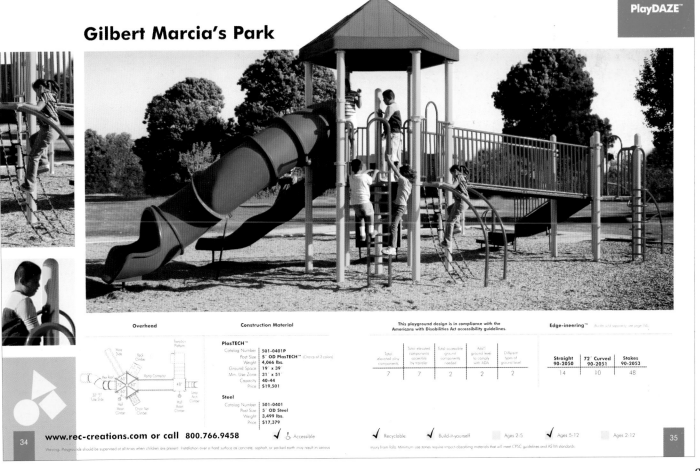

Gilbert Marcia's Park

Overhead

Wave Slide • Rock Climber • Transition Platform • Ramp Connector • Tot Roof • Loop Arch Climber • 32" Tube Slide • Half Moon Climber • Chain Net Climber • Half Moon Climber

Construction Material

PlasTECH™

Catalog Number	501-0401P
Post Size	5" OD PlasTECH™ (Choice of 3 colors)
Ground Space	19' x 39'
Min. Use Zone	31' x 51'
Capacity	40-44
Price	$19,501

Steel

Catalog Number	501-0401
Post Size	5" OD Steel
Weight	3,499 lbs.
Price	$17,379

This playground design is in compliance with the Americans with Disabilities Act accessibility guidelines.

Edge-ineering™ (Border sold separately, see page 94.)

Total elevated play components	Total elevated components accessible by transfer	Total accessible ground components needed	Add'l ground level to comply with ADA	Different types of ground level		Straight 90-2050	72" Curved 90-2051	Stakes 90-2053
7	7	2	2	2		14	10	48

www.rec-creations.com or call 800.766.9458

✓ ♿ Accessible

✓ Recyclable ✓ Build-it-yourself ☐ Ages 2-5 ✓ Ages 5-12 ☐ Ages 2-12

Warning: Playgrounds should be supervised at all times when children are present. Installation over a hard surface as concrete, asphalt, or packed earth may result in serious injury from falls. Minimum use zones require impact-absorbing materials that will meet CPSC guidelines and ASTM standards.

DESIGN FIRM
Riordon
Oakville, (Ontario) Canada
CLIENT
The John Forsyth Shirt Company Limited
ART DIRECTOR
Shirley Riordon
DESIGNERS
Shirley Riordon, Sharon Pece
PHOTOGRAPHER
Grimes Photography

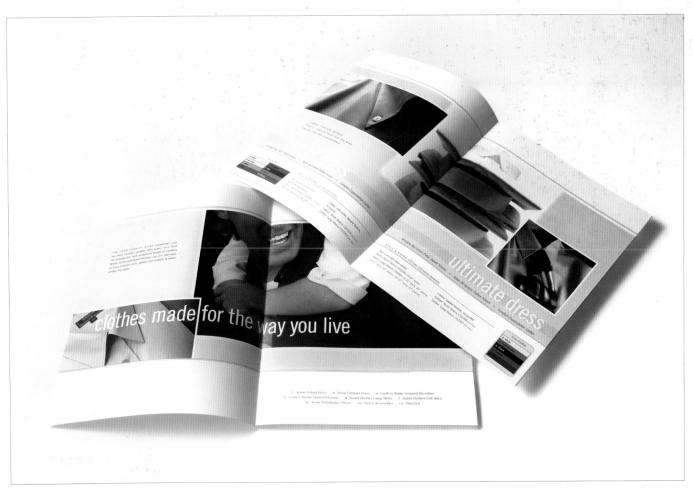

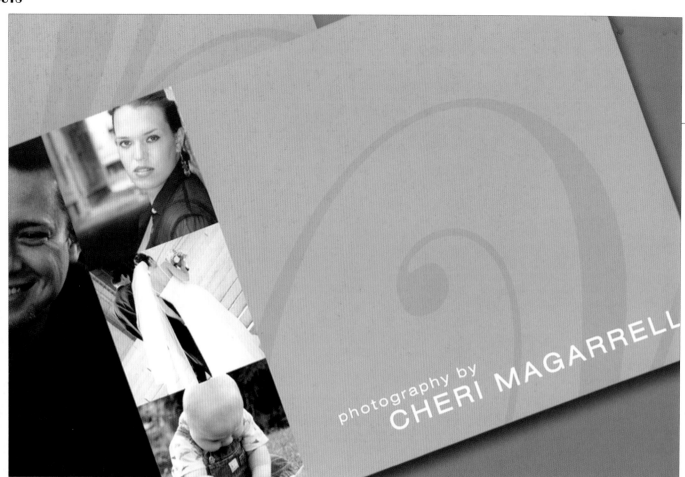

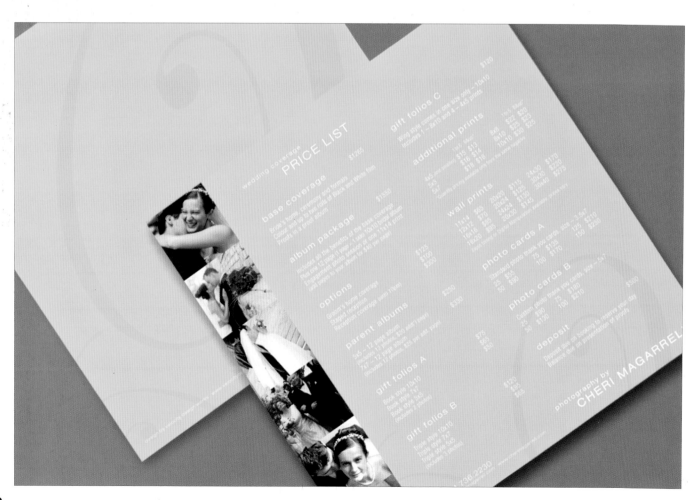

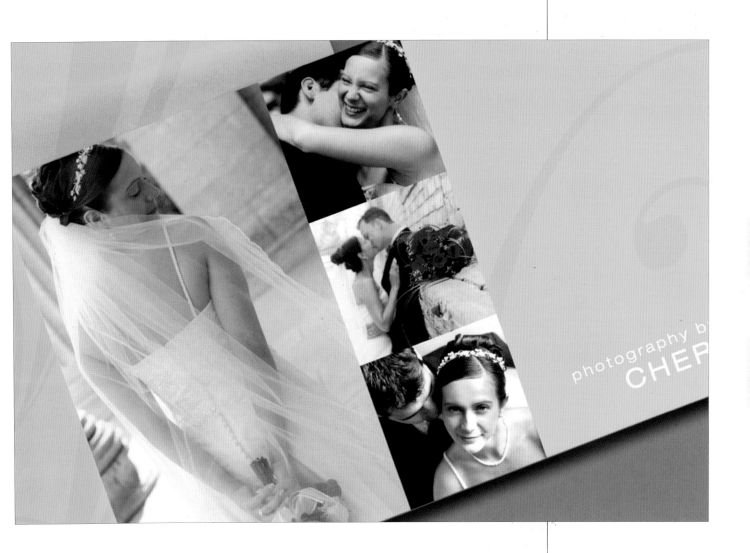

DESIGN FIRM
Velocity Design Works
Winnipeg, (Manitoba) Canada
PROJECT
Cheri Magarrell
CREATIVE DIRECTOR, ART DIRECTOR
Lasha Orzechowski
DESIGNERS
Lasha Orzechowsk, Krista Kline
PHOTOGRAPHER
Cheri Magarrell

DESIGN FIRM
Riordon
Oakville, (Ontario) Canada
CLIENT
Canadian Linen and Uniform Services
ART DIRECTOR
Ric Riordon
DESIGNER
Dawn Charney

DESIGN FIRM
Haase & Knels
Bremen, Germany
CLIENT
B.T. Dibbern GmbH & Co.
DESIGNERS
Sibylle Haase,
Hans Hansen,
Katja Hirschfelder

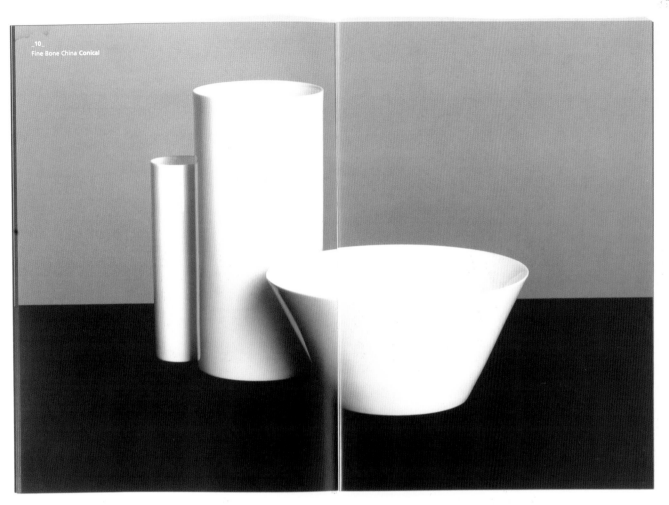

10
Fine Bone China Conical

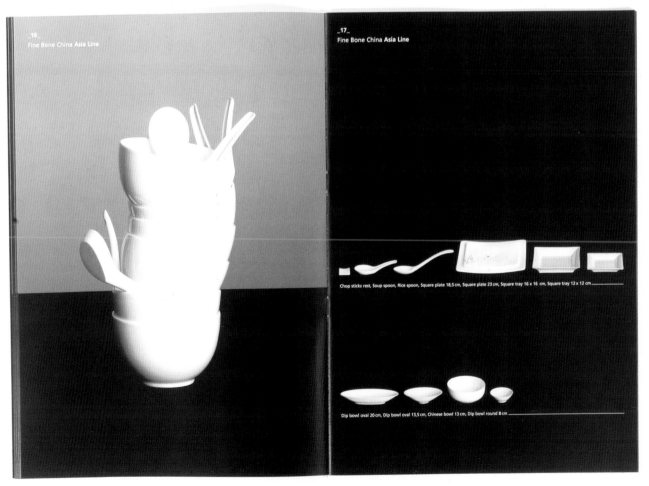

16
Fine Bone China Asia Line

17
Fine Bone China Asia Line

Chop sticks rest, Soup spoon, Rice spoon, Square plate 18,5 cm, Square plate 23 cm, Square tray 16 x 16 cm, Square tray 12 x 12 cm

Dip bowl oval 20 cm, Dip bowl oval 13,5 cm, Chinese bowl 13 cm, Dip bowl round 8 cm

295

1_____

1_____

DESIGN FIRM
KARAKTER Ltd.
London, England

CLIENT
Nice Systems

DESIGNERS
Clive Rohald,
Kam Devsi,
Rei Wing Chan,
Martin Watkins

2_____

3_____

2_____
DESIGN FIRM
Dever Designs
Laurel, (MD) USA
CLIENT
National Institutes of Health/
National Institute of Aging
ART DIRECTOR
Jeffrey Dever
DESIGNER
Kristin Devel Duffy

3_____
DESIGN FIRM
Noevir USA, Inc.
Irvine, (CA) USA
CLIENT
Noevir USA, Inc.
ART DIRECTOR, DESIGNER
Joseph Gaydos
DESIGNER
Rene Armenta

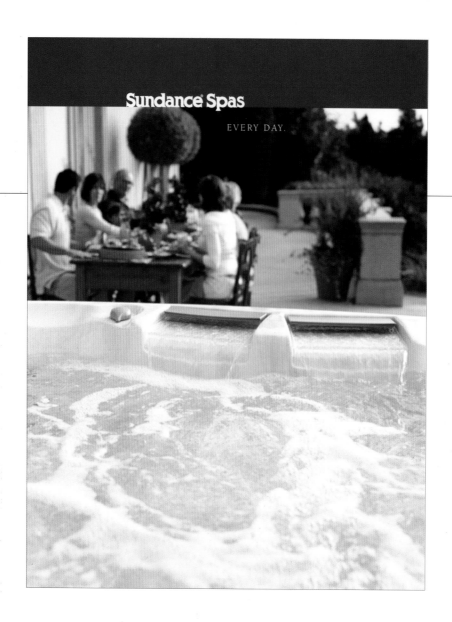

Sundance Spas

EVERY DAY.

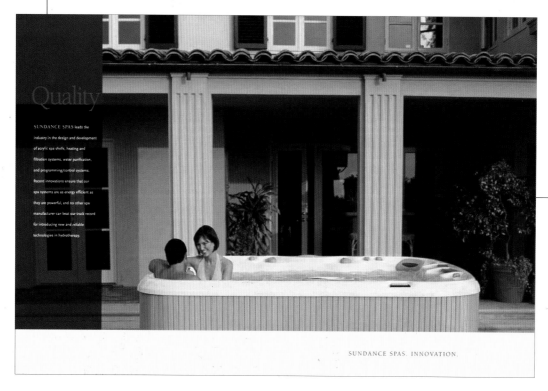

Quality

SUNDANCE SPAS leads the
industry in the design and development
of acrylic spa shells, heating and
filtration systems, water purification,
and programming/control systems.
Recent innovations ensure that our
spa systems are as energy efficient as
they are powerful, and no other spa
manufacturer can beat our track record
for introducing new and reliable
technologies in hydrotherapy.

SUNDANCE SPAS. INNOVATION.

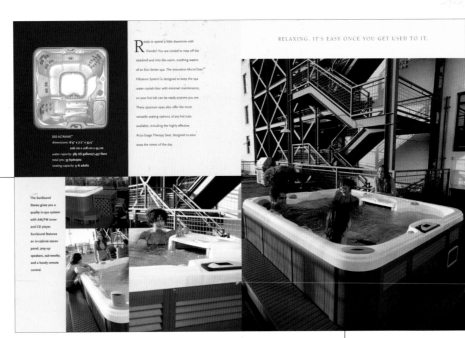

RELAXING. IT'S EASY ONCE YOU GET USED TO IT.

DAILY HYDROMASSAGE THERAPY.
FEELING GOOD BECOMES A HABIT.

AN EVERYDAY REMINDER OF WHAT
IT'S LIKE TO BE ON VACATION.

DESIGN FIRM
Kevershan Testerman
San Diego, (CA) USA
CLIENT
Sundance Spas
DESIGNERS
Patty Kevershan,
Patti Testerman,
Lynn Fleschutz

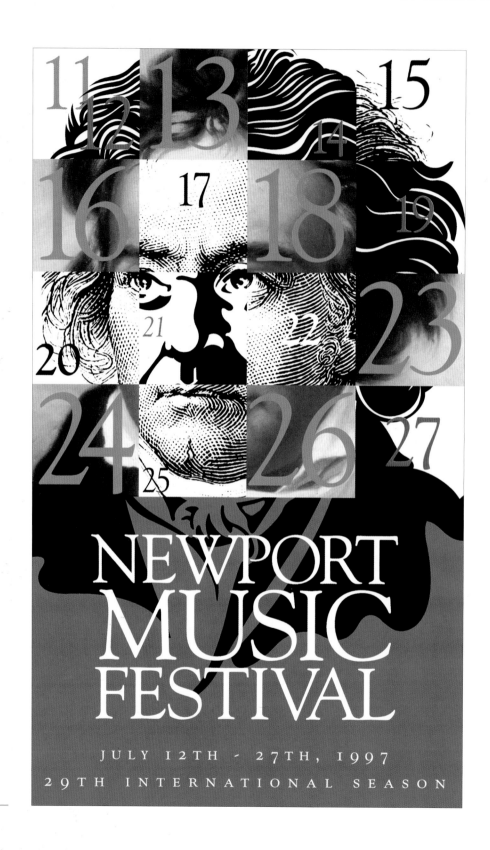

1_____
DESIGN FIRM
Tom Fowler, Inc.
Norwalk, (CT) USA
CLIENT
Newport Music Festival
ART DIRECTOR, DESIGNER, ILLUSTRATOR
Tom Fowler

2____

FREE + OPEN TO ALL
TUESDAY, OCTOBER 5, 2004
PRESENTATION OF AWARDS 5:15 P.M.

SHESLOW AUDITORIUM, OLD MAIN
DRAKE UNIVERSITY

DOORS OPEN 4:30 P.M.
RECEPTION FOLLOWING 6:30 P.M.

THE CENTRAL IOWA
ACTIVIST AWARDS

BOB MICKLE
AWARD WINNER
NEIGHBORHOOD + COMMUNITY

SALLY FRANK
AWARD WINNER
CIVIL + HUMAN RIGHTS

BRIAN TERRELL
AWARD WINNER
PEACE

AKO ABDUL-SAMAD
AWARD WINNER
EDUCATION + YOUTH ADVOCACY

LAVON GRIFFIEON
AWARD WINNER
ENVIRONMENT

SARA GRAHAM
DRAKE UNIVERSITY

BASIL MAHAYNI
IOWA STATE UNIVERSITY

AWARD FINALISTS STUDENT ACTIVISM

MATT GREEN
GRAND VIEW COLLEGE

JAY KOZEL
ROOSEVELT H.S.

WINNER TO BE ANNOUNCED

CAMEO APPEARANCE BY COLUMNIST DONALD KAUL

THE
cityview
ACTIVISTS
PROJECT

PRESENTING SPONSOR
Parrish Kruidenier Moss Dunn
Boles Gribble & Cook, L.L.P. Lawyers

Drake
DRAKE UNIVERSITY

cityview

2____

DESIGN FIRM
Jeremy Schultz
West Des Moines, (IA) USA

PROJECT
Cityview Activists Poster

DESIGNER
Jeremy Schultz

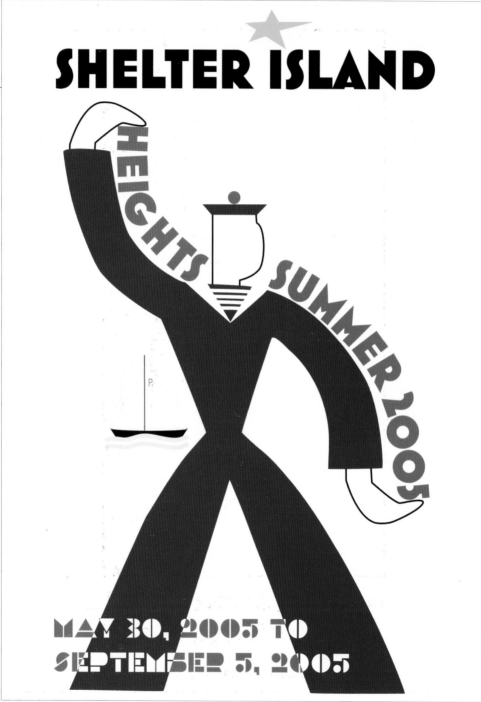

1_____
DESIGN FIRM
Acme Communications, Inc.
New York, (NY) USA
PROJECT
Shelter Island Poster
DESIGNER
Kiki Boucher

ric williams has a secret...
the secret book of god

www.DaltonPublishing.com

2_____

2_____
DESIGN FIRM
TAMAR Graphics
Waltham, (MA) USA
CLIENT
Dalton Publishing
DESIGNER
Tamar Wallace
PHOTOGRAPHER
Sharon Dominick

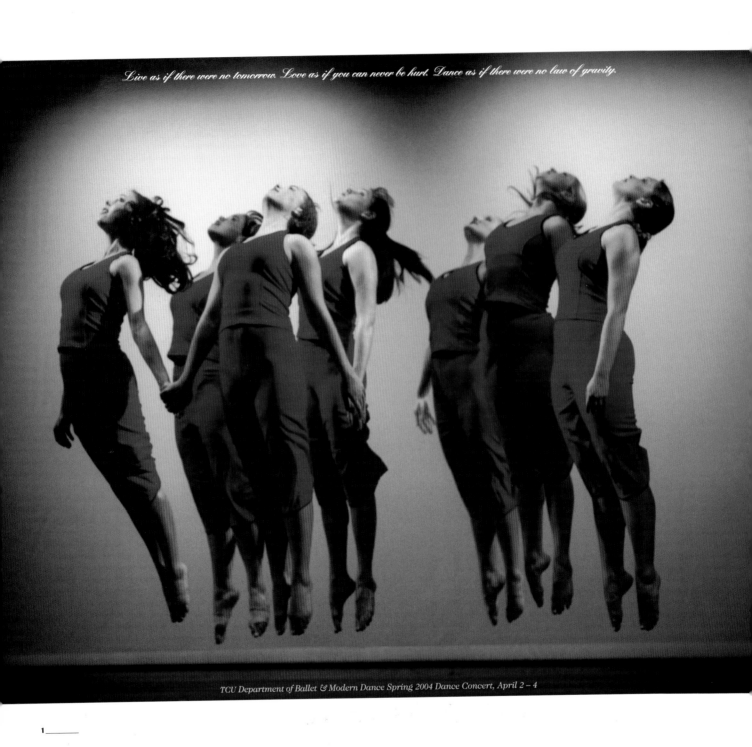

Live as if there were no tomorrow. Love as if you can never be hurt. Dance as if there were no law of gravity.

TCU Department of Ballet & Modern Dance Spring 2004 Dance Concert, April 2 – 4

1 _____

1 _____
DESIGN FIRM
Atomic Design
Crowley, (TX) USA
CLIENT
Ellen Shelton,
TCU Department of
Ballet & Modern Dance
DESIGNER, COPYWRITER
Lewis Glaser
PHOTOGRAPHER
Linda Kaye

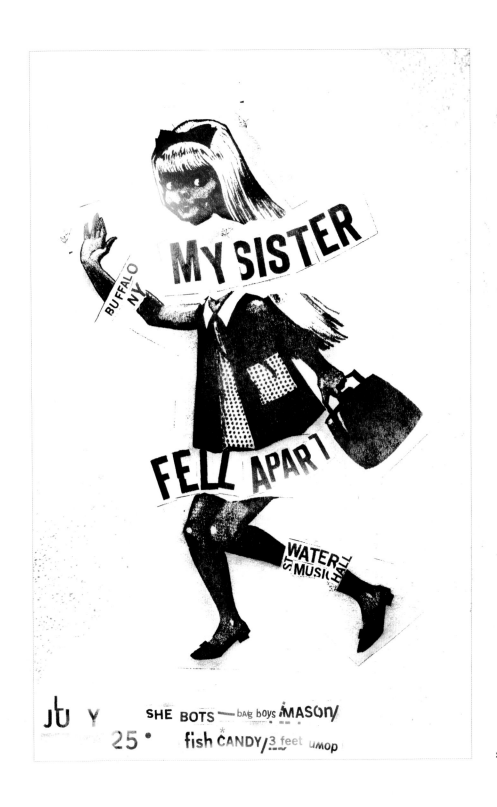

2_____

2_____
DESIGN FIRM
 A3 Design
 Charlotte, (NC) USA
PROJECT
 My Sister Fell Apart
DESIGNERS
 Alan Altman,
 Amanda Altman

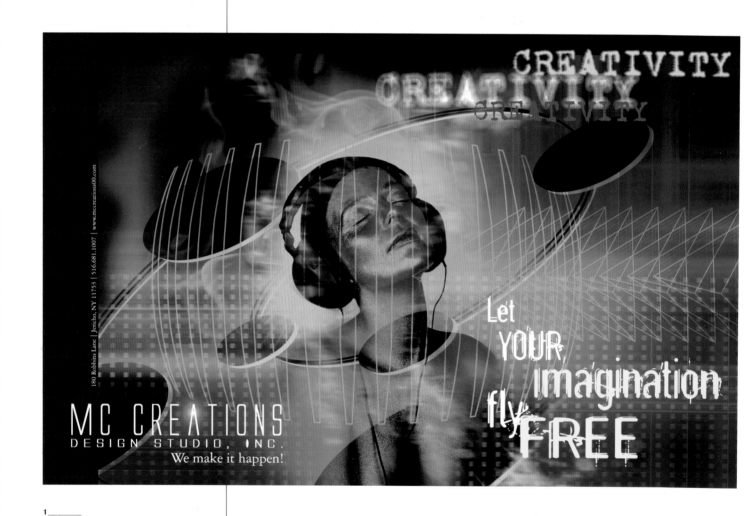

1_____

1_____
DESIGN FIRM
MC Creations Design Studio, Inc.
Hicksville, (NY) USA
DESIGNERS
Michael Cali,
Cynthia Morillo

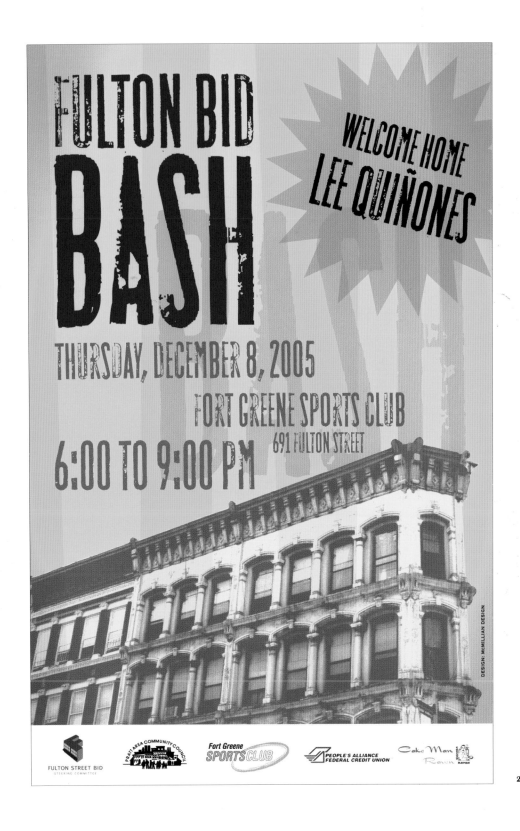

2_____
DESIGN FIRM
McMillian Design
Brooklyn, (NY) USA
CLIENT
Fulton Street BID
ART DIRECTOR, DESIGNER
William McMillian

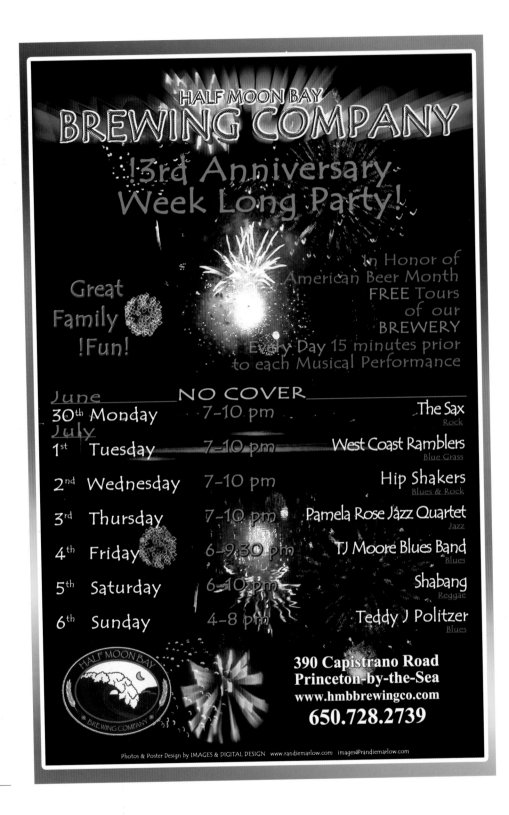

DESIGN FIRM
Images & Digital Design
Half Moon Bay, (CA) USA

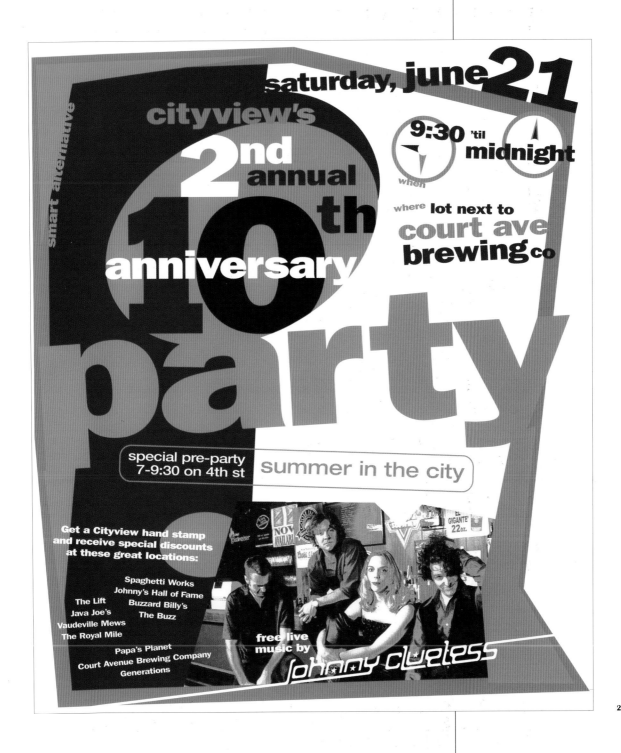

2_____

DESIGN FIRM
 Jeremy Schultz
 West Des Moines, (IA) USA
PROJECT
 Cityview 11th Anniversary Poster
DESIGNER
 Jeremy Schultz

OPEN SOON

cole haan

marc jacobs

stuart weitzman

donald j pliner

charles david

cordani

daniblack

isaac mizrahi

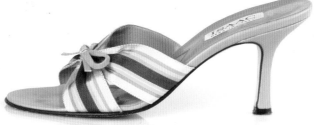

andre assous

prevata

michael kors

magnolia

rangoni

sesto meucci

ellen tracy

embellish

EMBELLISH

OPEN SOON

cole haan
marc jacobs
stuart weitzman
donald j pliner
charles david
cordani
daniblack
isaac mizrahi

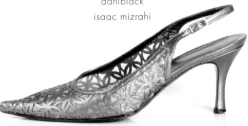

andre assous
prevata
dr. scholls
michael kors
magnolia
rangoni
sesto meucci
ellen tracy

embellish
EMBELLISH

OPEN SOON

cole haan
marc jacobs
stuart weitzman
donald j pliner
charles david
cordani
daniblack
isaac mizrahi

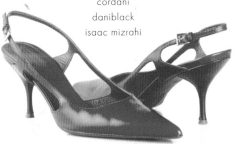

andre assous
prevata
dr. scholls
michael kors
magnolia
rangoni
sesto meucci
ellen tracy

embellish
EMBELLISH

1

1
DESIGN FIRM
Adventium
New York, (NY) USA
PROJECT
Colgate Total Poster
DESIGNER
Penny Chuang

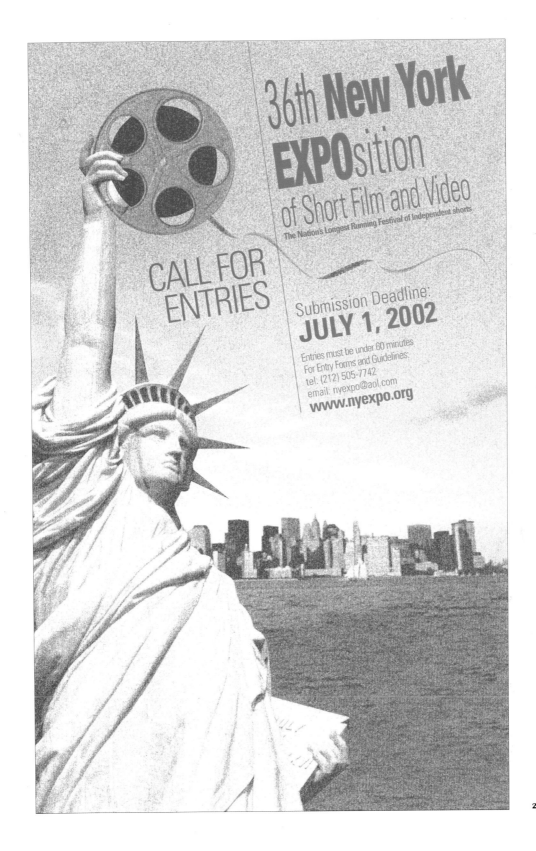

2_____

DESIGN FIRM
Adventium
New York, (NY) USA
PROJECT
New York Expo Poster
DESIGNER
Penny Chuang

m.f.a

Director of Graduate Studies, Division of Art & Design
Patti and Rusty Rueff Department of Visual and Performing Arts
Yue-Kong Pao Hall for the Visual and Performing Arts, Purdue University
552 West Wood Street, West Lafayette, IN 47907-2002
Tel: 765.494.2787 E-mail: adgraddirector@sla.purdue.edu

w w w . s l a . p u r d u e . e d u / a p b / g r a p d

Purdue University Master of Fine Arts Program

Industrial Design Interior Design Studio Arts and
Photography Visual Communications Design
Interior Design Studio Arts

1_____

1_____
DESIGN FIRM
Purdue University
West Lafayette, (IN) USA
PROJECT
Master of Fine Arts 2005
DESIGNER, ILLUSTRATOR, PHOTOGRAPHER
Li Zhang

2_____
DESIGN FIRM
EMartinDesigns
Liverpool, (NY) USA
PROJECT
Bobby McFerrin
Concert Poster
DESIGNER
Eric Martin

1_____

1_____
DESIGN FIRM
**Wet Paper Bag Visual
Communication**
Crowley, (TX) USA
CLIENT
Ellen Shelton, Chair,
TCU Department of
Ballet & Modern Dance
ART DIRECTOR, DESIGNER,
TYPOGRAPHER, COPYWRITER
Lewis Glaser
PHOTOGRAPHER
Richard Lane

2_____

DESIGN FIRM
At First Sight
Ormond, Australia

PROJECT
Career Advisers' Seminar Poster

DESIGNERS
Barry Selleck,
Olivia Brown

1 _____

DESIGN FIRM
Jeremy Schultz
West Des Moines, (IA) USA

PROJECT
Cityview 12th Anniversary Poster

DESIGNER
Jeremy Schultz

2_____

2_____
DESIGN FIRM
Joe Miller's Company
Santa Clara, (CA) USA
CLIENT
anotherposterforpeace.org
DESIGNER
Joe Miller

1_____
DESIGN FIRM
Mayhem Studios
Los Angeles, (CA) USA
PROJECT
FMC Poster
DESIGNER
Calvin Lee

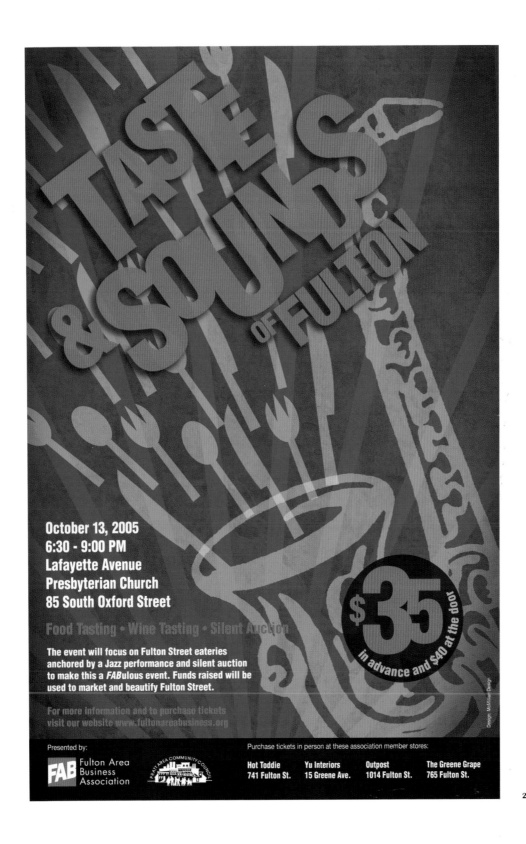

DESIGN FIRM
McMillian Design
Brooklyn, (NY) USA

CLIENT
Fulton Area Business Association

ART DIRECTOR, DESIGNER
William McMillian

1_____

1_____
DESIGN FIRM
Ellen Bruss Design
Denver, (CO) USA
CLIENT
Ellen Bruss Design
CREATIVE DIRECTOR
Ellen Bruss
DESIGNERS
Jorge Lamora,
Charles Carpenter,
Maurice Becnel

SYNTH
THESIS
DIS
TRIBUT
TION

SYNTHESIS AND DISTRIBUTION: EXPERIMENTS IN COLLABORATION

CURATED BY WILL PAPPENHEIMER, RON JANOWICH AND MERIJN VAN DER HEIJDEN
PACE UNIVERSITY ART GALLERIES

CHARLIE AHEARN AND COLETTE
JULIE ANDREYEV AND VJ FLEET
MIA BROWNELL AND MARTIN X PUCK
MARY CARLSON, JEANNE SILVERTHORNE AND MONICA DE LA TORRE
BARBARA CIUREJ AND LINDSAY LOCHMAN
LYNN CAZABON AND HASAN ELAHI
ART CLAY AND GUNTER HEINZ
ANGIE DRAKOUPOLIS AND DANIEL HILL
LAUREN GARBER, TATE BUNKER AND NEILL ELLIOTT
ROBIN HILL AND STEPHEN KALTENBACH WITH LAURIE SAN MARTIN AND SAMUEL NICHOLS
LAS HERMANAS IGLESIAS
LAURA LISBON AND SUZANNE MAURA SILVER
KRISTIN LUCAS AND FACT
MICHAEL MANDIBERG AND JULIE STEINMETZ
JILLIAN MCDONALD, KELTY MCKINNON AND BECKLEY ROBERTS
JOHN MILLER AND TAKUJI KOGO
WILL PAPPENHEIMER AND GREGORY ULMER
SAL RANDOLPH AND GLOWLAB
AURA ROSENBERG, JANE DICKSON AND "WHO AM I?" ARTISTS
ROBIN TEWES AND MARK TANSEY
MERIJN VAN DER HEIJDEN AND RON JANOWICH

2_____

2_____
DESIGN FIRM
Connie Hwang Design
Gainesville, (FL) USA
PROJECT
Synthesis and Distribution
Exhibition Poster
DESIGNER
Connie Hwang

R E B O Z O S
MICHOACANOS

Exposición
Del 1 al 30 de septiembre de 2003
Casa de las Artesanías

Una extensa colección de rebozos de todas las regiones de Michoacán.
Piezas elaboradas artesanalmente por manos michoacanas.
Disfruta estas prendas que son un mosaico de sentidos, dibujos, hilos y colores,
cada uno representa una expresión distinta de nuestras tradiciones.

Consume lo nuestro....

Septiembre, mes de rebozos michoacanos

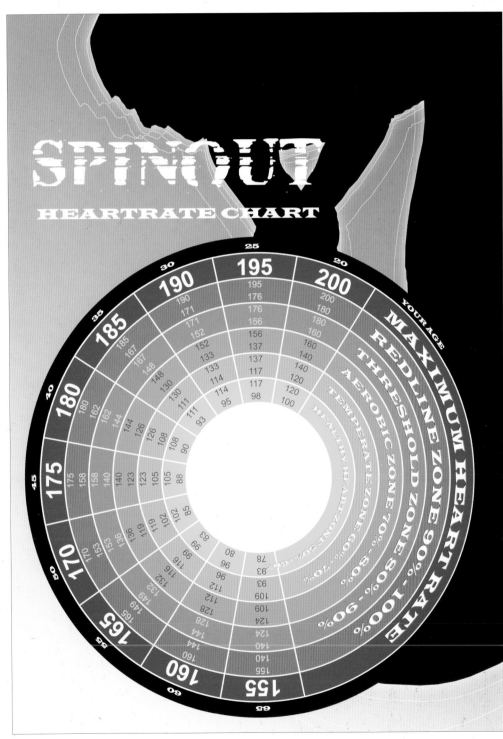

SPINOUT
HEARTRATE CHART

1_____
DESIGN FIRM
**Caracol
Consultores SC**
Morelia, Mexico
CLIENT
Casa de las Artesanias
de Michoacán, Mexico
ART DIRECTOR
Luis Jaime Lara Perea
DESIGNERS
Luis Jaime Lara,
Myriam Zavala
PHOTOGRAPHER
Luis Jaime Lara

2_____
DESIGN FIRM
At First Sight
Ormond, Australia
PROJECT
Spinout Poster
DESIGNERS
Barry Selleck,
Olivia Brown

2_____

1

1
DESIGN FIRM
John Wingard Design
Honolulu, (HI) USA
CLIENT
Hewg Productions, Inc.
DESIGNER
John Wingard

2
DESIGN FIRM
Images & Digital Design
Half Moon Bay, (CA) USA

An
Alfred Hitchcock
Production

LIFEBOAT

by John Steinbeck

1_____

1_____
DESIGN FIRM
30sixty Advertising+Design
Los Angeles, (CA) USA
CLIENT
20th Century Fox
Home Entertainment International
CREATIVE DIRECTOR
Henry Vizcarra
ART DIRECTOR
David Fuscellaro

2

DESIGN FIRM
kristincullendesign
Cincinnati, (OH) USA

CLIENT
University of Cincinnati,
College of Design, Architecture,
Art, and Planning

DESIGNER
Kristin Cullen

At left, the 1959 Varsity Basketball team prepares for a game with Joe Girard leading the team onto the court.
The 1951 football team, at right, works on its blocking skills.

the Fabulous

Bob Consadine and Tom Philo, at right, smile their approval of the sign, after SMA won the Baseball Championship of the Northern Conference for 1955. Below, tumblers Harold Brooks, Robert Rheinlander, Richard O'Brien and James Counter show their stuff.

1950s

1 _____

1 _____
DESIGN FIRM
Lehman Graphic Arts
Queensbury, (NY) USA
PROJECT
LGA Poster
DESIGNER
Lisa M. Lehman

2

2

DESIGN FIRM
Atomic Design
Crowley, (TX) USA

CLIENT
Atomic Design

DESIGNER, COPYWRITER
Lewis Glaser

1_____

1_____
DESIGN FIRM
Mendes Publicidade
Belém, Brazil
PROJECT
Cartaz do Círio 2005
DESIGNERS
Oswaldo Mendes,
Maria Alice Penna,
Walda Marques

HOLISTIC MEDICINE AND SOUL-BODY DUALISM IN PLATO

A BROWN BAG LECTURE BY COLEEN ZOLLER, ASSISTANT PROFESSOR OF PHILOSOPHY

SEPTEMBER 23, 2005 | 11:30 AM–12:30 PM | SHEARER DINING ROOMS 2 & 3

2_____

DESIGN FIRM
MFDI
Selinsgrove, (PA) USA
PROJECT
Plato Poster
DESIGNER
Mark Fertig

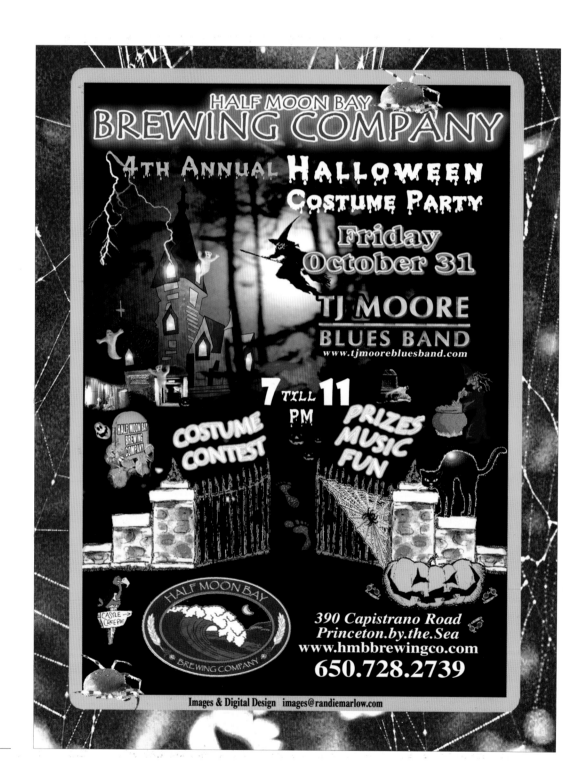

DESIGN FIRM
Images & Digital Design
Half Moon Bay, (CA) USA

2_____
DESIGN FIRM
Purdue University
West Lafayette, (IN) USA
PROJECT
Chinese Character
DESIGNER, PHOTOGRAPHER, ILLUSTRATOR
Li Zhang

1

1
DESIGN FIRM
Wet Paper Bag
Visual Communication
Crowley, (TX) USA
CLIENT
Keitha Manning,
American Dance Association
DESIGNER, ILLUSTRATOR, COPYWRITER
Lewis Glaser

2_____
DESIGN FIRM
MFDI
Selinsgrove, (PA) USA
PROJECT
Mars Poster
DESIGNER
Mark Fertig

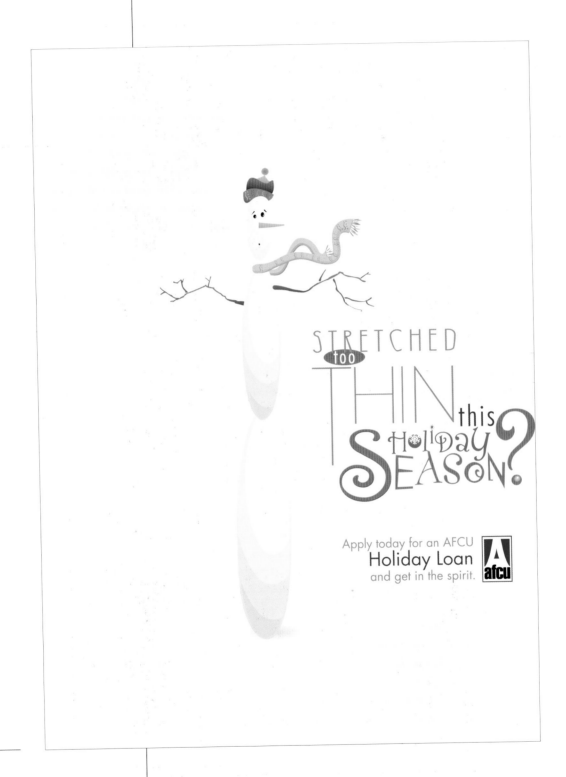

1
DESIGN FIRM
Rottman Creative
Laplata, (MD) USA
PROJECT
AFCU Snowman
DESIGNERS
Gary Rottman,
Robbie Whetzel,
Mary Rottman

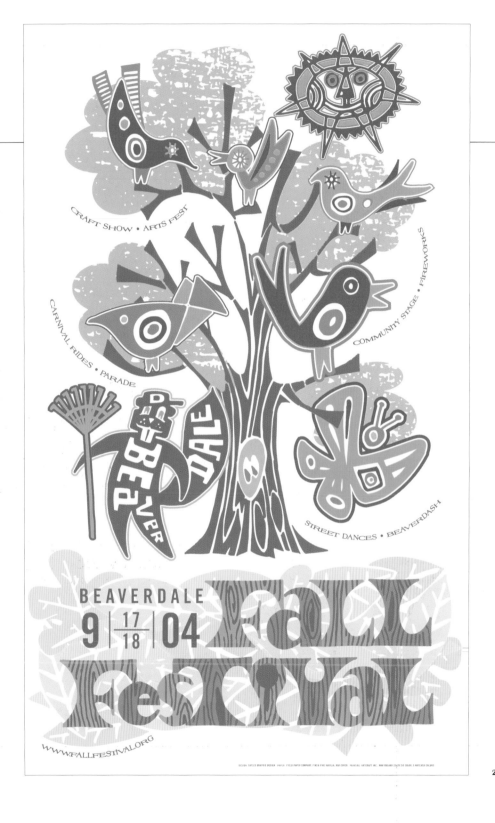

2_____
DESIGN FIRM
Sayles Graphic Design
Des Moines, (IA) USA
PROJECT
Beaverdale Fall Festival
DESIGNER, ILLUSTRATOR
John Sayles

1_____

1_____
DESIGN FIRM
John Wingard Design
Honolulu, (HI) USA
CLIENT
Kamaka Hawaii
ART DIRECTOR, DESIGNER
John Wingard
PHOTOGRAPHER
Bud Muth Photography

WE HOLD THESE TRUTHS
TO BE SELF-EVIDENT
THAT
ALL MEN ARE CREATED EQUAL
THAT THEY ARE ENDOWED
BY THEIR CREATOR
WITH
CERTAIN UNALIENABLE RIGHTS
THAT
AMONG THESE ARE LIFE, LIBERTY
AND THE PURSUIT OF HAPPINESS.

2_____

2_____
DESIGN FIRM
Atomic Design
Crowley, (TX) USA
CLIENT
Wet Paper Bag Graphic Design
DESIGNER
Lewis Glaser
COPYWRITER
Thomas Jefferson

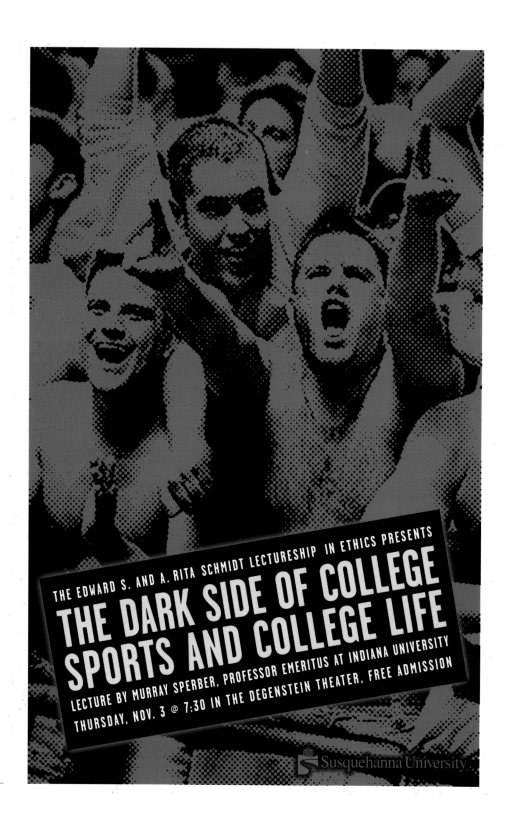

1_____

1_____
DESIGN FIRM
MFDI
Selinsgrove, (PA) USA
PROJECT
The Dark Side Poster
DESIGNER
Mark Fertig

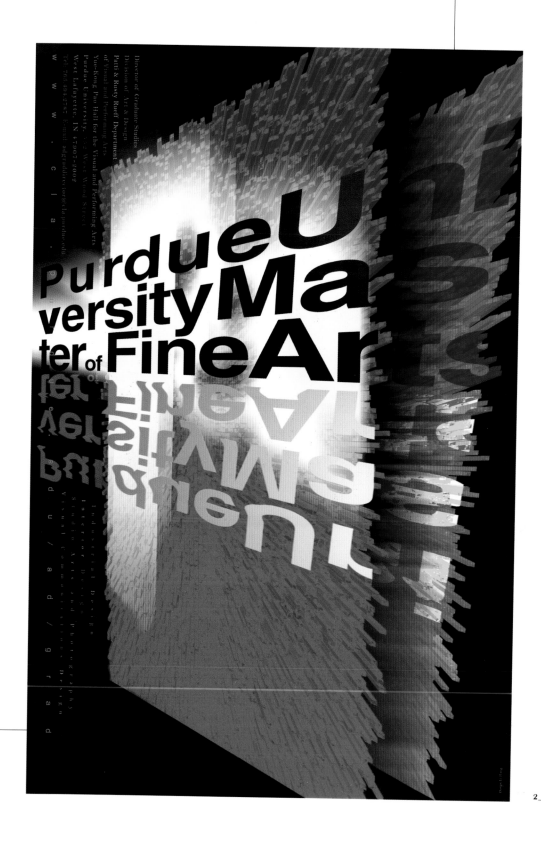

2

DESIGN FIRM
Purdue University
West Lafayette, (IN) USA
PROJECT
Master of Fine Arts 2006
DESIGNER, PHOTOGRAPHER, ILLUSTRATOR
Li Zhang

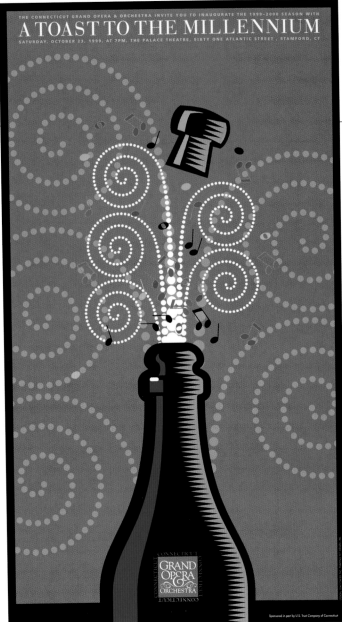

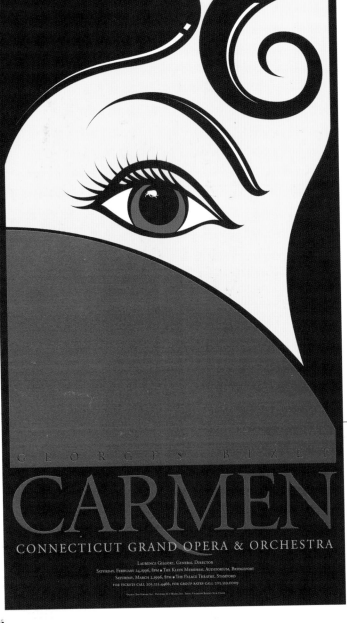

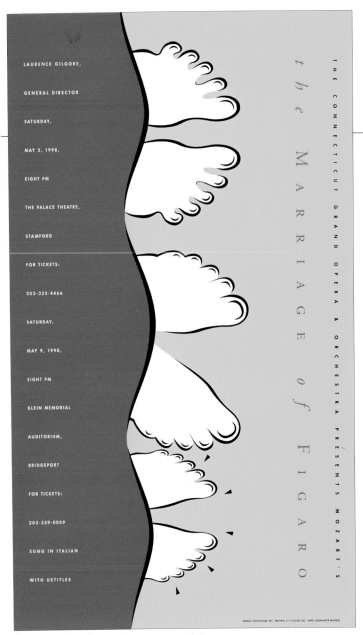

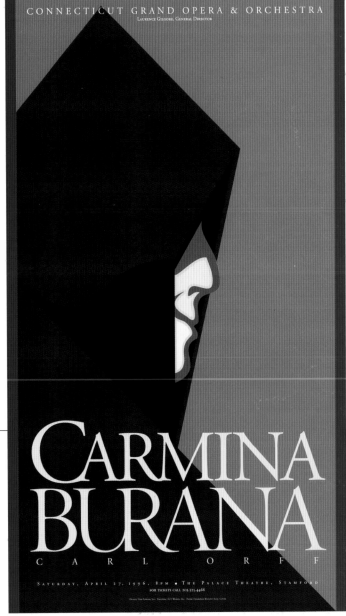

DESIGN FIRM
Tom Fowler, Inc.
Norwalk, (CT) USA
CLIENT
Connecticut Grand Opera & Orchestra
ART DIRECTOR, DESIGNER, ILLUSTRATOR
Tom Fowler
PRINTER
H.T. Woods

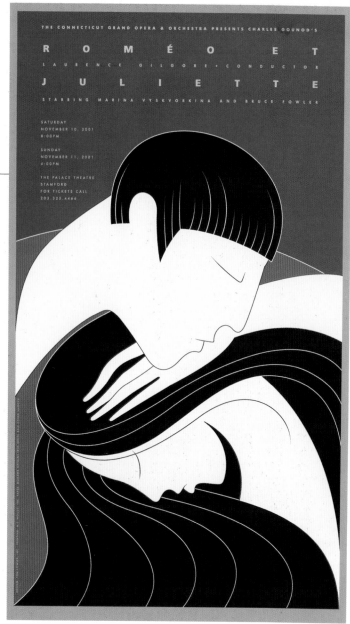

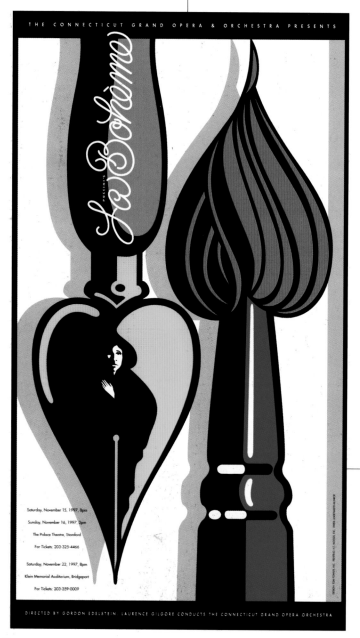

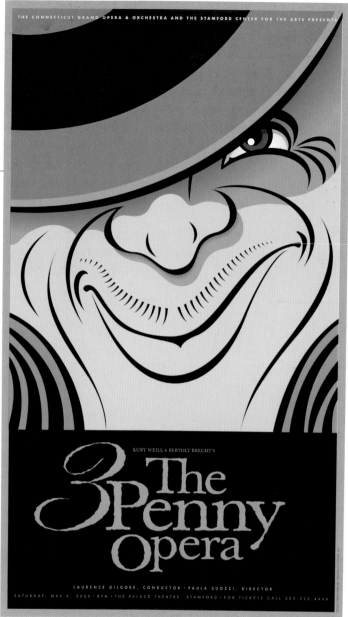

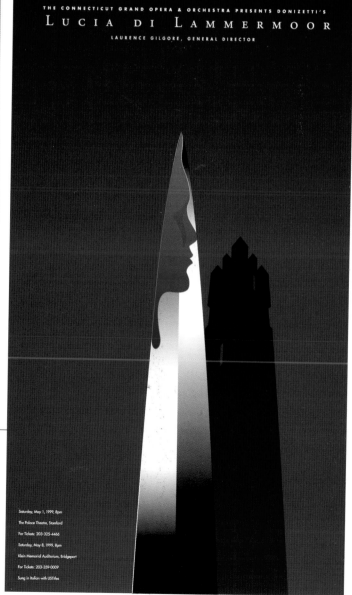

DESIGN FIRM
Tom Fowler, Inc.
Norwalk, (CT) USA
CLIENT
Connecticut Grand Opera & Orchestra
ART DIRECTOR, DESIGNER, ILLUSTRATOR
Tom Fowler
PRINTER
H.T. Woods

kisses on platform 2
a documentary about kissing

2
KISSES ON PLATFORM 2

PERTH BRISBANE 24C GF 598 23FEB

the journey

dates

Every single country has their significant
kissing icons, histories, cultures, rules, norms,
laws, habits, costumes. But most importantly
there are interesting local people with stories
about this inevitable and instinctive sign of
affection, the kiss!

So, the three girls set out from Australia as low
budget backpackers roughing it half-way across
the world. Moving by bus, train, boat, plane,
jeep, camel and when all else fails foot, towards
their final destination. They chase the story of
the original kiss in a hope to better understand
this expression of love that has spread like fire
across the world.

In Australia we will travel through some popular
Australian cities as well as the world-renowned
Australian outback, comparing how these different
lifestyles affect kissing habits within
Australia. We also get back to the countries
roots by passing through central Australia to get
an insight into the indigenous views on kissing.

05 FEB 2005

01 MAR 2005

17 MAR 2005

01 APR 2005

24 APR 2005

08 MAY 2005

30 MAY 2005

19 JUN 2005

02 JUL 2005

06 JUL 2005

13 AUG 2005

27 AUG 2005

09 SEP 2005

23 SEP 2005

13 OCT 2005

29 OCT 2005

16 NOV 2005

23 NOV 2005

1_____

DESIGN FIRM
Engrafik
Oslo, Norway

CLIENT
Kisses on Platform 2

CREATIVE DIRECTOR, DESIGNER
Reinert Korsbøen

TYPE DESIGN

A Tribute To Bodoni

"Studying typography is not only exhilarating but fundamentally imperative for any graphic designer."
~Eric R. Martin

2_____

2_____
DESIGN FIRM
EMartinDesigns
Liverpool, (NY) USA
PROJECT
A Tribute to Bodoni
DESIGNER
Eric Martin

1_____
DESIGN FIRM
Images & Digital Design
Half Moon Bay, (CA) USA

2_____

2_____
DESIGN FIRM
Peterson Ray & Company
Dallas, (TX) USA
CLIENT
Arlington Chinese Bible Church
CREATIVE DIRECTOR, DESIGNER
Miler Hung

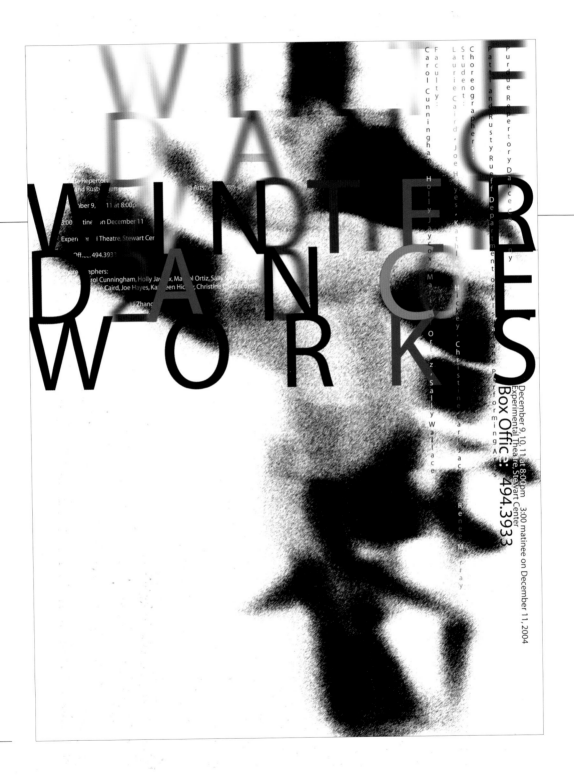

1_____

1_____
DESIGN FIRM
Purdue University
West Lafayette, (IN) USA
PROJECT
Winter Dance Works 2004
DESIGNER, PHOTOGRAPHER, ILLUSTRATOR
Li Zhang

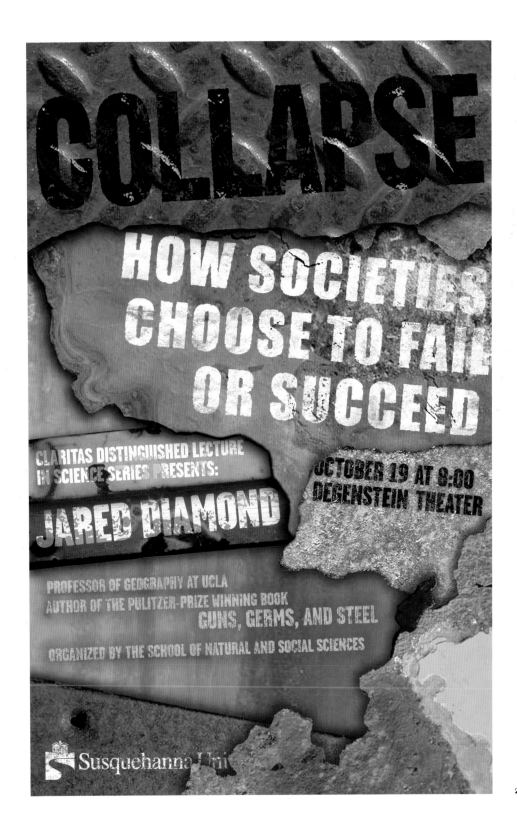

2_____
DESIGN FIRM
MFDI
Selinsgrove, (PA) USA
PROJECT
Collapse Poster
DESIGNER
Mark Fertig

353

- FRIENDSHIPS
- MENTORING
- FELLOWSHIP
- MUSIC
- FUN
- HOPE
- CRAFTS
- HELP
- ACCOUNTABILITY
- BALANCE

www.you
growgirl.org

you grow, girl

1_____

1_____
DESIGN FIRM
Sayles Graphic Design
Des Moines, (IA) USA
PROJECT
You Grow Girl Poster
DESIGNER, ILLUSTRATOR
John Sayles

2_____

2_____
DESIGN FIRM
Terri DeVore
 Hewitt, (TX) USA
PROJECT
 Mad Hatter Poster
DESIGNER
 Terri DeVore

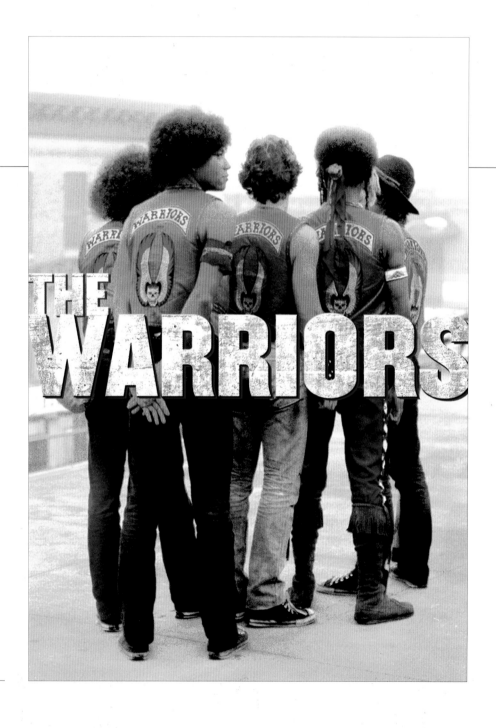

1_____

1_____
DESIGN FIRM
30sixty Advertising+Design
Los Angeles, (CA) USA
CLIENT
Paramount
Home Entertainment
CREATIVE DIRECTOR
Henry Vizcarra
ART DIRECTOR
David Fuscellaro

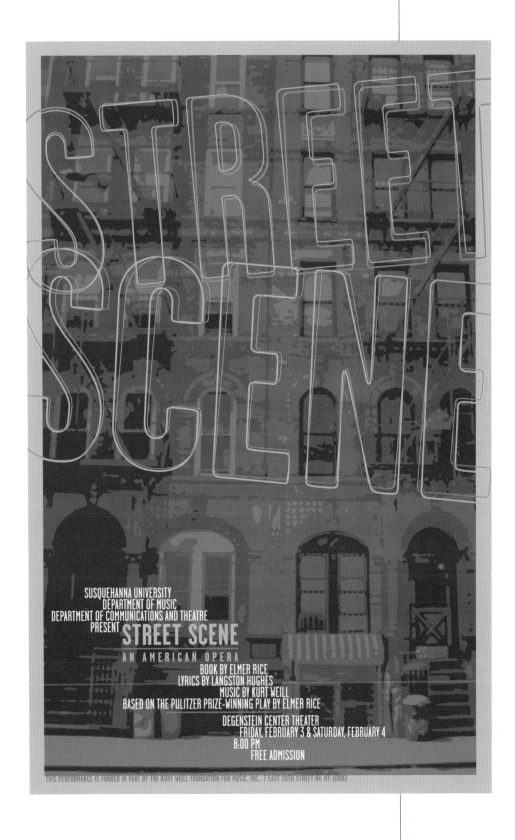

2_____
DESIGN FIRM
MFDI
 Selinsgrove, (PA) USA
PROJECT
 Street Scene Poster
DESIGNER
 Mark Fertig

1 _____

1 _____
DESIGN FIRM
The Bubble Process
Brooklyn, (NY) USA
DESIGNERS
Nicholas Rezabek,
Sean Higgins

DESIGN FIRM
Octavo Designs
Frederick, (MD) USA
CLIENT
New York New York Salon and Day Spa
ART DIRECTOR, DESIGNER
Sue Hough

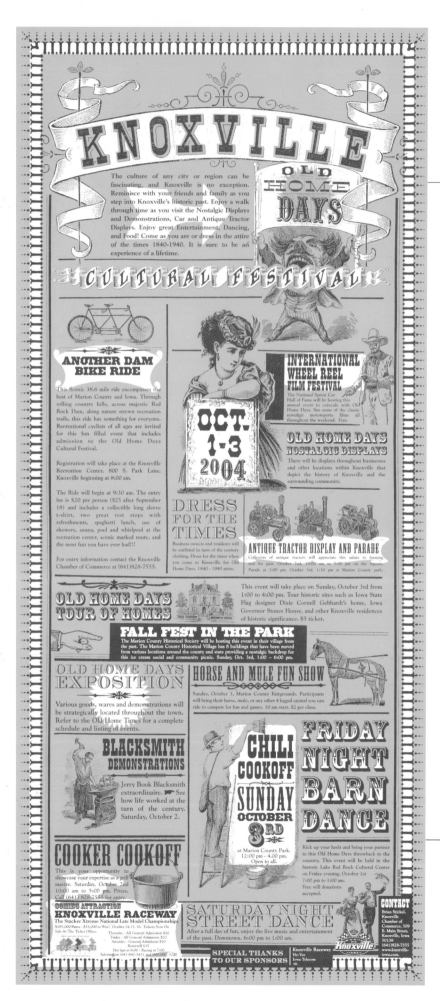

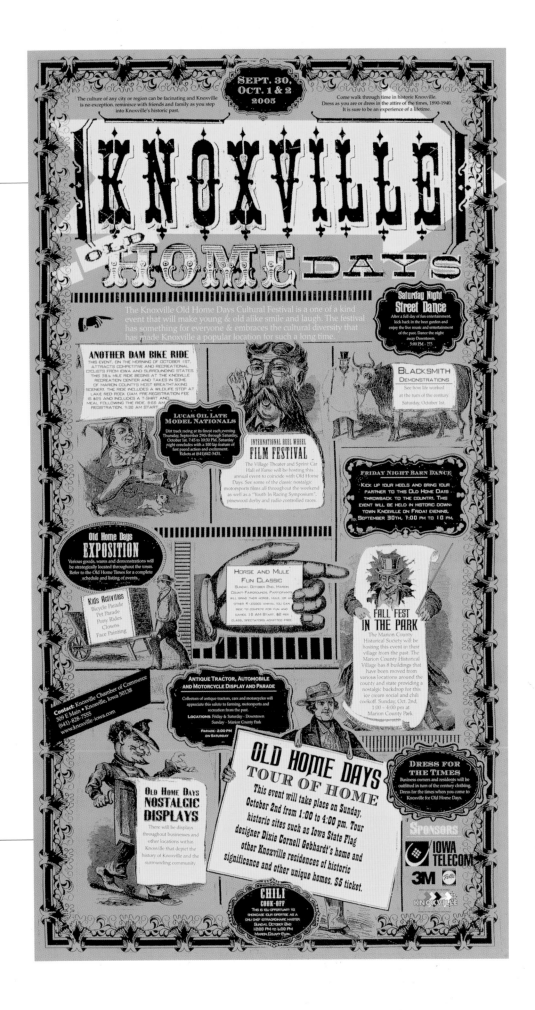

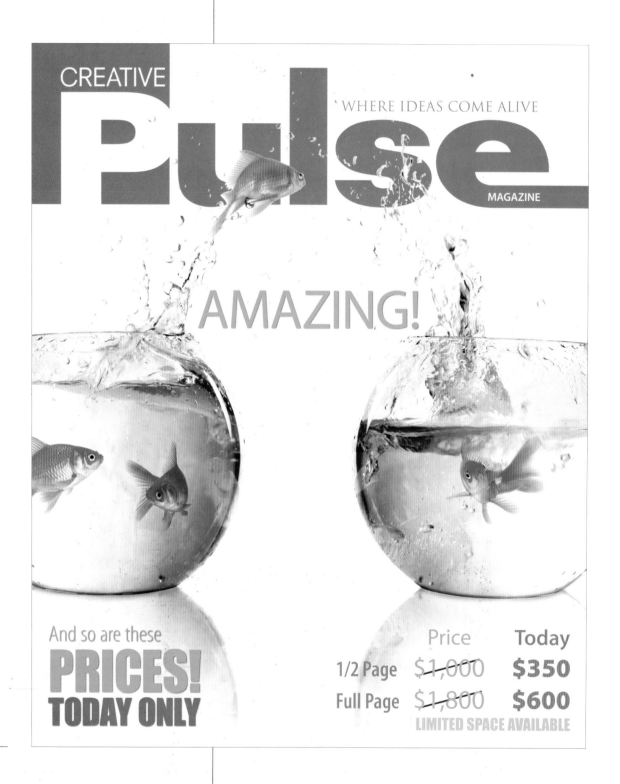

1_____

1_____
DESIGN FIRM
TAMAR Graphics
Waltham, (MA) USA
CLIENT
Creative Pulse Magazine,
Dalton Publishing
DESIGNER
Tamar Wallace

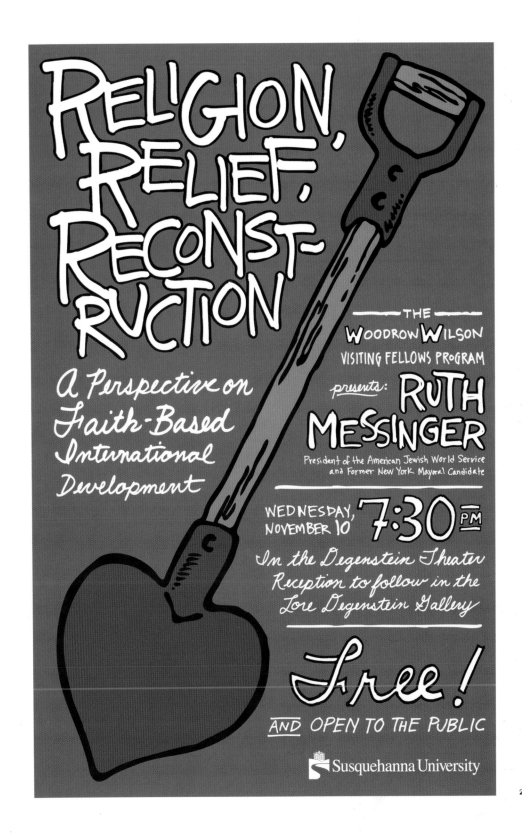

DESIGN FIRM
MFDI
Selinsgrove, (PA) USA
PROJECT
Wilson Lecture Poster
DESIGNER
Mark Fertig

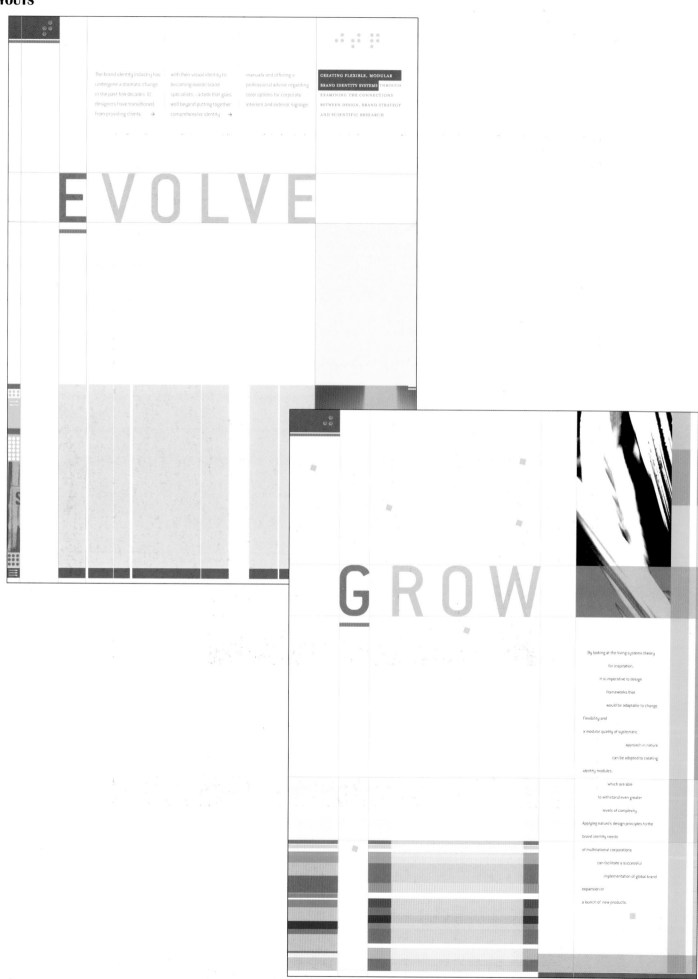

The brand identity industry has undergone a dramatic change in the past few decades. 3D designers have transitioned from providing clients →

with their visual identity to becoming overall brand specialists – a task that goes well beyond putting together comprehensive identity →

manuals and offering a professional advise regarding color options for corporate interiors and exterior signage.

CREATING FLEXIBLE, MODULAR BRAND IDENTITY SYSTEMS THROUGH EXAMINING THE CONNECTIONS BETWEEN DESIGN, BRAND STRATEGY AND SCIENTIFIC RESEARCH

EVOLVE

GROW

By looking at the living systems theory for inspiration, it is imperative to design frameworks that would be adaptable to change. Flexibility and a modular quality of systematic approach in nature can be adapted to creating identity modules, which are able to withstand even greater levels of complexity. Applying nature's design principles to the brand identity needs of multinational corporations can facilitate a successful implementation of global brand expansion or a launch of new products.

By scrutinizing a global conglomerate as if it were an ecosystem, I can then apply the living system's principles to create a brand strategy which works with the corporate business plan. By allowing for an existence of flexible and evolving relationships between brand components (i.e., corporate brand, sub-brands, endorsed brands, independently branded products and services, etc.), I can create relevant and effective brand architecture, which is able to withstand and adapt to the test of time and changes in economic, political and cultural infrastructures.

DESIGN FIRM
substance 151
Baltimore, (MD) USA
PROJECT
"Evolve", "Grow", "Change" Poster Series
DESIGNER
Ida Cheinman

SPONSORED BY THE DEPARTMENTS OF HISTORY AND CREATIVE WRITING

Susquehanna

OCT. 7, 2004 AT 7:30 ISAACS AUDITORIUM

2 MINUTES OF HISTORY

DAVID MARGOLICK

Contributing editor to *Vanity Fair* magazine,
Four-time Pulitzer Prize Nominee

1_____

1_____
DESIGN FIRM
MFDI
Selinsgrove, (PA) USA
PROJECT
2 Minutes Poster
DESIGNER
Mark Fertig

2_____

2_____
DESIGN FIRM
30sixty Advertising+Design
Los Angeles, (CA) USA
CLIENT
Paramount
Home Entertainment
CREATIVE DIRECTOR
Henry Vizcarra
ART DIRECTOR
David Fuscellaro

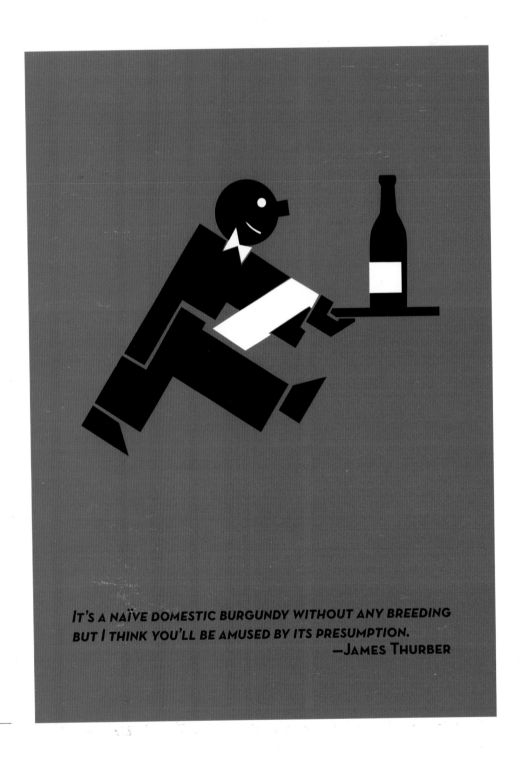

IT'S A NAÏVE DOMESTIC BURGUNDY WITHOUT ANY BREEDING
BUT I THINK YOU'LL BE AMUSED BY ITS PRESUMPTION.
—JAMES THURBER

1 _____

1 _____
DESIGN FIRM
Acme Communications, Inc.
New York, (NY) USA
PROJECT
Wine Waiter Poster
DESIGNER
Kiki Boucher

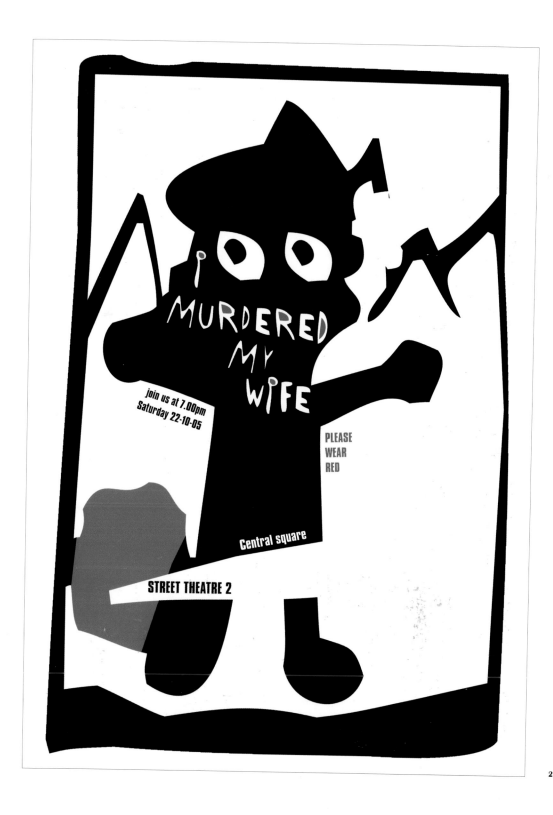

2 _____
DESIGN FIRM
Vaca Loca
Thessaloniki, Greece
DESIGNERS
Joanna Adamogianni,
Olga Chrysochoou

1_____

1_____
DESIGN FIRM
Sayles Graphic Design
Des Moines, (IA) USA
PROJECT
2004 Junior Olympic Games
DESIGNER, ILLUSTRATOR
John Sayles

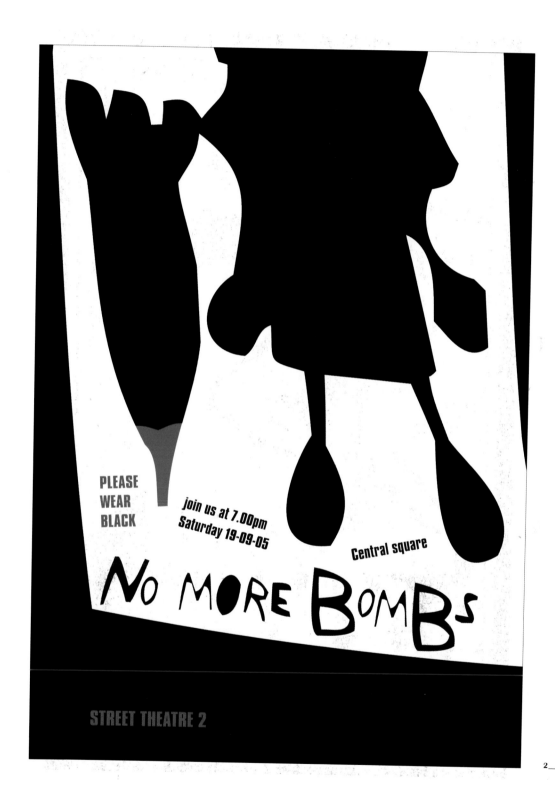

2_____
DESIGN FIRM
Vaca Loca
Thessaloniki, Greece
DESIGNERS
Joanna Adamogianni,
Olga Chrysochoou

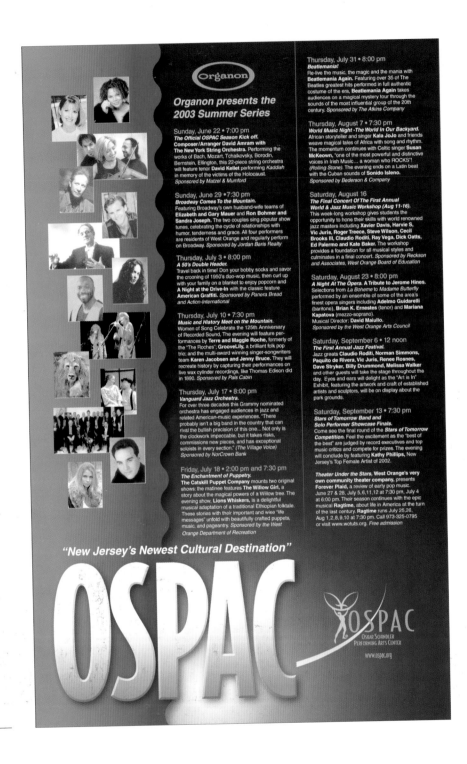

RESPECT OUR DIFFERENCES

R E S P E C T

Put Downs, Ethnic, Homophobic, Racial, and Sexist Remarks Are Not Accepted in Our School.

2_____

2_____
DESIGN FIRM
Octavo Designs
Frederick, (MD) USA
CLIENT
National Association of
School Psychologists
ART DIRECTOR, DESIGNER
Sue Hough

1_____
DESIGN FIRM
Sports Endeavors
Cary, (NC) USA
PROJECT
Coaches Show
CREATIVE DIRECTOR
Robert Stein
DESIGNER
Katie Guess

2_____

DESIGN FIRM
Sayles Graphic Design
Des Moines, (IA) USA

PROJECT
Drake University Student Activities Board
Ben Folds Concert Poster

DESIGNER, ILLUSTRATOR
John Sayles

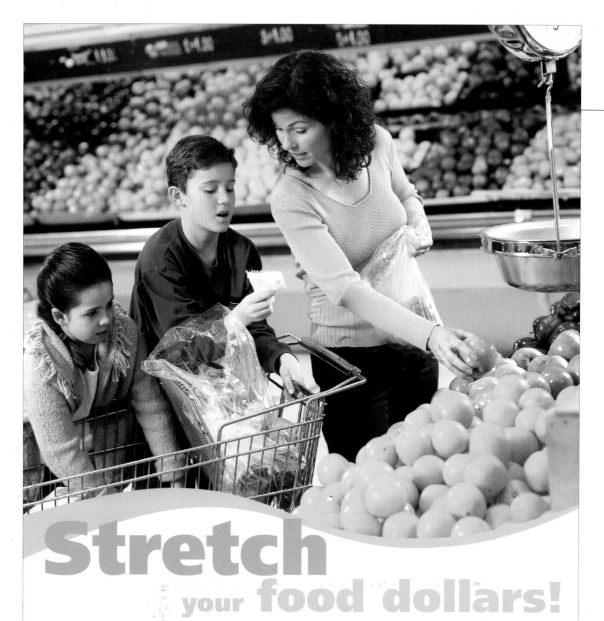

Stretch
your food dollars!

**Use a shopping list to help stretch your food budget
and make healthy choices at the grocery store.**

To find out more about eating healthy and being active, visit the *Eat Smart, Be Fit, Maryland!* website at:

www.eatsmart.umd.edu

EQUAL ACCESS PROGRAMS
Funding for the Food Stamp Nutrition Education Program provided
by USDA in cooperation with the Maryland Department of Human
Resources and the University of Maryland.

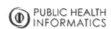
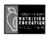
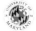

PUBLIC HEALTH
INFORMATICS

MARYLAND
COOPERATIVE
EXTENSION

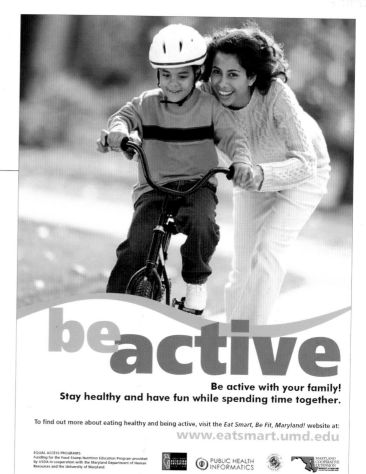

be active

Be active with your family!
Stay healthy and have fun while spending time together.

To find out more about eating healthy and being active, visit the *Eat Smart, Be Fit, Maryland!* website at:

www.eatsmart.umd.edu

EQUAL ACCESS PROGRAMS
Funding for the Food Stamp Nutrition Education Program provided
by USDA in cooperation with the Maryland Department of Human
Resources and the University of Maryland.

PUBLIC HEALTH INFORMATICS

MARYLAND COOPERATIVE EXTENSION

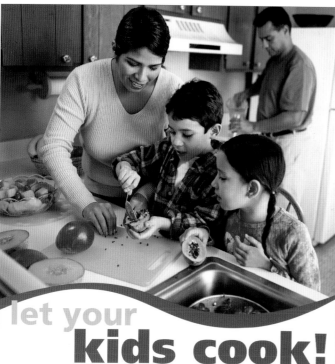

let your
kids cook!

Kids who help prepare meals and snacks
are often more willing to try new foods.

To find out more about eating healthy and being active, visit the *Eat Smart, Be Fit, Maryland!* website at:

www.eatsmart.umd.edu

EQUAL ACCESS PROGRAMS
Funding for the Food Stamp Nutrition Education Program provided
by USDA in cooperation with the Maryland Department of Human
Resources and the University of Maryland.

PUBLIC HEALTH INFORMATICS

MARYLAND COOPERATIVE EXTENSION

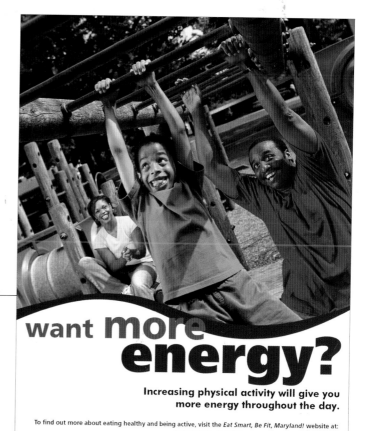

want more energy?

Increasing physical activity will give you
more energy throughout the day.

To find out more about eating healthy and being active, visit the *Eat Smart, Be Fit, Maryland!* website at:

www.eatsmart.umd.edu

EQUAL ACCESS PROGRAMS
Funding for the Food Stamp Nutrition Education Program provided
by USDA in cooperation with the Maryland Department of Human
Resources and the University of Maryland.

PUBLIC HEALTH INFORMATICS

MARYLAND COOPERATIVE EXTENSION

DESIGN FIRM
University of Maryland
Cooperative Extension—FSNE
Columbia, (MD) USA

CLIENT
The University of Maryland Cooperative Extension—
Food Stamp Nutrition Education Program

DESIGNERS
Amy Billing, Trang Dam, Meredith Pearson

1

1
DESIGN FIRM
Ray Braun Design
Seattle, (WA) USA
PROJECT
"Enemy of the People" Poster
DESIGNER, ILLUSTRATOR
Ray Braun

DESIGN FIRM
Sayles Graphic Design
Des Moines, (IA) USA
PROJECT
Designer Show House Poster
DESIGNER, ILLUSTRATOR
John Sayles

DESIGN FIRM
Sports Endeavors
Cary, (NC) USA
PROJECT
Relay For Life Series
CREATIVE DIRECTOR
Robert Stein
DESIGNER
Katie Guess

DESIGN FIRM
30sixty Advertising+Design
Los Angeles, (CA) USA
CLIENT
New Line Home Entertainment
CREATIVE DIRECTOR
Henry Vizcarra
ART DIRECTOR
Pär Larsson

INDEX